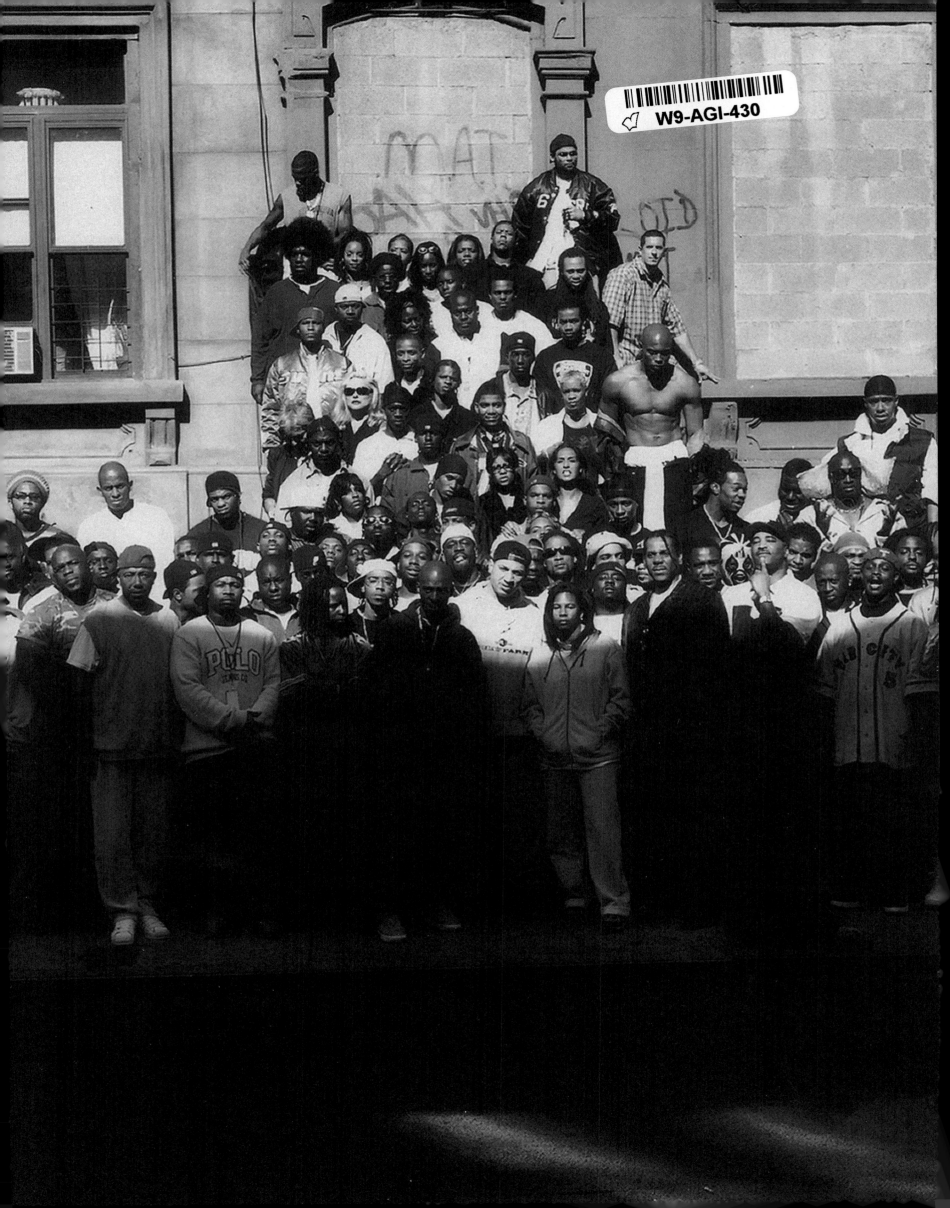

CONTACT HIGH: A VISUAL HISTORY OF HIP-HOP is an inside look at the work of hip-hop photographers told through their most intimate diaries—their contact sheets. Featuring rare outtakes from over 100 photo shoots alongside interviews and essays from industry legends, this gorgeous book takes readers on a chronological journey from old-school to alternative hip-hop, and from analog to digital photography. The ultimate companion for music and photography enthusiasts, **CONTACT HIGH** is a definitive history of hip-hop's early days, celebrating the artists who shaped the iconic album covers, T-shirts, and posters beloved by rap and hip-hop fans today.

CONTACT HIGH

CONTACT

CLARKSON POTTER/PUBLISHERS
NEW YORK

HIGH

A VISUAL HISTORY OF HIP-HOP

VIKKI TOBAK

CONTENTS

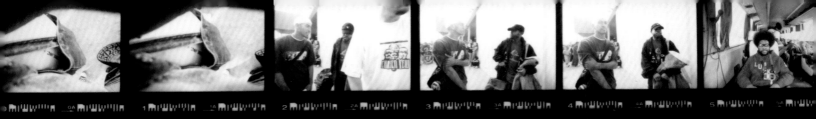

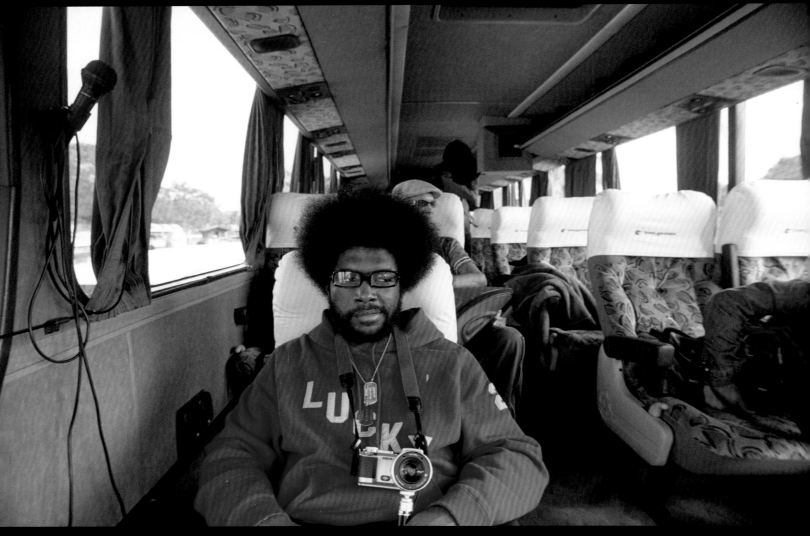

FOREWORD

BY QUESTLOVE

You know how people used to say that children should be seen and not heard? Well, music should be seen and heard. I grew up looking at pictures of the artists I loved, on album covers and in magazines and newspapers, and what I saw helped define what I heard. Many early rap albums used their covers to introduce themselves to their listening public. Sometimes that was literal: on DJ Jazzy Jeff and the Fresh Prince's breakthrough second album, He's the DJ, I'm the Rapper, *the title laid it all out for you. But sometimes it was more conceptual. I remember the cover of Run-DMC's* King of Rock, *where the duo's foreheads poked up just above the horizon line, DMC's glasses perched just so on top of his fedora. That album made a brave choice to move the focus away from the artists' faces, which somehow just made them more intriguing.*

Both of those albums had a sound that matched the way they looked, and there are so many other cases of that in hip-hop, such as the Three Stooges–like comedy of the Fat Boys' covers or the muscular simplicity of Kurtis Blow's covers. Mostly, it was eye-opening to see these artists who weren't that much older than I was, who came from cities not so different from Philadelphia, where I grew up. In the case of DJ Jazzy Jeff and the Fresh Prince, it was almost exactly like Philadelphia. That stuck with me, because when I looked at mainstream music at that time, I saw people who didn't look like me. I could look at soul or jazz, but those people were either my dad's age or they came from his time. But hip-hop looked like me.

When I think of the history of music, I also think of the history of music photography, and when I think of the history of music photography, my mind goes right to jazz. I think of the work Francis Wolff did for Blue Note, which (in conjunction with the design of Reid Miles) became a central part of the label's entire identity; of William Gottlieb's portraits of Billie Holiday and Louis Armstrong; and of the amazing Miles Davis photos taken by Irving Penn. I think of jazz first because it's further back in history; the faces and poses have had more time to turn into icons. It's just as true for soul music, for James Brown rising up from a split, for Marvin Gaye looking pensive on *What's Going On,* for Stevie, for Aretha, for Michael. And rock and roll, of course: when I say a name, whether it's Springsteen or Jagger or Dylan, the first thing that springs to mind isn't a snatch of melody, but a picture.

From the start, The Roots always tried to think about album art as a central part of our mission. Initially, because we were trying to make a name for ourselves and get recognized. Our album covers were portraits of the band. We followed the template that was established by all the people I mentioned above, and more, though it's worth noting that from the very start, we channeled the jazzy, Blue Note look, as a kind of touchstone to the music that came before hip-hop.

Ultimately, however, we broke the portrait mold, along with everything else, for *Things Fall Apart,* in 1999. For that album, we worked with art director Kenny Gravillis, who was often our partner in crime for our covers. Like many of our records, *Things Fall Apart* had a theme. It looked at issues of social unrest, social injustice, and the shakiness of human existence. Because of this, we wanted the title to resonate with people on three levels: as commentary on our band, on the hip-hop scene, and on the world around us, and we wanted people to begin to contend with those concepts from the moment they first encountered the album cover.

Later on, we opted for illustrations on our album covers, but then on *undun,* which came out in 2011, we went back to the streets and back to photography, using an image taken by the legendary New York street photographer Jamel Shabazz. We used the cover photo of *Seconds of My Life,* the 2007 collection of Jamel's photos, which was an amazing shot of three boys outside, two of them flanking the third as he's doing a backflip over an old mattress left out on the street. That image, titled "Fying High," had so many sides to it: innocence, hope, altitude, the inevitable fall. We ultimately used a black-and-white version of the shot because it looked more like the record sounded.

When I was young, I thought of iconic photos as the truth. They were so powerful, and they stayed in your mind. But the facts behind how those photos come to be are so much more complicated. Those shots are selected from a stream of Things Seen, in other words, part of a collection of many photos that exist of the moment one second before it, or one second after, or ten degrees to the right, or ten degrees to the left. Somehow, through the magic of the human eye, that one particular image comes to represent not just the moment, but the meaning of the moment. I love thinking about everything that surrounds that moment, because it contributes to the overall story. But in the end, I always go back to that one perfect shot.

Here is another story about one perfect shot: Back in the late 1950s, the photographer Art Kane set up a gigantic group portrait of jazz stars called *A Great Day in Harlem.* He assembled dozens of singers and players on the steps of a Harlem brownstone. More than forty years after that Art Kane photo, *XXL* magazine decided that it wanted to remake it for the hip-hop generation. They issued invitations to hundreds of artists, hired the legendary photographer Gordon Parks, and used the same brownstone on East 126th Street. The shoot was on September 29, 1988, the day that I finished mastering *Things Fall Apart,* and a big day for hip-hop releases (albums out that day included Jay-Z's *Vol. 2 . . . Hard Knock Life,* OutKast's *Aquemini,* A Tribe Called Quest's *The Love Movement,* and *Mos Def and Talib Kweli Are Black Star*). The Roots were represented by four members: me and Tariq and Scratch and Kamal. At that point, we were a little bit out of the hip-hop community: we had been touring straight for five years, taking gigs in Europe and Japan, making our living playing shows that other bands didn't want. It established us, but it established us apart from everyone else. So that day was the first day we were really allowed to play reindeer games. We got to meet EPMD, and Wu-Tang, and Rakim, to see Kool Herc and Da Brat, E-40 and Wyclef. I couldn't believe how many people knew who we were. Big Pun knew us? Fat Joe knew us? Run, from Run-DMC, showed up just in time, running down the block; we cheered him on like it was *Chariots of Fire.* The final photo has something like 177 hip-hop stars in it, and just as many stories.

What are the other stories? What are the other photos that came from those stories? All across the history of hip-hop, images have worked in concert with the music to bring the music into the spotlight. Some of those images are in this book. So train your eye on them. Focus in on them. Give them exposure. And every other camera pun, too.

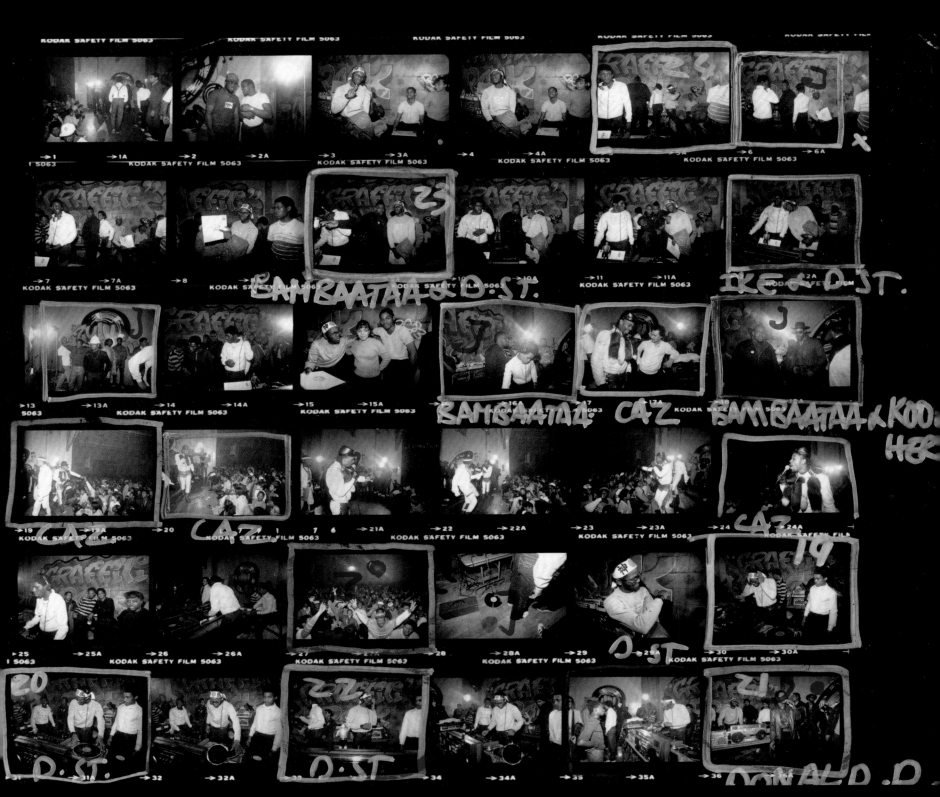

NTRODUCTION

KKI TOBAK

hotographs, like music, are imprinted onto our collective conscious-
ss. Both define our individual and cultural identities and help shape how
e view the world as well as ourselves. In the case of hip-hop, a medium that
compasses so many transformative moments from politics to race to style,
th the visuals and the music become a part of us. It's not just that one pow-
ful song that has a way of getting under your skin, it's also the visuals that
ually captivate, and stick with us for years to come. It's this union of hip-
p visuals and music that we honor in this book.

Contact High spotlights the photographers who ve played critical roles in bringing these visuals to a global stage. By tracing a timeline of almost rty plus years of hip-hop culture through contact eets, one gets a rare glimpse into the creative pro- ss. Organized chronologically, *Contact High* stands a visual archive of hip-hop—an intimate look at e making of the imagery that shaped the sound.

When I set out to do this project, I wanted focus on hip-hop's visual identity. Most people new what hip-hop sounded like but what did it ok like? For hip-hop artists, that one pose, press ot, or album cover would play a major role in aping their personas. It was in many ways, eir one shot to show the world that they had e skills, style, swagger, and bravado to be an on. And so I wanted to see more deeply how ese decisions were being made, about the ori- ns of this imagery, and how it would ultimately ape the visual culture of hip-hop.

My own love of music started when my fam- y emigrated from Kazakhstan to Detroit when was five years old. I started school not speak- g English, and it was the music on early Detroit dio, Stevie, and Aretha, and early house music, at gave me a window into what I came to under- and as America. In the early '90s at nineteen ears old, I moved to New York from Detroit and t a job at Payday Records/Empire Management. t that time, Payday represented some of the most nportant names in underground hip-hop: Jeru e Damaja, Showbiz & A.G., Masta Ace, Mos ef's first group, Jay-Z's first singles deal—but ang Starr is what the label was really known r. I worked with them, as the director of public- y and marketing, as they were recording *Hard to arn*. I would accompany them on all their shoots nd interviews, and I got immersed in that world. learned what it was like to see the images being reated in real time. Later, I became a music and ulture journalist interviewing new artists for *ibe, Paper, ego trip*, and *Mass Appeal*, who were ind enough to host the *Contact High* series as I esearched for this book. Working closely with hose artists and witnessing hip-hop's nascent imes laid the foundation for my love of hip-hop

Hip-hop has always been about innovation, about making something out of little or noth- ing. In the early days, a sold-out show could be made from two turntables, a microphone, a piece of cardboard, and a can of spray paint. The per- formers at these shows were rebels and storytell- ers, artists and visionaries, who understood the power of words and the power of imagery, and so did the photographers who captured them. From portraits created in the studio to documen- tary-style shots, the photographers in this collec- tion honored and preserved those early days of hip-hop, recognizing the art form well before it became mainstream. Their careful eye and love for the sound built the archives of hip-hop imag- ery that exist today, crafting a collective cultural document that has gone on to inspire conversa- tions about art, identity, race, and popular culture.

With *Contact High,* I wanted to showcase those ways that hip-hop has made a cultural impact. The visual signifiers are all there in the photos: detail- ing the rise of personal expression through street style and the voice of a nation captured with time and light. Some of these photos are of artists like Jay-Z, Kendrick Lamar, and Kanye West as they first took the scene, embodying the "come up" or ascension to greatness. Some are of Rakim rockin' his Dapper Dan–made jacket with the symbolic number-7 Five Percenter symbol. Others are of the Beastie Boys goofing around for their *Check Your Head* album cover, Run-DMC posing in their neighborhood of Hollis, Queens, or Biggie being crowned a king.

In the process of curating this collection, I visited dozens of archives and realized just how many images are still out there. Some of these photographers hadn't looked at these photo- graphs or their contact sheets in years; their rolls of film—many stored away in shoeboxes and closets—held iconic moments that were tucked away, still unprocessed. Most of the images were shot on 35mm slides, some in large and medium formats, and some were just snapshots taken on inexpensive starter cameras like the Pentax K1000. I've also included a small selection of digi- tal contact sheets to showcase the shift to digital

For those who might need a primer on w exactly a contact sheet is: it's mainly a work document. Often compared to an artist's sket book, a contact sheet is an intimate glimpse i the working process. Back when every photo v shot on analog film, the negatives would be c tact printed onto photography paper, allow photographers, editors, and artists to see the range of images and use them to decide on "money shot." Photographers typically don't sh their contact sheets—it's their visual diary, a showing the shots that were mistakes or di work isn't always easy, which is why gettin deeper glimpse into the most recognized ima of hip-hop is so special.

In getting access to these original and u ited contact sheets, we can see how photog phers thought about sequencing, when to c the shutter, and how they took photos f different perspectives. The observer is give behind-the-scenes sense of walking along photographers and seeing the images thro their eyes, thereby witnessing the hit-or-r shots, the over or underexposures, the un tainty, as well as the discipline and rigor of ana photography. It's the rare process of seeing l the final shot comes to be, or what street pho rapher Henri Cartier-Bresson coined the "deci moment," when that one telling shot appears reveals something special.

Today, the way we digest and create tural imagery has radically changed. Where editors and publicists used to edit down v the public saw, now, in the age of Instag Lightroom, and digital technology, the "dec moment" is determined through an entirely ferent process. Likewise, hip-hop culture morphed and changed, making the preserva of these pictures more important than ever. I spirit of archiving this visual history, I hope book can be of service in preserving the origi hip-hop culture and making sure none of it d pears. As you look through these images, I you'll think of the defiant lyrics of Biggie's "Ju and likewise chuckle at those who never tho hip-hop would take it this far

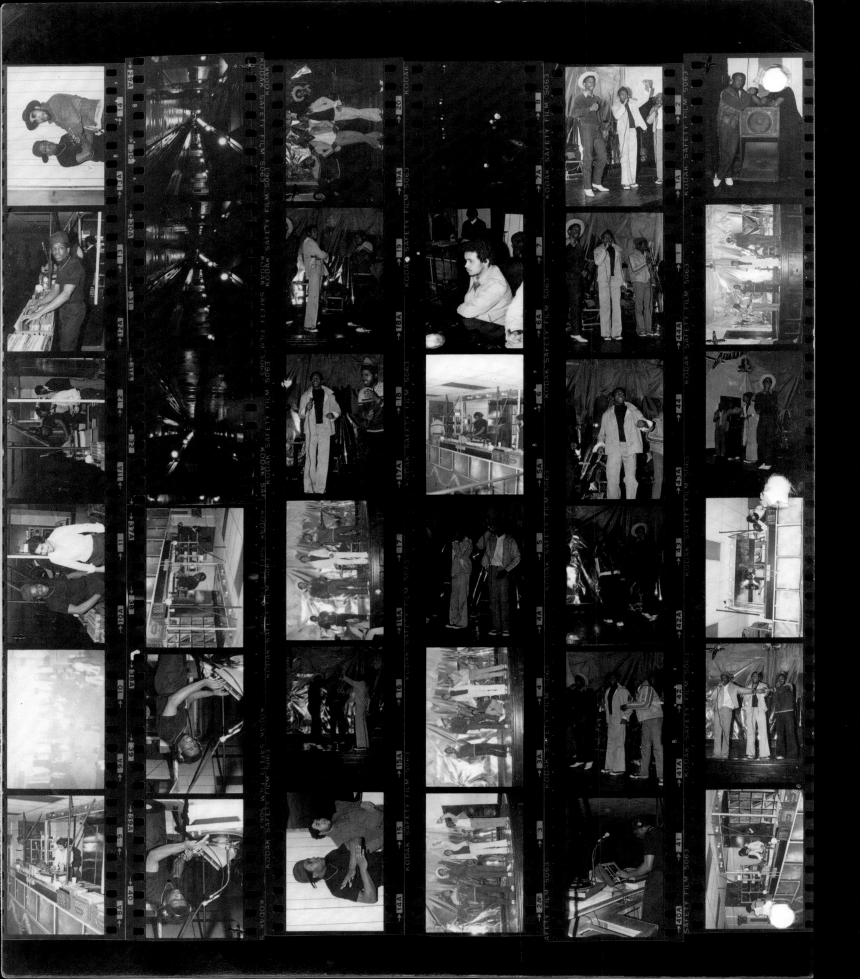

JOE CONZO JR.

TONY TONE AND KOOL HERC

The first time Joe Conzo met Clive "Kool Herc" Campbell, he knew right away it was an important moment. He'd already heard all the stories about the hip-hop prodigy: about how several years earlier, the sixteen-year-old Jamaican immigrant threw a "back to school" party in the rec room of an apartment in the South Bronx. Or about how Herc had seemingly invented hip-hop by utilizing two turntables and a mixer to isolate "the break" between main sections of a song. Repeated, looped, and extended, breaks became the foundation of a new kind of music.

Conzo first met Tony Tone, a founding member of The Cold Crush Brothers, a year prior, while they all attended South Bronx High School. Conzo would travel to clubs with Cold Crush and take photos that were usually used on flyers to promote subsequent shows.

"Kool Herc was already an urban legend by the time we met. I was a lot younger than him, so to actually meet this person dominating the sound system on the west side of the Bronx was a big moment. He was a big, intimidating guy, but I was able to befriend him. Herc didn't really like having his picture taken, and in fact he happens to hate this picture because his tongue is sticking out.

"I was in eleventh grade at South Bronx High School when I first started photographing hip-hop. Back then, I was a chubby kid with an Angela Davis afro. I wasn't into sports or anything, but I was into photography. My Minolta SR-T 200 became my best friend and I took it everywhere. My classmates DJ Tony Tone and Easy AD had formed a group called the Cold Crush Brothers the year prior. Cold Crush got a gig playing at T-Connection, so I went with them to shoot it.

"Since we were teenagers, we were only allowed inside because Cold Crush had a gig that night. It was the first night I photographed them as a group. Before this, I had only shot at park jams, so there I was, this little Puerto Rican kid just hanging out with this legendary DJ, watching other DJs do their thing. Charlie Chase was DJ'ing that night instead of Herc, and he was playing all these disco songs that my parents listened to except he was playing them in this new way. That was the moment that hip-hop 'kidnapped' me."

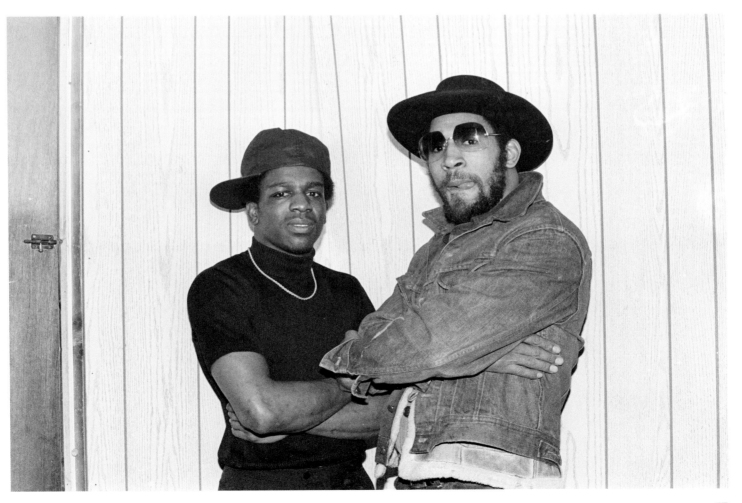

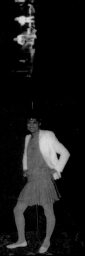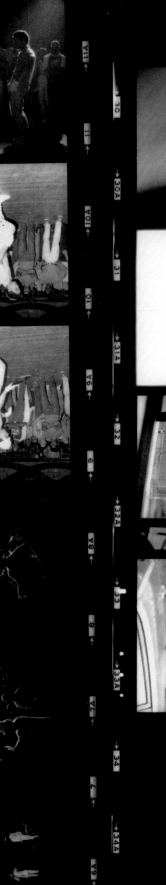

JOE CONZO JR.

THE POPPER

Joe Conzo's anonymous popper—who has never been identified—speaks to the culture of hip-hop's early days when kids were just doing what they loved. The night this photo was taken, white-gloved b-boys in Kangol caps took to the dance floor at the Roseland Ballroom in what Conzo describes as the biggest dance cypher he has ever seen. Dance cyphers, as hip-hop purists will attest, were sacred spaces meant for break dancing or b-boying. When a particularly good part of a song—the "break"—came on, it was time for dancers to get on the floor. The song's short instrumental break, usually simplified and rhythmic, would be looped by the DJ so dancers could have extended time on the dance floor to showcase their moves. This is where the term "break dancing" comes from.

"I was taking pictures of this one b-boy but the flash didn't go off, so the photo is actually a mistake. But even though there was no flash, I got that great silhouette instead. I didn't even know I had the shot until I developed the film in the darkroom and made the contact sheets. The image was buried in a shoebox that my mom saved for years. I overlooked the significance of some of my early photos back then because I was just shooting for myself, developing film in my bathroom that I'd turned into a makeshift darkroom. At the time, I didn't have anywhere to publish these photos, as not too many magazines were publishing hip-hop photography. And like most film shooters, I didn't have a lot of money for film—it was really expensive—so I chose my shots carefully and sparingly. The rest of the contact sheet shows a random beach trip and some crowd shots I took on the same roll, but most of it is dark because I was still figuring out how and when to use the flash and learning through the process."

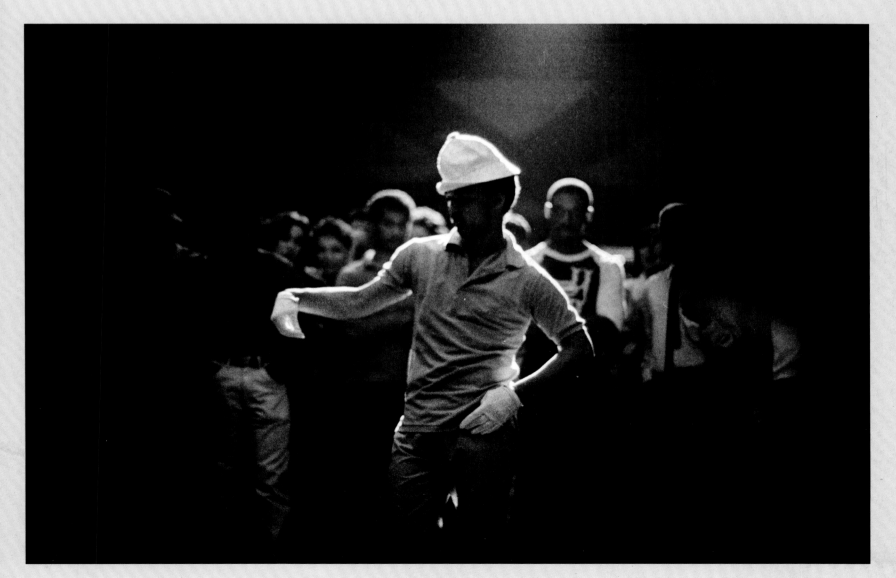

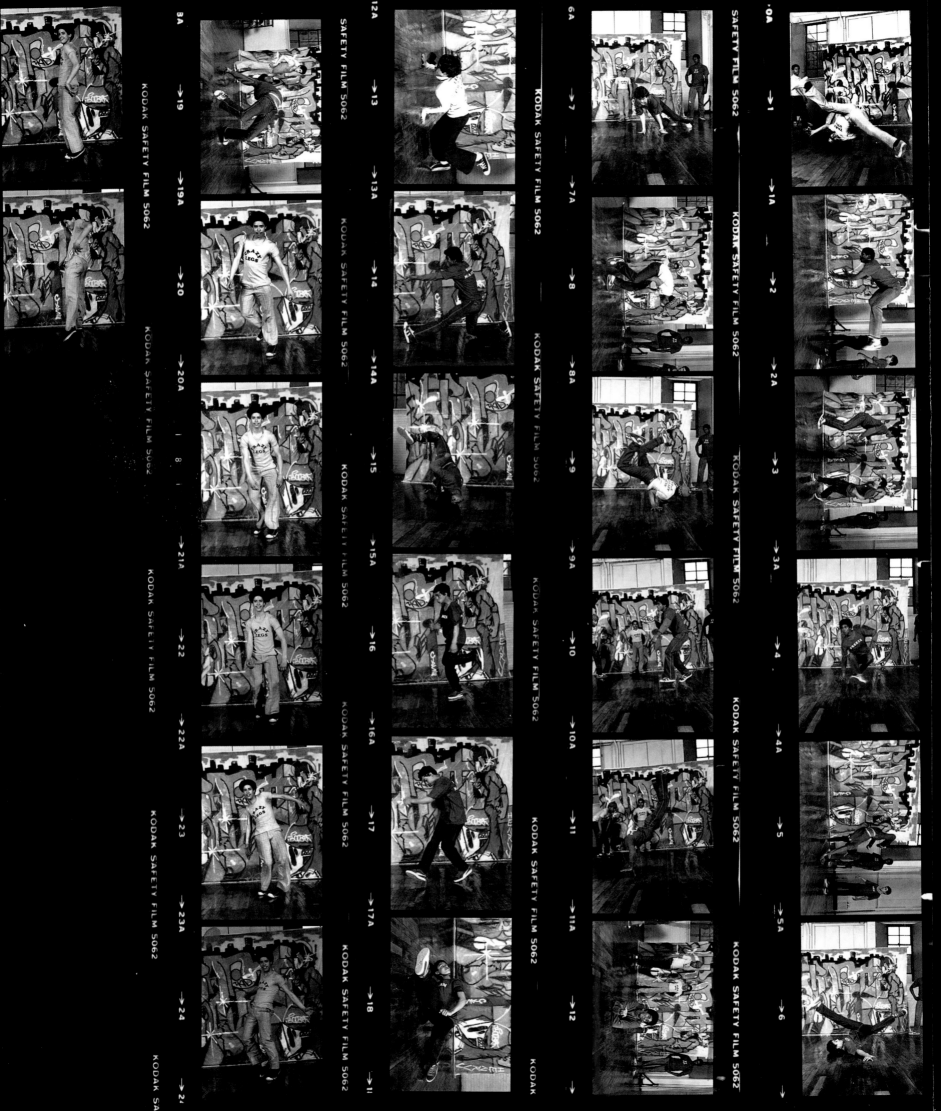

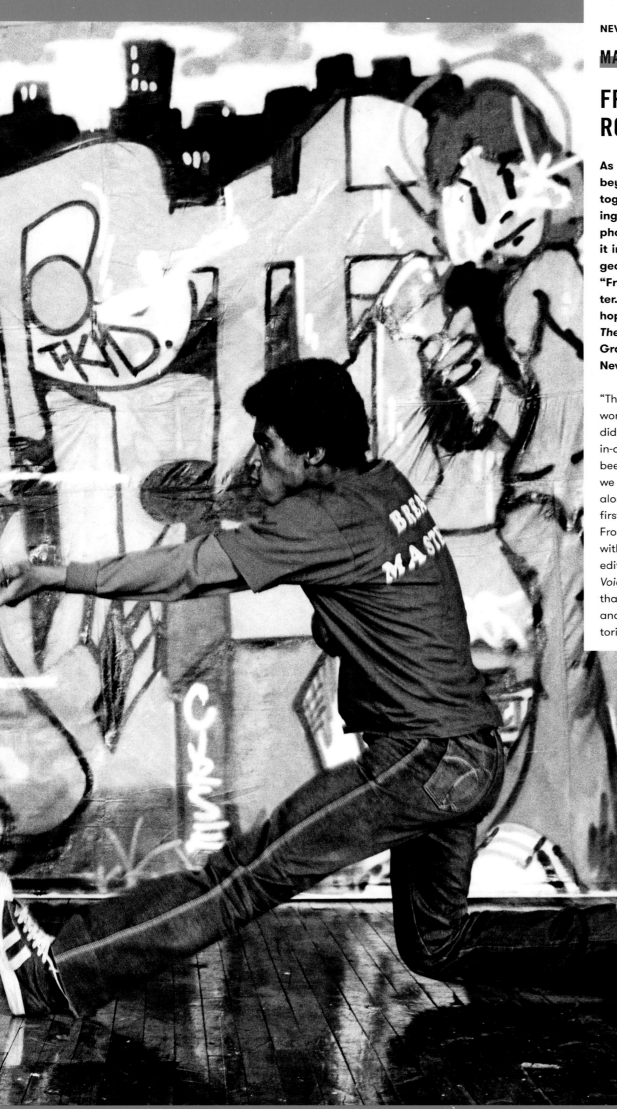

MARTHA COOPER

FROSTY FREEZE, ROCK STEADY CREW

As hip-hop started to gain media attention beyond its local beginnings, a few photographers became known for documenting the culture. Martha Cooper, then a staff photographer at the *New York Post*, deemed it important to point her camera at the burgeoning scene and its characters. Wayne "Frosty Freeze" Frost was one such character. In one of the earliest media stories on hip-hop culture, his image graced the cover of *The Village Voice* in an article titled "Physical Graffiti: Breaking Is Hard to Do," exposing New York, and later the world, to b-boying.

"This was a case where words and pictures worked closely together. The front-page photo did not stand alone, it was accompanied by an in-depth article written by Sally Banes. We had been working on this story for a year by the time we finally got it published. The written piece along with the photos was an excellent, serious first representation of the dance. The photo of Frosty by itself would have been meaningless without context. Film crews and international editors jumped on the story after seeing it in the *Voice*. I believed I had discovered a youth culture that was unique to New York City at the time, and wanted to document it in the spirit of historic preservation."

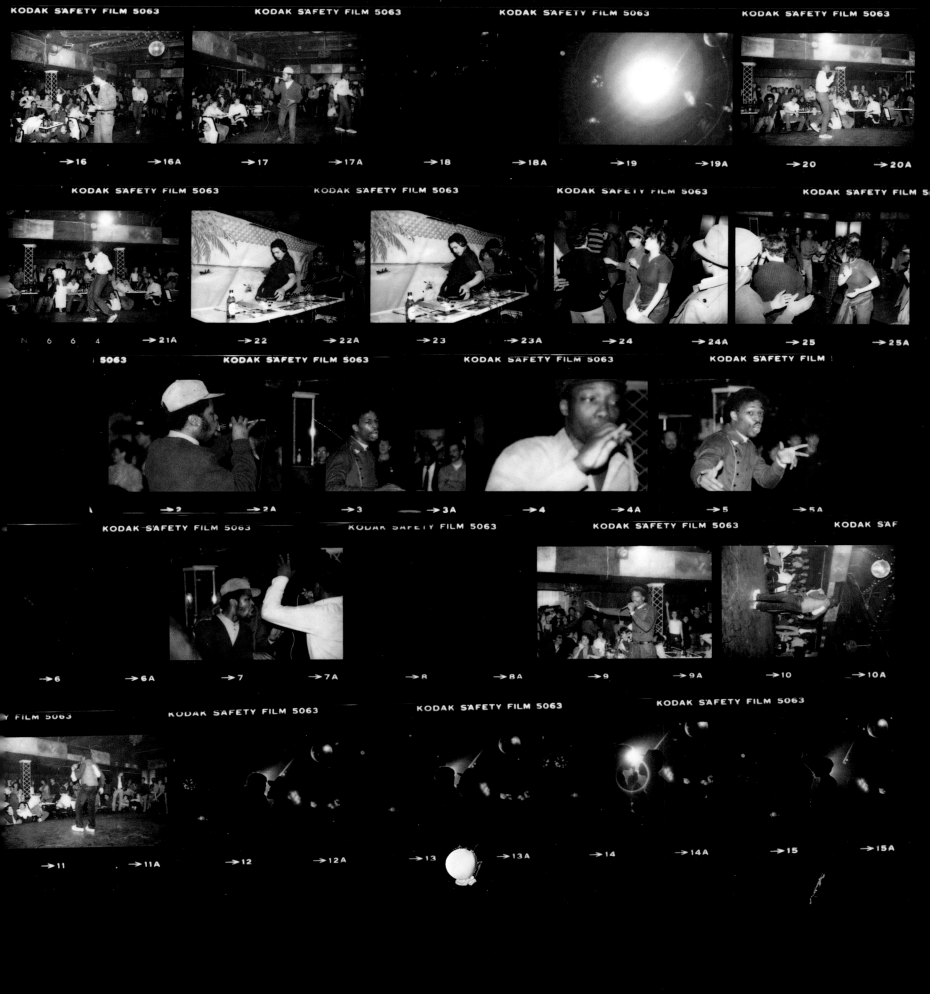

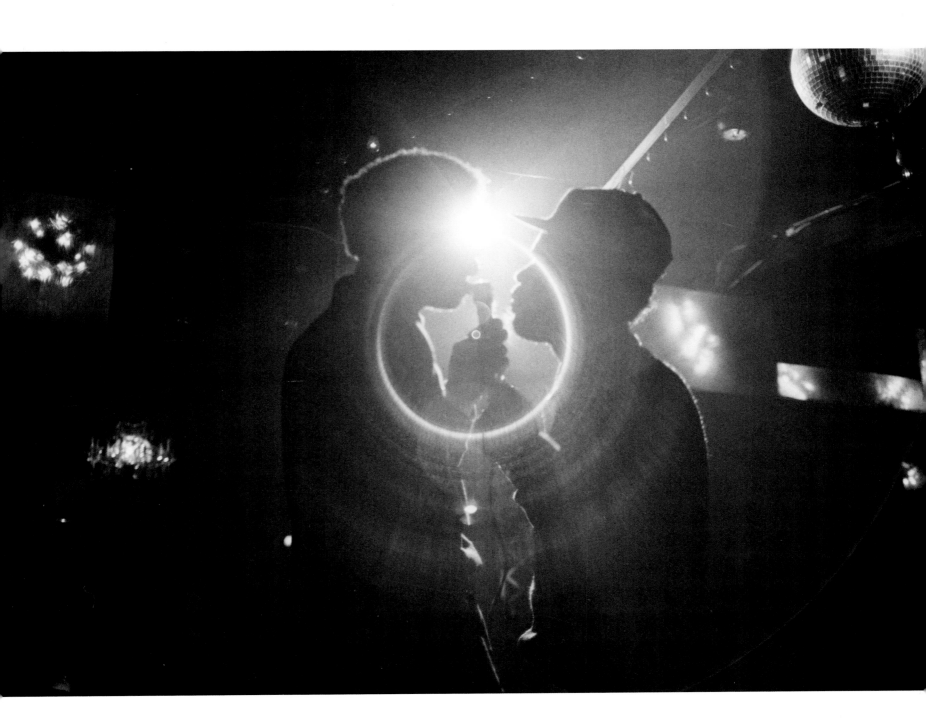

MANHATTAN, 1981

JOE CONZO JR.

GRANDMASTER CAZ AND JDL AT CLUB NEGRIL

"The contact sheet has so many important faces on it. The DJ in frames 22–23 is DJ Charlie Chase. JDL is considered one of the first hype men of hip-hop. I was just fortunate enough to be part of that generation that wanted to make a statement socially about what we were doing in the streets. We brought the reality of our lives into the clubs, and you could hear it in the performance when rappers would get up on the mic. You could hear all of it in the clubs. At the same time, hip-hop was also party music, and style was a big part of how we expressed ourselves.

"This photo was taken during a style turning point in hip-hop. People were starting to wear leather pants, suits, fedoras, even punk rock was increasingly part of the scene. Everyone had their own style. There was a lot of originality and authenticity back then."

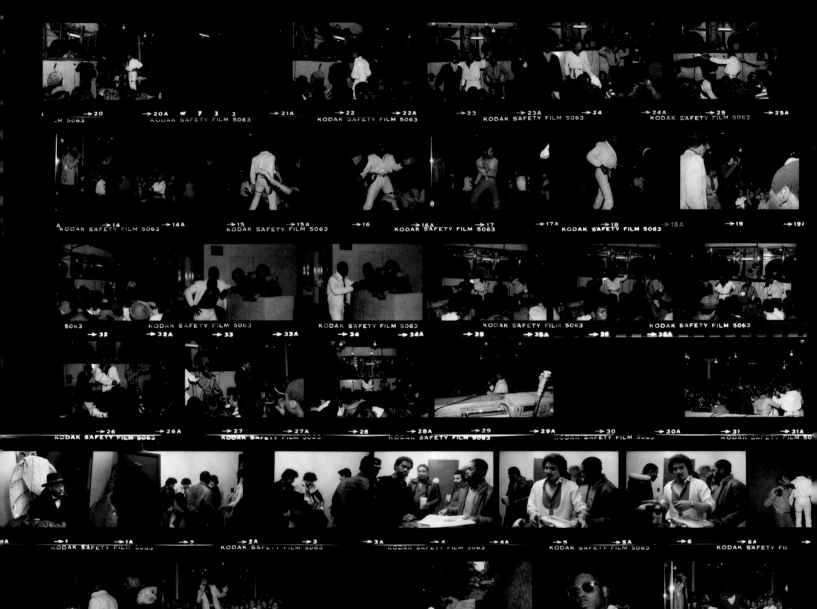

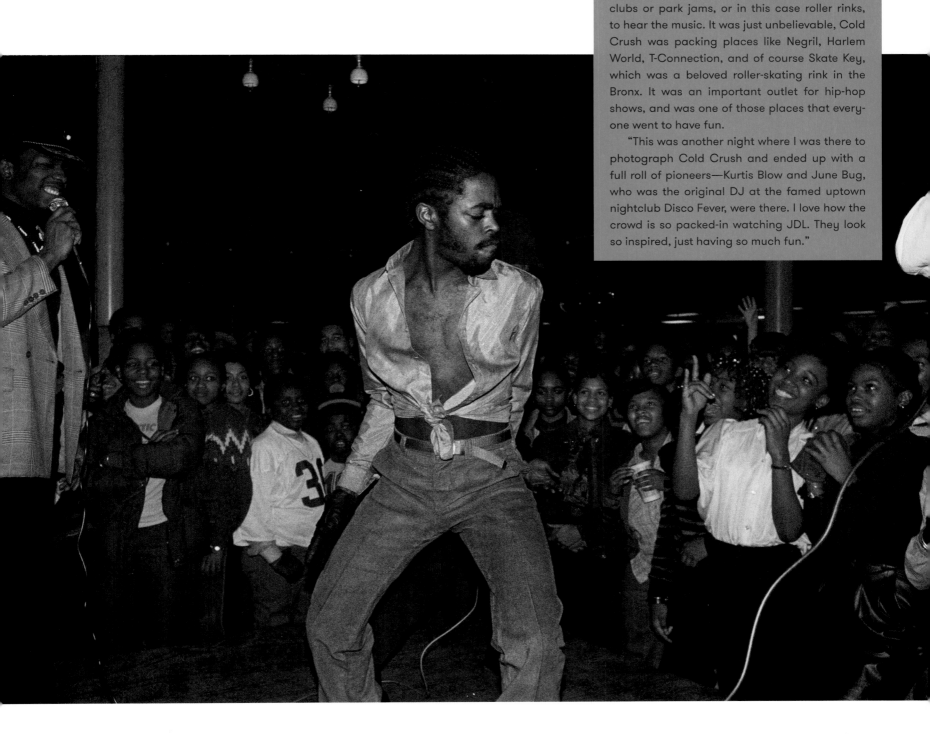

THE BRONX, 1981

JOE CONZO JR.

JDL AT THE SKATE KEY ROLLER RINK

"Hip-hop wasn't on the radio yet and there weren't even albums, so you had to go to the clubs or park jams, or in this case roller rinks, to hear the music. It was just unbelievable, Cold Crush was packing places like Negril, Harlem World, T-Connection, and of course Skate Key, which was a beloved roller-skating rink in the Bronx. It was an important outlet for hip-hop shows, and was one of those places that everyone went to have fun.

"This was another night where I was there to photograph Cold Crush and ended up with a full roll of pioneers—Kurtis Blow and June Bug, who was the original DJ at the famed uptown nightclub Disco Fever, were there. I love how the crowd is so packed-in watching JDL. They look so inspired, just having so much fun."

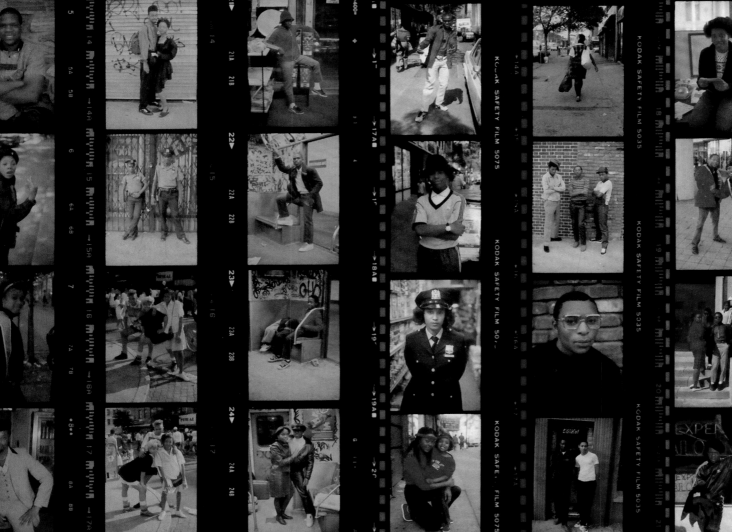

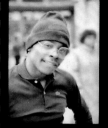
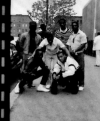
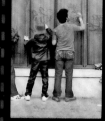
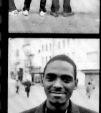

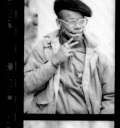
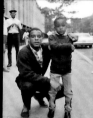

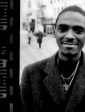

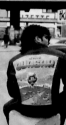

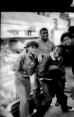
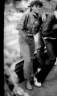

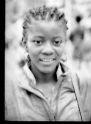
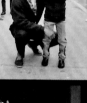
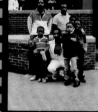

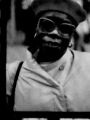

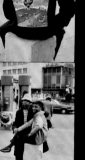

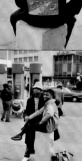

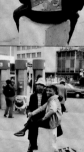

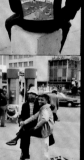

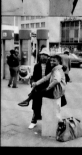

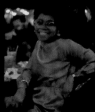
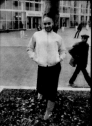

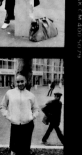

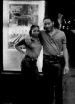

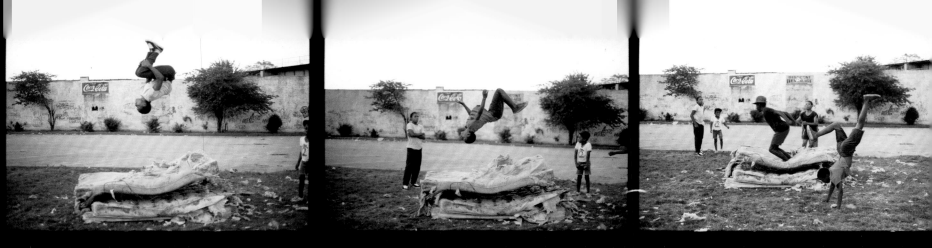

BROOKLYN, 1982

JAMEL SHABAZZ

"FLYING HIGH" AS SEEN ON THE ROOTS' *UNDUN*

There's an adage that says, "See the light in others and treat them as if that's all you see" and Jamel Shabazz capturing the style and humanity of defining moments in the New York streets does exactly that. Way before "street style" was a common subject and the subculture became a commodity, Shabazz captured urban New York youth, relying on visual signifiers like Cazal glasses, shearlings, Adidas Superstars, Puma Clydes, and so forth. It took a keen eye, empathy, and curiosity to create great street imagery, but to call Shabazz a provocateur is to only see part of the story. At the age of fifteen, Shabazz borrowed his mother's Instamatic camera, taking it along to junior high school to photograph his friends, which planted the seeds of his career as a documenter of the black urban experience. Following a stint in the army, Shabazz became a corrections officer at Rikers Island in 1983 and worked there

for twenty years, photographing the streets after his shift, many of his subjects young men from around the way who Shabazz says "represented my 'younger brothers.'"

"It was typical of me to walk around various communities within Brooklyn, and on the day I made 'Flying High,' I was leaving a friend's home when I came upon these four adolescents having a good time in a vacant lot in the Brownsville section of Brooklyn. They were performing incredible acrobatic feats like seasoned Olympic athletes. I watched in amazement as they used this old worn-out and discarded mattress like a trampoline, which led me to reflect on my own youth and how my cousin and I had engaged in similar activities. I set the aperture and shutter speed accordingly on my Canon AE-1 SLR camera and popped off three frames in succession, thus creating one of my most iconic photographs. In 2011, Def Jam reached out to

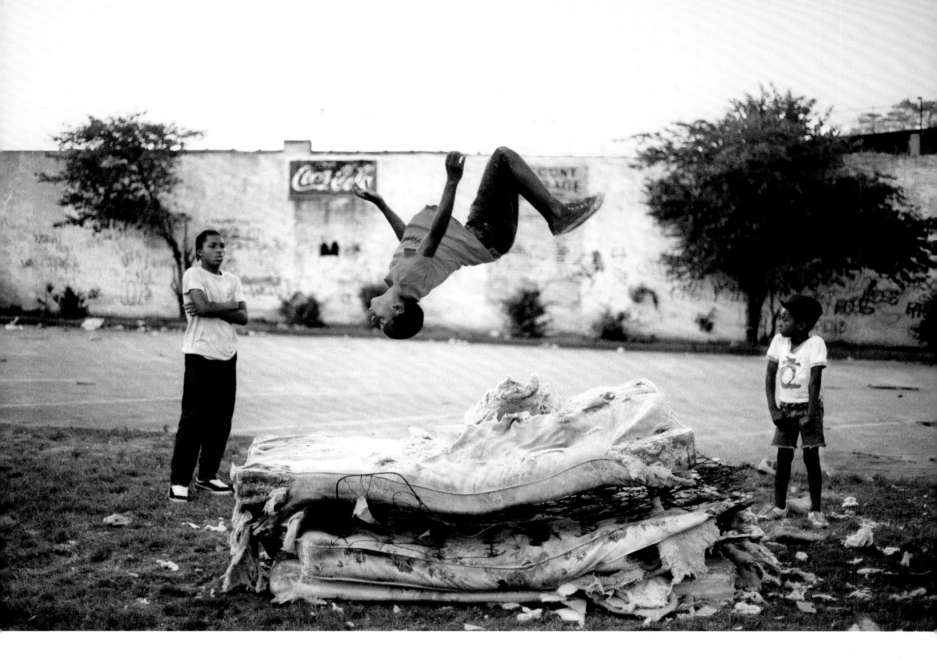

me requesting to use 'Flying High' for the cover of The Roots' upcoming album, *undun*. I was ecstatic, and the rest is history.

"The majority of my subjects were very keen on how they wanted to be represented, and I wanted them to play a major role in that decision. There was a lot of thought put into every session; from setting up the right pose to finding a suitable backdrop. I was very strategic in picking locations to shoot at. During the week, I would go to two local high schools: Tilden in the morning and Erasmus in the afternoon. Both were just minutes away from each other and had an endless number of students that were open to having exchanges with me. After the school session, I would travel to downtown Brooklyn. There, the famed Albee Square Mall became my primary base of operations, where one-third of my earlier photographs were created. During the weekend, my favorite spot was Times Square, a place where there was never

a dull moment, especially during the summer months. For many of the urban communities, that was like our Hollywood. Shooting there allowed me to meet and photograph people from all of the five boroughs, as well as those from out of town. The camera became part of my being. It is my third eye that is always with me, and at the ready.

"Other than my camera, I think that music is the greatest manifestation of who I am. Gamble and Huff, Gil Scott-Heron, Curtis Mayfield . . . I was always drawn to the beautiful photographs that graced album covers over the years, and as a documentary photographer I strive to create images that convey messages, often drawing inspiration from musical artists. Many of those songs provided me with a deep insight into what I was feeling inside, and what I felt I needed to create visually as a photographer."

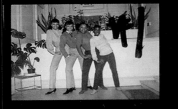

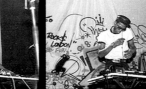
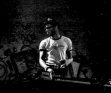

→1A →2 →2A →3 →3A →4 →4A →5 →5A →6 →6A →7

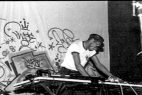
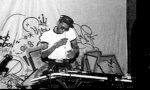

→15 →15A →16 →16A →17 →17A →18 →18A →19 →19A →20 →20A

25A →26 →26A →27 →27A →28 →28A →29 →29A →30 →30

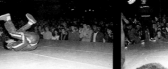
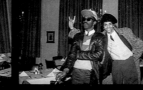

→13 →13A →14 →14A →15 →15A →16 →16A →17 →17A →18 →18A

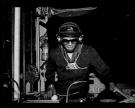
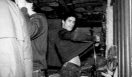
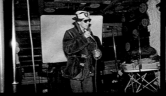
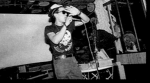

A →11 →11A →12 →12A →13 →13A →14 →14A →15 →15A →16 →1

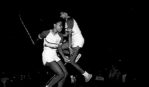
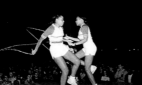

→33 →33A →34 →34A →35 →35A →36 →36A

JANETTE BECKMAN

GRAND MIXER D.ST.

"I was still living in London and the first international hip-hop tour (organized by Bernard Zekri from Celluloid Records) was making its first stop in London. I was working for *Melody Maker* shooting subcultures, mainly the flourishing punk scene. I raised my hand in a meeting when they asked who wanted to go and shoot this. I went to the hotel to meet everyone on the tour and was just blown away by their unique style. You can see on the contact sheet just how many important pioneers were there: Afrika Bambaataa, Fab 5 Freddy, the Double Dutch Girls, graffiti legend Rammellzee, Futura, the Rock Steady Crew, and of course D.ST. (short for Delancey Street, where he used to buy his clothes in New York City). Shooting this tour inspired me to move to New York and shoot the hip-hop scene there. I never looked back."

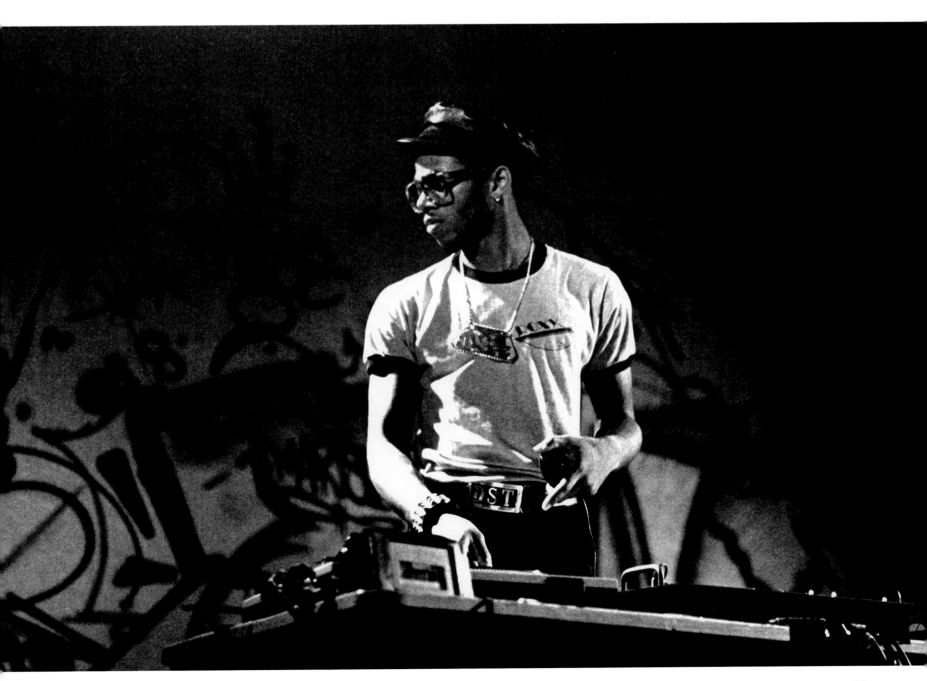

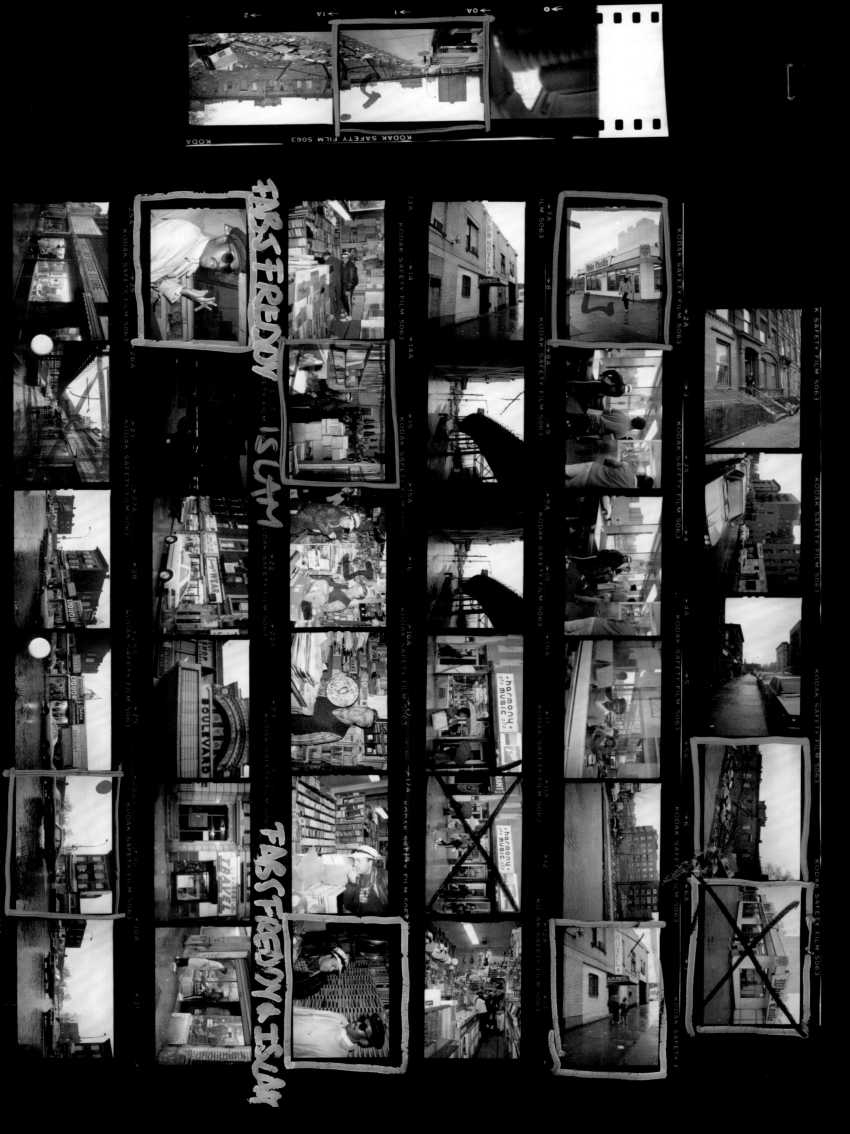

SOPHIE BRAMLY

FAB 5 FREDDY

"I dropped everything I was doing and followed these early hip-hop pioneers everywhere they went for four years. I had moved from France and was totally infatuated with the scene and driven by my intuition that these were important moments, even if I wasn't necessarily conscious of how historic they would ultimately be.

"This photo of Fab 5 Freddy was taken during a shoot I organized in the Bronx of important places in the hip-hop scene like Disco Fever and Harmony Music, a mom-and-pop record store where a lot of DJs were buying their vinyl. I shot mostly with a Nikon F.

"At one point Afrika Islam, who lived in the Bronx, also joined us. He's the one wearing a white hat inside White Castle and the record store. I always loved the unlikely architecture of White Castle, and it was the go-to spot for b-boys in the Bronx, so when we passed it I asked Freddy to pose as if he was walking out of the place. On the contact sheet, you can see parts of the Bronx, which is a real window into that time, with all the storefronts and vacant lots. And, of course, Fab."

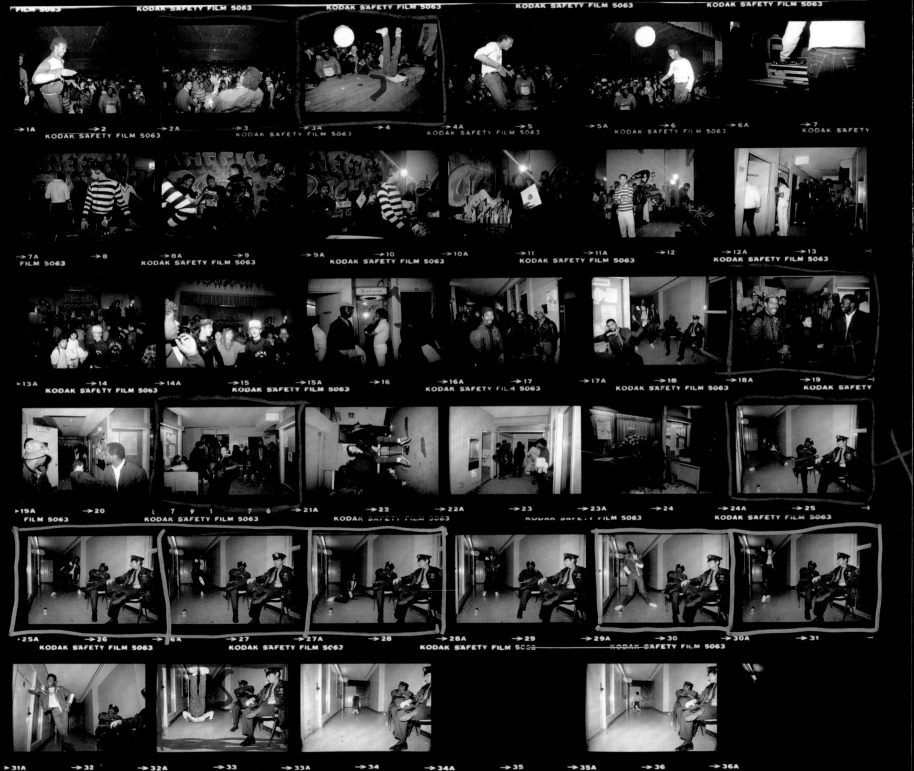

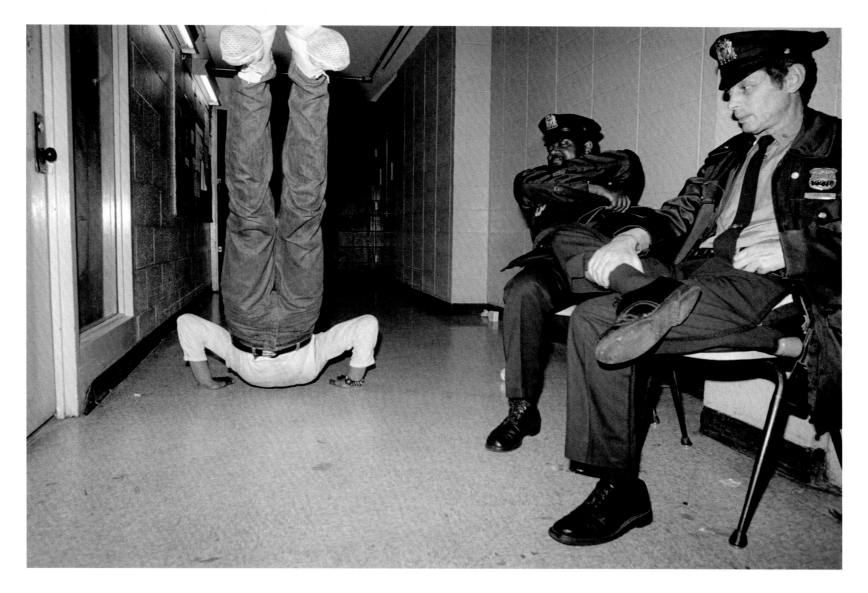

THE BRONX, 1982

SOPHIE BRAMLY

MOHAMMED AT BRONX RIVER HOUSES COMMUNITY CENTER

Less than a mile south of Bronx Park and the zoo were the Bronx River Houses, a public housing community built in the '50s that up until World War II was home to a primarily Jewish community. By the '80s it was the home base for a burgeoning black and Latino community, and is the birthplace of many hip-hop legends. One such legend is Afrika Bambaataa, who founded the Universal Zulu Nation at Bronx River in 1973 as a way to organize against gang culture. On any given weekend night, the Bronx River Houses community center was the place to be—a spot where Bambaataa used to host his Zulu Nation parties that brought in crowds of people from the neighborhood and beyond.

"Mohammed was a dancer and a member of Magnificent Force, a group of b-boys made up of dancers from various crews. I took this photo one evening when Afrika Bambaataa was celebrating the nine-year anniversary of the Zulu Nation. I had gone there to photograph the event, and at one point we were in the hallway and I saw these two cops falling asleep in a corridor. I asked Mohammed to dance next to them. It only lasted a couple of minutes because neither of us were very comfortable doing this, but the cops were cool and never said a thing. It was a very innocent moment. When you look back at what was happening in this place, it can seem like it was just a bunch of kids, but in a historic context, you see that hip-hop molded some of the most radical ideas of the twenty-first century."

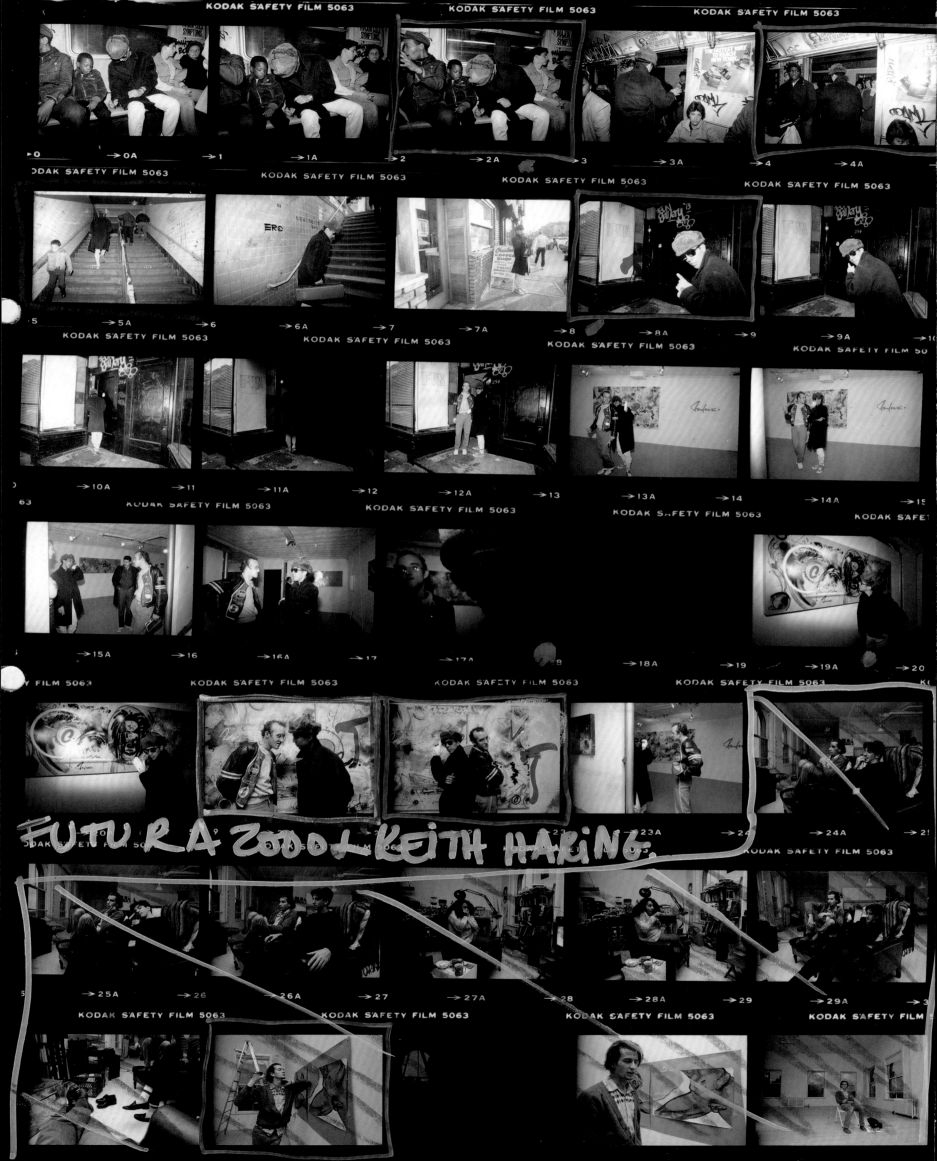

SOPHIE BRAMLY

FUTURA AND KEITH HARING

Sophie Bramly captured this image of graffiti artists Futura (formerly known as "Futura 2000") and Keith Haring at FUN Gallery, a legendary East Village space opened in 1981 by Patti Astor and Bill Sterling. LEE (Quinones), Zephyr, Dondi White, Kenny Scharf, Fab 5 Freddy, Lady Pink, and Jean-Michel Basquiat are among the significant artists who were regulars at the gallery.

"I had this idea to shoot a day in the life of Futura, who, along with Keith Haring, was an important artist in the graffiti scene. I wanted to capture the life of a graffiti artist, as most of them were still seen as outlaws on one side, but were celebrated in esteemed art galleries on the other. I thought it was almost schizophrenic in a way. I started at Futura's studio and got a feel for how he created his work and what his moments in the studio were like. I then followed him into the subway where he did a small tag, and later, into some backyard where he created a piece in broad daylight. Graffiti artists often worked at night when it was less likely they would be spotted, so this was pretty brazen. When we got to FUN Gallery, Keith was already there. Futura was having a show, and I asked him and Keith to pose in front of one of the paintings. I had them stand back-to-back as if they were in a mock duel, because there were talks at the time of whether or not Keith was a legitimate graffiti artist. Keith crossed over into the mainstream art world, and some thought his work was too commercial. But over time, the photo has become recognized as a great portrait of two legends hanging out."

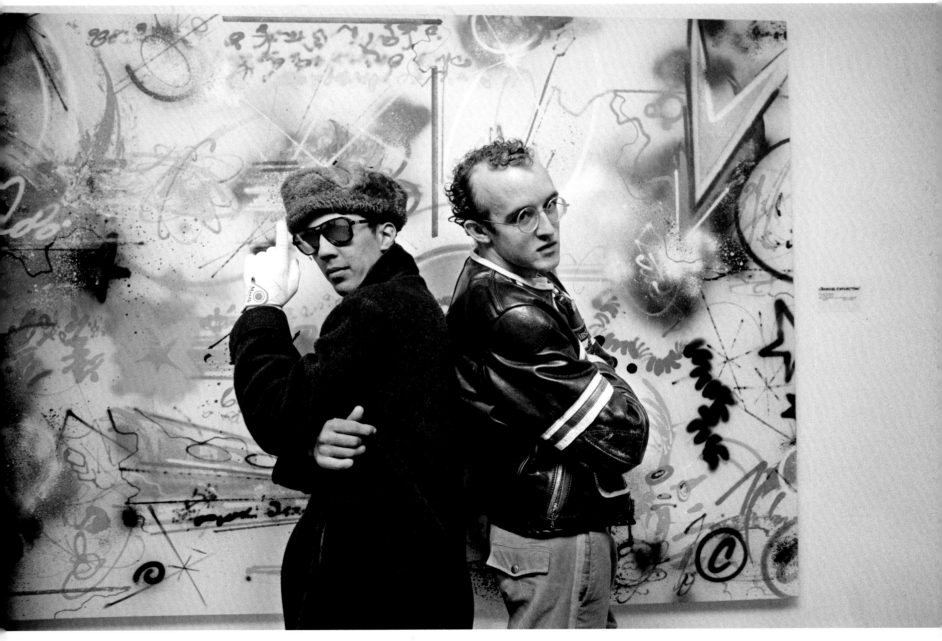

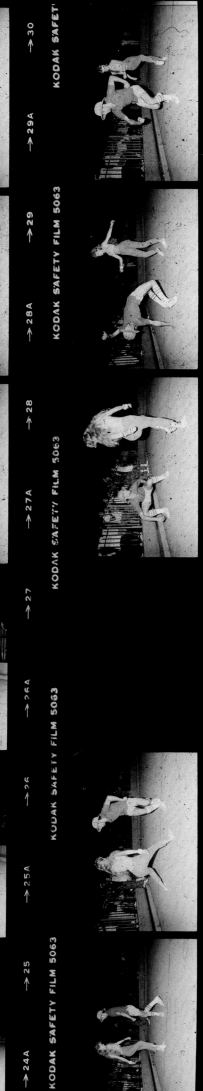
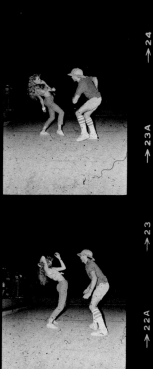

SOUTH BRONX, 1983

RICKY FLORES

B-GIRLS IN THE BRONX

"52 Park was one of those locations in the South Bronx that was the nexus of music culture for the Puerto Rican community, as well as one of the places that nurtured the beginnings of hip-hop. I was actively documenting my community because I wanted to show what was really happening in the South Bronx. The media called it 'The Bronx Is Burning' and was portraying us as burning down our own community, and that was just not true. Yes, there were burning buildings, but that was only a part of our story. This was our neighborhood and our culture happening all around, so it was important to me to show what that really looked like.

"This photo of Mirna and Danny, looking great and having fun, was the real truth. It's also significant because you don't often see a girl doing floorwork. Usually breaking is thought of in two ways: 'toprocking,' which is done standing up; and footwork-oriented moves known as 'floorwork' or 'groundwork,' and you didn't see women doing a lot of floorwork in the early days. It's a tangible reminder of the role that women played in hip-hop's development, which has been buried for a long time because the culture is so male-dominant. I came to realize over time that these photos were documents of history and very important."

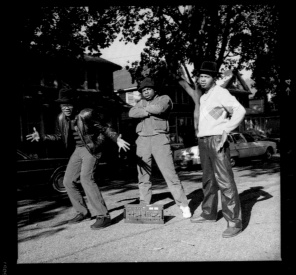
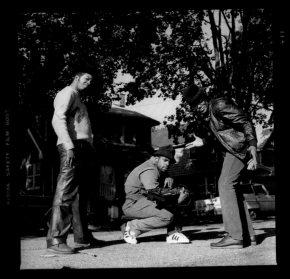

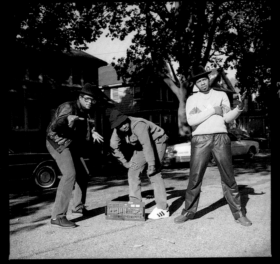
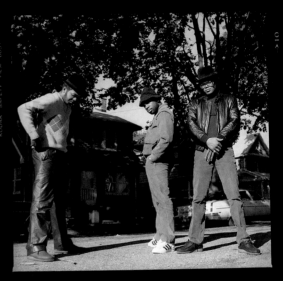

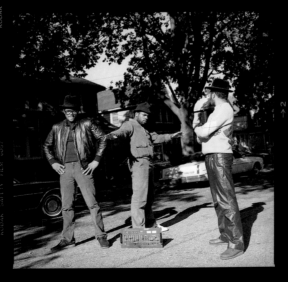
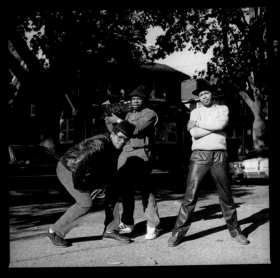

100584.3

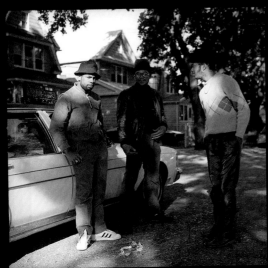
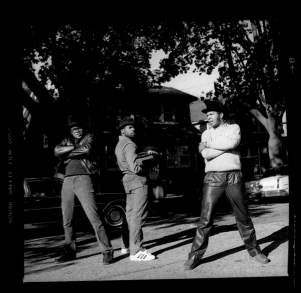

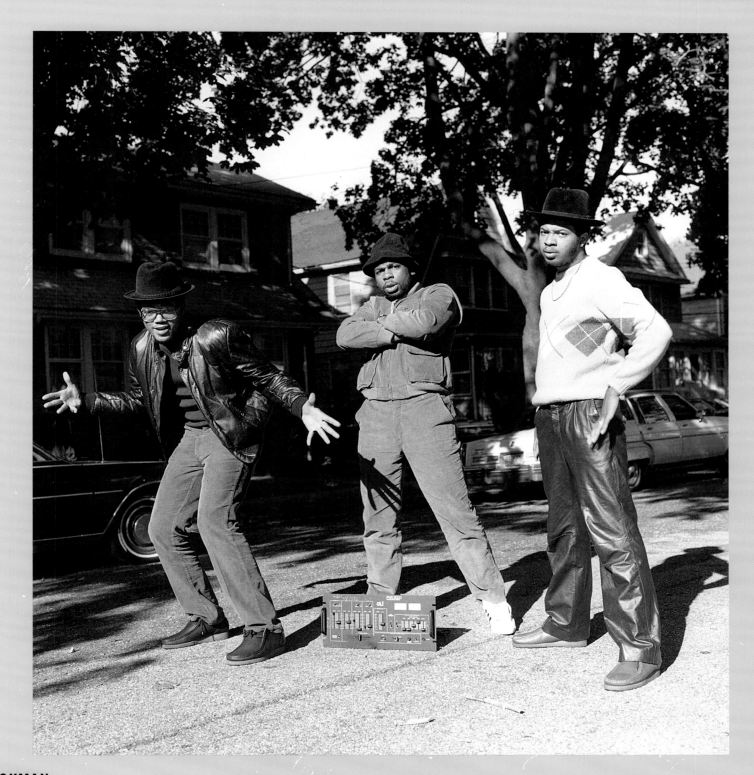

QUEENS, 1984

JANETTE BECKMAN

RUN-DMC

"The British style magazine *The Face* asked me to photograph an up-and-coming rap group, Run-DMC. Someone at their record label gave me a phone number and told me to call and make arrangements. I called up a landline and it turned out to be Jam Master Jay's mom's house. He told me to meet them in their neighborhood in Hollis, Queens, and said he would meet me at the Hollis, Queens, subway stop. I had no idea where Hollis, Queens, was or what to expect but I jumped on the train with my Hasselblad, which is a medium-format camera that takes really great portraits. It's a little heavy for street photography, but the photo needed to have that portrait kind of feel.

"When I got there, Jam Master Jay was waiting for me as promised. Run-DMC and their friends were perfectly styled, wearing Kangol hats, the Adidas sneakers, the Cazal glasses. It was a middle-class neighborhood, so it was different from the 'Boogie Down Bronx.' No matter how middle-class it gets, though, there'll always be street culture. The people from the neighborhood are real proud of Run-DMC. The photo is important because the times were changing in hip-hop. A group could come from a middle-class neighborhood and rap about their lives. This is one of my favorite photos, a moment in time that ended up being one of my best-known shots."

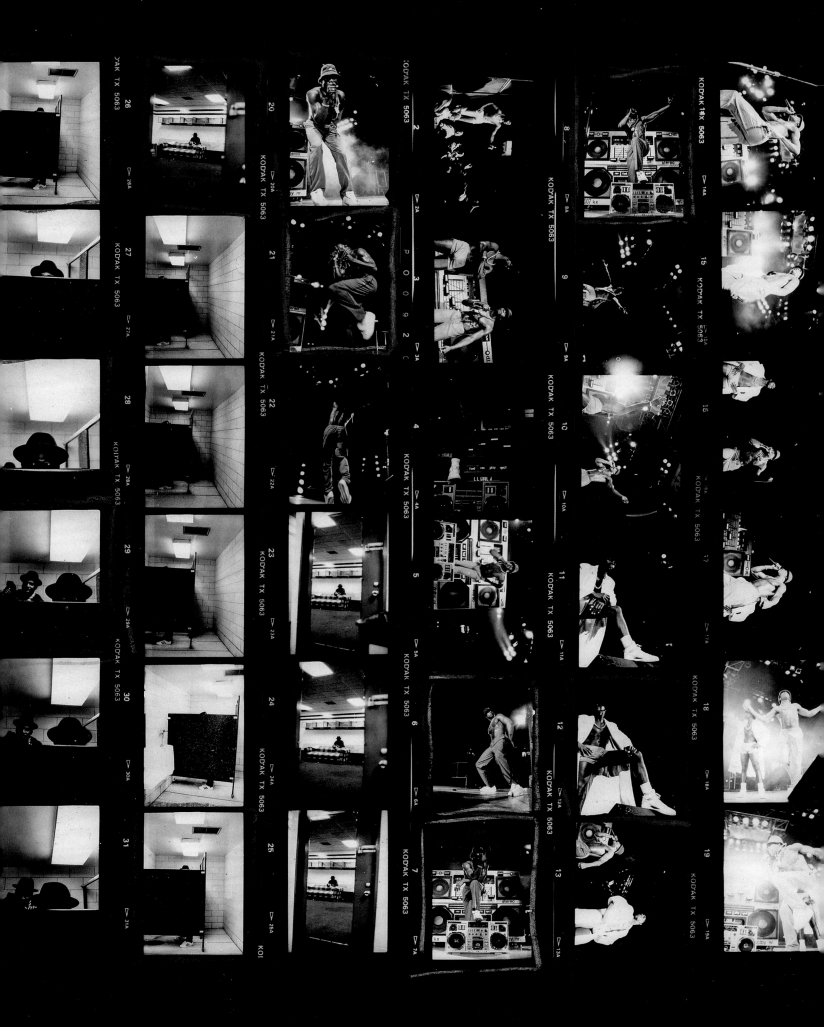

LAWRENCE WATSON

RUN-DMC AND LL COOL J AT THE FIRST ALL-RAP SPECTACULAR

"*New Musical Express* magazine (*NME*) wanted me to get an image of Run-DMC that was epic enough to make the cover, which was challenging since the group was on tour and didn't stop long enough in one place to really do a proper session. The upside was that I was able to get all these candid moments with them, like these fun bathroom shots of them behind the stalls.

"Run-DMC were at the peak of their success with fans all over the world, and it was amazing to see them all come out waving their Adidas trainers (an homage to their song 'My Adidas'). They put on an amazing live show. That night Spectrum Stadium was so packed that you could feel the energy all around.

"One of the contact sheets shows my series of LL Cool J, who also gave an epic performance that night. I was lucky to be the only photographer in the pit at this show, and I got an image of LL with his boom box mirrored by Jam Master Jay's DJ console behind him. It was just so epic up onstage. LL, the boom box—it was a lucky moment, being in the right place on the right night to capture a great moment in hip-hop history."

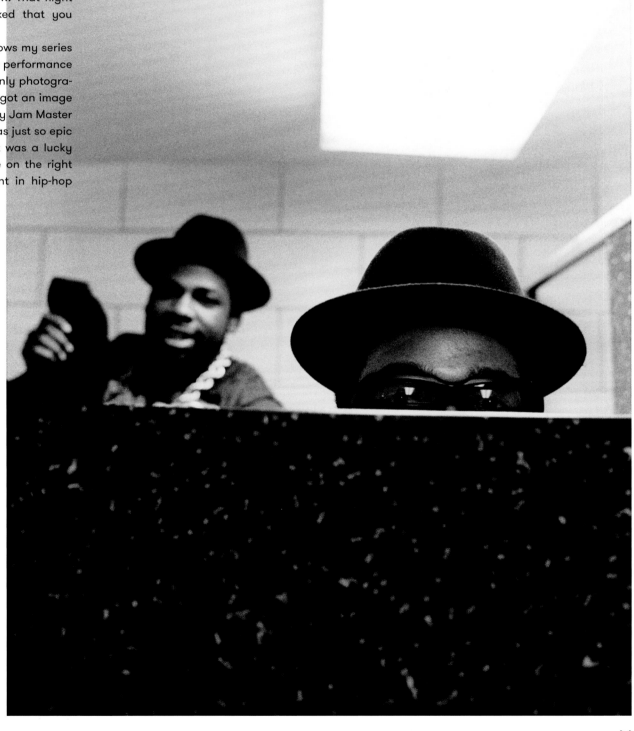

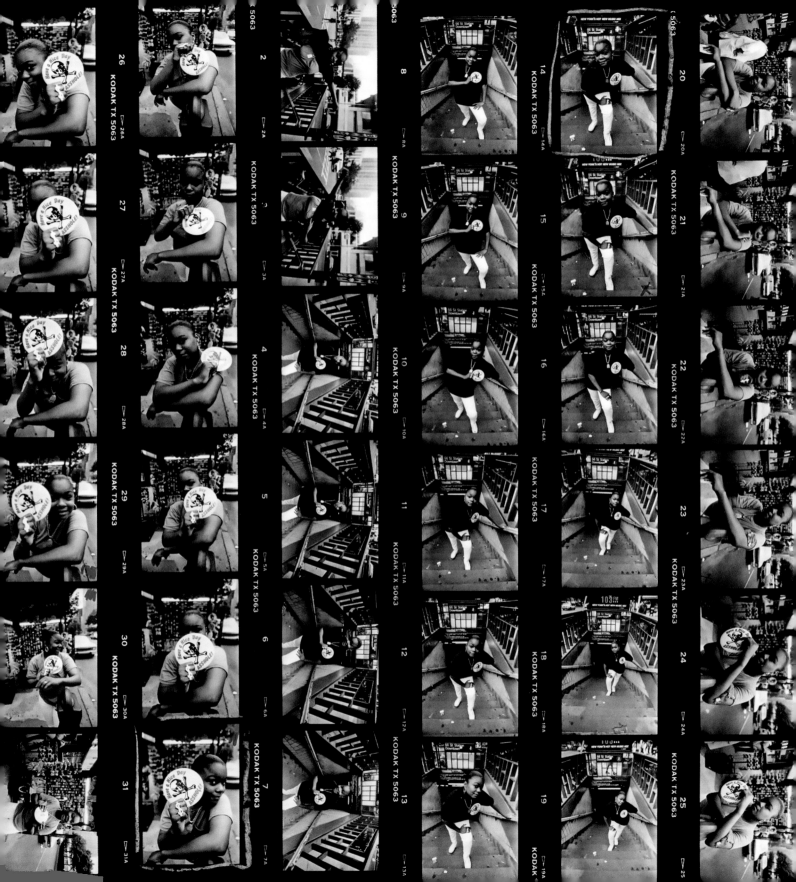

LAWRENCE WATSON

ROXANNE SHANTÉ

Lawrence Watson was sent to photograph Lolita "Roxanne Shanté" Gooden for *NME* magazine a few years after the infamous "Roxanne Wars." Shanté had just released her song "Have a Nice Day," in response to another beef, this time with rival hip-hop collective Boogie Down Productions. The song addressed a conflict about the origins of hip-hop. The Juice Crew's lyrics in "The Bridge" claimed that hip-hop originated in Queensbridge, while Boogie Down and KRS-One maintained it originated in the South Bronx, responding with hits like "The Bridge Is Over" and "South Bronx." Once again, Roxanne, a Queensbridge native, found herself at the center of a hip-hop battle, this time known as the Bridge Wars.

"This was a press session for her single 'Have a Nice Day.' I wasn't really aware of the details that prompted the song, but in hindsight, the fact that we found that pin is such a funny coincidence. We were walking around looking for good places to shoot and walked over to the 66th Street subway station. We managed to find a stall selling a bunch of tourist stuff and she sees the giant badge that said 'Have a Nice Day Asshole' on it and just starts having fun. We both thought it was so funny but clearly she had a deeper insight into its significance. What I was really focused on was her confidence. She had a great presence even at such a young age, and the moment coincided with an important time when women in hip-hop were becoming a force."

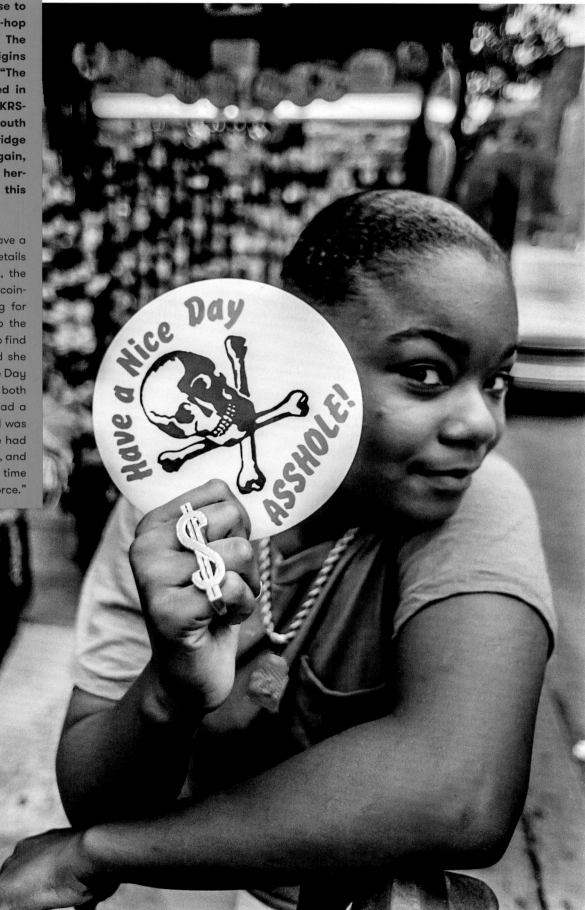

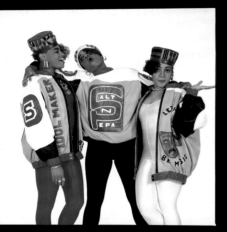
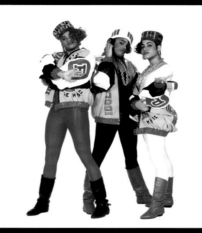
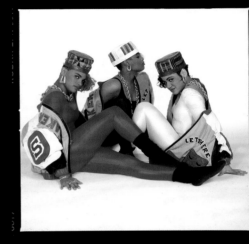
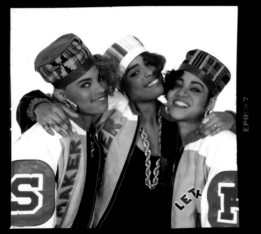

JANETTE BECKMAN

SALT-N-PEPA,
SHAKE YOUR THANG

"I met Salt-N-Pepa long before they made their first record. They were like sisters; funny, cool girls from Queens wearing big gold earrings and chains with fake Louis Vuitton bags. I did a small shoot with them for a British magazine, and they later introduced me to their manager, Hurby 'Luv Bug' Azor, who asked me to shoot the album cover. On the day of the shoot, they came wearing leather baseball jackets created by the one-and-only Dapper Dan (designed by Christopher 'Play' Martin of Kid 'n Play at Dap's studio on 125th Street), with kente cloth hats, spandex, and gold dookie-rope chains. They used fashion to express their strength and femininity. Dapper Dan's creations turned up in many of my photos of hip-hop artists. The influence he had on fashion and the culture overall is unmatched, and nobody has touched him since."

HELL'S KITCHEN, NEW YORK, 1988

GLEN E. FRIEDMAN

PUBLIC ENEMY, *IT TAKES A NATION OF MILLIONS TO HOLD US BACK*

In 1988, Public Enemy released *It Takes a Nation of Millions to Hold Us Back*, a game-changing album with "too black, too strong" lyricism and visuals that spoke to a new political movement grounded in black consciousness.

"With Public Enemy, my relationship went back to the days of their first demos. I respected their work and they respected mine.

"Sometime later, when they were all working on their second album, I went over to Green Street studios where they were recording, and Chuck told me the proposed title of the LP. The gears in my head started working very quickly and soon after I threw out the idea of them breaking out of a jail, because they were escaping from this nation that was holding them back.

"One of the producers from the Run-DMC film *Tougher Than Leather* got us permits to go into

this old holding facility in Hell's Kitchen on 30th Street. My idea was to have Chuck D knocking out the surveillance camera with his fist, and shoot it using a fish-eye lens so that his fist—and what it represented—would look huge just as he's about to slam it dark. To make it look as if you were watching on a surveillance system, I made a video on VHS tape and took photos off the TV monitor.

"The image I wanted to use on the front cover was 22A in the contact sheet. But somewhere along the line, a majority of the team thought the concept was a bit too sophisticated and conceptual for the intended audience and package.

"I think it was Hank who ultimately made the cover decision, telling me to consider that most sales at the time were just of those tiny cassette boxes, which is how frame 17A became the cover. He pointed out that it showed more jail cell bars and would work better on a cassette. But I felt

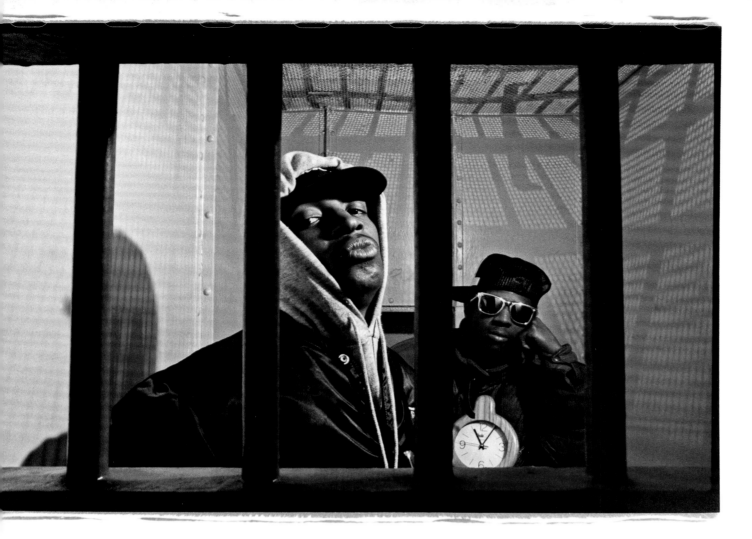

"**Glen's photos are iconic. He recognized the importance of our music, culture, and visuals, and the images he took for *It Takes A Nation* are powerful and lasting.**" —Chuck D

so strongly about the composition and attitude of frame 21A being so much better, that I threatened to scratch the negative of 17A if they tried to use it.

"Hank said, 'If you scratch the negative, we'll be forced to use a graphic. We don't have time for anything else, the image is dope, don't fuck us up.' I knew this was going to be a groundbreaking album and I wanted to be part of it, so I didn't scratch it. Ultimately the image of Chuck's hand punching out the surveillance monitor was used on a European pressing for the 12-inch single, 'Don't Believe the Hype,' and the sequence of them breaking out of the cell made it onto the back of the LP and was used in ads, and the CD booklet. Of course I don't regret giving in on this one—lesson learned. But at least years later I'm able to share all the better images in books and stories like this one."

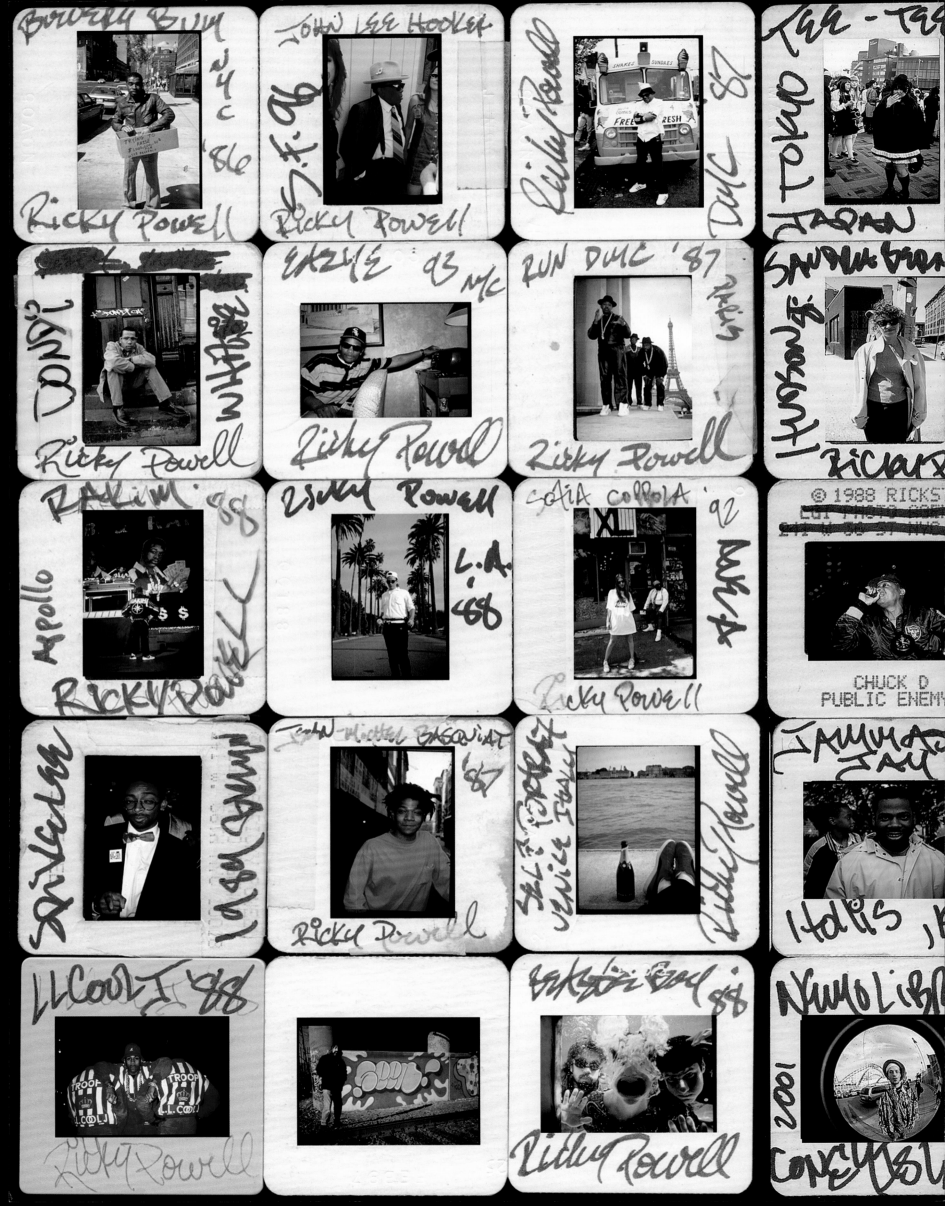

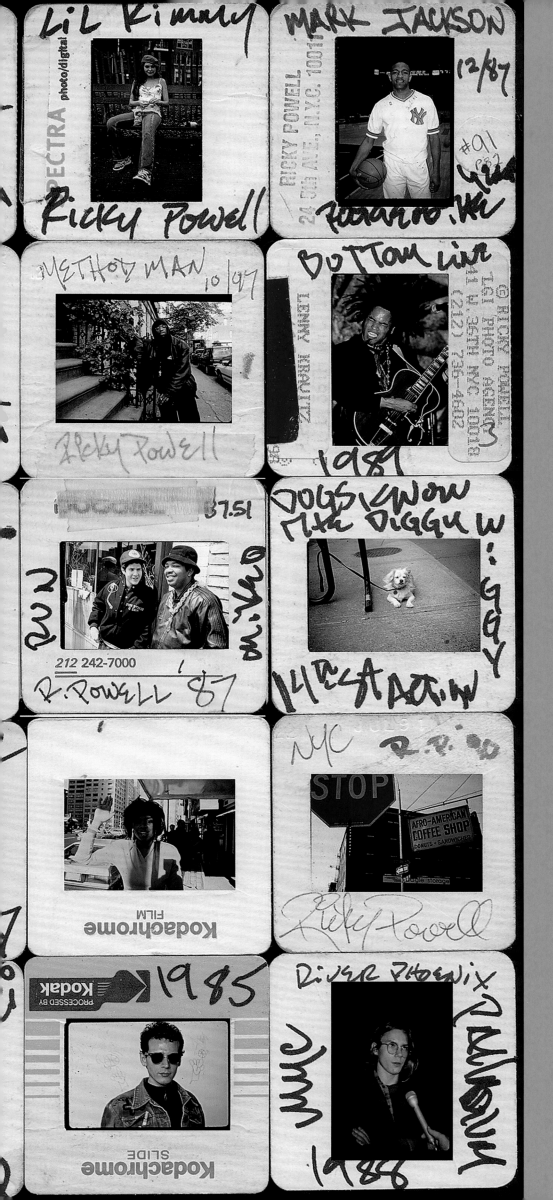

RICKY POWELL

NEW YORK STREET CULTURE

Although, strictly speaking, this assemblage of slides is not a contact sheet, it reveals the long career of one of hip-hop's most important shooters. Ricky Powell captured the defining moments of hip-hop and the 1980s downtown scene in New York City. He photographed everyone from LL Cool J, the Beastie Boys, and Run-DMC to Andy Warhol and Jean-Michel Basquiat. Powell was planning to become a gym teacher when he found a Minolta Hi-Matic AF2 35mm camera belonging to an ex-girlfriend. With a healthy dose of Scorpio revenge for "getting played like a wet tuna sandwich," Powell used the camera to document some of hip-hop culture's most important players.

"I'm very solo, self-reliant, independent, and clique-free for the most part. I like to photograph people who are individuals, whether it's my friend Kim on a park bench or LL Cool J in a custom Dapper Dan leather Troop jacket. A lot of my photos are just chill moments. I'm fortunate as a photographer and New York person that I got to meet and hang out with so many cool people. My photo of Eazy-E at the Hilton Hotel on 54th and 6th was for *Seconds* magazine. We were going to talk about a single he was putting out in 1993. Basically I just went up to interview him and I brought my Minolta auto-jammy camera, my Pentax K1000 with this fish-eye lens, and my camcorder video camera. He answered the door with a huge blunt and said, 'For you, Ricky Powell!' I was like wow, this is going to be a fun interview. He was very relaxed and let me photograph him while he was rolling more blunts.

"Another photo I love is of my friend, who I call the Funky Bohemian (Nemo Librizzi). He's ten years younger than me, a generation behind. I've known him since he was like fourteen or fifteen. His father (Rick) had a gallery on Watts Street.

"A lot of people ask me about photographing Basquiat. My first job out of college in the '80s was working as a frozen lemonade vendor. My stand was well known because I would have my big radio, a couple of chairs, and a bottle of rum in case someone wanted a shot with their lemon slush. One day Basquiat comes up to my stand and says, 'All right, can I get one?' He pulls out a one-hundred-dollar bill and I'm like, 'Dude, you ain't got nothin' smaller?' So as he's reaching into his pocket, that's when I pulled out the camera and took the shot. It's become a very famous picture, and the significance of that shot is that I took a number of famous photos while I was working 'bullshit' jobs."

BILL ADLER

CONTACT SHEETS: FREEDOM OF CHOICE

Creating photographs rarely has to do with the camera itself—it has to do with the photographer's insight into the character of their subject. I learned this firsthand just before the start of my senior year in high school, when I sat for my yearbook photo. I'd had my hair cut, I wore a sports coat and a tie, and I was stiff as a board. With the moment of truth upon us, the photographer had a tip for me: "Say sex." At the time, I hadn't had actual sex with another human being, but the prospect of it lit me up like a birthday cake. The photographer clicked his shutter, and I've been frozen that way, grinning like a fool, for the last four and a half decades. It's a very good photo.

I don't recall if that was the only frame the photographer shot that day, but chances are it wasn't. More likely, he shot a roll of film—twelve or twenty-four or even thirty-six frames—and then made a contact sheet, so that he'd get a decent look at all the frames without having to print each one. Finally he (or my parents) chose the best image. At the time, that was state-of-the-art and it was still state-of-the-art in the '80s and '90s when most photographers were taking the iconic photos for which they're known.

During the early days of hip-hop image making, very few professional stylists and makeup artists attended photo sessions for rappers. The artists certainly wanted to look good, but they weren't going to work very hard to do so. They would show up dressed the way they would dress every day, and that's what they were usually photographed in. Come-as-you-are was

pretty much the rule of the day. The standard for looking good was largely set by Run-DMC, who I worked with at Def Jam Records, and whose image was every bit as electrifying as their music. They had put out two or three very successful singles in the year leading up to the release of their first album, but up until that time, almost no one knew what the hell they looked like or how they dressed. The cover portrait of the guys, shot by Trevor "Butch" Greene (known these days as Talib Haqq), revealed all the elements of their style: Stetson hats, Lee jeans, and Adidas sneakers. The look was stylish, but store-bought—the everyday gear of a Queens street hustler, which was in stark contrast to the otherworldly getups being sported by pop stars like Michael Jackson. It was a key moment in hip-hop photography, captured of course with a limited number of shots using film.

These days, photography with film is nearly obsolete and so are contact sheets. But when film was new, it hugely advanced the tedious existing process. Consider poor Abraham Lincoln sitting for Mathew Brady back in the 1860s. Photos were shot on glass plates then, one image at a time, and if the first image wasn't a winner, the photographer had to insert a brand-new plate into the camera and start over. The whole routine was expensive, time-consuming, and difficult. Like everyone else at the time, Lincoln had to hold each pose for two-to-four minutes, as if he were cast in concrete, because that's how long the exposures were.

With the advent of better cameras and the wide availability of 35mm film in strips or rolls during the '20s, exposures were reduced to a fraction of a second, and the photographer was free to click away, one frame after another, until he used up the roll. This allowed the folks who were posing to

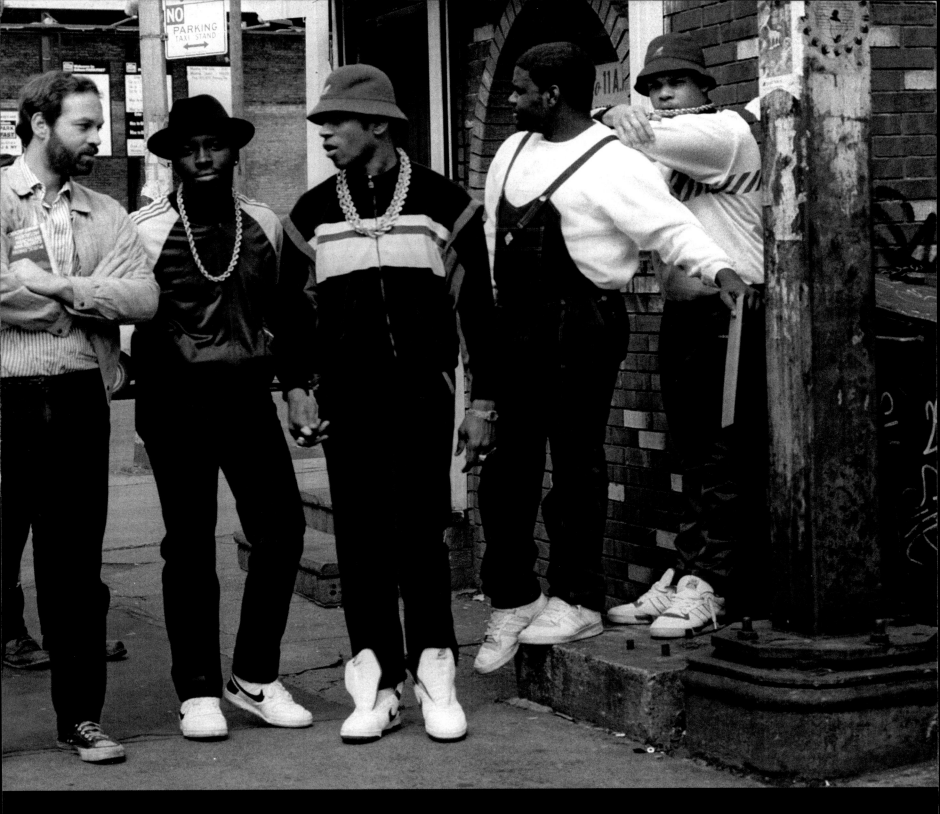

scratch an ear or blink their eyes or cough—the kinds of things humans, unlike statues, will sometimes do. But equally important, it also allowed the photographer to reject certain frames once he got a squint at the contact sheet. Now, in the twenty-first century, an amateur photographer like me gratefully selects the "continuous shooting" setting on his digital camera when it's time to shoot portraits. As long as I keep my finger on the trigger, the camera will automatically shoot either three or five frames per second, whichever I choose. It's a new era for photography, but I can't help but think about how the roles of the photographer and their subject have remained constant.

There was a great photographer named Charles Harris who worked for a black weekly newspaper called the *Pittsburgh Courier* from the '30s through the '70s. Nicknamed "Teenie" because of his physical stature, he took to referring to himself

as "One-Shot Harris" because he swore that that's how he rolled professionally. Lulu Lippincott, who curated a show of Teenie's work for the Carnegie Museum of Art in Pittsburgh in 2011, was interviewed then about the man's methods:

He did an awful lot of society portraiture and studio portraiture, and those are always beautifully posed and beautifully lit. He had a routine to get people to relax. And then when they were ready, he'd pull the camera up and snap. He was always telling people, "I'm just taking one photograph, so you have to get it right."

Me, I'm at least slightly skeptical. I'd love to see his contact sheets.

BILL ADLER is the former director of publicity at Def Jam Recordings. A longtime advocate for hip-hop photography, he founded the Eyejammie Fine Arts Gallery, which was devoted to the medium. In 2015, over four hundred exhibition prints from the Eyejammie collection were acquired by the National Museum of African American History and Culture. Adler is a collaborator on several books, including *Rap!: Portraits and Lyrics of a Generation of Black Rockers* with Janette Beckman and *Frozade Moments: Classic Street Photography of Ricky Powell.*

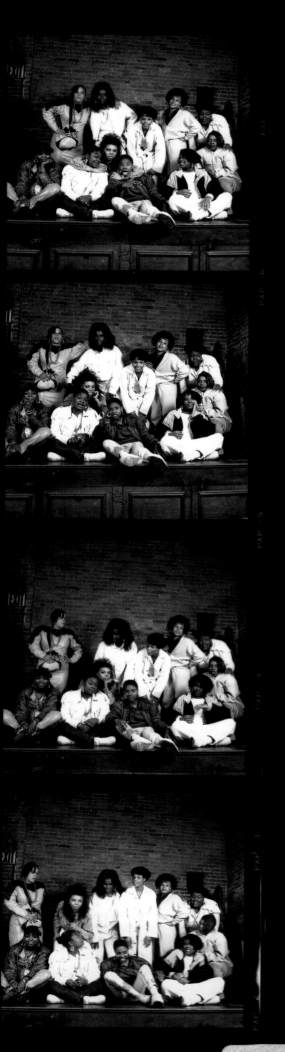
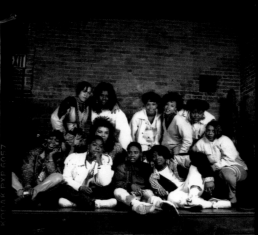
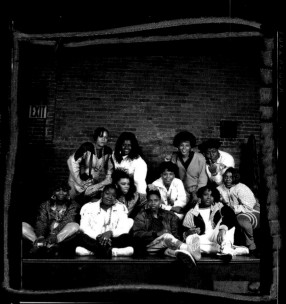
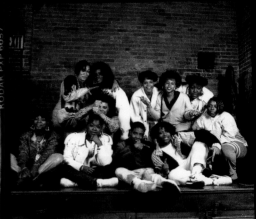
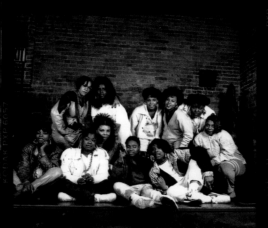
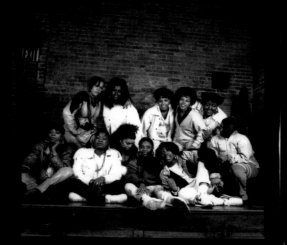
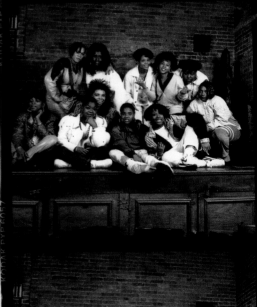
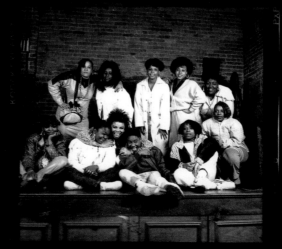
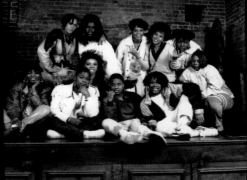

WOMEN RAPPER'S

© JANETTE BECKMAN

JANETTE BECKMAN

"LADIES OF HIP-HOP" SHOOT
FOR *PAPER* MAGAZINE

"I had been working as a photographer for *Paper* magazine since their first issue in 1984. They told me they were going to get the ladies of hip-hop together for a shoot in a Mexican restaurant on West Broadway. The ladies started to arrive, and the boys who arrived with them or worked at the restaurant were told they had to leave the area where we were shooting. We really wanted to create a vibe where they could relax and be themselves.

"It was an amazing group: Millie Jackson was there, the 'godmother of rap.' We also had Sparky D, Sweet Tee, Yvette Money, Ms. Melodie, Roxanne Shanté, MC Lyte, Synquis, Peaches, and also a few of Sparky D's dancers. Everyone was supporting each other and got along really well. To me, this feels almost like an old 'school portrait' with the teacher in the middle. It was great to celebrate the women in such a male-driven industry."

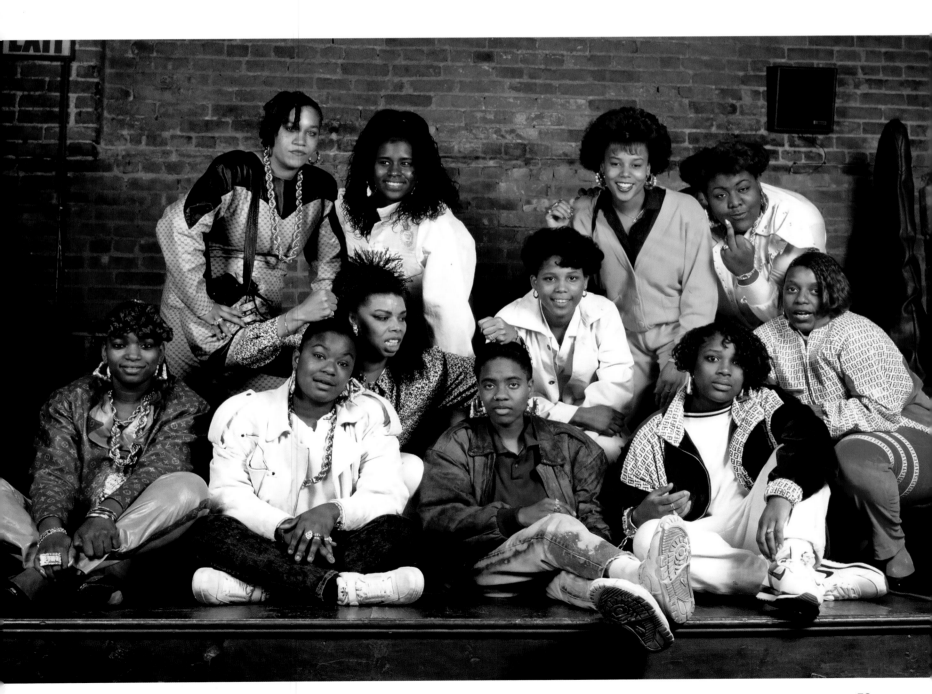

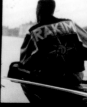
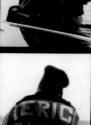
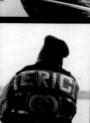

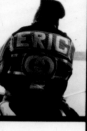

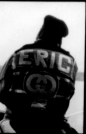

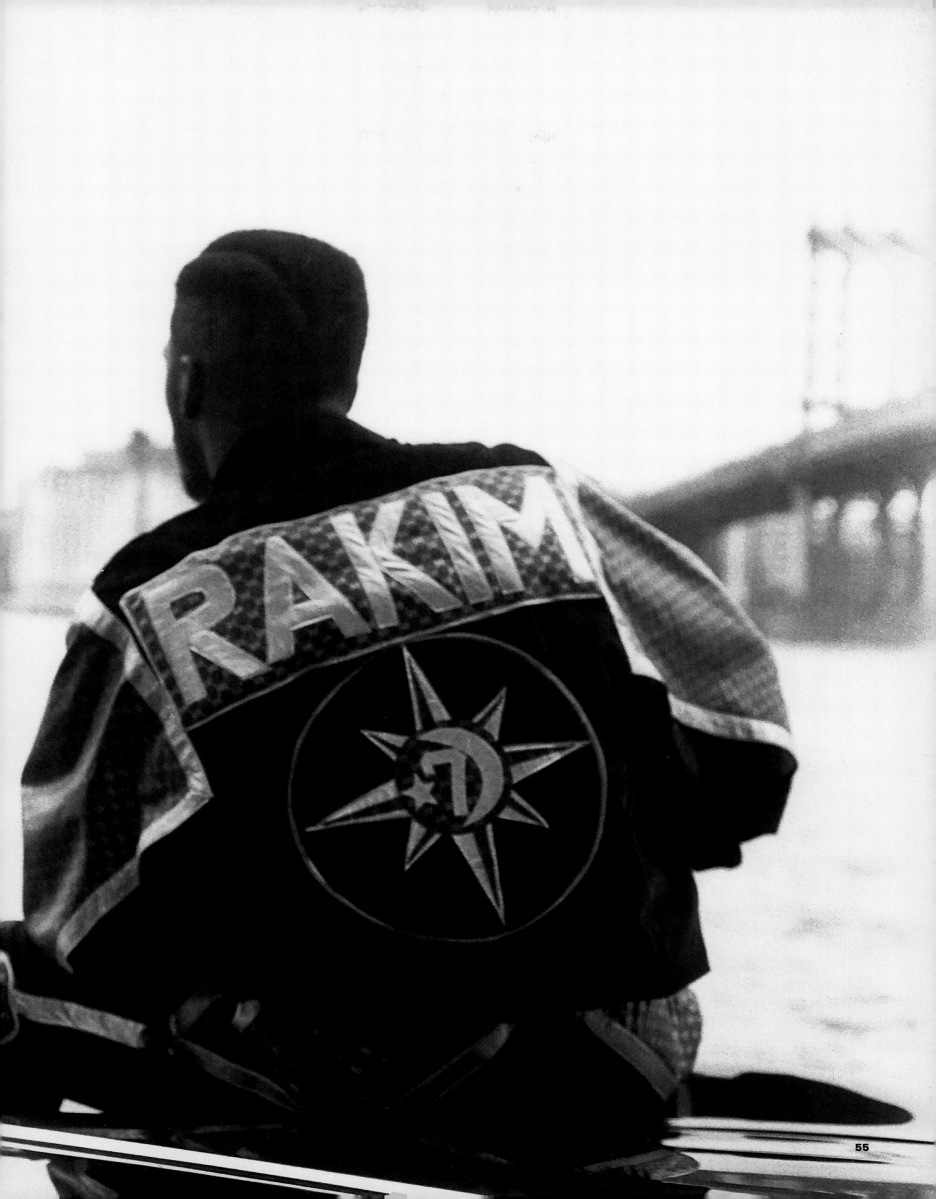

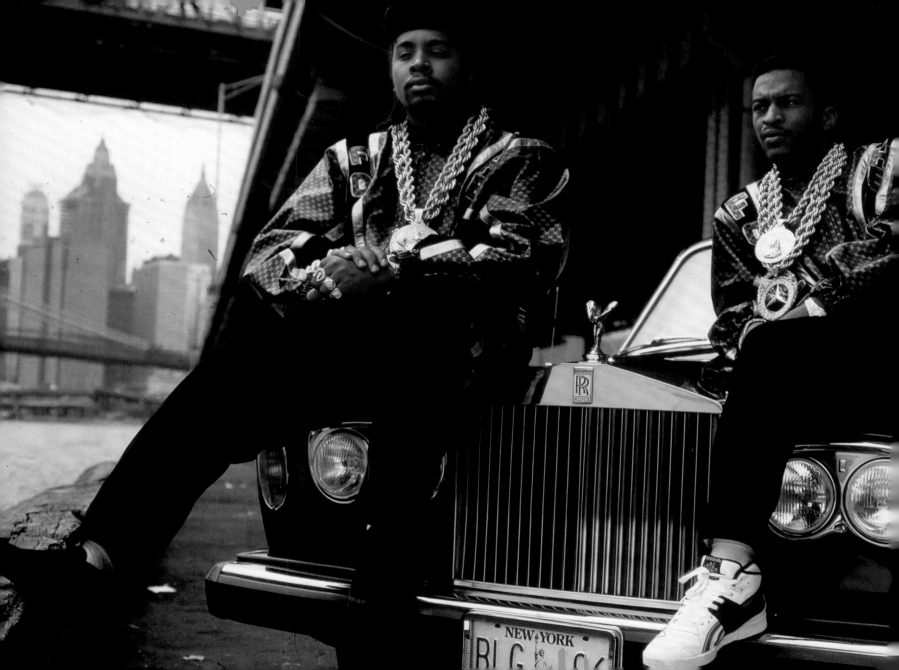

DREW CAROLAN

ERIC B. AND RAKIM, *FOLLOW THE LEADER*

"I felt a huge responsibility taking these photos. I knew this record was groundbreaking because of the samples being used and the flow of the rhymes. Nobody even came close to Eric B. and Rakim. They were untouchable. Rakim changed up the whole game when he started rhyming with a new lyrical style.

"I wanted to present the two of them as 'leaders,' and to do that, I shot them from a low, 'heroic' angle, making sure to incorporate the design of their cars into the shot since that was such a power pose.

"One of the unspoken rules of album covers was that you had to show the face or at least the front of the artist. But these guys were willing to turn their backs to the camera for the cover shot, and I thought that was really dope. The concept was that if you are following the leader, this is what you'd see—their backs. You can also see their Dapper Dan–branded jackets really well.

"We shot by the bridges in Lower Manhattan, since they represented the connections to the other boroughs and beyond. I had rented some 4×4 silver reflectors to bounce any ambient light around, since the riverfront and the bridges could create lots of shadows and obstructions. I thought the morning light made for a perfect setup for this cover, so we tried to shoot really early.

"But as the morning progressed, the light I was hoping for came and went, as both Eric and Rakim were nowhere to be found. We were standing around in thirty-degree weather watching the winter light head towards New Jersey and wondering when they would show up. Eventually, Eric showed up first with his crew driving a Rolls-Royce of insane magnitude—the kind of vehicle that you look at, but certainly don't touch.

"Finally, Rakim showed up driving his Mercedes and behind him were a slew of SUVs carrying his posse. He gets out of the car, looks at me, and says, 'How long is this going to take? I got to get back to Queens!' I told Rakim that we would get him out of there as soon as we possibly could, but I was also like, 'Um, this is your album cover, let's get it right!'

"I shot some with the Hassey and then fired off a roll with my motorized Nikon FM. All the film was Ektachrome transparency, which is a color reversal film photographers loved for the fine grain and clean colors it produced. That film was also excellent for crisp tones and contrasts, and that's why the look of these photos is so sharp. As it turned out, the label was happy, I was pleased, and Rakim made it back to Queens with time to spare."

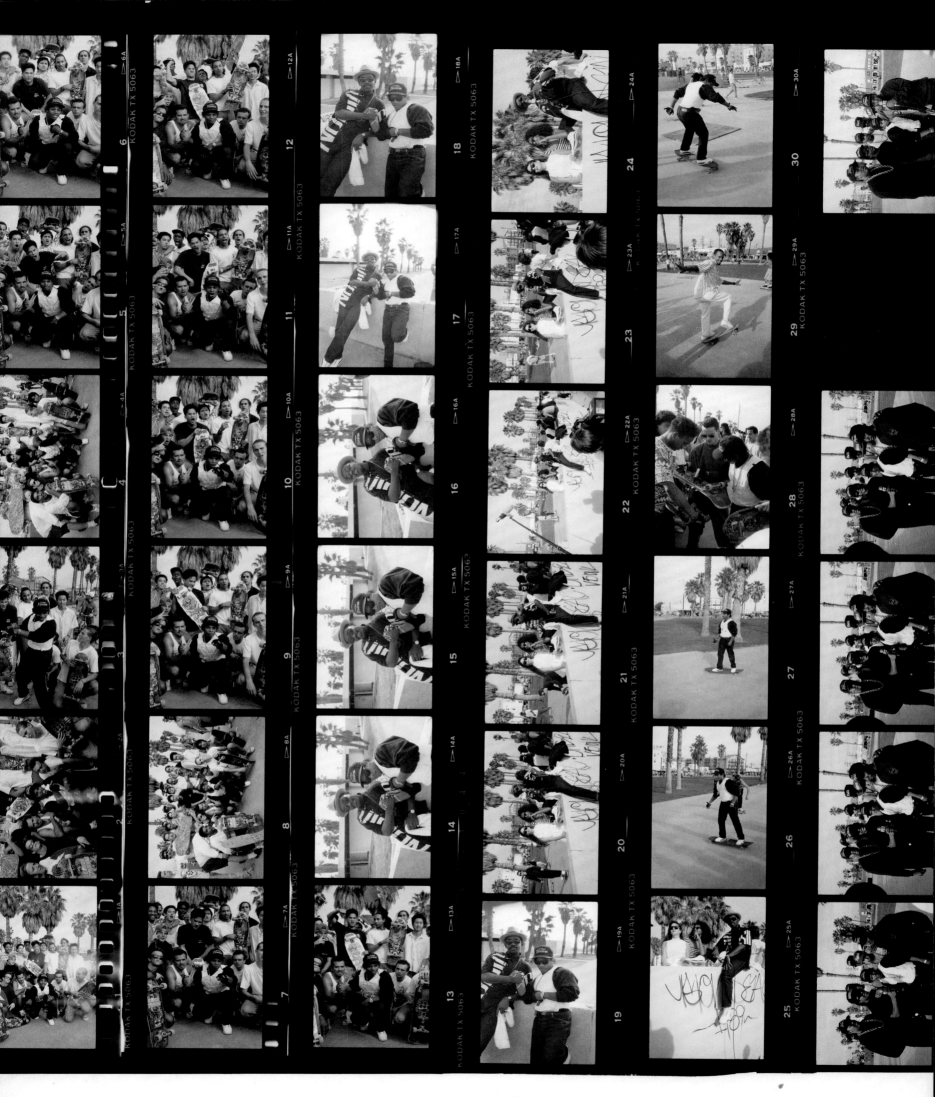

VENICE BEACH, LOS ANGELES, 1989

ITHAKA DARIN PAPPAS

EAZY-E AND N.W.A

"I look at these shots and think, 'Damn, I lived through something real!' At the time, I was the principal freelance photographer for Priority Records and was capturing almost all of the in-house Eazy-E and N.W.A images.

"I think Eazy was wearing that bulletproof vest for legitimate reasons. This was at the height of his fame with N.W.A, and Venice was a bit rougher back in those days. Literally anything could have gone down, especially since that skateboard wasn't even his. He signed it for someone and I think he kind of borrowed it without asking. Eazy wasn't skating as part of the shoot, he was just goofing around waiting for the *YO! MTV Raps* interview, which was part of an hour-long episode about him and N.W.A. I'm not even sure he ever knew I took those five or six frames.

"All of these images were taken on one of my Nikon cameras. I had a small flash unit on it, but just used it a couple of times for some of the portraits later on, and one or two of the shots of Eazy. I remember I wasn't sure if I should have used any of my film on that shot, because I wanted to make sure I had enough for the shoot of the whole group with Fab 5 Freddy.

"Before I started listening to hip-hop, I read a lot of Beat Generation authors. The first-person narrative intrigued me—it all felt very real, like I had a bond with those writers. Obviously, there was just a bit of distance between me and them because they were writing about cities I didn't know well, and about periods of time that happened before I was born. But when I first started shooting Eazy and N.W.A, it was a revelation because these were today's first-person storytellers."

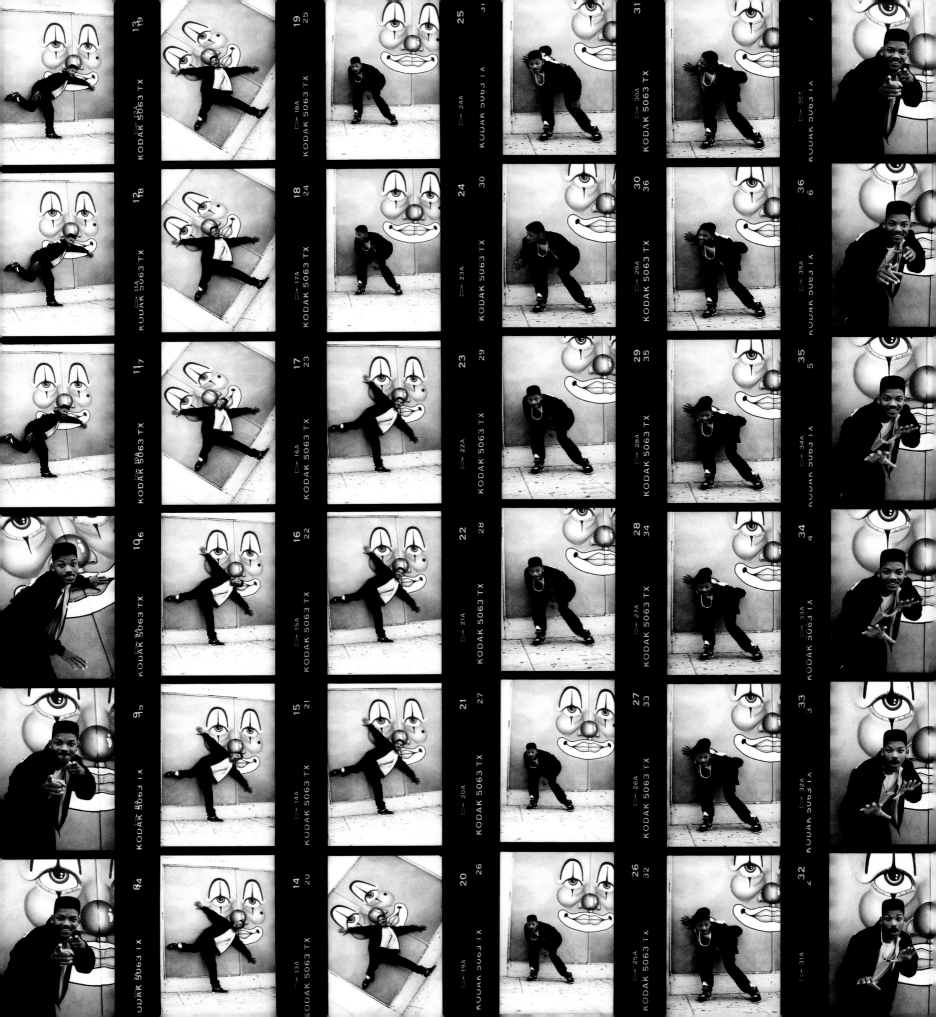

MIKE MILLER

WILL SMITH

"This was during an interesting time in Will's career where he was almost caught between two worlds. He was widely known as this TV darling because of *The Fresh Prince of Bel-Air*, but also had a burgeoning hip-hop career with DJ Jazzy Jeff. I knew him as a hip-hop artist first. Just two years before this photo, I saw him free-style at the Dragonfly in Silver Lake when he was just beginning his acting career. The next time I saw him was for this shoot. I picked him up in the Hollywood Hills and we shot around LA, he was loose and clowning around throughout the session. I used a Nikon F2 with TriX400 film. This was also the year Will Smith and DJ Jazzy Jeff won the Grammys' first-ever award for Best Rap Performance for their song 'Parents Just Don't Understand.' But the Grammys didn't even plan to televise the rap category, and I believe Will and Jeff decided to boycott the ceremony. It's amazing to think that rap wasn't even a big enough category yet, especially now when both hip-hop and Will himself have become so global and mainstream."

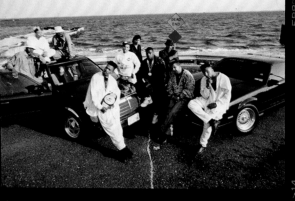
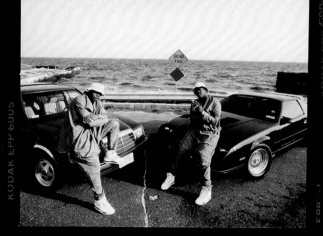
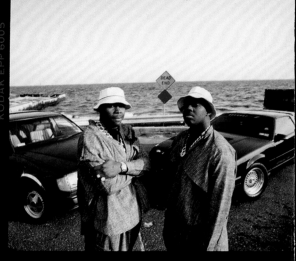

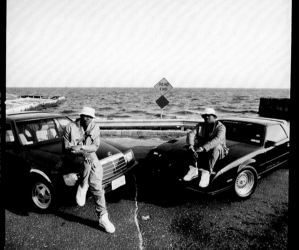

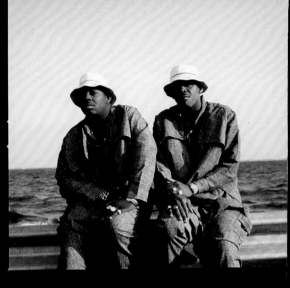
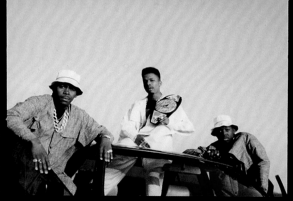
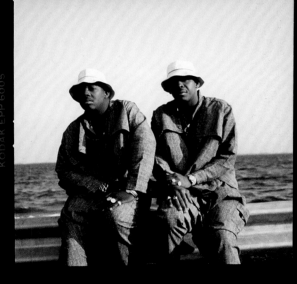

JANETTE BECKMAN

EPMD, *UNFINISHED BUSINESS*

"I was working a lot for a label called Sleeping Bag Records and I had photographed EPMD on a few occasions. They were already a legendary duo, Erick 'E-Double' Sermon and Parrish 'PMD' Smith, or 'Eric and Parrish Making Dollars' as they are commonly known. They told me to meet them at a specific spot near where they lived in Babylon, Long Island: 'Go down this road, you're going to hit the water, and we will be there at noon.'

"So, I got there at noon with my assistant, and they didn't turn up. It was winter, probably November, so the sun was setting pretty early. I was used to rappers being late, but the guys were *really* late. At 3:00 p.m. the light started to go down, and we had been waiting for several hours, so we finally went to find a phone box to call their manager. He told me they were getting their rims polished up in the Bronx and I'm like, 'The Bronx! That's hours away and the sun is going down!'

"Just as I was finishing the call, I heard that V-8 engine roar and they come roaring down the road. I got them to form a V-shape with their cars, which I thought would showcase them well for the shoot. Then they got out and they were wearing these outfits that looked like pajamas. That look ushered in this new style of casual sweat suits and a whole new look for hip-hop. We didn't have stylists or hair and makeup people back then, so it was purely their own unique style. The whole session took about half an hour and turned out to be a really important shoot, especially since these cars, a Mercedes 300SL and a Chevy IROC-Z, were considered a status symbol in car culture. The rims matter, they're a culture on their own, and that's why they were up in the Bronx for so long getting their rims polished. I'm glad I waited for the shot."

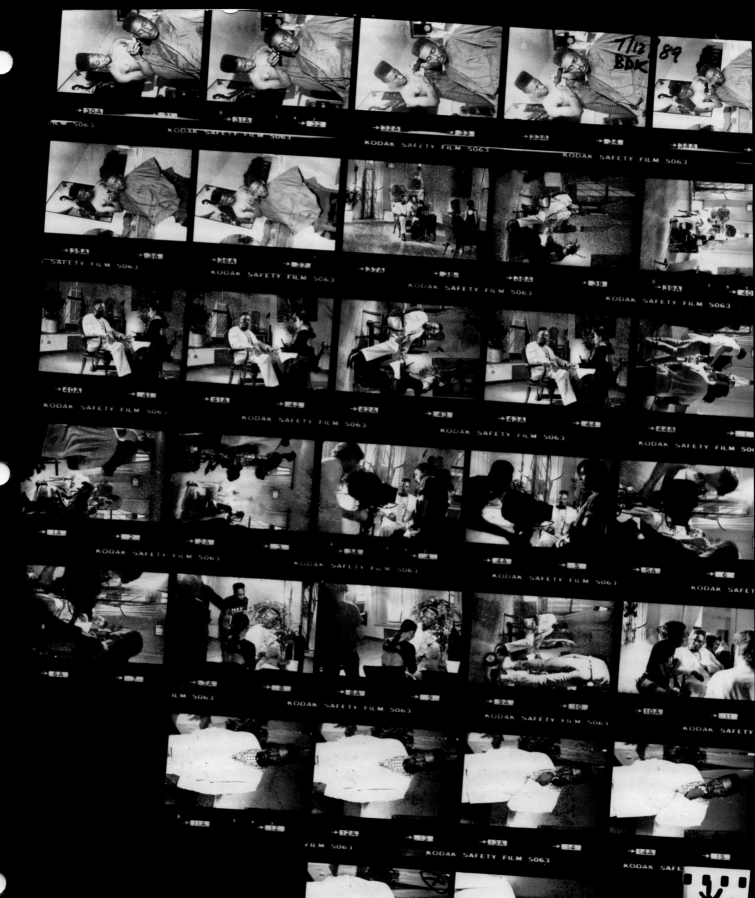

AL PEREIRA

BIG DADDY KANE

"I started out very much on the humble back in the 1980s. I had a day job as a medical copy editor but would go to Rudy's Records on 23rd Street on my break and memorize the contact info on the back of early hip-hop albums. Later, I would go home and call those numbers and ask if I could photograph some of their talent. If I didn't get an answer, I would type letters and ask to come by their offices and take photos.

"I asked Big Daddy Kane's label if I could hang out and shoot sometime, and they told me to meet him on the set of a video shoot at the John Allan's men's club in downtown Manhattan. At this point everyone was in love with Rakim, but Kane for me was the most exciting guy with the flow. He was like the gold standard in rhyming and just had an amazing presence. During the break, he thought he needed a touch-up to his hair so he asked his brother Scoob to fix him up. You can see he's wearing these awesome Fendi-print Dapper Dan pants. Super low-key, they just went into the back room and did their thing. Kane was in this fancy white suit putting out this air of astute power. The way he portrayed himself on the set was a real contrast to the intimacy of the haircut pic. I think nowadays people would be more aware of having that image out in the world, since it was truly a private moment that was not meant to be captured on film. But back then we didn't really think about it. These candid moments were part of what we did as photographers."

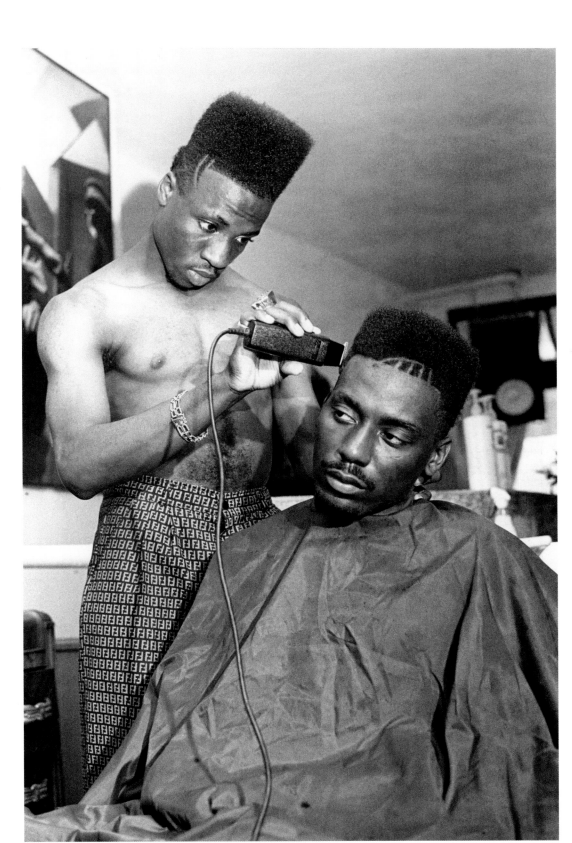

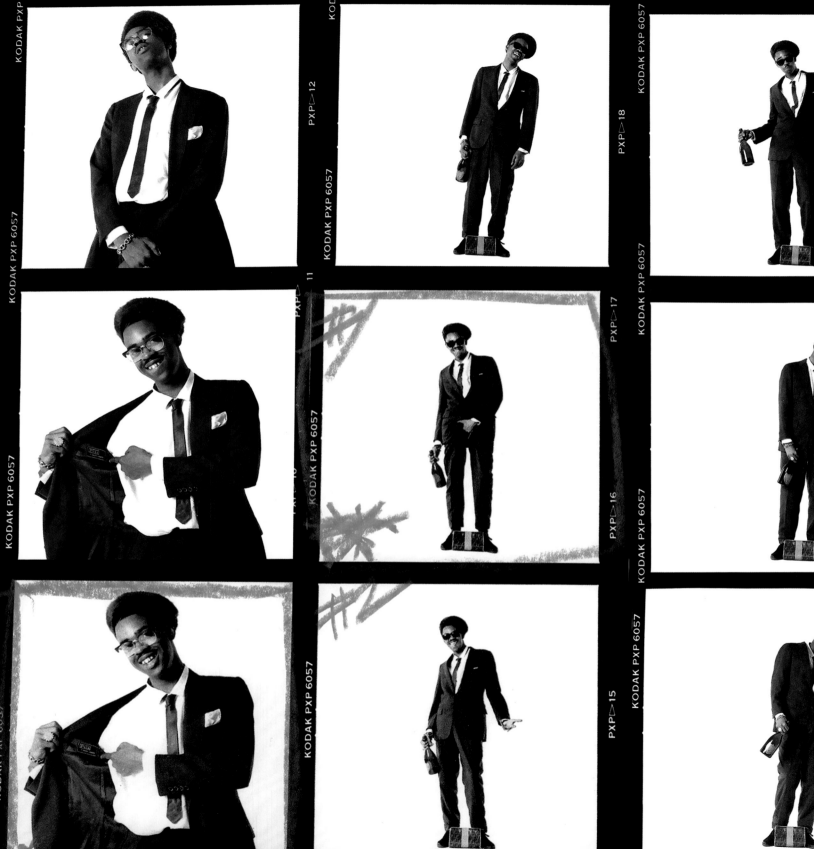

JANETTE BECKMAN

SLICK RICK

"Bill Adler was the press officer for Def Jam at the time and came along with Ricky—the three of us were all hanging out playing music in my studio on Lafayette Street in this old industrial building. Either Bill or Ricky had brought a bottle of champagne to the photo shoot to have some fun.

"My studio was set up with a white backdrop and I made a mark on the ground where I thought Rick should stand. My style is a collaboration between me and the subject, so I don't need a lot of tech or camera equipment. He stepped right up and stood there wearing a suit and Kangol hat. Slick Rick is British, and his style reminded me of these cool Jamaican ska/mod kids from Brixton.

"He put his bag down on the floor while holding the champagne bottle, drinks some champagne, grabs his crotch, and that was it. Snap! I took that picture within the first two minutes of the photo shoot and I knew that was it. To me that image and that attitude was just so hip-hop.

"We ended up taking a bunch of other shots, but I knew that was the one. It's like a physical feeling that comes over you. It was not the image they ultimately ended up choosing for the press photo, but when I saw the contact sheet later, I knew that was the iconic shot."

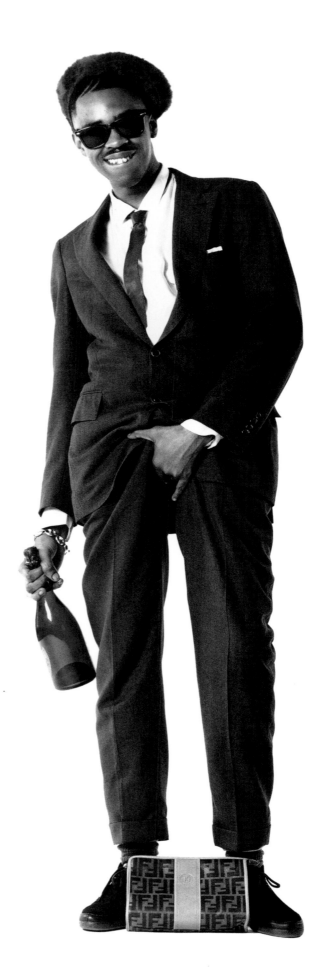

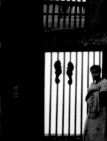
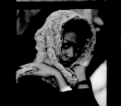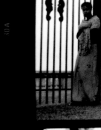

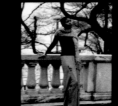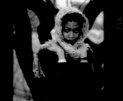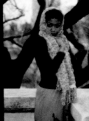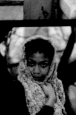
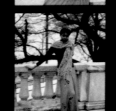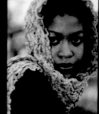
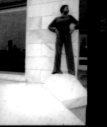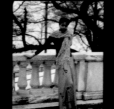

More popular than rock and roll, and more American than apple pie, hip-hop has filtered into every element of modern society. Like jazz or blues, it is a phenomenon that resonates with people of multiple generations and diverse backgrounds because, at its core, it is about giving a voice to the voiceless, and building communities using innovation and creativity. Hip-hop serves as an example of self-representation, perseverance, and human potential.

I was raised in Detroit, and grew up listening to hip-hop (and Prince, but that's a different discussion). I often spent my weekends with my cousins at my grandmother and great-grandmother's duplex on the west side of the city, choreographing dance routines to Afrika Bambaataa and the Soulsonic Force's *Planet Rock*, or looking out the front window awestruck by the poetry and honesty of Grandmaster Flash and the Furious Five's "The Message." I still remember getting ready for a party and jamming to A Tribe Called Quest's "Bonita Applebum" and the hardcore sounds of N.W.A, or driving in the car with friends and being embarrassed that I liked the raunchy tunes of Too $hort. These songs, these familiar sentiments, this art form, shaped my adolescence and helped me understand the world and its possibilities.

As the curator of photography and film at the Smithsonian National Museum of African American History and Culture, memories from my youth inform how I consider works for the permanent collection. I believe it is important to offer a greater understanding of ordinary people, and document moments that help expand narratives around a subject. This applies to the evolution of hip-hop as well. The range of images in this collection provide useful insights into how hip-hop culture is comprised of humble beginnings, and ordinary people who have created extraordinary moments from this youth culture.

I am also interested in artifacts that tell great stories and offer deeper insights into the way we understand life and our place in it. In 2016, the museum acquired the Eyejammie Hip-Hop Photography Collection, our biggest acquisition to date and the museum's largest single collection of hip-hop photographs. It consists of nearly five hundred images from more than eighty photographers, along with archival documents about the Eyejammie Fine Arts Gallery that Bill Adler established and ran in New York City for four years in the early 2000s. The collection represents a wide range of hip-hop imagery, from Big Daddy Kane getting his hair cut, Flavor Flav holding court with his friends at Adelphi University, and LL Cool J making his debut performance in the basement of a high school in New York, to images showcasing Southern hip-hop and wonderful West Coast rappers. Individually, the collection is comprised of portraits of different artists at various stages of their career; but as a whole, the photographs provide a glimpse into the growth and development of hip-hop culture—from its early, gritty aspirational days to the multibillion-dollar industry it has become.

Having this work in the museum's permanent collection not only documents these great artists, both historic and contemporary, but above all, it brings to light the origins of hip-hop culture. It demonstrates how the music grew out of a way of life and a community comprised of ordinary, working-class, and predominantly black and Latino youth. By preserving the work of these various photographers, this culture of everyday people immediately becomes part of a national conversation that will be accessible to generations forever. Ultimately, making hip-hop music and elements of the culture part of a permanent collection dedicated to telling the American story through an African American lens is important. People should see these images, learn about the origins of this culture, and draw parallels, not just with the past, but with the possibilities for the future.

RHEA L. COMBS, PhD, is curator of film and photography at the Smithsonian National Museum of African American History and Culture, and director of the museum's Earl W. and Amanda Stafford Center for African American Media Arts (CAAMA).

"Ernie didn't just shoot photos, he was part of the culture and that was important to us. If you don't know the culture, you can't archive it. It's not about him taking a picture of you, it's about how he can build a relationship with you and have your visuals express who you truly are." —Chuck D

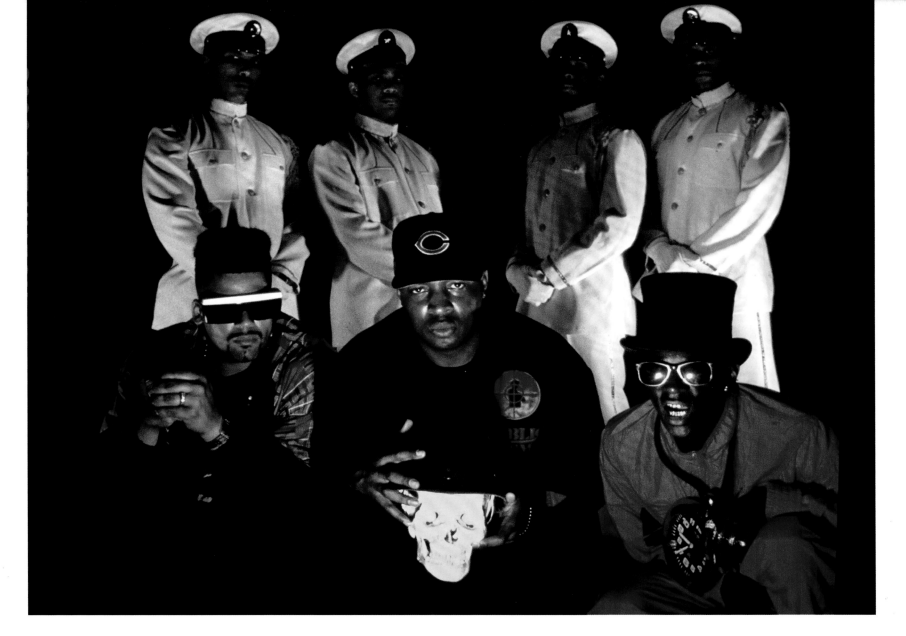

LONG ISLAND, 1990

ERNIE PANICCIOLI

PUBLIC ENEMY, *APOCALYPSE 91 . . . THE ENEMY STRIKES BLACK*

"While taking some film to be developed at a lab called Spectrum, I heard something new on the radio. The sound, the politics, moved me. It was Public Enemy. The lab technician said he knew the group and gave me the contact information for their label. I called them up, and in those days you could usually get right to Bill Adler or Russell Simmons. Sure enough, Bill picked up, and I said I wanted to photograph these guys.

"Within a week, I was meeting with Chuck D, Flavor Flav, Terminator X, Professor Griff, and the S1Ws. I felt I was in the presence of people who had the potential to create revolutionary change. We became family, and I photographed the group for various magazines over the next few months. Once, when I was laid up from knee surgery, I got a call from Chuck, who wanted me to do a cover shoot for Terminator X. 'I can't,' I said. 'I'm on crutches.' And Chuck was like, 'Is your finger broke?' So the S1Ws picked

me up for the shoot, and from that day on they liked my work.

"When it came time for *Apocalypse 91*, we collaborated at a photo studio in Long Island where Chuck worked as a kid. I got all my books on Malcolm X and the Black Panthers and had the S1Ws pose with all this iconography. There's a lot of symbolism in this photo. There are seven people, and the number 7 symbolizes God in the Five-Percent Nation. Chuck has a skull in his hands, which represents death, and four of them look like pallbearers. Terminator X is making an X with his thumbs as a reference to his moniker and the practice of black men replacing their last names with the letter. Flav and the S1Ws appear serene, and yet they also look militant and ready.

"I used a Mamiya 645 to shoot this cover, and I love the way it has spoken to the political power of hip-hop."

GEORGE DUBOSE

MASTA ACE AND BIZ
MARKIE DOLL

"This was for the cover of Masta Ace's 12-inch single 'Me and the Biz' from his second album, *Take a Look Around*. Ace had written the song and Biz Markie was supposed to make a guest appearance on it. But Biz and Marley Marl, the producer, had a dispute about publishing credits or something, and Biz refused to do his part on the single. Instead of Biz, it was Ace imitating Biz's voice that wound up on the track. When it came time to do the shoot, the video director had the idea to photograph him with this large puppet that looked like Biz Markie. I didn't know what to think of all this, but we did the shoot and that was that.

"The Biz doll wasn't particularly lifelike, but it had a lot of character. It was pretty rough-looking in fact, but it became very iconic over the years. I think the guys at *ego trip* magazine still have it somewhere. It's so fascinating how hip-hop gets archived, and what items become the stuff of legend. The Biz doll is definitely one of those things."

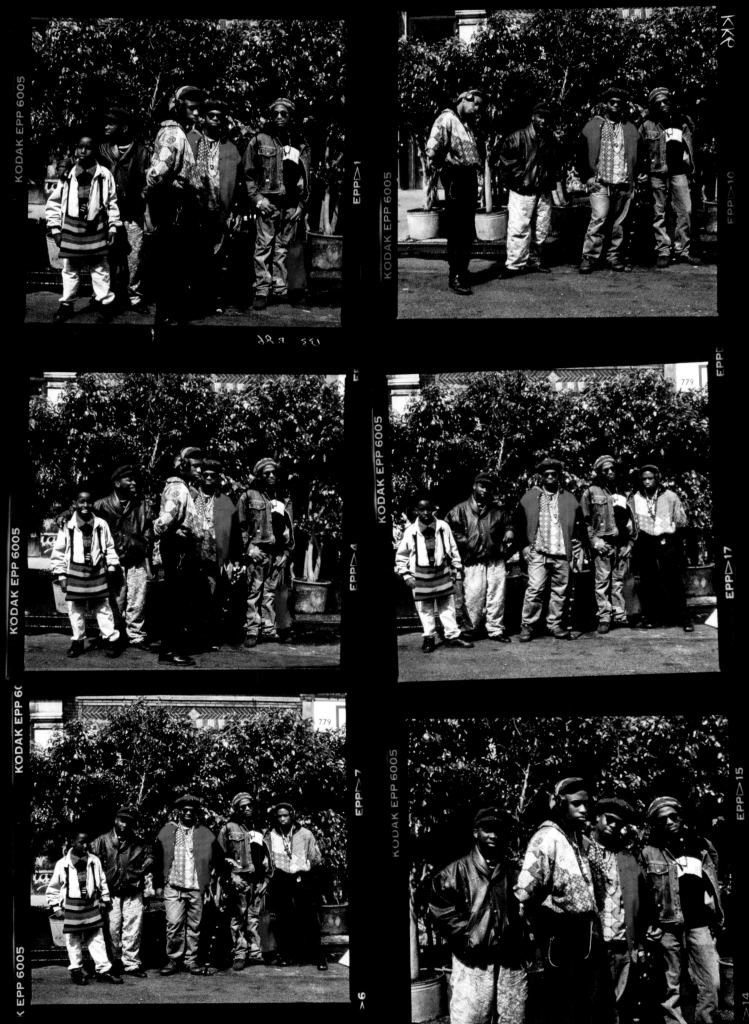

JANETTE BECKMAN

A TRIBE CALLED QUEST

"When A Tribe Called Quest first came out, it was quite revolutionary. It helped usher in a new era of Afrocentrism in music and also had a major impact on style. Their attitude seemed to be about peace and love and coming together rather than battling each other, and I wanted to express that in the shoot. We wanted to get a photo in nature to express those elements but they didn't have much time, so I decided to take them to the Chelsea flower district, the closest place I could find with tropical-looking trees in NYC. The shot, taken with my Hasselblad square format camera, was taken for a book I was doing with Bill Adler called *Rap: Portraits and Lyrics of a Generation of Black Rockers*. Jarobi's little brother was in the shot too. They were all so young!"

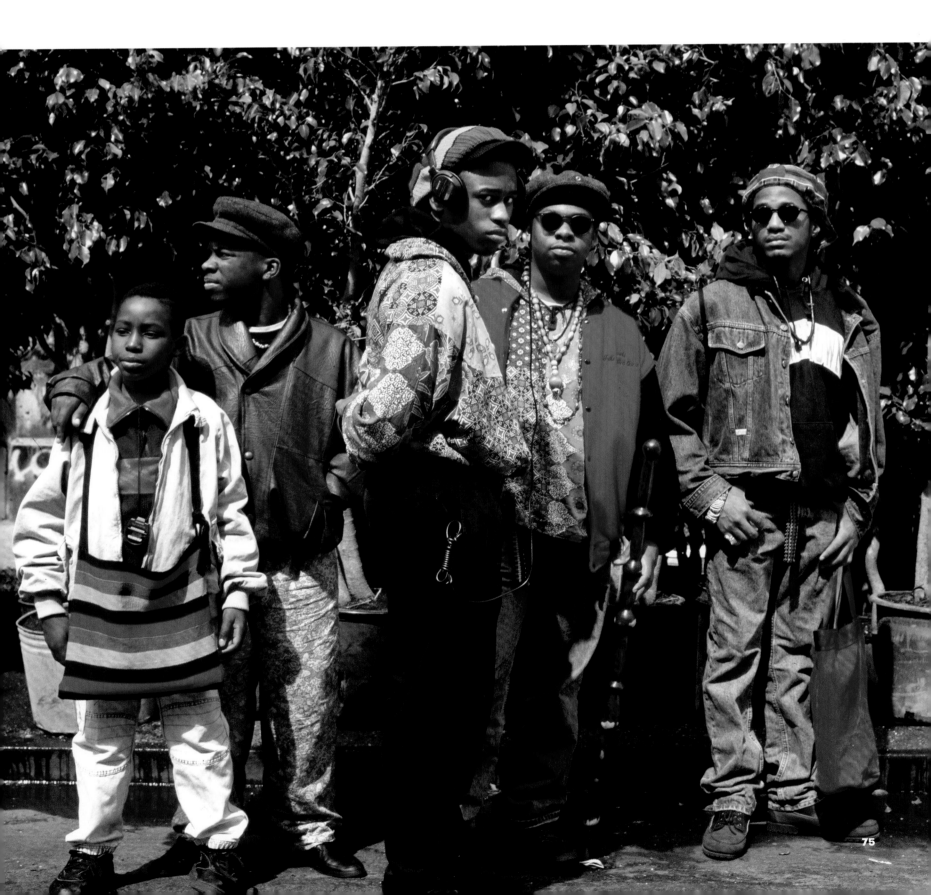

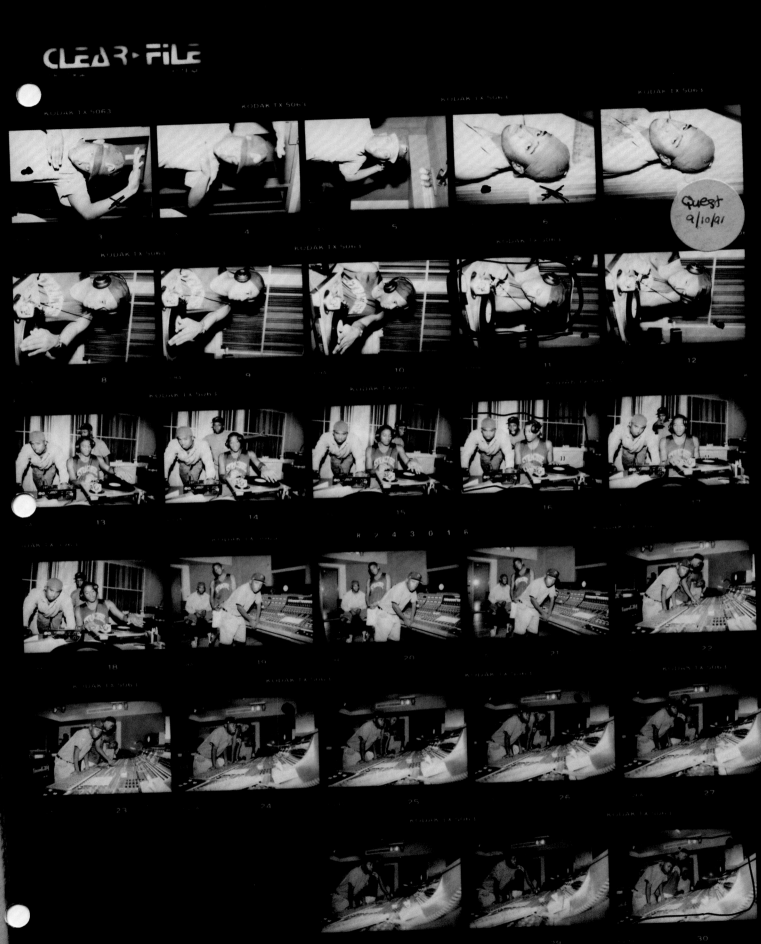

Quest
9/10/91

AL PEREIRA

PHIFE DAWG AND A TRIBE CALLED QUEST IN THE STUDIO

"I knew Tribe was at work on some new material, and I always preferred to shoot musicians while they were actually in the process of creating music. That was like a magic moment to me. The guys already knew me a bit so they were comfortable with me just hanging out and having fun. Phife was a real lighthearted guy. I kept trying to get him to pose but he was playing around behind me, so I turned around and quickly got the shot. I think the photo captures another side of him, a more multidimensional person. I also love the frame where Tip is putting the needle on the turntable. He was a guy that if you wanted to talk music, he was more than happy to get into it. We would talk about different records and really go deep into music history.

"This was just a few weeks before people started hearing their second album, *The Low End Theory*. Word on the street was that it was for serious hip-hop heads, and the album was being talked about as a game changer."

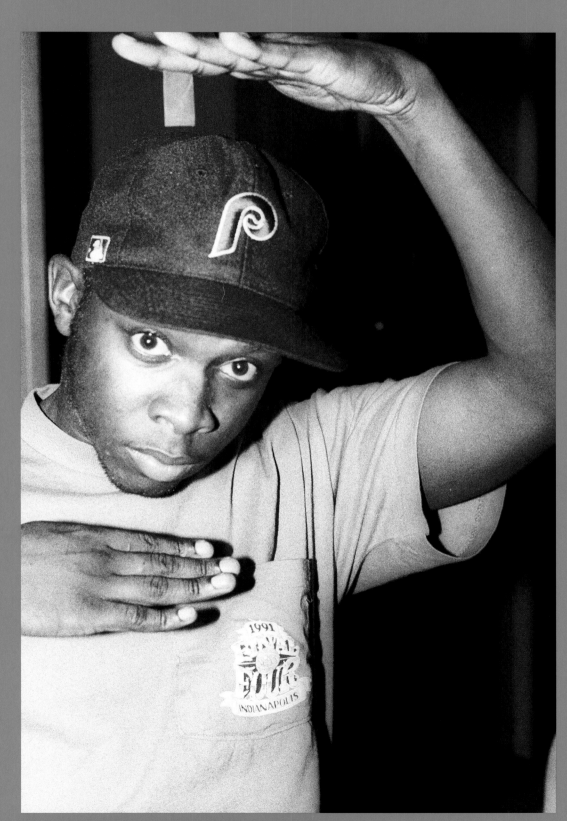

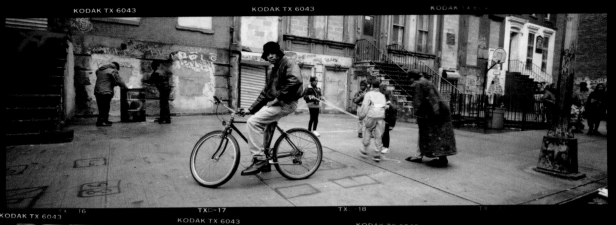

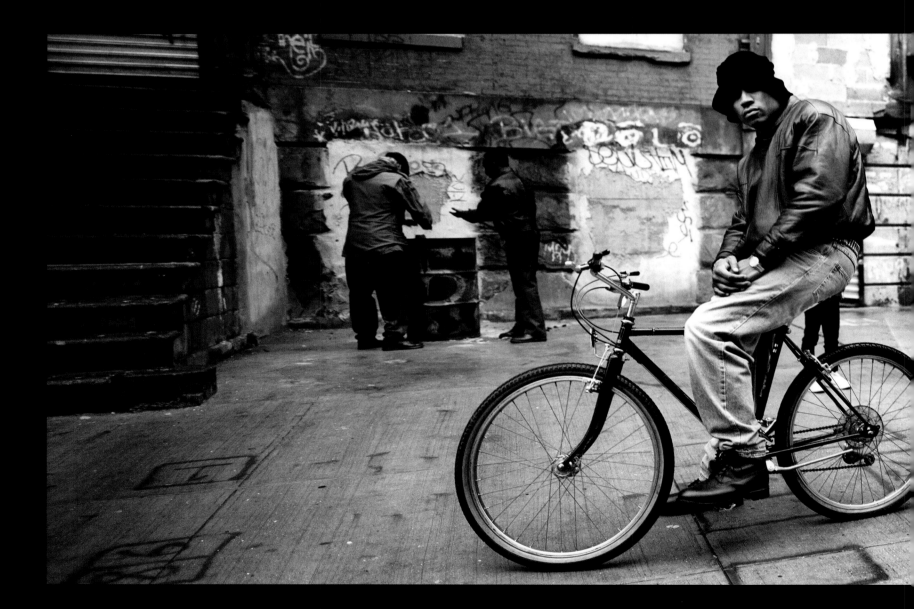

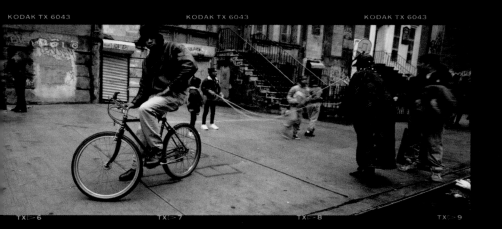

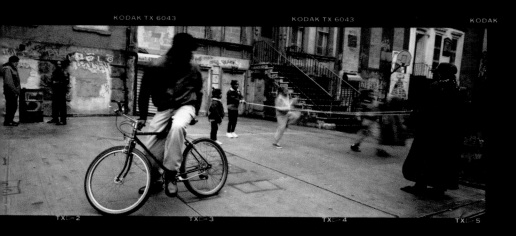

DANNY CLINCH

LL COOL J, *14 SHOTS TO THE DOME*

Danny Clinch is responsible for some of the most iconic music images of our time. Documenting across music genres from rock to hip-hop, the humble New Jersey–born lensman is known for his ability to convey moments of musical greatness with intimacy and grace.

"This was photographed for LL's *14 Shots to the Dome* album on 127th Street and Malcolm X Boulevard. I arrived early with my team to set up, get an idea of lighting conditions, and explore what the street and neighborhood were going to be like to photograph. The street was full of brownstones and had this classic Harlem vibe to it. LL arrived alone in a really nice car and stepped out to greet us. He looked around and noticed there were some guys on the block and apparently they weren't too keen on us shooting there unless we OK'd it with them first. LL immediately jumped back in his car and drove away, coming back a few hours later in an SUV with a bunch of guys from his Queens neighborhood. My team and I were patiently waiting on the sidelines while they figured some stuff out, and when I saw them all shake hands, I knew we were good to go."

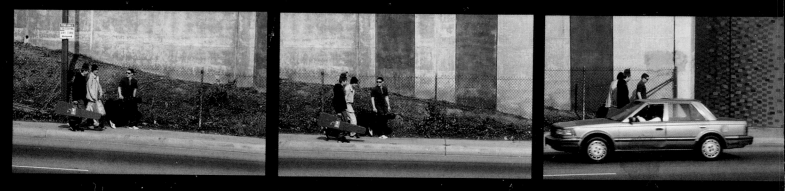

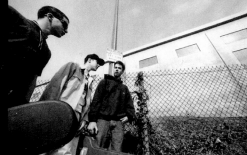
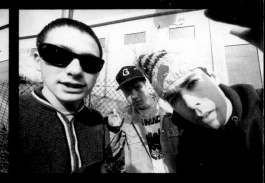

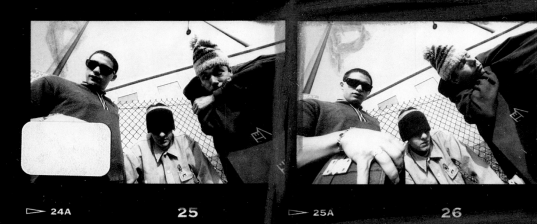
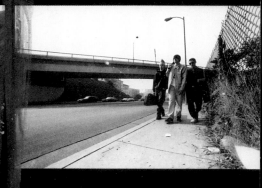

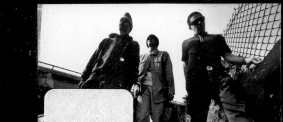

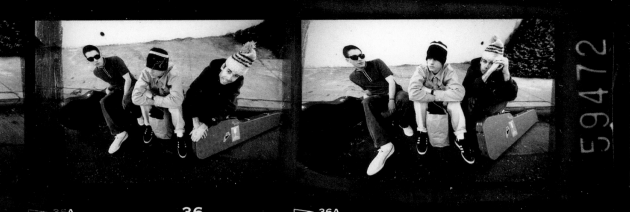

KODAK 5063 TX 36 KODAK 5063 TX

59472

35A 36 36A

II 11A

17 KODAK 5063 TX 18 KODAI

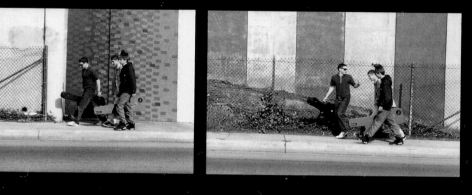

17 17A 18

23 KODAK 5063 TX 24 KODAI

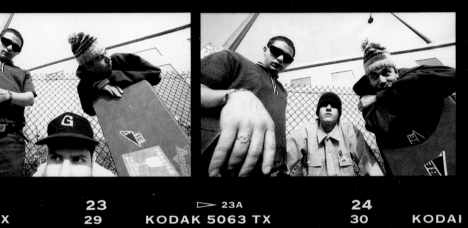

23 23A 24

29 KODAK 5063 TX 30 KODAI

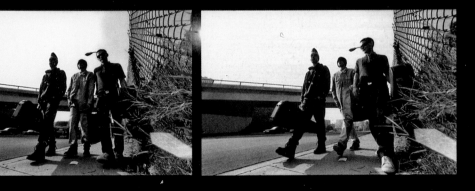

29 29A 30

33 KODAK 5063 TX 34 KODAI

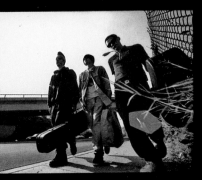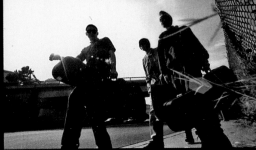

33 33A 34

GLEN E. FRIEDMAN

BEASTIE BOYS, *CHECK YOUR HEAD*

"It had been several years since I'd seen the Beasties. When they heard I was in LA, they invited me down to their studios out in Atwater Village, to check out their skate ramp in the studio, shoot some hoops (also in the studio), and listen to *Check Your Head*. I was totally inspired by the album, so I told them that we should take photos before I had to go back to New York. They said they were into it, that it would be like old times.

"Unfortunately, the album cover had already been laid out, but I was unfazed. When Adam heard how determined I was to shoot the cover, he had an idea—he wanted me to create their version of a photo I had shot for the cover of Minor Threat's 7-inch EP *Salad Days*. Knowing how much he loved that image, I had this vision for the cover to portray a group of hardcore kids walking with instruments the way they would in the early '80s, up Avenue A in the East Village or down Broadway going to rehearsal. And that was how I saw the Beasties, with their instruments and a new attitude. I wanted to show people that we were bringing it back to the base of who they were as a group.

"We met up early in the morning on Franklin Avenue by the Capitol Records Building. I took pictures of them just walking up and down the sidewalk, and then one photograph of them sitting on the curb. I only shot three frames and that was at the end of the roll, but I knew the curb shot was their version of the *Salad Days* photo.

"Over the next few days I got the film developed and made some 8×10 prints. Then I called Mike, who reiterated that 'the cover is already done,' but to send them over anyway. I had a fax machine with a halftone mode, so it relayed the photographs in a dot pattern, giving them a slightly pixilated look. As I was scanning the images to send, I noticed the quality wasn't actually that bad. Mike called me back a few days later and said, 'We're on deadline, but we love this photo. It's the cover! And we love the look of your faxes so much, we're going to just use the fax on the cover!' I was like, 'Oh fuck! You've got to be kidding.' It was typical Beastie Boys shit, you just gotta laugh.

"There were conspiracy theories floating around for years that the position they're in on the cover was meant to be a subliminal ad for Adidas, since they seem to be sitting in the same shape as the brand's 'trefoil' logo. Or that each guy was supposed to represent one of the Three Wise Monkeys, known as the 'see nothing, hear nothing, say nothing' monkeys. Neither scenario was intentional.

"Of the three frames in this specific sequence, the one used on the album cover (frame 35), was the first one I shot and in my opinion isn't the best composition. Adam's face is partially covered, which I did not like, but that was the one they picked. I was told that they would use my favorite (the last of the three) on their merchandise later, and they did. In the middle one, Adam's smiling, which wasn't the attitude at all. It's just a blooper, really, and he was probably laughing at that moment. In retrospect, it's great to have now that he's gone. Great moments, good times."

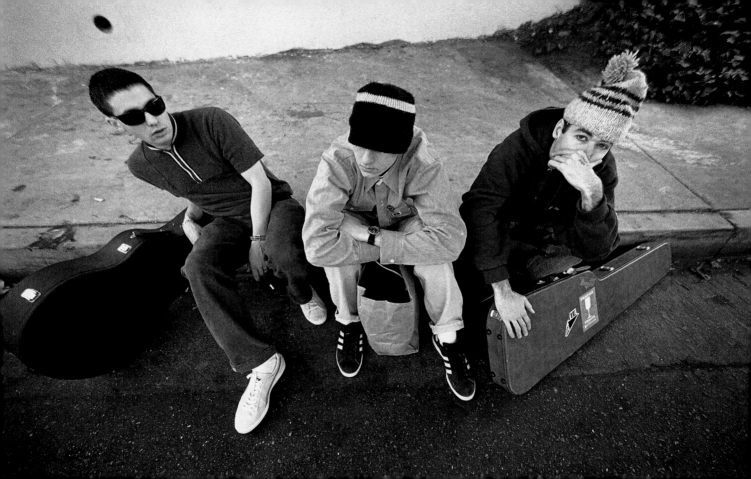

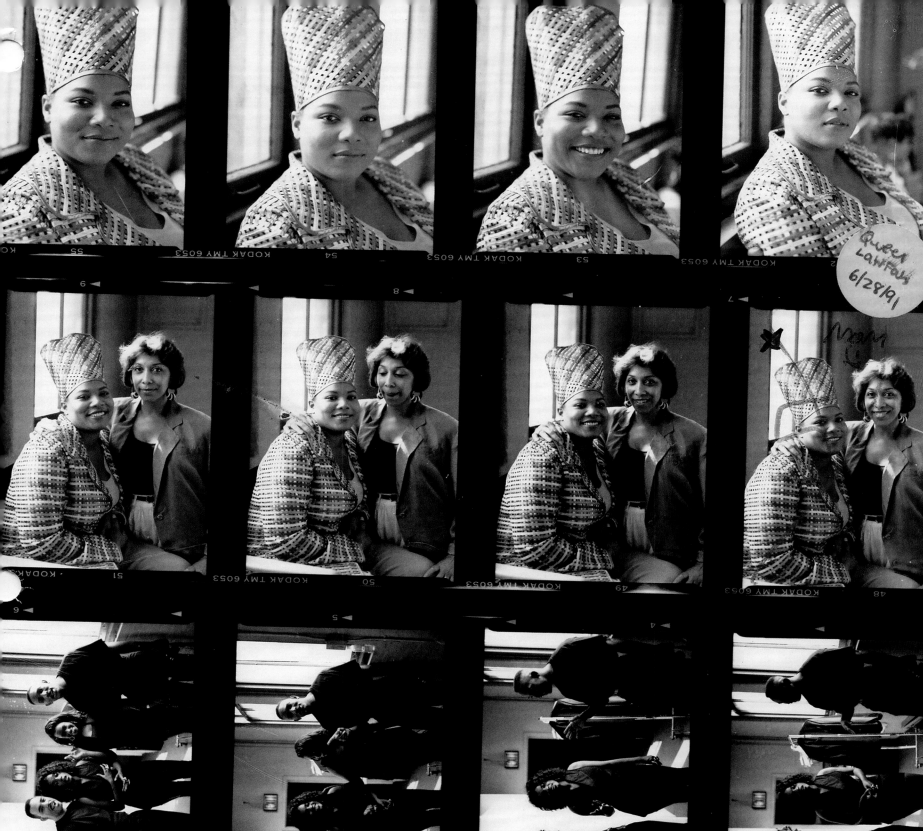

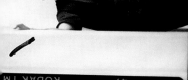
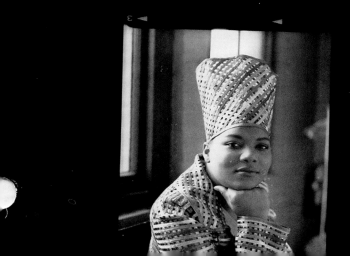
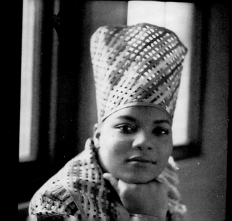

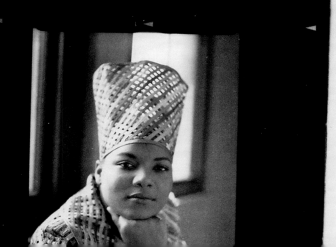

AL PEREIRA

QUEEN LATIFAH

"I shot this on the set of the 'Fly Girl' video with a Pentax 645 Medium 2¼" negative using a manual focus with a 75mm/2.8 lens.

"Latifah was on Tommy Boy Records at the time. Her mom was a big part of her career and made sure Dana (that's what I called her) was always aboveboard. She was at the shoot as well, and on the contact sheet you can see her with Dana and her dancers. You can see that some of the light was leaking in here too—I almost lost that shot.

"I believe the artist's ideas inform their image, so I love collaboration. It was actually her idea to do the smoking gun kind of pose. She did all the heavy lifting with that shot, and really brought power to it. Dana was always a visual person and understood the power of media and photography. She was an unapologetic champion for black feminism, pride, and Afrocentrism, and it was all expressed in her lyrics, her style, and her media image. She was the Queen in command."

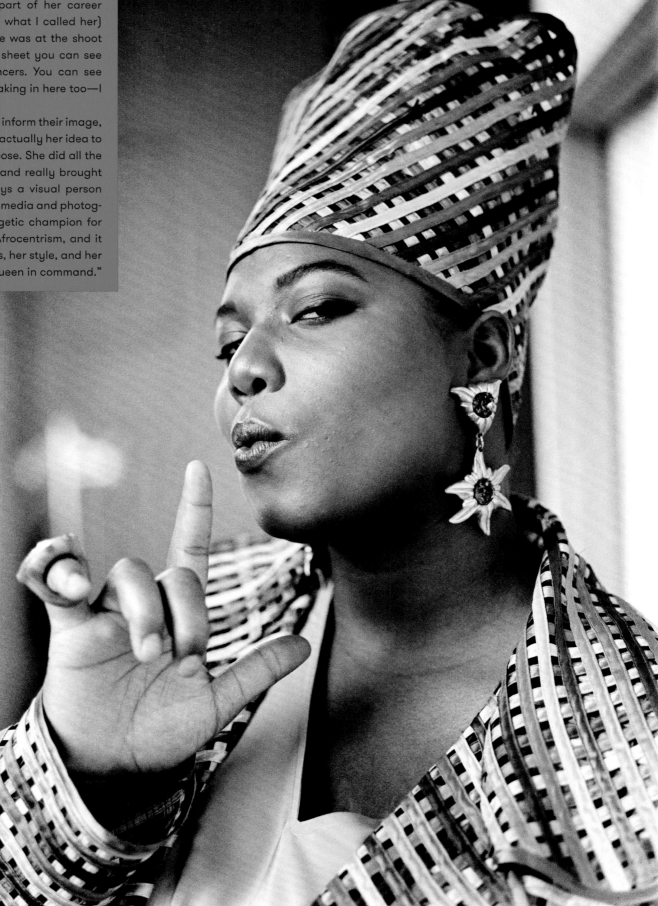

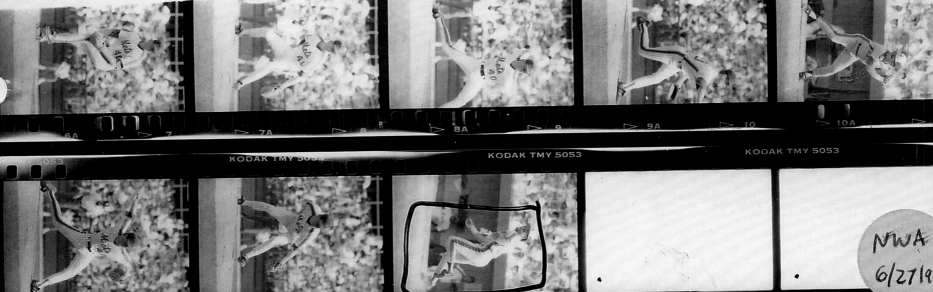

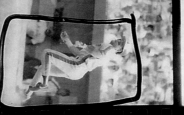

NWA
6/27/9

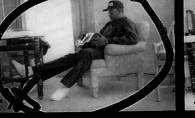
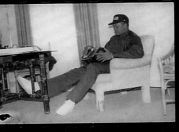
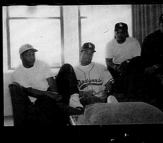

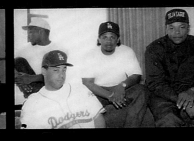

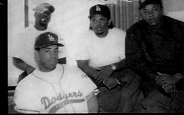

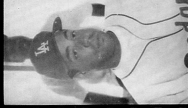
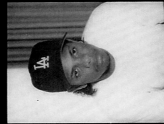
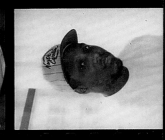

AL PEREIRA

DR. DRE

"I was coming from shooting a Mets game so I was kind of in a rush by the time I got to the hotel where N.W.A was staying.

"Because I had already put in a full day of shooting, I just wanted to get in a few shots of the group. Nothing too special, just a quick snap of the moment. The first half of the film roll has my shots from the game on it, but I just used the film I had because the group was from the West Coast and I didn't know when I would get the chance to photograph them again.

This was when N.W.A was at the height of their career but I believe Ice Cube had left the group over a dispute; that's why he isn't in the photos. They were promoting their album *Niggaz4Life*, which ended up being the group's last. Apparently Dre had twisted his knee the night before so he was laying low while the rest of the group was planning to go out in the city.

Dre was also getting some bad press due to the allegations circulating that he assaulted media personality Dee Barnes. I think it was a complex time in his life.

"I took a few basic 'look at the camera' shots, and everyone except Dre left to hit the town. As I was putting away my camera equipment and getting ready to leave, I looked back and Dre was sitting there really focused, lost in thought. I grabbed the camera out of my bag and got this shot. I imagined he was thinking about his next move."

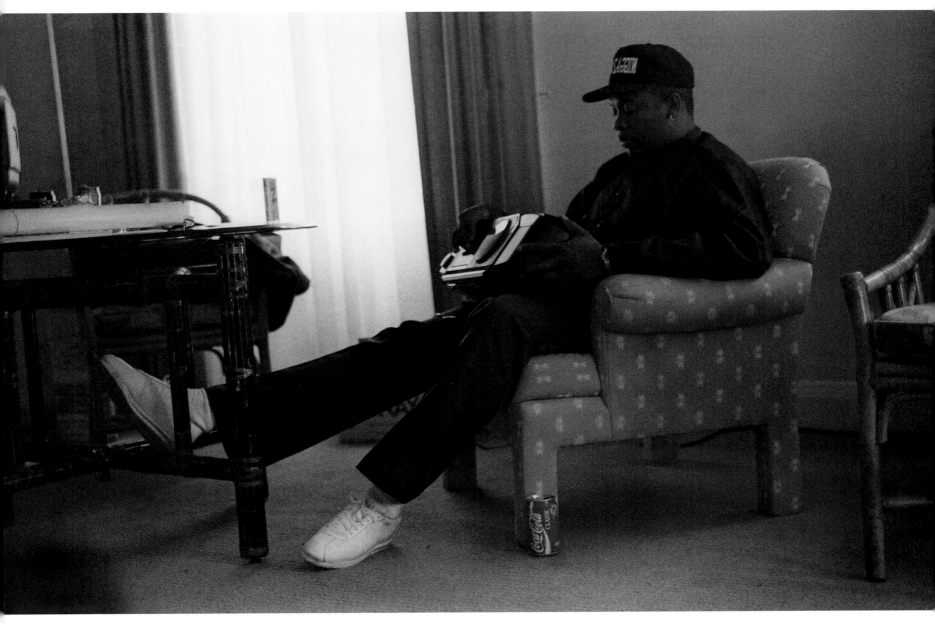

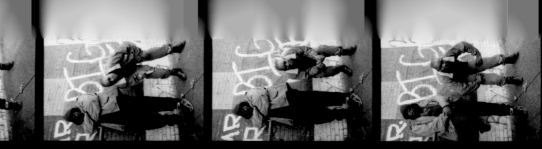

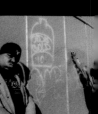
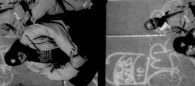
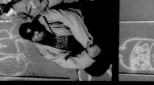
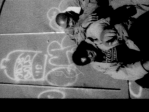

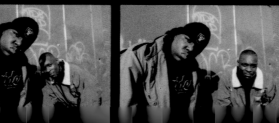
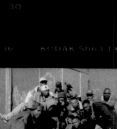
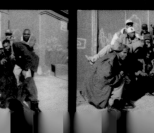
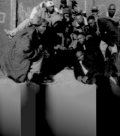

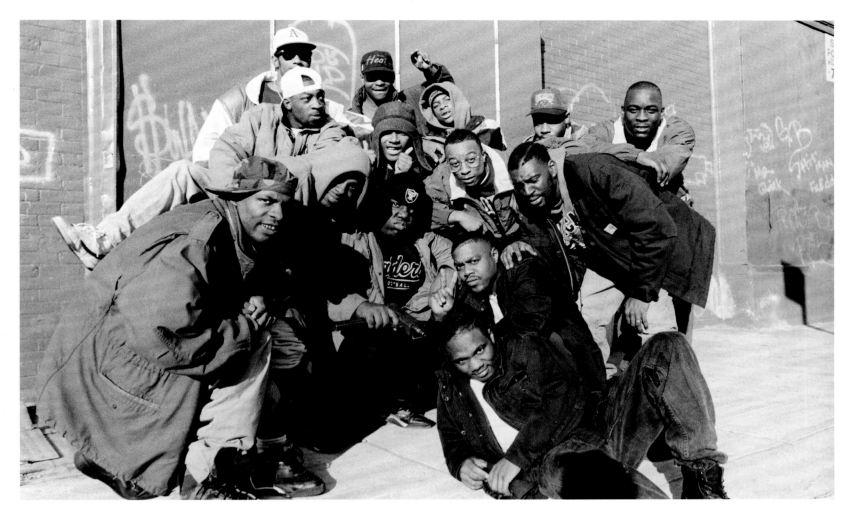

BROOKLYN, 1992

GEORGE DUBOSE

BIGGIE SMALLS' FIRST PHOTO SHOOT

The corner of Bedford Avenue and Quincy Street in Brooklyn is by now synonymous with the origin story of one of hip-hop's native sons. Baby-faced and confident AF, Biggie Smalls participated in his first public rap duel at that intersection during an impromptu block party in the late 1980s. It made sense, then, that when it came time for nineteen-year-old Biggie to choose a location for his first professional photo shoot, he insisted on that corner.

The shoot was done as a favor to Mister Cee (Big Daddy Kane's DJ), who asked photographer George DuBose to photograph a young rapper that he had produced a single for.

"Since I had gotten so much work from Big Daddy Kane and put together so many projects for him, I thought I could throw a 'freebie' to Mister Cee but tell him that I wasn't going to Bed-Stuy with any camera equipment unless he came along. But if I was telepathic, I would have shot more film, at least some in color. As this was a 'no budget' shoot and Biggie was unknown to anyone at the time, I only shot thirty-six frames and got the hell out of Dodge.

"Apparently, the intersection of Quincy Street and Bedford Avenue was Biggie's 'corner,' so it was important to include the street signs

in the background of my shots. That forced me to shoot up at him from a very low angle, so the sign was visible in the camera frame. I used a Canon F-1 with a 35mm lens and probably Kodak's Tri-X processed in Agfa Rodinal. I like the way Rodinal defines the grain of the film rather than making the grain soft. Grainy films are usually my favorite.

"About twenty of Biggie's friends showed up midway through the shoot and were really excited about what was happening and wanted a photo of everyone together. I then found myself looking for a place to pose twenty guys that showed up seemingly 'out of the blue.' I chose a wall of graffiti that was not too far from the intersection that would accommodate everyone. Only after I closely examined the photos in the darkroom did I realize that some of the graffiti referred to or was done by Biggie.

"I used the last two shots on the roll to get those group shots. I had to keep asking Biggie to point the Uzi anywhere but at the camera, and right when he would point it elsewhere, I would look in the viewfinder and see that he was pointing it at me. I asked him again, and then only took two photos. By then I was at the end of my roll (and my rope) and was like, 'Thanks. That's it, we got it.'"

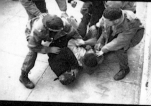

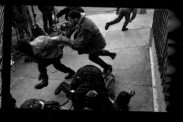
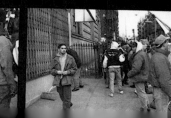
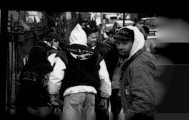

ADGER COWANS

TUPAC SHAKUR ON THE SET OF *JUICE*

When Ernest Dickerson's directorial debut, *Juice*, was released in 1992, it instantly drew praise for its honest portrayal of inner-city life. Set in Harlem in the early '90s, the film centered on four young men—played by Omar Epps, Khalil Kain, Jermaine Hopkins, and Tupac Shakur in his first starring role—whose lives are tragically changed as a result of one wrong decision.

The set photographer was Adger Cowans, the first African American man to work in Hollywood shooting film stills on movie sets. A former apprentice of Gordon Parks, Cowans would eventually achieve the same star status as his mentor, becoming a highly sought-after photojournalist and fashion photographer in the late '50s, and is closely associated with Kamoinge, an important collective of photographers who champion the black experience. During the filming of *Juice*, Cowans and Tupac forged a close bond.

"Tupac and I got along great. Now there was a guy I felt something about. I think he was too smart for his own good at times. I had photographed on several film sets prior to *Juice*, but this was one of the few that had a black director and mostly black cast. When I started shooting on film sets many years prior, I walked around with a 35mm Leica M2 and they were like, 'Where's your real camera?' Most things were shot on a larger-format Hasselblad. When the 35mm cameras came out, they weren't taken very seriously. Now I shoot on everything. I have an RZ, I have a 4×5, I have two Nikons. But back in the day the Leica M2 was my favorite and that's what I photographed *Juice* with. Set photography was a very specific kind of shooting. When a shot is going down, the director is standing right there, so you have to think of little games to get your picture, because the director was always watching me to see where I was standing for a good vantage. You had to be stealthy while concentrating on what you were trying to express."

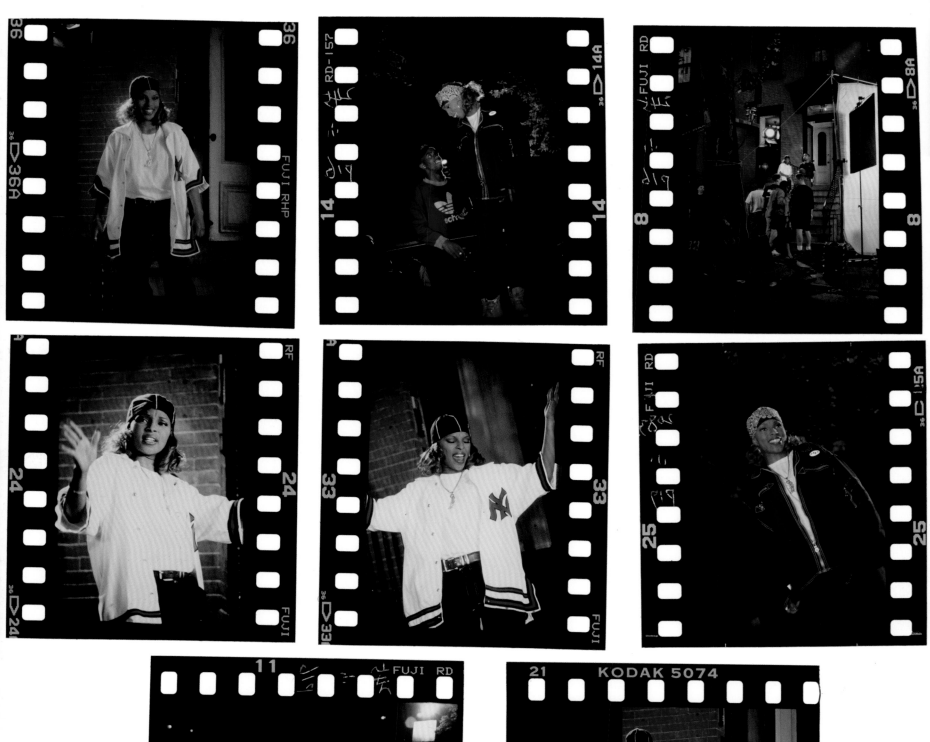
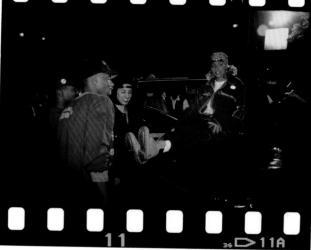
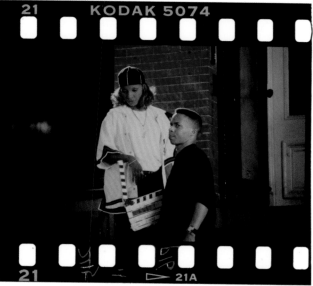

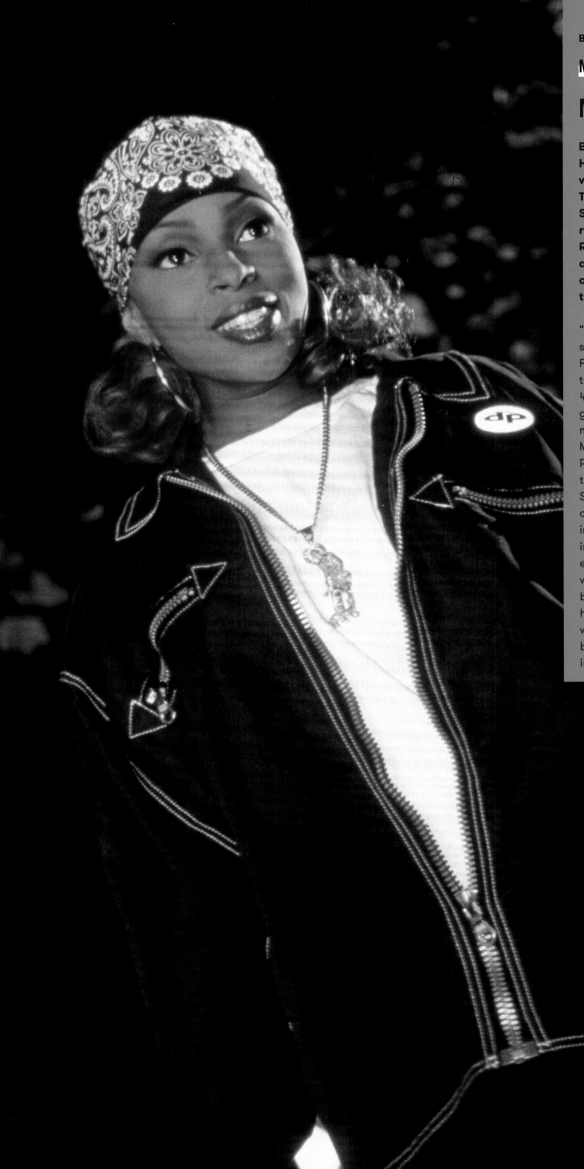

MICHAEL BENABIB

MARY J. BLIGE

Before Mary J. Blige became the "Queen of Hip-Hop Soul," she was a girl from around the way. With her baseball hat to the back and Timberlands, the young singer from Yonkers' Schlobohm housing projects would come to redefine not only the fusion of hip-hop and R&B but also urban style for women. Blige, along with Sean "Diddy" Combs and some other visionary stylists, were instrumental in the creation of her game-changing style.

"This was on the set of her music video for her single 'You Don't Have to Worry,' directed by F. Gary Gray. Some of the images were used for the cover of the remixed version of *What's the 411?* Puffy did the remix, which meant this was going to be played in the clubs, so I wanted to make sure the photos I got really captured what Mary was all about. In the frames, you can see Puff next to one of Mary's dancers and Mary on top of the Jeep, which belonged to the stylist Sybil Pennix. Sybil was initially Puffy's assistant at Uptown Records but then moved into creating and styling Mary's look, which of course included the baseball jerseys and the hoop earrings. The hoops were real b-girl, which she wears to this day. I shot on slide transparencies because the turnaround was so quick. Puffy hadn't started Bad Boy at this time, he was still working with Andre Harrell at Uptown Records, but he was already a force of nature. He was instrumental in making Mary a star."

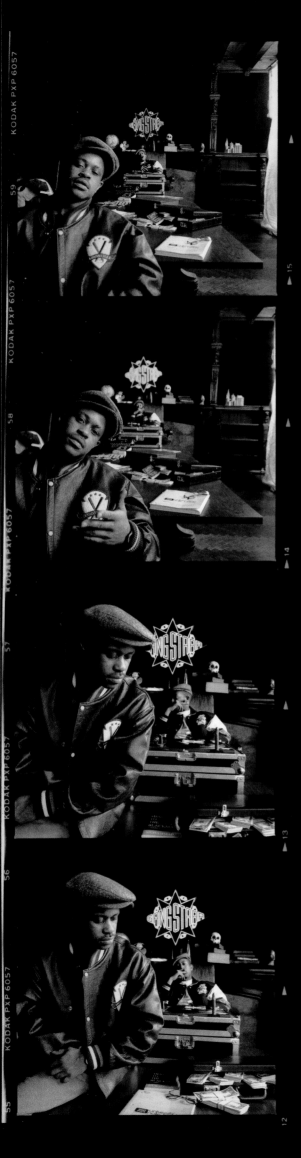
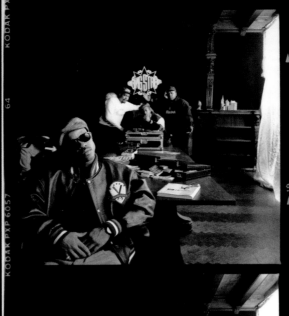
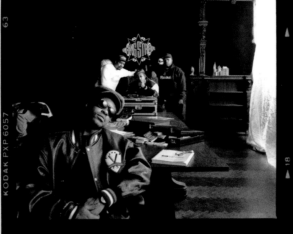
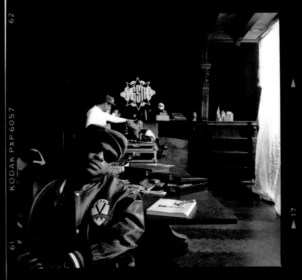
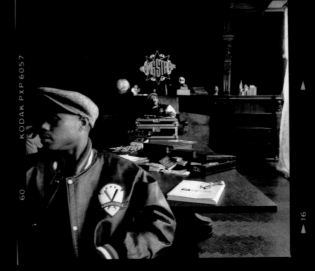
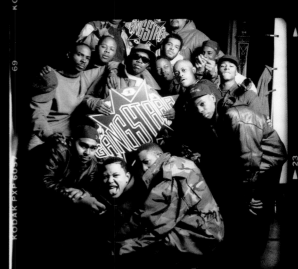
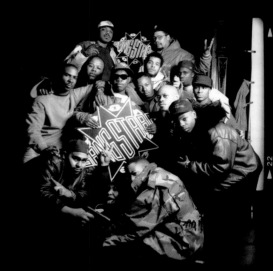
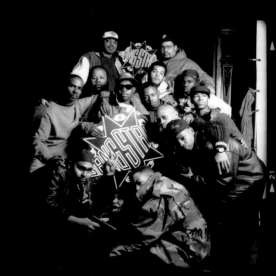
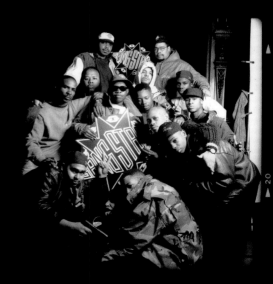

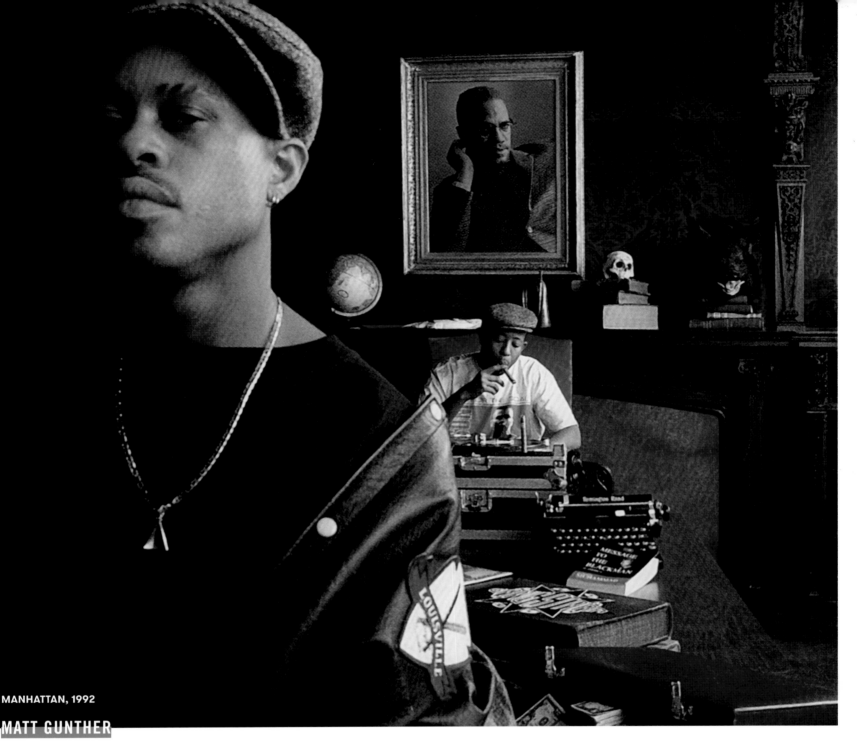

MANHATTAN, 1992

GANG STARR, *DAILY OPERATION*

"Guru, aka Keith Elam, was one of those rare artists who wants to find a kinship with the photographer before working with him. He had a lot of ideas about certain visual elements that would define Gang Starr as a group. He was very political and knew a lot about history and leaders of the civil rights movement. For the album, Guru wanted to include some of this political thought into the imagery to convey rappers being simultaneously 'paid' and taking a role of leadership—he wanted to make a statement.

"We shot at a historic brownstone on the corner of 79th and Fifth Avenue in Manhattan. I shot with my Hasselblad medium-format camera, which was perfect for an album cover because of the shape of the prints it produced. I brought the Malcolm X image to the shoot as Guru told me that he wanted that in the shot, staying true to the brotherhood. The cover also featured the book *Message to the Blackman in*

America by Elijah Muhammad, which belonged to DJ Premier. He just happened to bring it to the shoot, and we decided to put it in. We took some alternate shots with the Gang Starr logo replacing the Malcolm image. I love that contact sheet and am sad to say that the version with the original Malcolm X sequence is lost.

"In addition to the Malcolm X print and the *Message to the Blackman in America* book, we also had a briefcase with money spilling out in the foreground as well as a globe and the wolf's head. There was also a Remington Rand typewriter, a closed turntable case, and Guru and Premier were both wearing similar bomber jackets. I suppose there's a lot of symbolism on this cover. Then we took some shots with their crew Lil' Dap, Jeru the Damaja, Phat Gary, Gordon, Big Shug, and others to end the day. Getting a shot of everyone was really important to them."

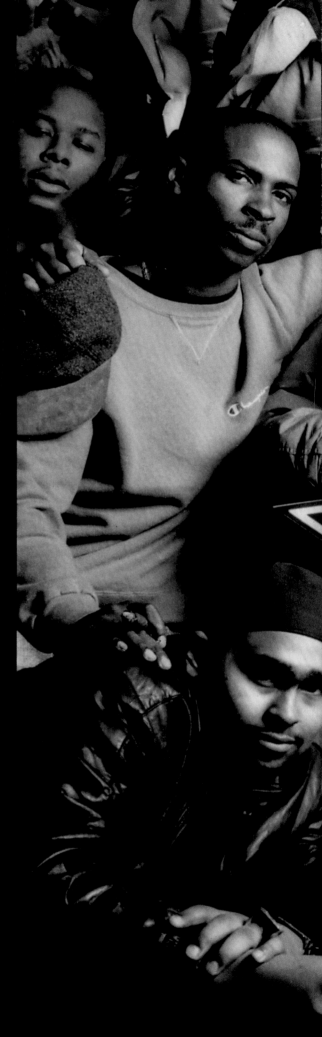

DJ PREMIER

MESSAGE TO THE HIP-HOP WORLD: THE IMAGERY OF GANG STARR

I always loved that moment of seeing an image and being like, "Boom, that's the one." When Gang Starr, Guru, and I were working on the album cover for Daily Operation, *we really thought about the imagery we wanted to put on the cover. It was important to us to make sure the images represented who we were and told our story as a group.*

At the time, Guru was really political and I was becoming a Five Percenter and learning about knowledge of self. The Five-Percent Nation, sometimes referred to as the Nation of Gods and Earths, was a movement founded in Harlem in 1964 by a former member of the Nation of Islam. A lot of hip-hop artists—such as Nas, Rakim, the Wu-Tang Clan, and even Jay-Z—reference Five Percenter language and ideas in their lyrics. Part of the teachings of the Five Percenters is learning about conscious leaders like Malcolm X and reading certain books.

Guru and I both just happened to be wearing the same style of leather jackets and hats when we showed up. That was pure coincidence and I guess the style of that time. I remember, we were all complaining about the boar's head and the skull on the wall because we thought we would get a lot of flack from our boys for having those in the background. We were worried they would be like, "Yo, what's up with the boar's head?" So we didn't like that at all, but we also couldn't Photoshop it out or anything.

We took a photo with our crew towards the end of the shoot. My man Rob is holding my gun in his hand, and Dap has a little revolver in his hand, Because this was shot before social media, we weren't thinking about the outtakes being out in the world. If this was today, we would've made sure everyone was watching themselves. We would've been too worried that the images would be misinterpreted. It's crazy to think about. We were just young and living.

Some of us made it through and others didn't, but that's what makes these images so special. Especially since Guru passed away in 2010, being able to have a document of our shared history is really something. Today, I'm just glad we can archive and preserve these images. I don't even think many artists got their contact sheets back to make the little X on the selection, and I loved that process.

DJ PREMIER (also known as Premo) is considered one of the greatest hip-hop producers of all time. Along with Guru, he was part of the legendary group Gang Starr. Besides helming albums for Gang Starr, Premier's productions appear on many of the East Coast's most important records, including Nas's *Illmatic*, the Notorious B.I.G.'s *Ready to Die*, Jay-Z's *Reasonable Doubt*, Jeru the Damaja's *The Sun Rises in the East*, and Mos Def's *Black on Both Sides*.

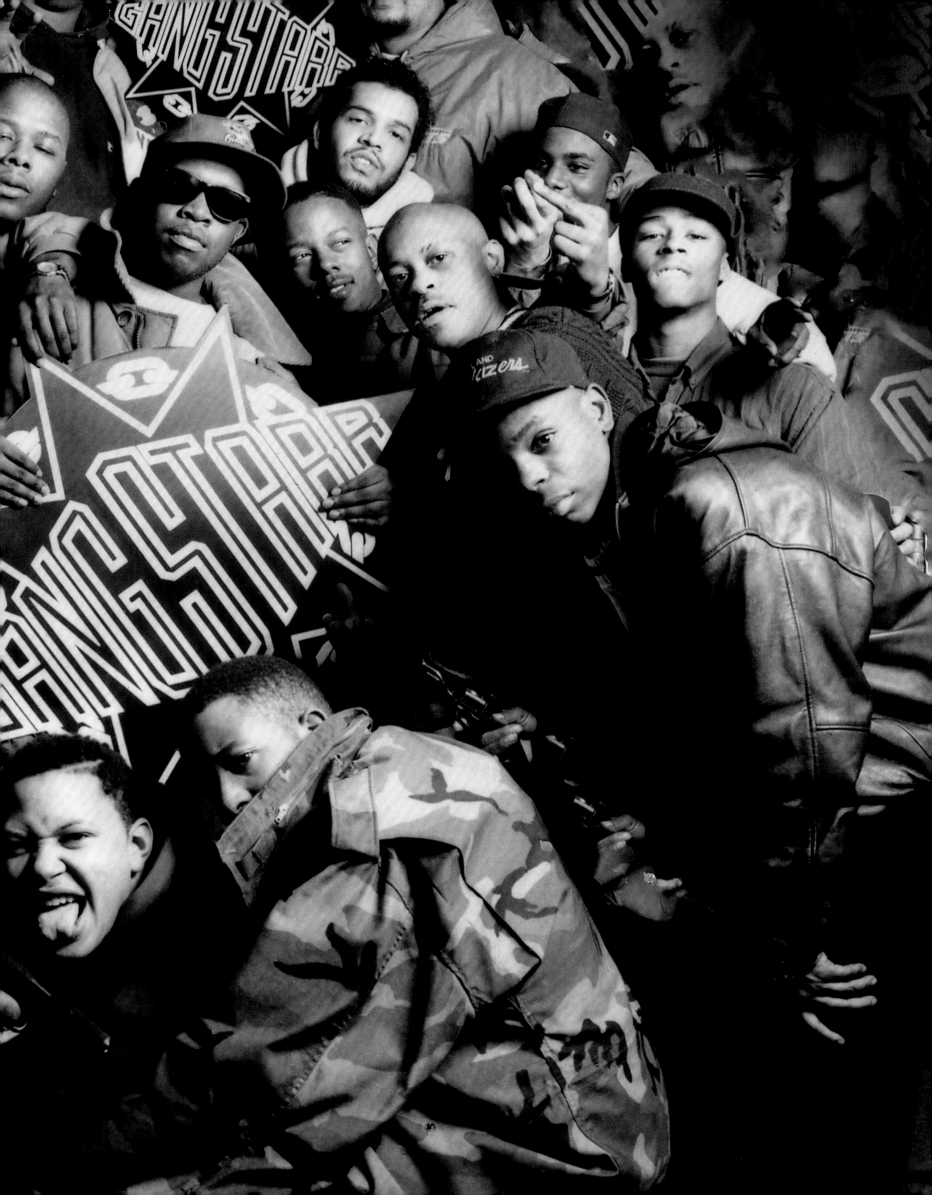

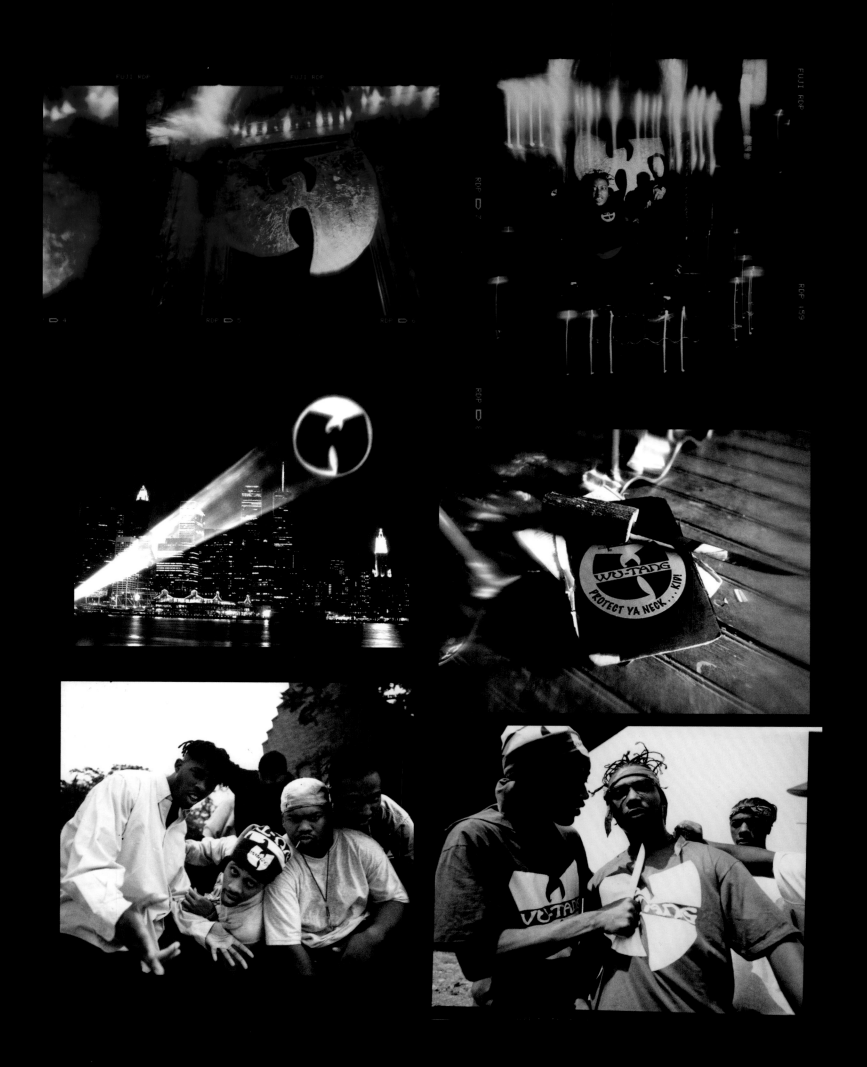

DANNY HASTINGS

WU-TANG CLAN, *ENTER THE WU-TANG (36 CHAMBERS)*

"I was in Atlanta at a Jack the Rapper convention when I got a call from RCA Records art director Jackie Murphy. She said, 'I've got this really exciting group, Danny. This is all you. It's this crazy group called Wu-Tang Clan.' At the time, their debut single 'Protect Ya Neck' was playing in the underground clubs. It turned out that they were going to perform later that day at Jack the Rapper, so I agreed to check them out.

"I went to their performance and there were just some guys onstage old-school rapping. All of a sudden this dude wearing a stocking mask over his face walks onstage and just stands there staring at them, in the middle of their set. The group, I don't remember who it was, was like, 'What the fuck, son? We're doing a set over here.' The man in the stocking mask just goes over, snatches the microphone from the dude, and pushes him to the side. Then all these other dudes with masks rush the stage and clear everybody off. They even kicked off the sound guy. And then, in unison, they just start going, 'WU-TANG CLAN AIN'T NUTHIN' TO FUCK WIT'! WU-TANG CLAN AIN'T NUTHIN' TO FUCK WIT'!'

"The place went bananas. Everybody was jumping around and screaming, 'Wu-Tang! Wu-Tang! Wu-Tang!'

"I knew right away. I was doing that album.

"A few weeks later in New York, I met up with RZA at Firehouse Studio, where they were finishing the album. It was the most disgusting studio I've ever seen—holes in the walls with wires coming out and blunt wrappers all over the place. It was like a dungeon. I'll never forget what RZA told me when I walked in. He said, 'Man, you see this sweatshirt I got on? I been wearing this shit for like three days. But I'm gonna blow up because I got beats. I'm gonna be an empire.' I don't know why that's still in my brain.

"We ended up talking about everything. We talked about *Enter the Dragon* with Bruce Lee and about karate. I grew up with all of the Bruce Lee movies. When I was listening to the album in the studio, I heard all these ancient sounds, these bells, these beats, all these kung fu effects. RZA said, 'Yeah, I want to do some monastery-looking thing because we're a clan, we're a crew.' I was like, 'I got you.'

"Then we got to work conceptualizing the visuals. I loved their logo, so I was like, 'Let's take this logo and just make it fuckin' big and gold.' I got an artist to carve it out of foam core and paint it gold. Then we got a crazy church location called the Angel Orensanz Foundation on the Lower East Side. I thought it would be a great location because of its monastic vibe. That went well with the whole Shaolin style they were going for. Today, that place is gorgeous, but back then it was an abandoned synagogue and it was just destroyed. There were rocks coming out of the walls. It was crazy.

"The day of the shoot, I got a Winnebago and waited for the crew at the Staten Island Ferry. It was RZA, ODB, Ghostface, Inspectah Deck, the GZA, and Raekwon. For whatever reason, U-God, Method Man, and Masta Killa didn't show. RZA was like, 'Yo, man, we need the whole crew here.' But I told him this was it. We had to do something because the label wasn't going to spend any more money on these guys.

"I remembered their show at Jack the Rapper and I thought it would be cool to shoot the cover in the same style. They were like, 'You mean not showing our faces?' I was like, 'Yeah, man, you guys are the Wu-Tang Clan! You're selling the Wu-Tang Clan. Let's get some hoodies and put the logo on there.' For a long time, only I and the Wu-Tang knew exactly who was behind those masks.

"We also went to the Queensboro Bridge and shot pictures of them there. We used that photo of them standing in formation underneath the bridge for inside the album. My lighting for the cover image was very complex too, with tungsten lighting, candles, and strobes. That's why the cover looks like nothing else from this time period. I was inspired by the way rock-and-roll album covers were very experimental and I wanted to bring some of that into hip-hop. When the group saw what I created they were like, 'What the fuck? This looks amazing!'"

VISUALIZING THE WU

When I started Wu-Tang, I didn't just want a distinctive sound, I wanted the visuals and everything to be one united thing: our W *logo, the visual references to kung fu, the swords, and of course the album cover. Lyrics and language were the cornerstones of what we did, but the visuals completed that vision. From many elements, we have one.*

The title of our debut, *Enter the Wu-Tang (36 Chambers)*, was a reference to the Shaw Brothers kung fu film *The 36th Chamber of Shaolin*. The visuals from that film and other kung fu films were a big inspiration to me. I first saw the film when I was eleven years old on Channel 5, and then again when I was thirteen or fourteen on 42nd Street. I was this little dude in the middle of all these dope dealers and hustlers watching these films, and I would sit in those theaters all day, from 9:00 a.m. until they closed at night. The story was about one man who was being oppressed. The villains destroyed all his local schools, and he had to flee and learn to build himself up. Then he comes back and teaches his philosophy of Shaolin to everyday people so they can be strong.

The message in that film resonated with me more than a lot of American history, and the film, along with many others like it, resonated in the black community as well. It was the underdog thing, the brotherhood thing, and also the escapism. It was a whole other world. To a young black man, it was eye-opening to see another community going through that kind of oppression. To see that heroism, how one man would fight against injustice, and how men would lay down their lives for what they believed in, was a powerful thing for me and my community.

A lot of movie theaters would show double features combining blaxploitation films alongside kung fu films, and that influenced an entire generation. Growing up as a black kid in America, I didn't know that that kind of story had existed anywhere else. I was inspired watching Bruce Lee and Jim Kelly, and started recasting my Staten Island neighborhood as Shaolin and finding musical parallels between the five-note Chinese scale and hip-hop rhythms. I also began putting together the group with kung fu–inspired stage names to form Wu-Tang. All of it ultimately became the foundation for *Enter the Wu-Tang (36 Chambers)*. What's a chamber? It's something a man must conquer, something a man needs to go through, and that's what influenced the title of our album. The opening track, "Bring Da Ruckus," actually starts with a sample of dialogue from the film: "If what you say is true, the Shaolin and Wu-Tang could be dangerous." And then I come in with "Bring the motherfuckin' ruckus . . . ," and that was meant to convey our whole aesthetic. It was gritty but also highly conceptual.

For the album cover shoot, we worked with Danny Hastings, but before we even talked photography I really wanted Danny to hear the music, so I invited him up to the studio. It was really grimy, but we were in our element. I think I had worn the same sweatshirt for days and was just deep in the studio, deep in the music. I could tell that Danny really liked it, and I could see the wheels turning, thinking about how this sound could be translated into photography. That was an important part of the collaboration for me. When we first started out, we would go onstage with stocking caps on our heads. We felt like ninjas. I always wanted to have that feeling of imminent threat. Bum-rush the music industry. Rob it. Like we're here to shake things up. And Danny, who had seen us perform in Atlanta a few months prior, really got it. That's partially why our faces are covered on the album cover, but the equally accurate reason is because not every member of Wu-Tang was at this shoot. Danny understood the Wu aesthetic and he just improvised. When he suggested we do the stocking mask concept, it just clicked. To this day, only we know who is actually in the cover shot.

All these early images of hip-hop are part of our collective foundation. We really created a visual legacy, and I was blessed to be part of it.

RZA revolutionized hip-hop in the '90s as the leader of the Wu-Tang Clan. He is considered one of the architects of hip-hop culture as a rapper, a producer, an actor, and an acclaimed director and composer on a number of films.

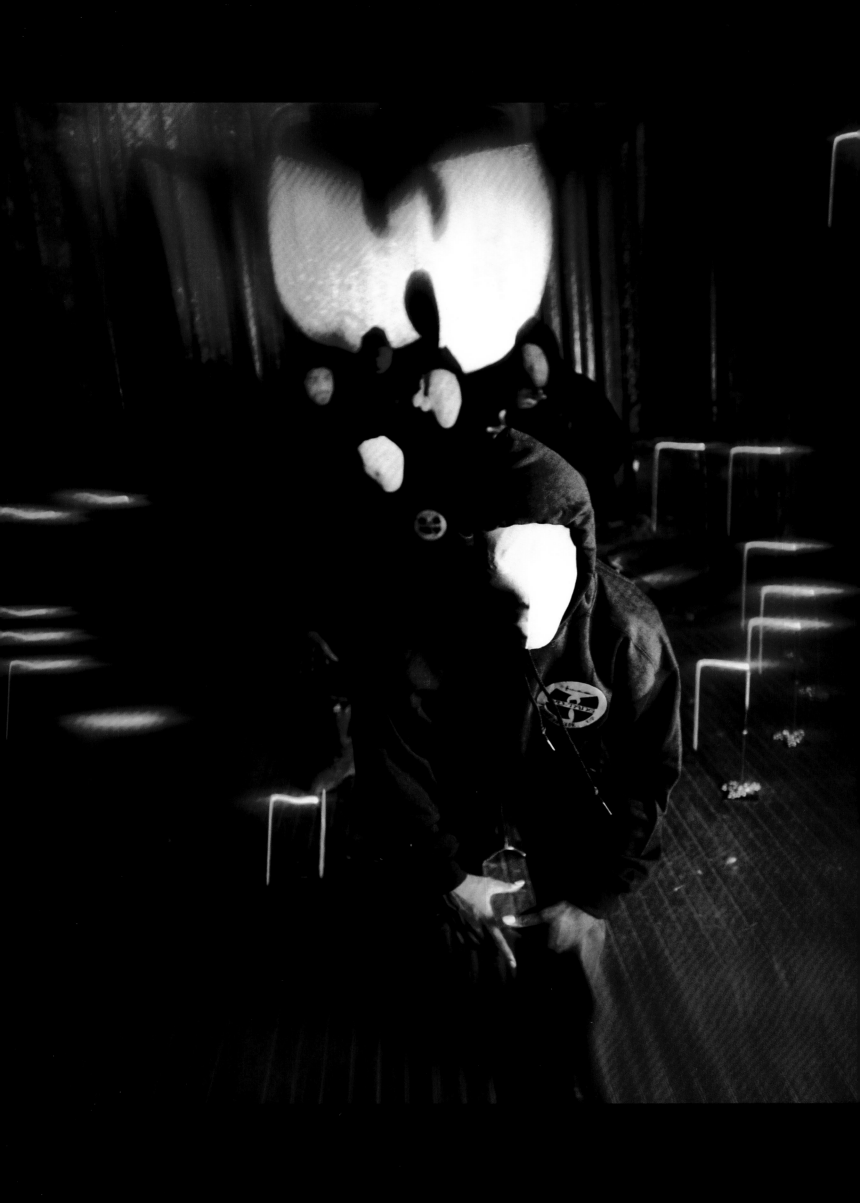

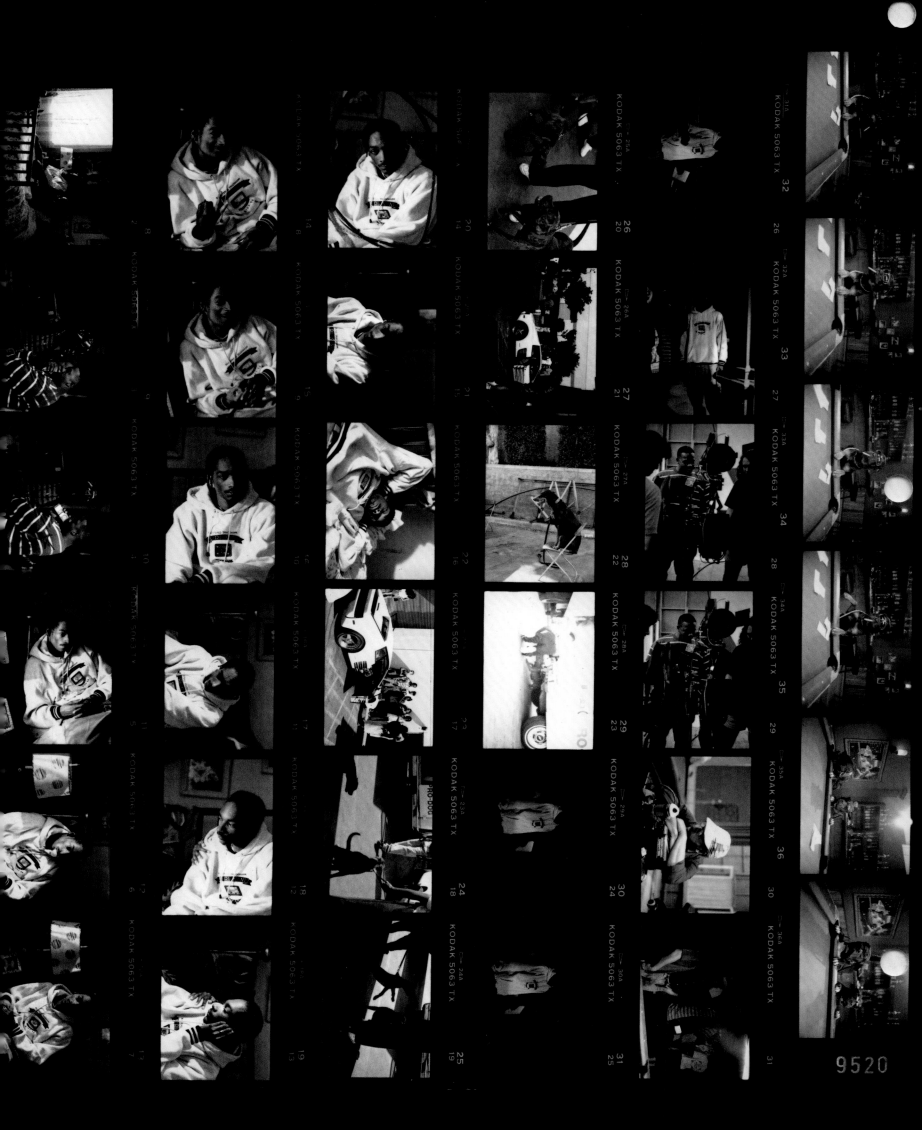

LISA LEONE

SNOOP DOGG'S FIRST VIDEO SHOOT

Bronx-born photographer and filmmaker Lisa Leone is a New Yorker in the truest sense. A no-nonsense straight shooter, Leone felt comfortable photographing all facets of New York hip-hop during the golden age, whether it was at a concert, in a recording studio, or on the street. So when Fab 5 Freddy called Leone to photograph Snoop Dogg in Los Angeles on the set of his first video for his single "Who Am I? (What's My Name?)," Leone knew she was about to leave her comfort zone.

"We shot on the roof of VIP Records, a record store and studio in Long Beach where Snoop recorded some of his first materials, and then we went to a nearby park for the second shoot. As we were setting up the equipment, I suddenly heard cop sirens and helicopters above, and then people started running. Despite being afraid, my instinct was to get out my camera and start taking pictures. Fab was like, 'You're gonna get us both shot! Stop taking photos and run!' I never actually found out what the drama was all about. It was just gang stuff, I guess.

"The contact sheet is from a few weeks later in the studio. When he arrived, he just looked at me and said, 'I remember you. You were the one driving Fab the other day in the park. Yeah, you cut me and Suge [Knight] off when we were trying to drive away.' So we laughed about that and proceeded to shoot the video. I love the frame of Fab and Dre in deep concentration, Dre holding the old-school brick phone. You can also see the dog that Snoop transforms into in the video. I think it was a Doberman Pinscher. The dog was chill. But that main shot of Snoop laying back with the braids, that's the one. This was so early in his career and he still had a bit of shyness to him. In some of the frames, he looks vulnerable and tender. The start of a long journey."

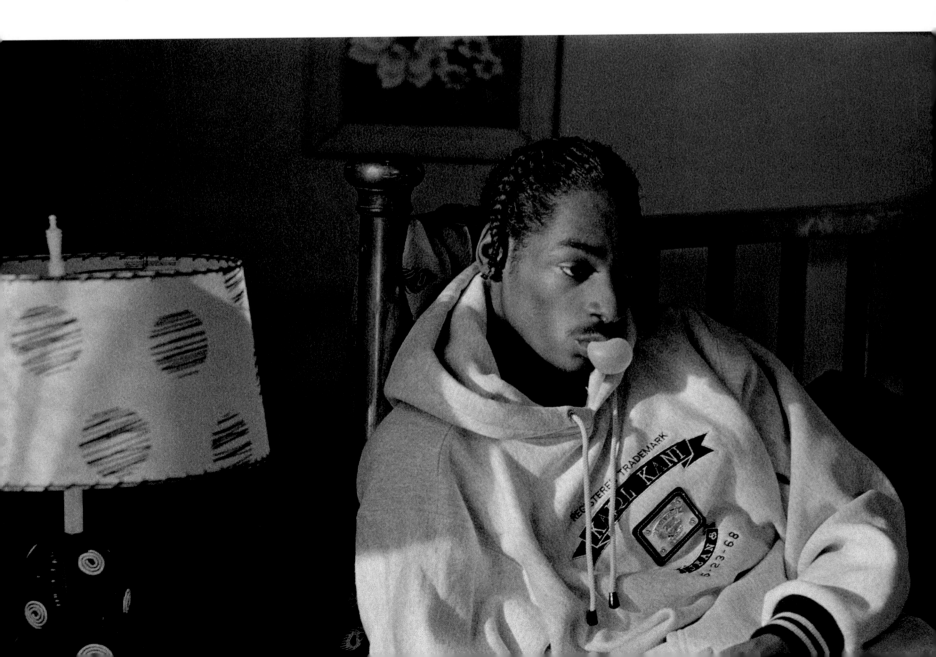

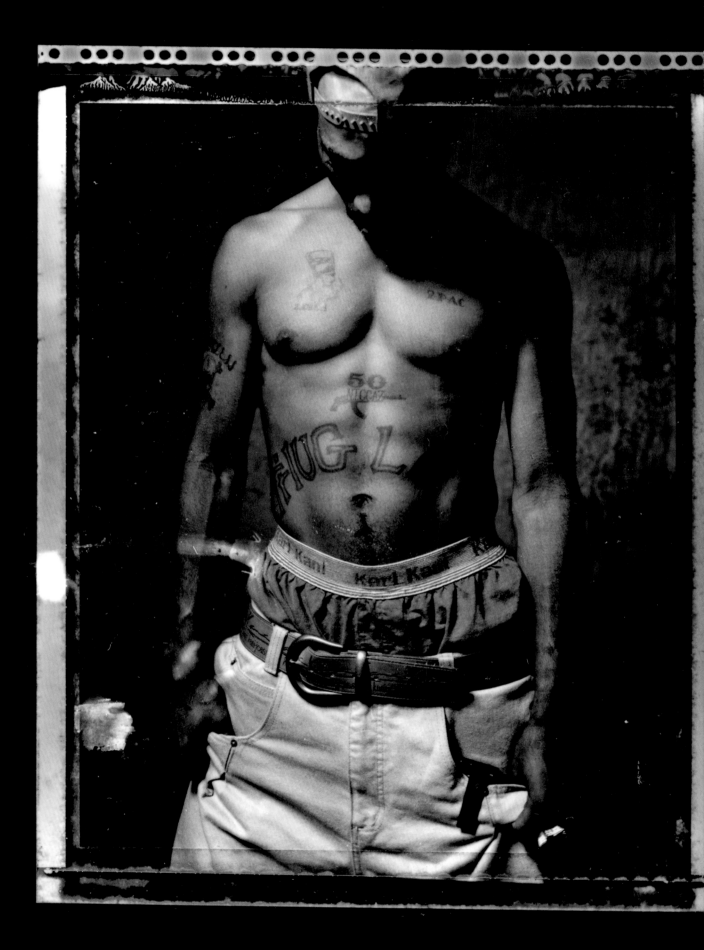

TRIBECA, NEW YORK, 1993

DANNY CLINCH

TUPAC SHAKUR

Tatted and quietly defiant, Tupac Shakur stands shirtless in what is arguably one of the most recognized portraits of the prolific and provocative icon. A child of Black Panther activists, Tupac blended political thought and street culture consciousness with a visual legacy to match. The portrait originally ran in *Rolling Stone* in 1993 as part of a short profile piece, but three years later, Shakur was murdered in a drive-by shooting in Las Vegas. That year, *Rolling Stone* put Clinch's iconic photo of the rapper on the cover, an image that has come to symbolize a life taken too soon.

"Photographing Tupac was one of my first *Rolling Stone* assignments and I had no idea it would be for the cover. This was Tupac's first *Rolling Stone* shoot, and he understood the magnitude of what was happening and took it very seriously. He showed up at my studio on Reade Street in Tribeca with just one guy, which was unusual. A lot of artists would come with a whole entourage and just make themselves comfortable. I photographed primarily with a large-format camera and he was really intrigued by the format of this big old-view camera where you cover your head with a focusing cloth. Tupac was really curious about the process and I love curious people, so that made for a great session. At the time, I remember, he brought a bunch of clothes with him, including a Thug Life jacket and, at one point he was changing and I saw all his tattoos. I don't think I would have ever asked him to take off his shirt but when I noticed his *Thug Life* tattoo, I knew that would be a powerful image."

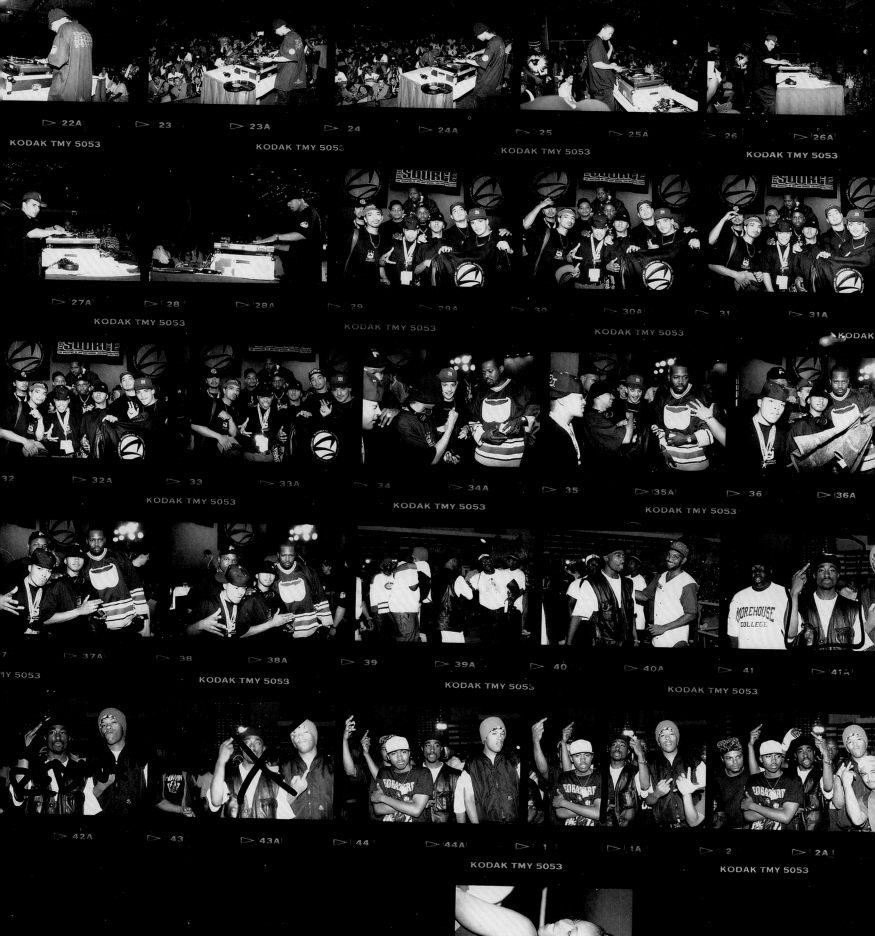

AL PEREIRA

BIGGIE, TUPAC, REDMAN, AND NAS AT CLUB AMAZON

It's the photo that broke the hip-hop Internet. The research for this book turned up a never-before-seen image of young Tupac and Nas at a party at Club Amazon on the West Side of Manhattan. Al Pereira was already known for his shot of Biggie, Tupac, and Redman that was taken on the same night, but he didn't realize the other image existed until he looked at the contact sheet nearly twenty-five years later.

"This was before Nas released *Illmatic* and so the really famous guys in the room were Tupac, Redman, and Biggie, although he was still unsigned. They were the major stars. One of the frames also has a young guy named Polo Ice wearing the iconic Polo Bear sweater, a nod to the Lo-Lifes, an infamous boosting/shoplifting crew who were known in hip-hop circles.

"Earlier in the night, I was covering a DJ battle organized by DJ Clark Kent, DJ Scratch, Mix Master Mike, DJ QBert, and lots of future DJ legends. Later, I saw Tupac and asked him to do some photos. He was smiling in the shots and his boys start yelling at him, saying, 'Don't be soft, don't be soft, you gotta be hard, give 'em

the finger!' So he started giving me the finger, then Redman jumps into the shot and this big guy came over. I had no idea who Biggie was, so to me he was just some guy ruining my shot of the famous guys. Nas was the other guy in the frame that I didn't know, but he came over and they were all posing together, having fun. I was just clicking and in the energy of it all.

"I also love that the image meant so much to Nas as it showed one of his closest confidants, Draws, in several frames. I am thrilled that my photography contributed to hip-hop history and the narrative of two legends before they were famous, just hanging out."

> "Thank GOD there's pictures like these that pop up here and there. I never liked taking pictures back then so this photographer knew what he was doing. Rest in peace Draws from QB to my right." —Nas

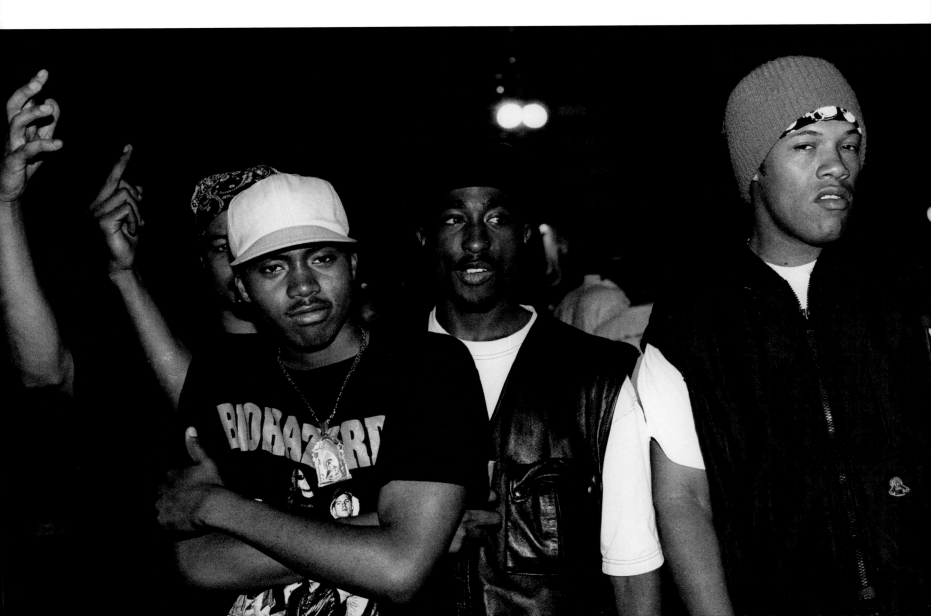

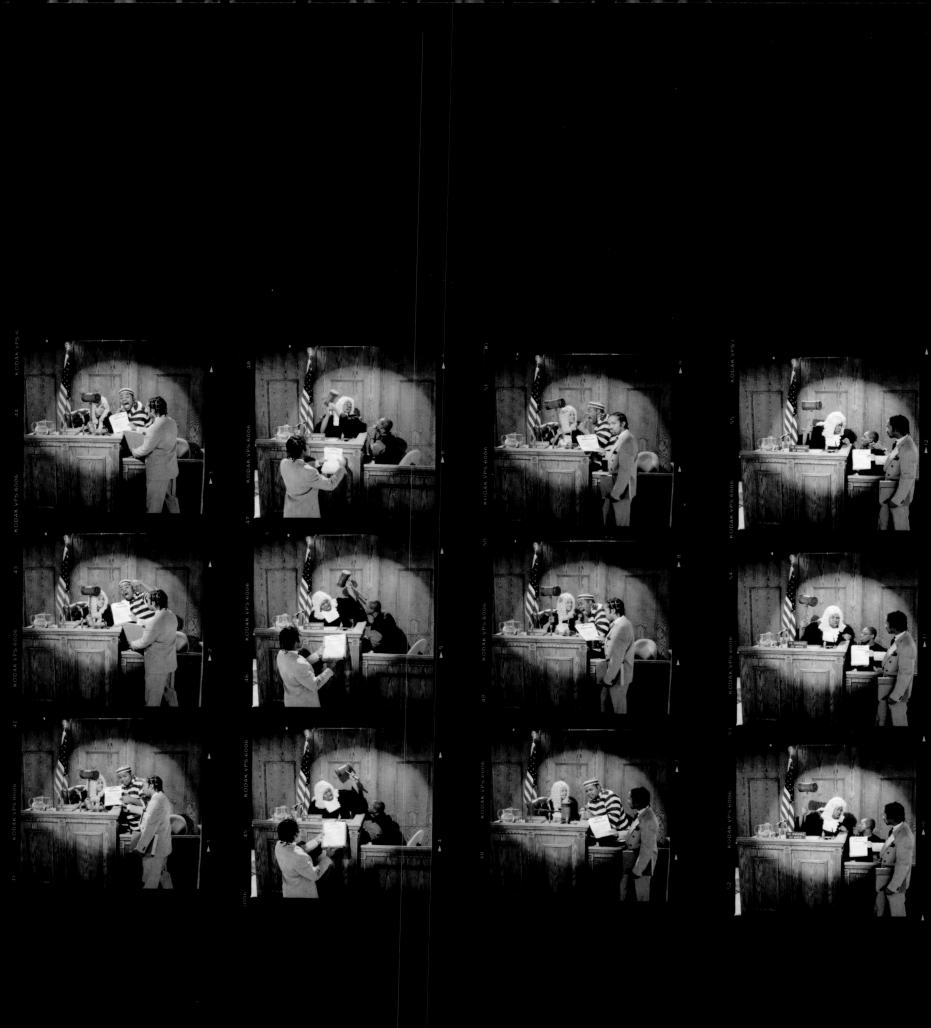

GEORGE DUBOSE

BIZ MARKIE, *ALL SAMPLES CLEARED!*

On Biz Markie's 1991 album, *I Need a Haircut*, the song "Alone Again" sampled several piano bars from Gilbert O'Sullivan's 1972 hit, "Alone Again (Naturally)." O'Sullivan subsequently sued Markie over the sample and won in a precedent-setting decision for all future sampling clearances.

Two years after the landmark case, Markie released *All Samples Cleared!* Both the album's title and the cover art nod to the courtroom drama where the sampling case was held, with Markie playing both judge and defendant. This is where photographer George DuBose comes in.

"The concept for this album was to have Biz as the judge *and* as the prisoner in the dock. I searched for real courtroom locations, but the witness box was always too far from the judge's bench for us to get the image we wanted. So I built a courtroom in my studio with the witness stand right next to the judge. I've always wanted to turn that courtroom set into a cocktail bar in my house. I placed the camera on a tripod so the perspective didn't change and just moved Biz and Cool V in different positions. I shot with a Hasselblad, which I almost always used for album covers that I was making in a studio. The film I used was a fine-grain color negative 120-format film. Normally, I shot with transparency film, but since I knew that I was going to have to assemble the final photo from two other photos, I chose to use color negative and made direct prints. When I had the two final prints back from the lab, I used a razor blade to cut along vertical and horizontal lines of the prints and then glued them together and re-photographed them for the final artwork.

"I chose a good image of Biz as the judge and then a funny image of him as the prisoner, with Cool V as his attorney presenting sample clearance documents to the judge. I even made a little dig at Gilbert O'Sullivan by writing large on the sample clearance *F.G.O'S.* (Fuck Gilbert O'Sullivan)."

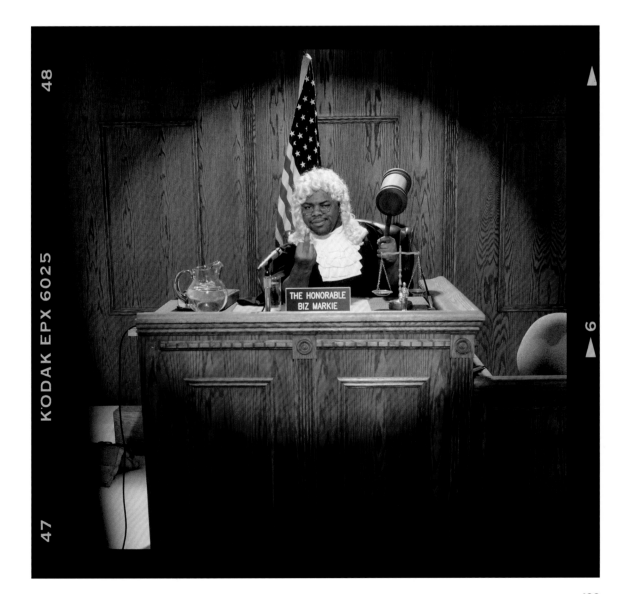

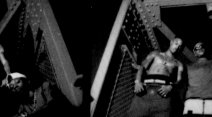
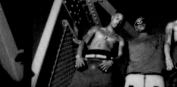

DANNY HASTINGS

JODECI, *DIARY OF A MAD BAND*

"This was my first time shooting a famous group. I was nervous, but this shoot also made me realize I was made for this career. The energy when [Jodeci] walked in was like 'We're gods,' and my energy in return was like 'I got this,' but truthfully, I was nervous the shoot wasn't going to happen. They showed up seven hours late and only gave me half an hour to work with. The shoot was set to begin at 8:00 a.m. in Queens and I had been waiting all day. I had already paid a security guard to make sure no one bothered us while we did the shoot. The location was an abandoned Metropolitan Transportation Authority lot and I shot with a Mamiya RZ67, a Profoto 1200, a medium softbox, a few assistants, and a generator. The way they dressed was a big part of their music so the stylist, Sybil Pennix, put the group in fisherman waders. Dalvin and DeVante wore them with no shirts on, and Timberland boots.

"The final cover image was shot at the beginning of a pedestrian overpass. I was positioned four steps below them, shooting up, using an 80mm lens. I remember I didn't want the lighting to come from underneath them, so we put the softbox on a huge high-roller to give me some height on the light. I used strobe lighting and cranked up the shutter speed so the sky appeared drastically dark. This shoot was very technical and also high-pressure because they were such big stars and I had to work quickly. Luckily, I had an itchy trigger finger so I went for the killer shot. When I went to the lab and developed the film I realized I had GOLD!"

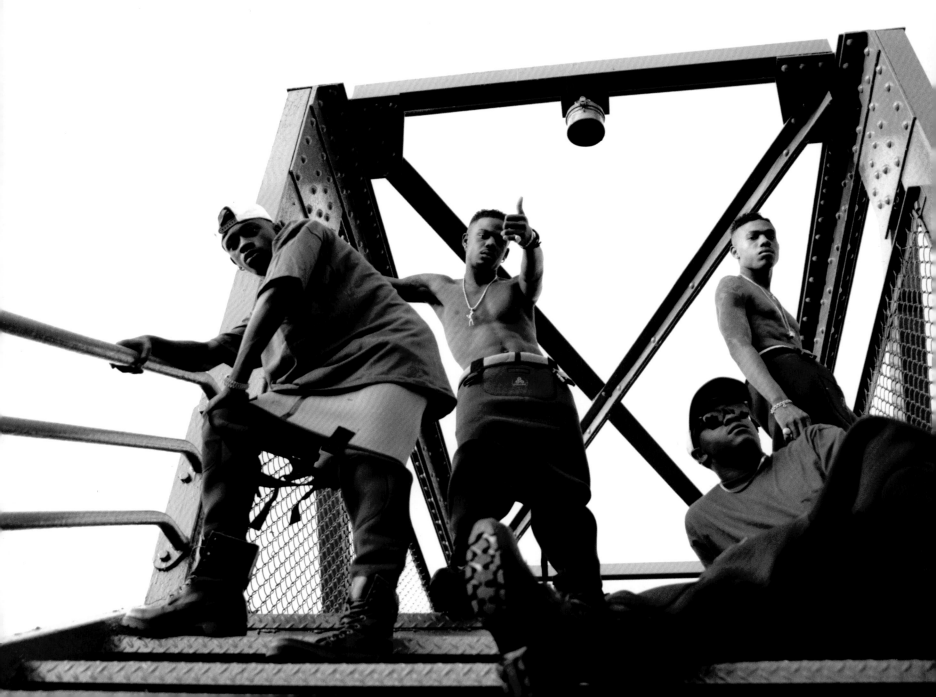

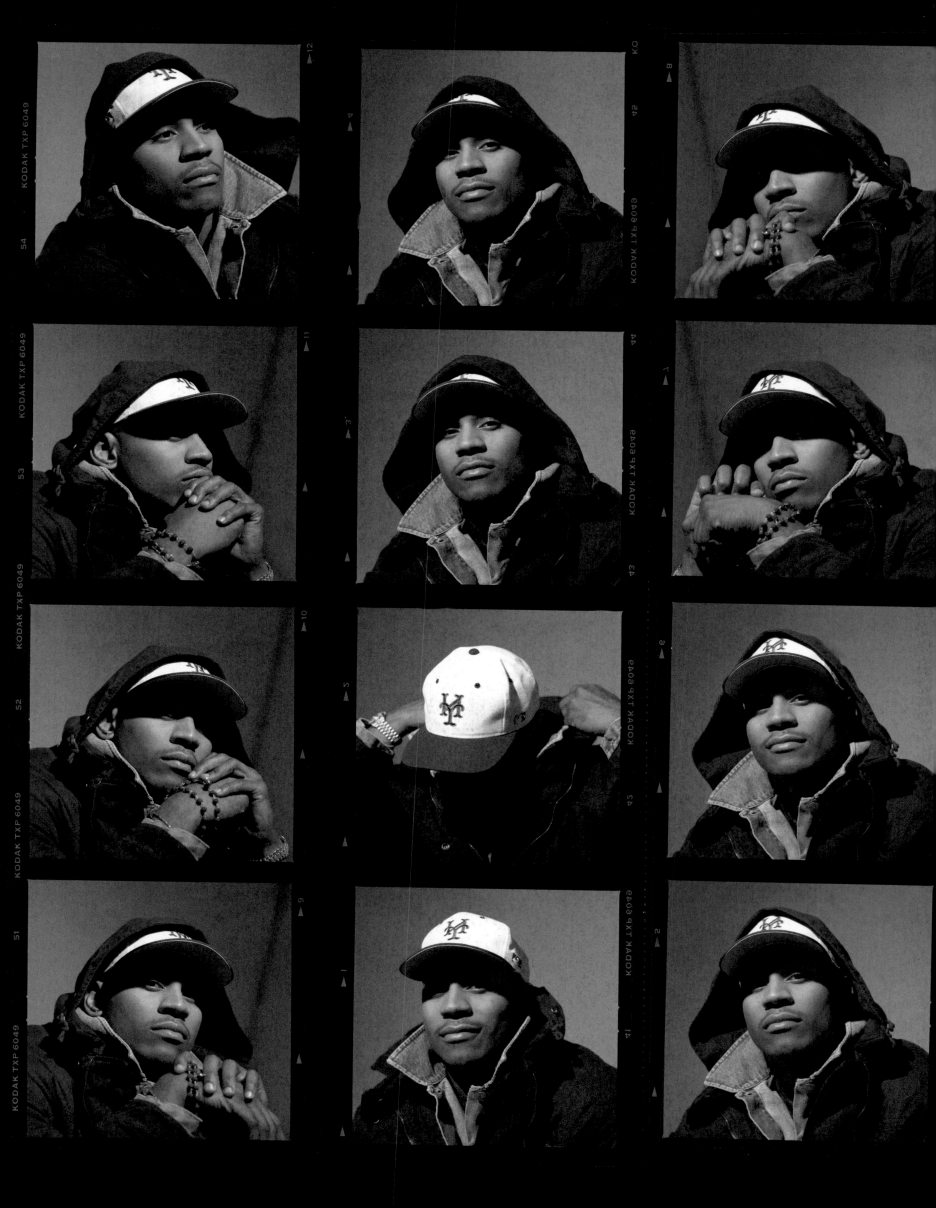

JAYSON KEELING

LL COOL J

When it comes to regrets, photographer Jayson Keeling has a few. Like the time he didn't let LL Cool J take his shirt off during a cover shoot for *YSB* magazine (despite multiple requests from the ladies on set that day). But Keeling thought a shirtless LL was too expected and cliché; he wanted a bold, cinematic portrait of the rapper. LL, who was promoting *14 Shots to the Dome*, wasn't accustomed to hearing "no" from the creative team but he trusted Keeling, and together they made a clean, singular portrait.

"I had a close friend named Kingman Huie, we attended the High School of Art and Design together. Kingman got the commission for *YSB* first and then somehow put me on. This was just my second assignment. I didn't know anything about LL personally at that point, and was quite new to taking photos. I shot this on a Hasselblad medium format. I was using the lights from the hardware store, three large bulbs, harsh and simple and they cast these amazing shadows. LL even asked me, 'Why aren't you using those lights that flash?' and I was like, 'I don't know how to use them.'

"Image to image, LL put on these little nuances and expressions and gave a lot of gesture with purposeful power. He was brooding in some shots and playful in others and sexual in some. That of course was a big part of his persona at the time. The women on the set were all like, 'Get him to take his shirt off' and even he said, 'I wanna take my shirt off.' But I insisted that he didn't because it was expected. But I regret that now. I have regrets from most shoots I do, and this was one of those moments."

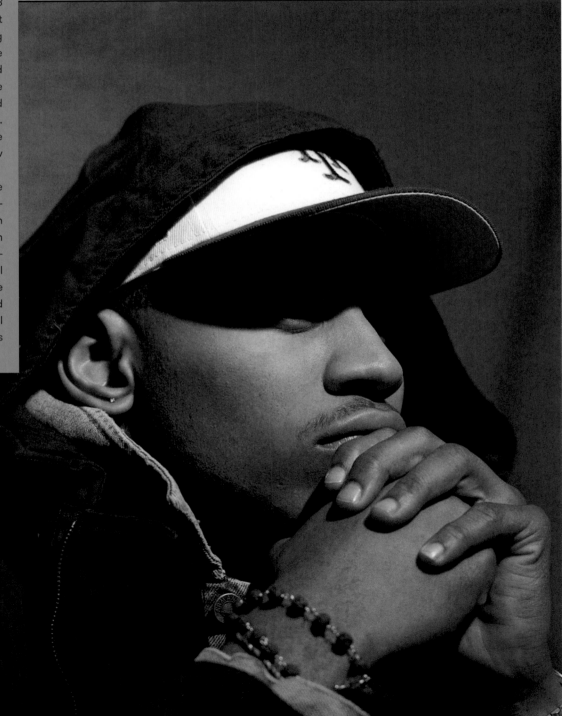

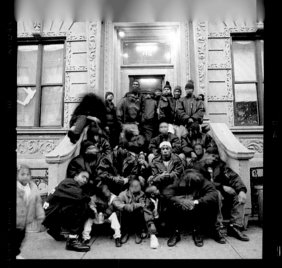
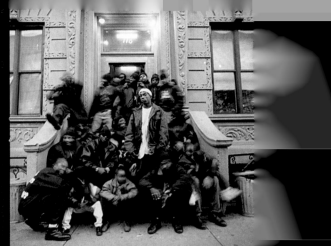
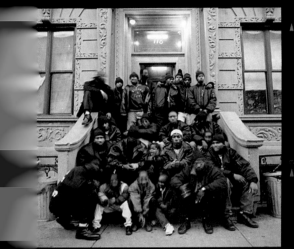
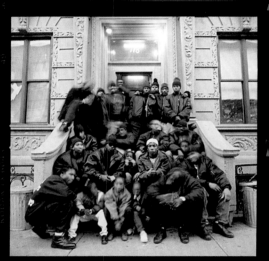
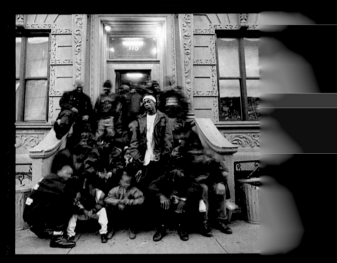
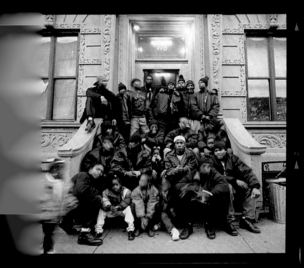
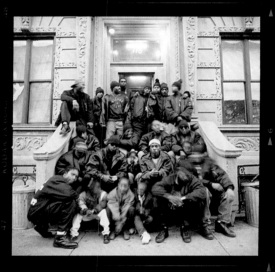
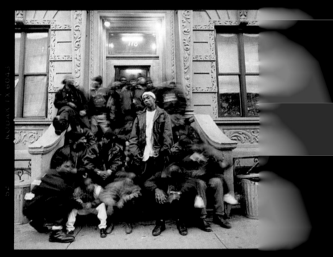
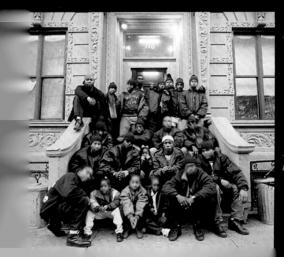
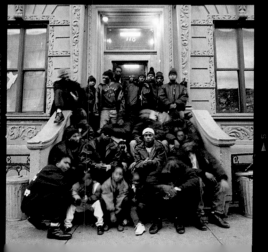
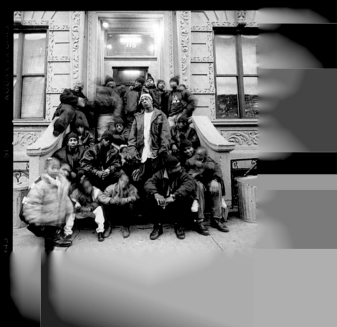

DANNY CLINCH

BIG L, *LIFESTYLEZ OV DA POOR & DANGEROUS*

Lamont "Big L" Coleman grew up in Harlem, and that's where Danny Clinch wanted to photograph the young rapper for the cover of his debut solo album, *Lifestylez ov da Poor & Dangerous*. Big L had coined his block near 139th and Lenox the "danger zone," and it was also here that Big L was killed six years later after suffering multiple gunshot wounds. A lyrical master of underground hip-hop, Big L was part of the D.I.T.C. (Diggin' in the Crates Crew), and beloved in his neighborhood.

"I photographed Big L on his home turf and the whole neighborhood came out to support him. He had so much love, and you can see that in the photos. They were really rooting for him, like, 'This is where we're from and here's a guy from our neighborhood putting out an album about our shared experiences and being true to who we are.' This photograph reflects that sentiment and that's important. It was important to Big L and important to me as a photographer. On a deeper human level, there's a sadness of working with him so early in his career and then him passing away not that long after. Man, life is short."

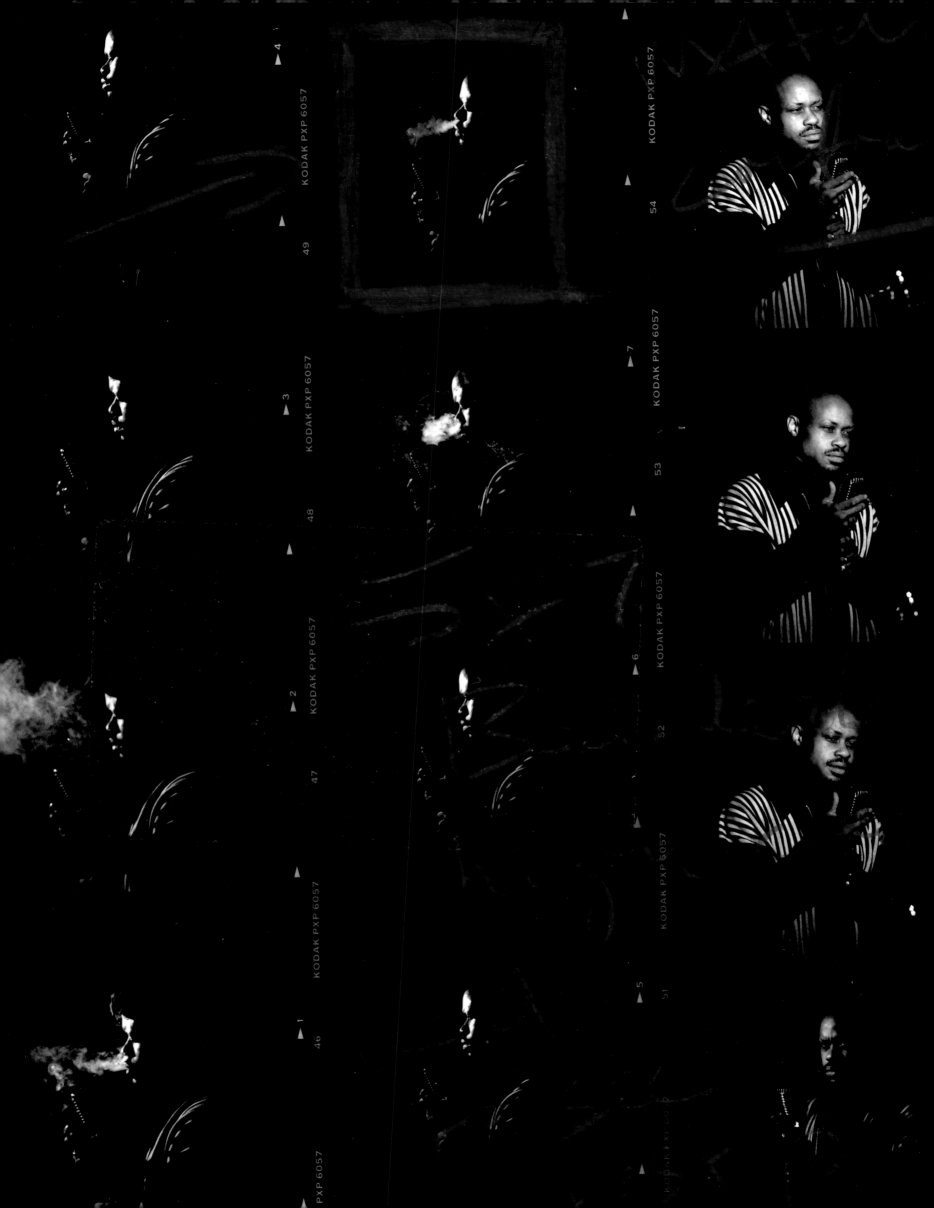

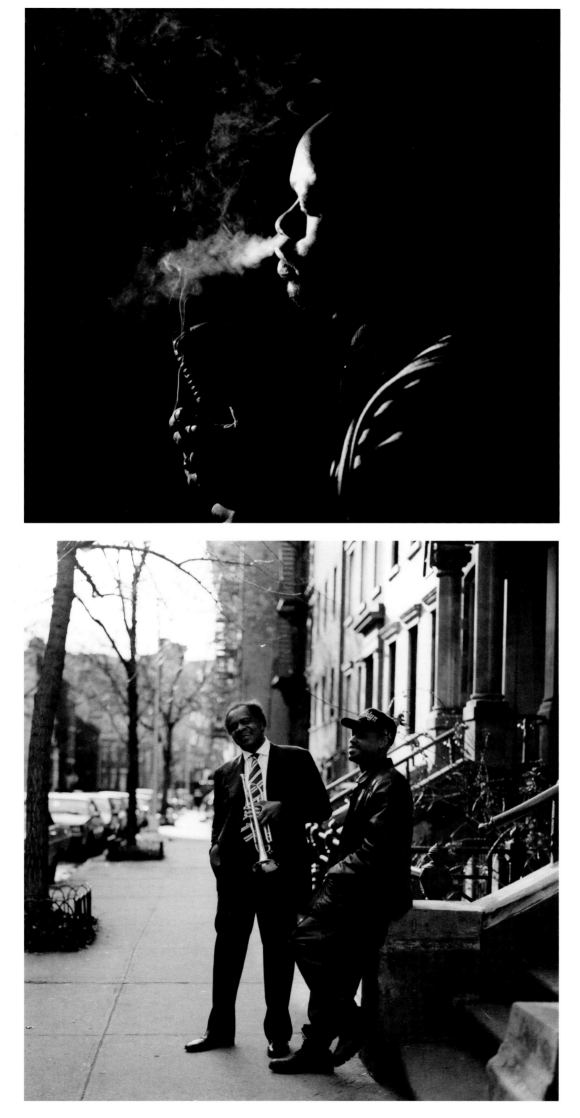

MARK HUMPHREY

GURU, *JAZZMATAZZ*

"The image on the cover of *Jazzmatazz* actually came out of a moment that wasn't even part of the official photo shoot. We had been shooting all day and Guru needed a break, so he went over to the side, rolled a blunt, and was just relaxing. It was like when you could smoke at the movies and the smoke would rise up in the light of the projector making all these swirls. I ran over and asked him to step up to the mic. It was just a magical moment and so evocative of a jazz club and the mood. As a photographer that's what you do; you find those moments.

"We shot this at the Village Vanguard in Greenwich Village, which was quite cavernous, dark and moody. I remember there was snow on the ground, so it must have been early '93. I wanted to shoot a high-contrast silhouette. At the time, I loved that hard cinematic lighting. The record label knew they wanted to riff on the classic jazz thing, but we really went with the flow that day. There was no talk of making this shoot look like old Blue Note covers or anything. It was Guru's first full-length project without DJ Premier, even though they were still going strong as Gang Starr. For *Jazzmatazz*, Guru collaborated with the jazz musicians instead of sampling their records. He had bebop jazz trumpet master Donald Byrd, vibraphonist Roy Ayers (one of the most sampled musicians in hip-hop), and also Lonnie Liston Smith, Branford Marsalis, and just so many other amazing people.

"Donald Byrd is perhaps the greatest Blue Note artist, and he was very committed to being at all the shoots and live events. I think Donald was diabetic or something, and during one of the shoots, he, Guru, and I went around the corner to get him something with sugar. Donald had brought his trumpet, and on the way we happened upon this brownstone block in the village. I got a great shot of them, just these two friends and collaborators. Those shots are the down moments, which I love."

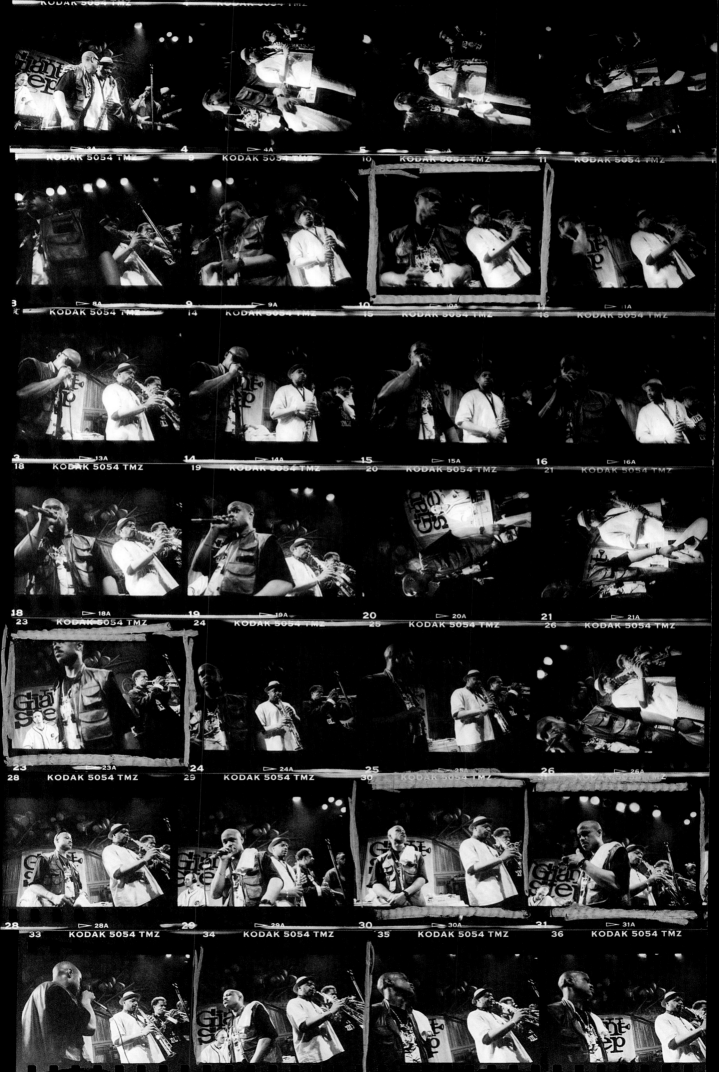

ALICE ARNOLD

JAZZMATAZZ LIVE

"You could really feel the energy in the club scene during this time. You had hip-hop free-styles taking place in the underground clubs, and being there live was very much part of the culture. This was also a time when hip-hop producers were sampling jazz quite heavily on records. Hip-hop fans were accustomed to hearing funky drum samples and jazz horn compositions on their mixtapes or on the radio, but they were not used to seeing these sampled sounds live . . . Some even thought of jazz as this old white guy thing.

"So Guru bringing this all together and then performing live with the jazz musicians was really powerful. The first Jazzmatazz concert I photographed was at a club night called Giant Step which was held weekly at S.O.B.'s [Sounds of Brazil], a small club at the western edge of SoHo. I shot three rolls that night, and looking through the contact sheets now, I can still feel the excitement and the power of Guru's vision to reach backwards to jazz music in order to expand the hip-hop world. This cross-generational collaboration was really important.

"The stage lighting at S.O.B's was well designed, so I was often able to shoot without a flash and create images with deep blacks and luminous highlights, in the tradition of jazz photographers Herman Leonard and Francis Wolff. Additionally, the club attracted music aficionados and serious dancers, which inspired me to make images that could encompass the spirit of the room. The contact sheet really shows the energy of those live shows."

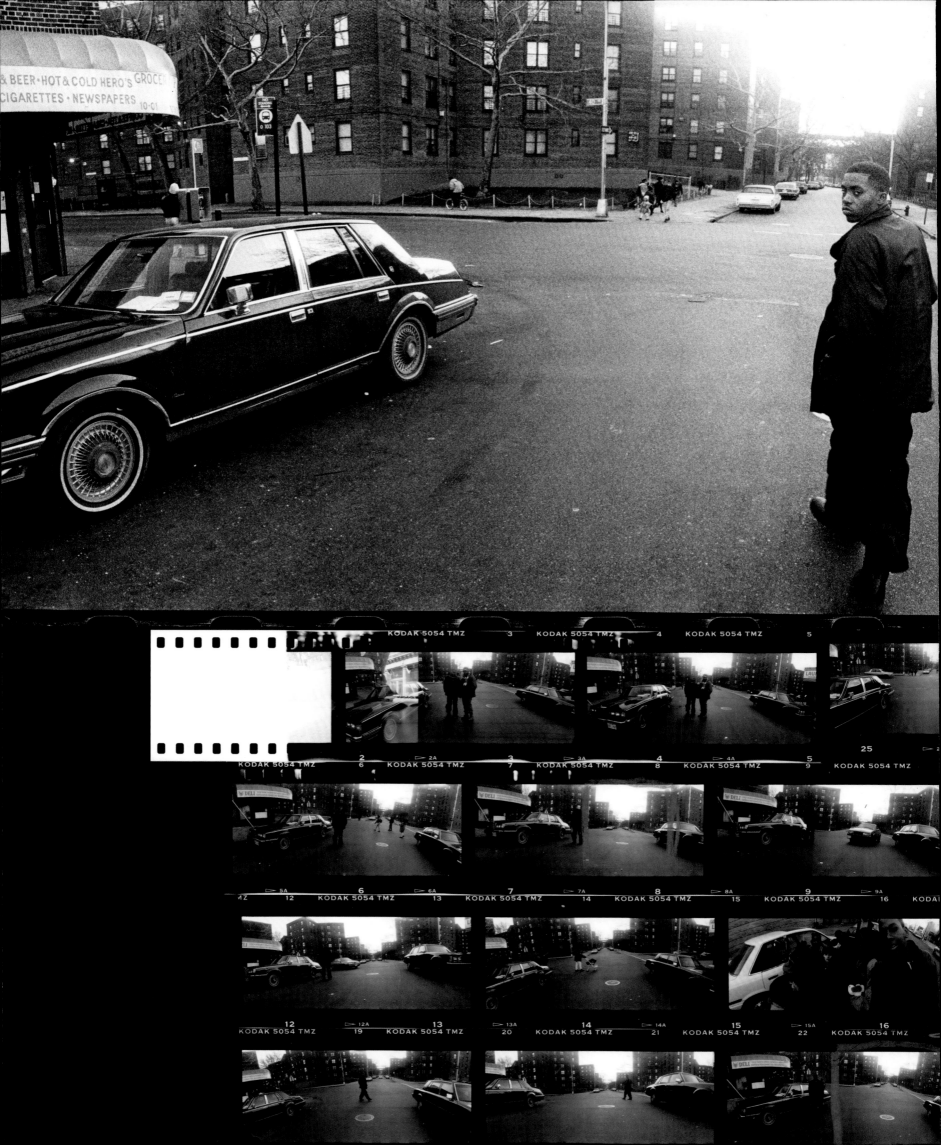

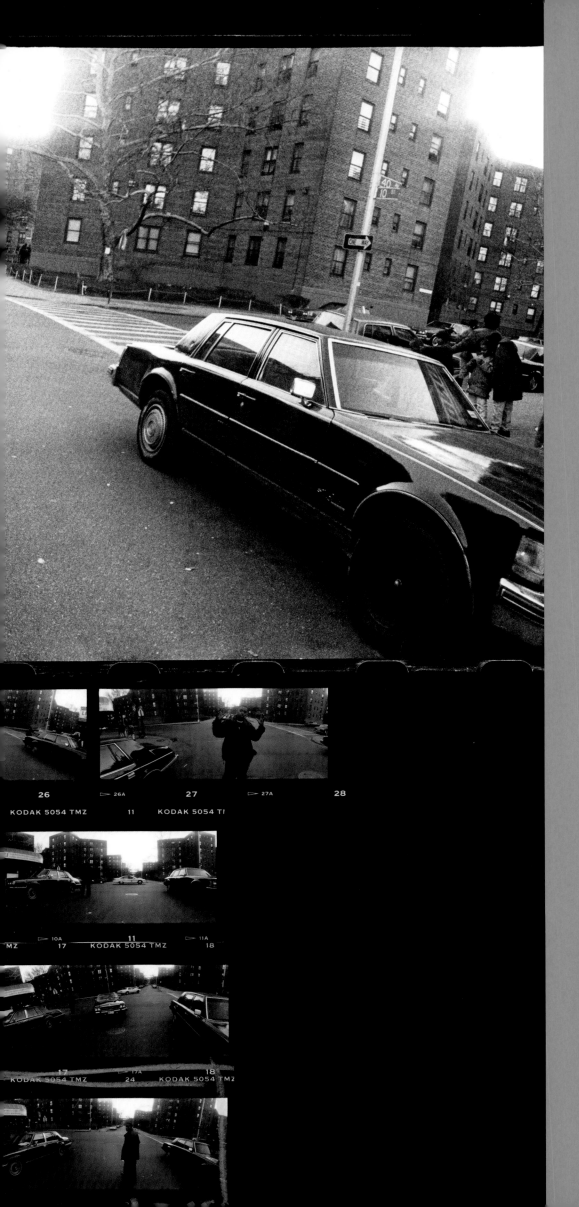

DANNY CLINCH

NAS, *ILLMATIC*

"I was still an intern and assistant to Annie Leibovitz when I was sent to photograph a group called 3rd Base. I remember being like, 'This is a make-or-break for me, this assignment is really important.' That day, I connected with MC Serch and he told me that he was working on some projects, and that he would keep me in mind as the photographer.

"A few months later I got a call from Serch: 'I'm working on this project with a new rapper. He's called Nasty Nas.' He wanted me to come out to Queensbridge because it was really important to Nas to show where he was from on his first album. Nas is a very cinematic writer, and I wanted to make sure I captured him around his neighborhood since it's such an important part of his lyrics. He took me all around the neighborhood, including the building where he grew up. He was already somewhat of a celebrity in his neighborhood, and a lot of his friends came out to see what was going on. He was very confident. He wasn't ever afraid of the camera.

"My style was very gritty and raw and I wanted to shoot in a photojournalistic style. In one image, my personal favorite, I used a Widelux camera for this very expansive cinematic image where he's looking back at me like he's showing me the way as we walked around his neighborhood. Nas is in between two identical late-1980s Cadillac cars; I just love the symmetry of that moment. It gives a mirror effect to the photo that makes a lot of people look twice, and it encapsulates the album's 'come into my world' concept."

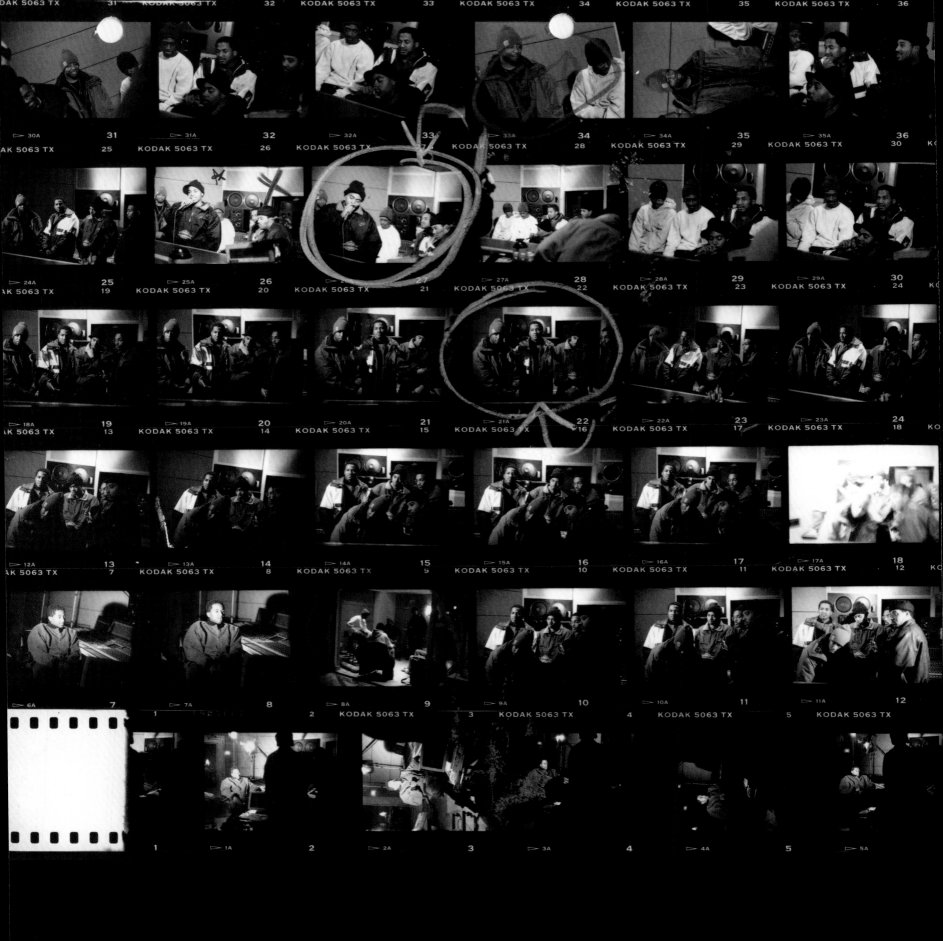

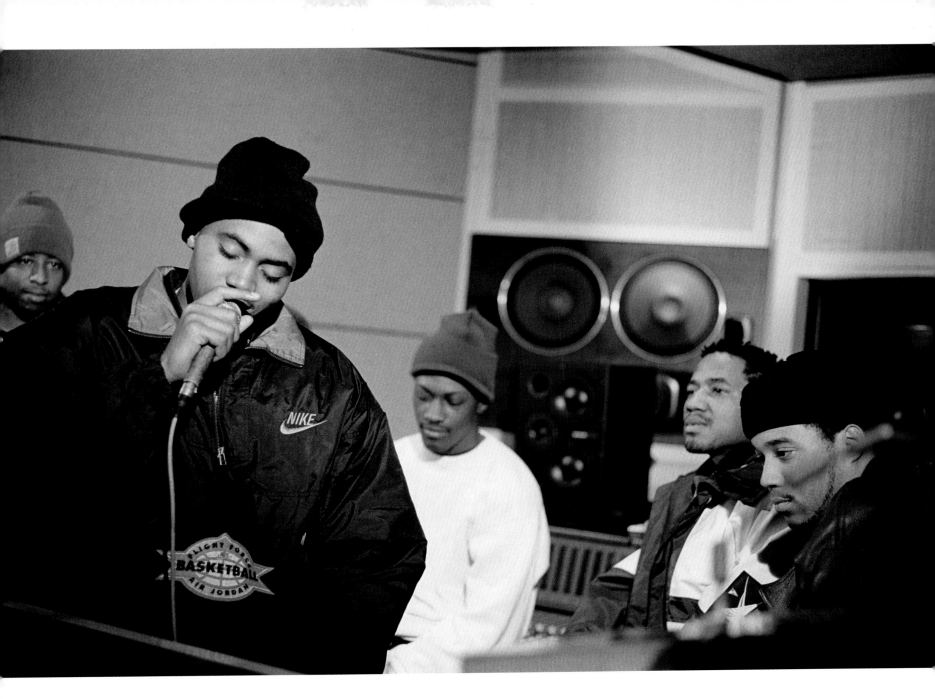

NEW YORK CITY, 1993

LISA LEONE

NAS IN THE STUDIO

"I had been to a lot of recording sessions before, but the *Illmatic* session felt different. There was a sense of calm, it was serious. That's what I was trying to capture. This contact sheet is from a session at Sony Music Studios. There were other sessions for the album at Chung King Studios, D&D, Battery Studios, and Unique Recording Studios, but this is the one I was given access to.

"The one photo of Nas with his eyes closed at the mic; that just says it all. He is so focused, on a whole 'nother level, and it captures the moment. That's the shot right there. The other shots on the contact sheet are amazing too because they have all these hip-hop icons like Preemo, Large Professor, L.E.S., and Q-Tip. The expression on Preemo's face says a lot, you can tell that he is clearly blown away by what he's hearing from Nas.

"I always tell young photographers today, don't just go in and start shooting, hang for a while, try to vibe and be part of that energy and then you can be connected to the moment. Feel the energy. Don't just click away; really see."

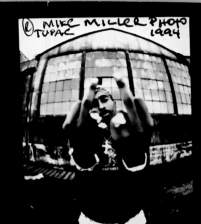

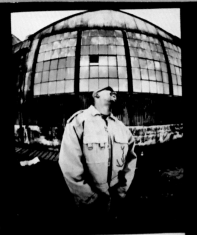

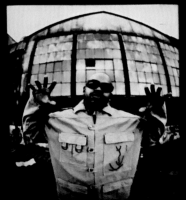

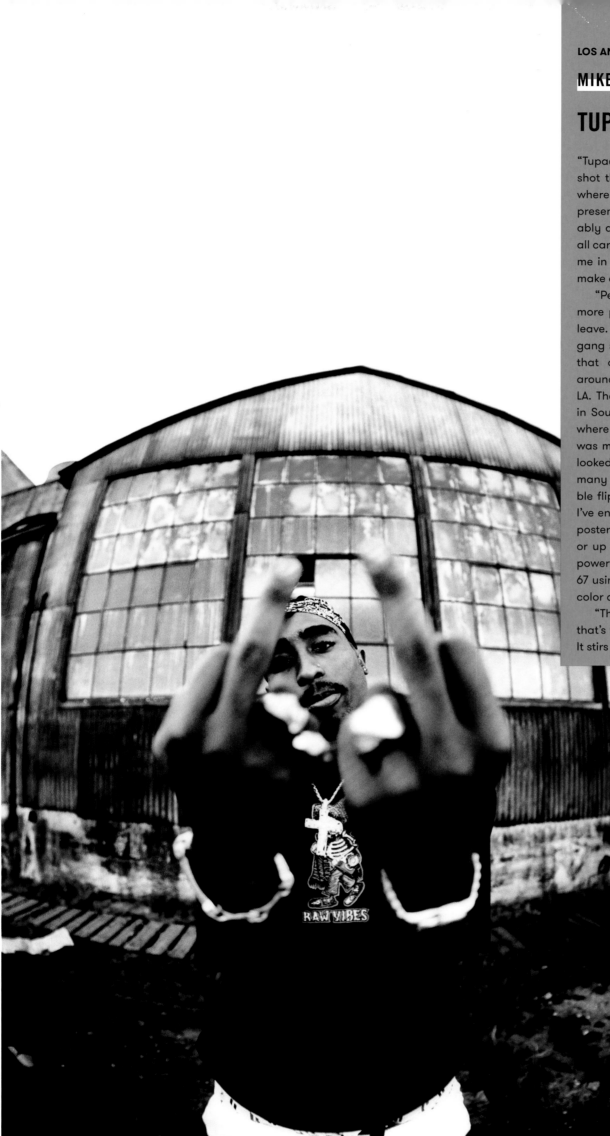

MIKE MILLER

TUPAC SHAKUR, *THUG LIFE*

"Tupac was at the height of his career when we shot this. We first met up at Runyon Canyon, where he had a condo. He was very charming, present, and highly intelligent. There were probably around fifteen people in his crew, and we all caravanned from location to location. He told me in private that he was happy to be able to make an album with everyone he grew up with.

"People recognized him everywhere, and more people started showing up so we had to leave. We did have to worry about some gnarly gang situations, but nothing serious happened that day. We spent twelve hours shooting around LA—East LA, Watts/Compton, Downtown LA. Then we went to an abandoned train yard in South Central LA in the Rollin' 40s, which is where we got the double-middle-finger shot. It was meant to be an outtake at first but when I looked at it, I knew. I was happy there were so many good shots, but the image with the double flip-off resonates with so many people that I've encountered. People have told me they had posters of it on their walls when they were kids or up in dorm rooms. It really stands out as a powerful image, and it was shot with a Pentax 67 using Kodak cross-process film, so there's no color correction.

"This image is fun and defiant, and I believe that's why so many people identify with Tupac. It stirs up a lot of emotion."

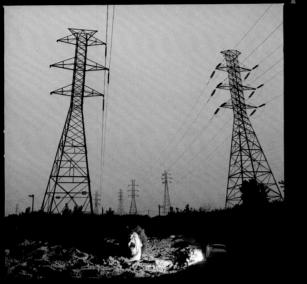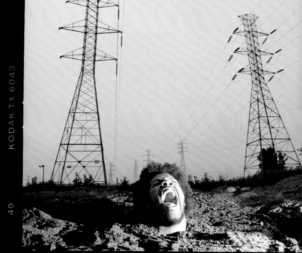

DANNY CLINCH

REDMAN, *DARE IZ A DARKSIDE*

Redman's second album, *Dare Iz a Darkside*, featured a cover image with Red's screaming head submerged in dirt, an homage to Funkadelic's 1971 *Maggot Brain* cover. The photo was created in a time before digital photography and editing software would have made the image possible without actually submerging Redman in dirt.

"We didn't have the option for digital retouching or editing and had to be very strategic with the lighting. We also had to actually put Redman in a green garbage bag so he wouldn't get his clothes dirty. We buried him from the neck down, which made him feel a bit vulnerable, and I remember someone stepping on the ground really close to him when he was submerged and he got *really* freaked out. We photographed in front of radio towers, which looked very industrial, and then went to another location in Newark to continue shooting. We already had our concept for the cover, but you always have to be open to other things and also have to capture varying imagery that will be used for publicity images or the inside of an album."

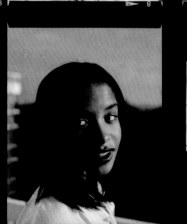
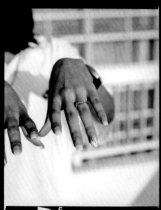

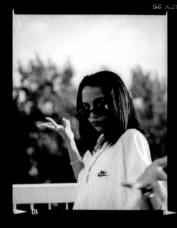

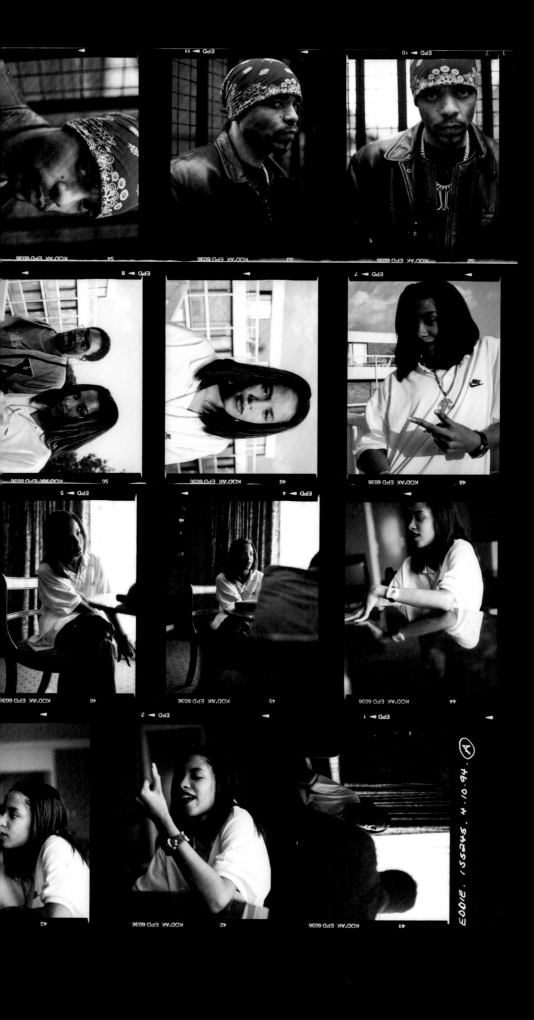

EDDIE OTCHERE

AALIYAH

"The first time I photographed Aaliyah, she was still super young and just starting out. She was visiting London, doing some promotion for her album, and I got to do a photo session with her at the Hotel Swiss Cottage. I was using a Bronica camera and 50 ASA film, which is a very slow film and does better in natural light, so we went out onto the balcony and got some really great shots. She was very quiet and spoke in this way I imagined a true singer would talk. Like her speaking voice almost felt like she was singing.

"Capturing a young woman at this point in her career was really special, and I felt that I had a responsibility to honor where she was at that time. I understood that it was a heavy thing to be a young woman coming up in the public eye. She was still a teenager and whatever was going on between her and R. Kelly was coming to light, and the pressure for her seemed difficult.

"She had this Tasmanian Devil chain tucked into her shirt, and I also photographed her hand, which seemed to have a wedding ring on it. I had heard the rumors that she and R. Kelly had secretly married even though she was underage, but I was just there doing my work as a photographer and trying to tell the story that way. She must've been around fifteen years old and I was just a few years older, like eighteen at the time. When she was posing she was really shy and awkward. She was still a child. On one of the contact sheets you can also see photos I took of Ice T and some of her other friends.

"By the time we met up again a few years later in 1997, she had changed. I got the sense she was no longer a child. She was wearing a camo bandana and had a bit of a toughness about her, even though at her core she was still, and always will be, this beautiful soul. I even named my own daughter Aaliyah."

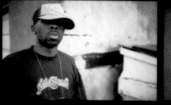
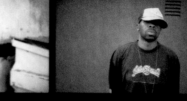
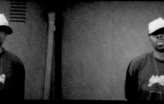
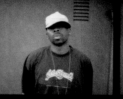
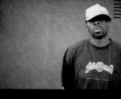
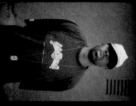
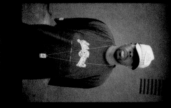
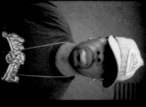
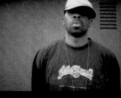
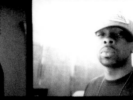
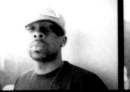
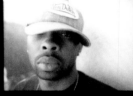

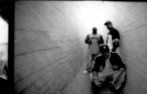

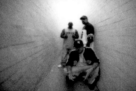
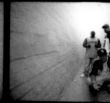
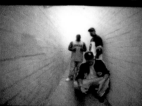
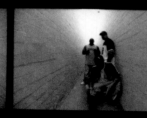
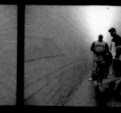
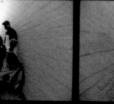
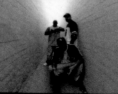
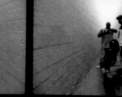
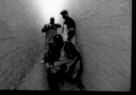
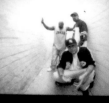
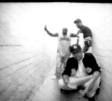
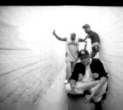
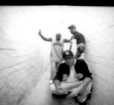
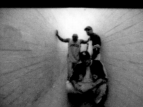
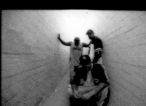

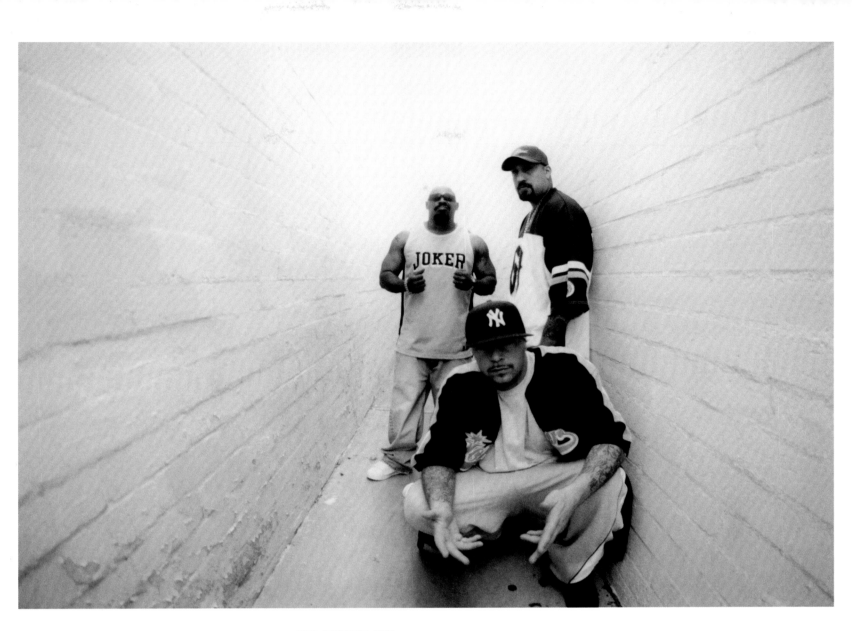

LOS ANGELES, 1994

ESTEVAN ORIOL

CYPRESS HILL

Photographer Estevan Oriol first started taking pictures after his father, famed photographer Eriberto Oriol, gave him a Minolta camera and explained two concepts to his son: shutter speed and depth of field. Then he put his finger on the shutter release and said, "Push here." He told his son, "You should be documenting all the stuff you're doing. You know, you live a pretty cool life."

The "cool life" Oriol's father was referring to was his son's experience as a club bouncer and tour manager for groups like Cypress Hill and House of Pain. As a trusted member of their inner circle, Oriol documented candid moments and had unprecedented access to the growing West Coast hip-hop scene.

"I shoot much like a documentary shooter, and because I was so close with Cypress Hill, I was usually in places where I could photograph them in their quieter moments between touring and stuff. One day, we were all outside of DJ Muggs' studio where Cypress recorded a lot of

their songs. Muggs was working with a new artist and he wanted me to take the photos for his demo.

"The alley was long and narrow, and I noticed that it would give this tunnel effect when I posed the guys there. I thought it would be great to get Cypress framed in between the long stretch between the buildings. I knew that shot would be classic.

"Much of the contact sheet is dedicated to this young artist who I don't know whatever happened with. That happens sometimes, when you look back on a contact sheet and realize you dedicated so much time and focus on certain photos that never saw the light of day. I guess if this were during digital, I might have deleted those shots but there they are, right alongside the classic Cypress Hill images."

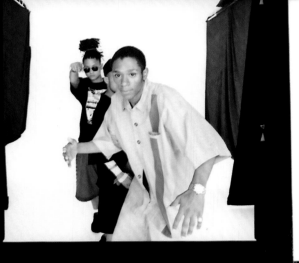
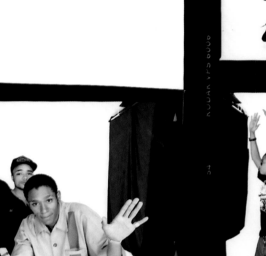

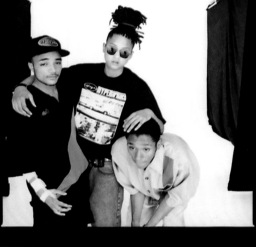
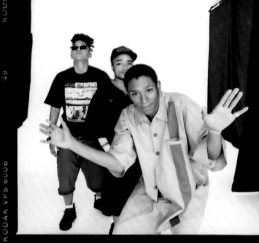

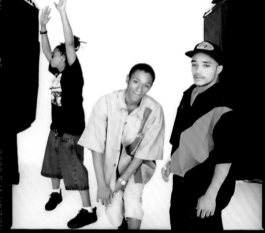

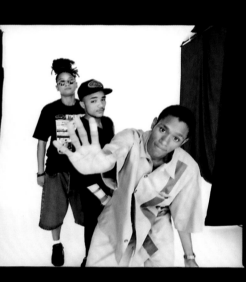
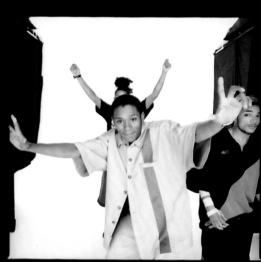

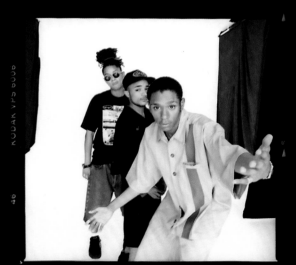

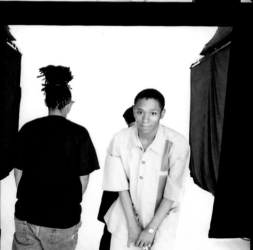

307911- 4A.

JAMIL GS

URBAN THERMO DYNAMICS

"I used to go to poetry events at a small café on Fulton Street in Fort Green, Brooklyn. I believe it was the Brooklyn Moon Cafe and it was a hub for progressive, Afrocentric hip-hop. It seemed like everybody in the poetry/hip-hop world came to perform at Brooklyn Moon, including Digable Planets, Common, Saul Williams, and a young dude, Dante Smith, who came to be known as Mos Def and now Yasiin Bey.

"When Payday Records told me they had signed him, his younger brother DCQ, and younger sister Ces, and asked me to shoot their press photos, I was excited. I didn't style them or anything, they had the personality and a style all their own. We shot this on Laight Street near Chinatown, where I was working for another photographer. I used his studio, moonlighting a bit I guess you could say, and we just had fun with it. They had that classic '90s Brooklyn hip-hop style, and you could feel that youthful energy in most of the shots. Yasiin had that leader quality I just knew was going to take him far."

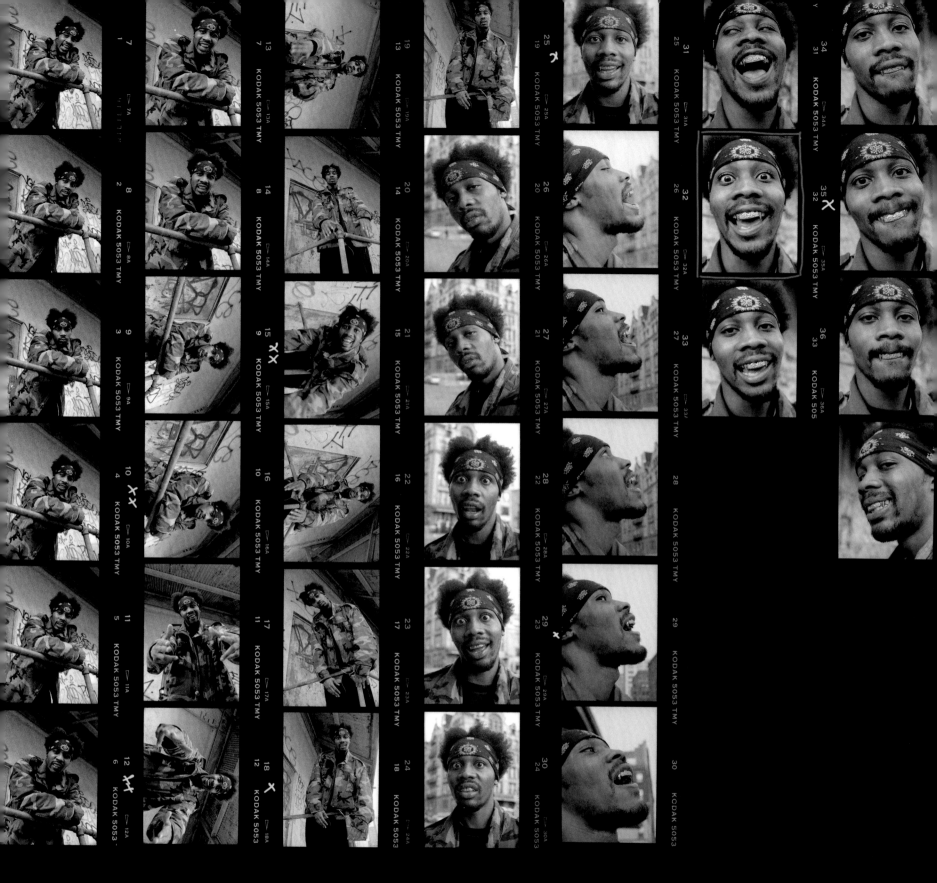

"When I was about nine years old, I had a dream that
I had metal vampire teeth and I brought my dream to
life. I went down to Albee Square Mall in Brooklyn to
this jeweler who makes jewelry for everyone in hip-
hop. This frame with my eyes going crazy, I
remember doing it and thinking the photographer
was just shooting my teeth and when I saw the full
frame I was like, 'What the . . . ,' but I grew to really
like and laugh with that photo." —RZA

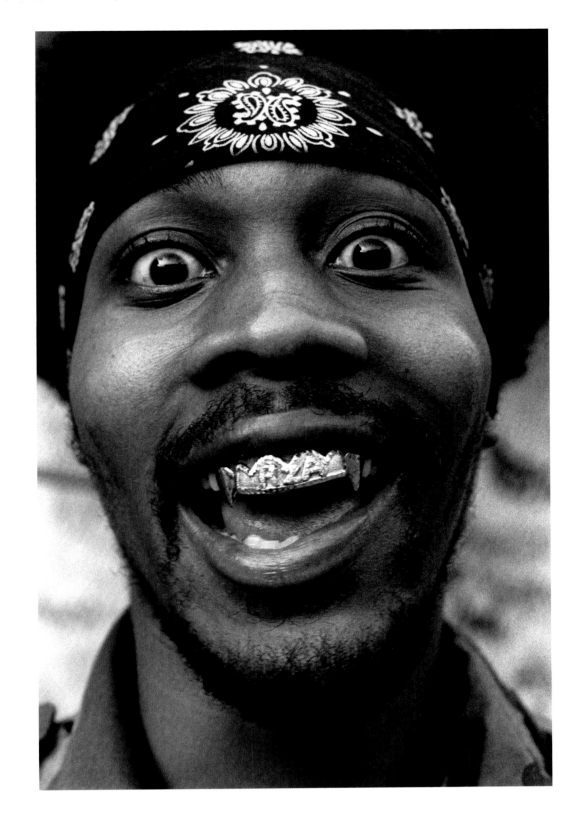

NEW YORK CITY, 1994

DAVID CORIO

RZA ON THE SET OF GRAVEDIGGAZ "NOWHERE TO RUN, NOWHERE TO HIDE" VIDEO

"*Enter the Wu-Tang (36 Chambers)* had come out the previous year and RZA was working on a clothing line, producing, and had also got Gravediggaz together, so he was all over NYC at that time. For this shoot, I don't think either of us had any preconceived idea of what we wanted. It's always better when it is a natural process. I never use any assistants or stylists, and there weren't any record label people or art directors involved. We ended up getting this really enigmatic shot, and you can't do that kind of close shooting with too many people.

"It was difficult to get the right angle as RZA doesn't tend to stay still for too long. The light was beginning to go too, which was good light for shooting in. It's what's called the 'magic hour,' which really lasts for about twenty minutes or so when the sun has set but the sky is still bright. You can see that the highlight in his eyes gives a nice soft, directional light. This photo has a classic portrait feel and was later used on a limited edition Supreme T-shirt.

"My camera setup has always been to travel light. I probably had two Nikon F-801s at the time and a 24mm, 35mm, and maybe an 85mm lens. I never used zoom lenses, as the apertures meant you couldn't shoot in low light, and I always shoot with the manual exposure and manual focus.

"I guess this single shot of RZA was more personal, as the record label didn't really want it. I had always developed my own film and printed my own photos, so I went home and developed the film in the kitchen of my studio apartment on Thompson Street. That close-up is the shot that pops out for me."

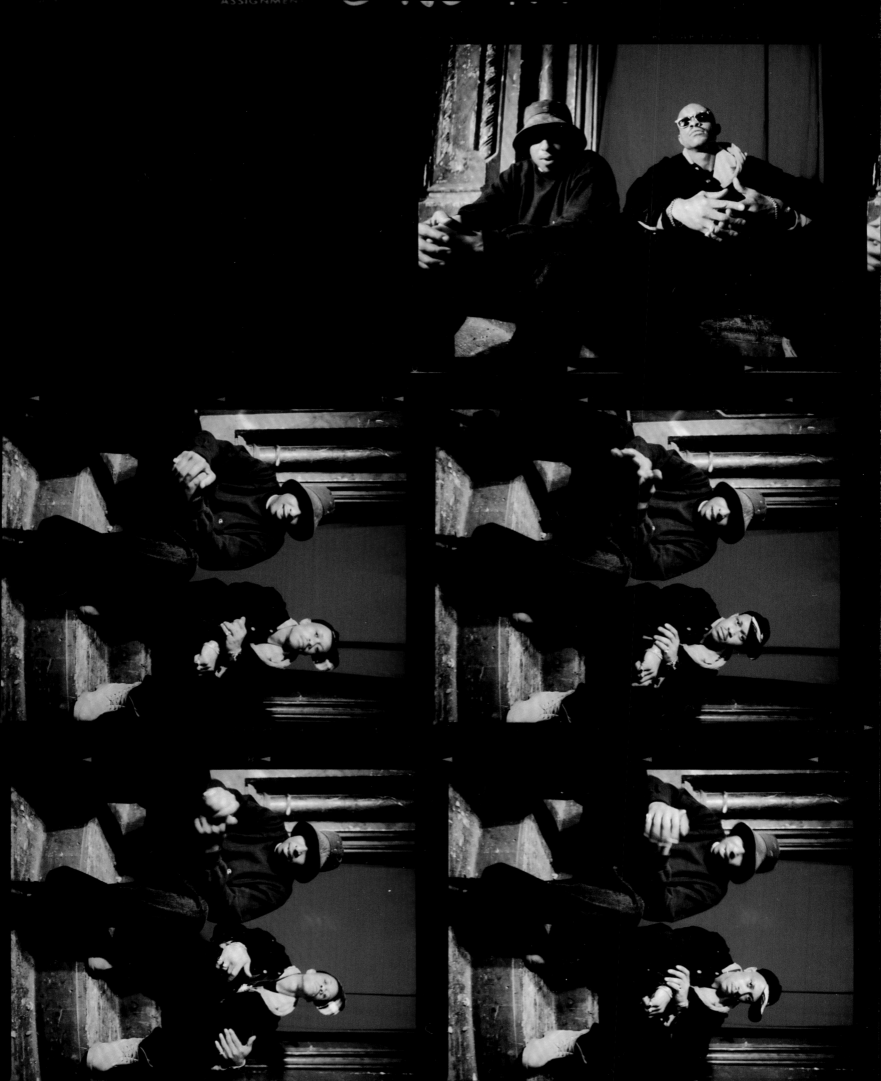

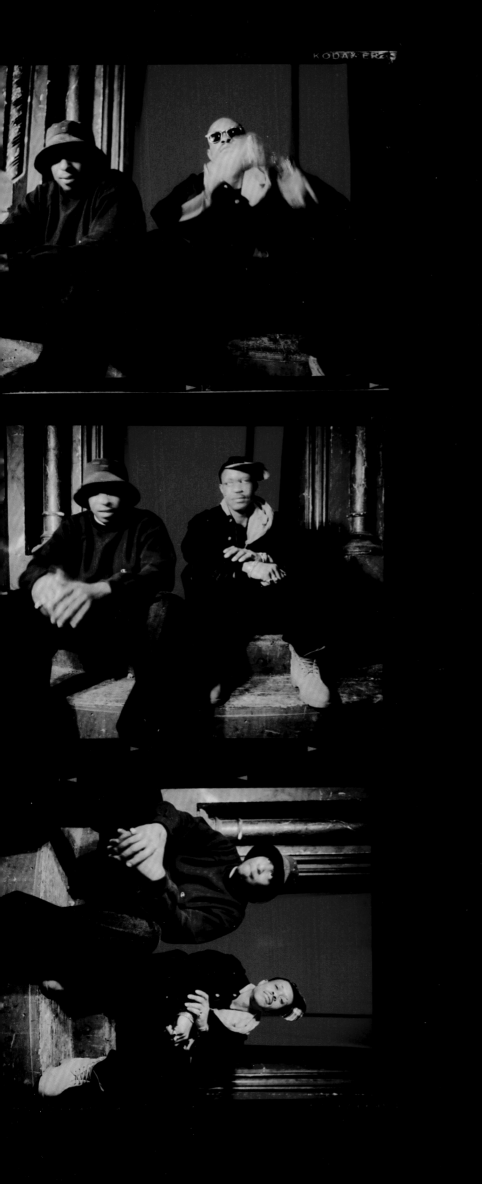

DANNY HASTINGS

GANG STARR, *HARD TO EARN*

"From the moment we met, I immediately felt a personal connection to Guru and Premier, because I was already a part of that culture. They let me hear the album, and I always appreciated when artists would allow me to listen to their music before we worked together. I was first and foremost considering what this music was, and what kind of imagery would serve the music.

"At the time, I was looking at a lot of the rock-era records and was inspired by how conceptual they were and I became interested in cross-processing film and other techniques. I wanted to bring some of that to hip-hop with the various colors and unique portraiture. This was before Instagram filters and Photoshop manipulations, so the only way a photographer could manipulate color contrast and saturation was to either push the film or cross-process it. I shot mostly on reversal film and cross-processed through negative chemicals to get the contrast and saturation. I also decided to experiment with Tungsten light and daylight positive film, which is usually a no-no for professional photographers because it often results in photos looking orange.

"Throughout the shoot, Guru kept insisting we position Premier in the foreground. He kept emphasizing that a DJ and producer such as Preemo was equally as important as the rapper. 'You always see the DJ in the background,' he said. 'I want Preem in the front.' He was insistent on sharing the spotlight, and he took the backseat during the entire shoot."

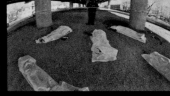

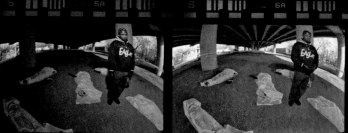
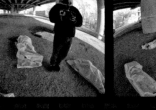
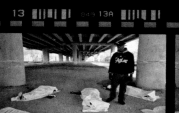
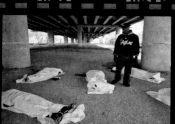

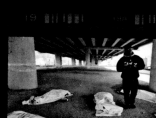
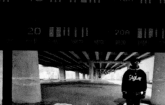

BRIAN "B+" CROSS

GOODIE MOB, *RAP PAGES* COVER SHOOT

"Atlanta was just starting to make some noise in the hip-hop world, and Goodie Mob were really pushing boundaries with music that wasn't just East or West Coast. It was really something new. This was their first magazine cover and they wanted to shoot in Atlanta, so I went down there with our art director, Brent Rollins. They lived in an area they called S.W.A.T.S. ('Southwest Atlanta, Too Strong'), and they used to record at Curtis Mayfield's house, which is where we met up with them. We started talking about where we should have the shoot, and they told us about this place where they used to hang out as kids that was once used to test military explosives. We decided to sneak in.

"We get there and it was very swampy and they were like, 'We should get in the water,' and we were like, 'Yeah, fuckin' do it.' The photo had this baptismal vibe. I was in an experimental photography phase with cross-processing and all this, so that's why the finished photo had this look to it. I've run into them in years to follow and we always talk about the staying power of that photo."

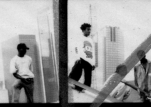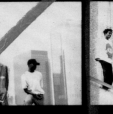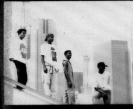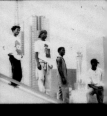
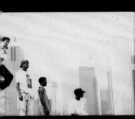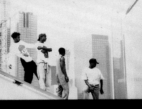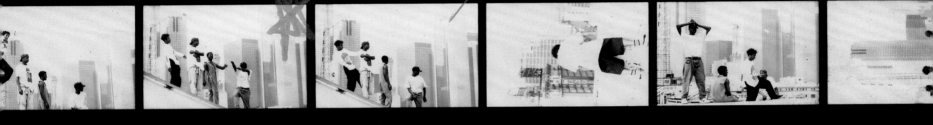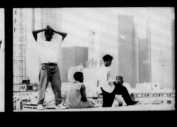
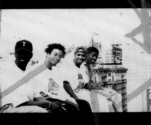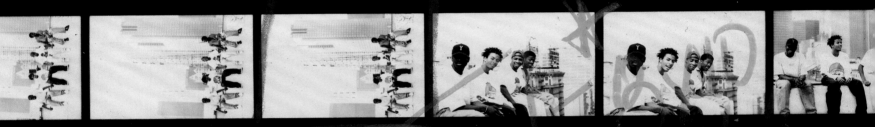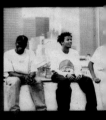
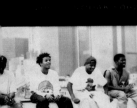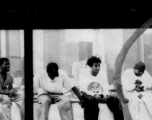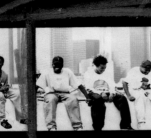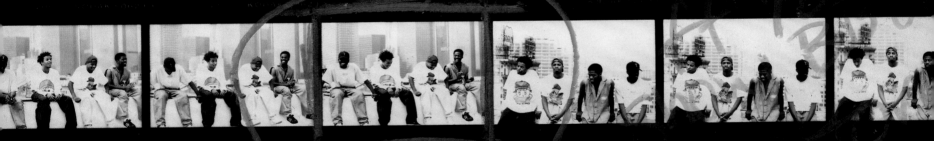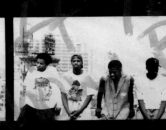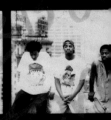
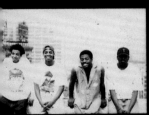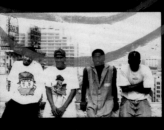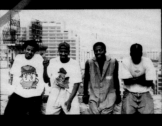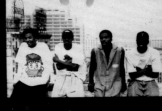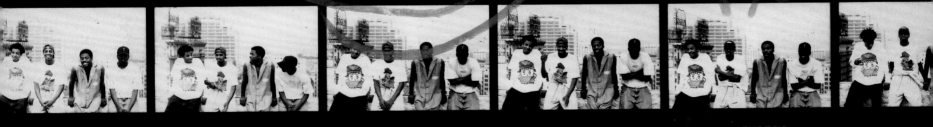
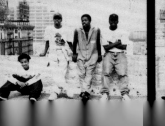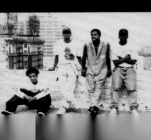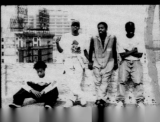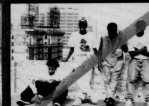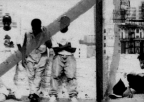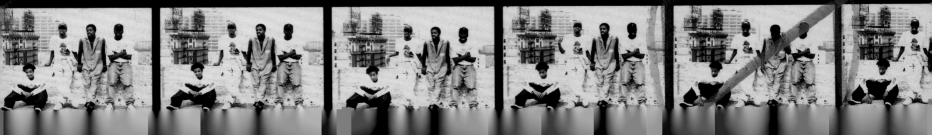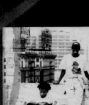

MARK HUMPHREY

THE PHARCYDE

"I was already familiar with the group, because we were all part of a scene that was growing around a club called Brass. It was this soul/jazz and hip-hop club that had the same vibe as what was happening in New York with groups like A Tribe Called Quest and the whole Native Tongues Posse. Pharcyde was very much a part of this scene, and that's where I saw some of the very first LA performances of Jamiroquai, the Roots, Digable Planets, and more. Every Sunday, Brass was the 'go to' club to hear DJs playing what was fresh, mixing together acid jazz, rare groove, house, and even Jamaican dancehall.

"We shot this at my studio in Downtown LA—that's my building on the cover, with their feet dangling off."

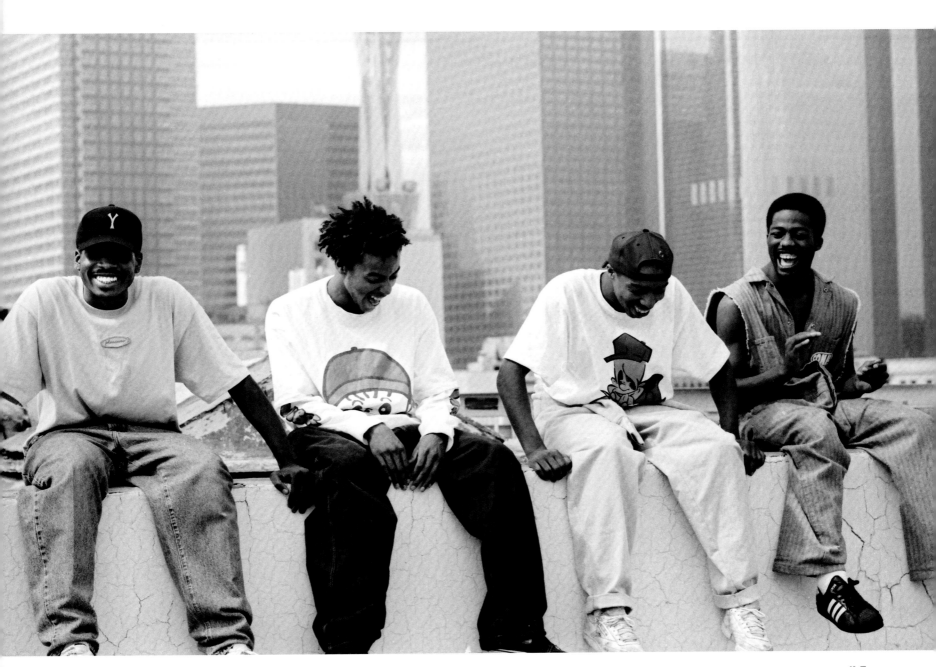

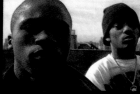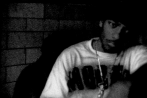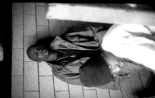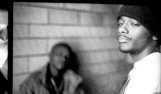

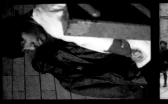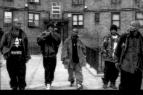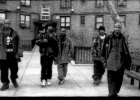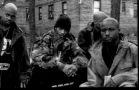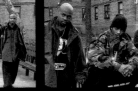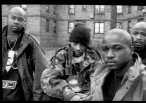

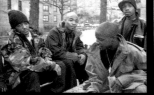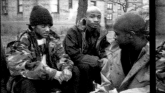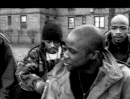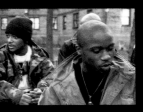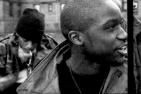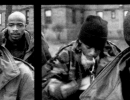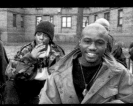

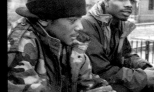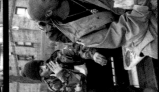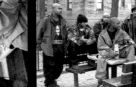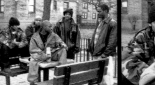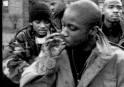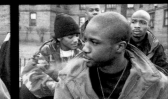

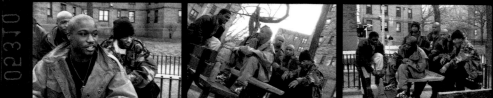

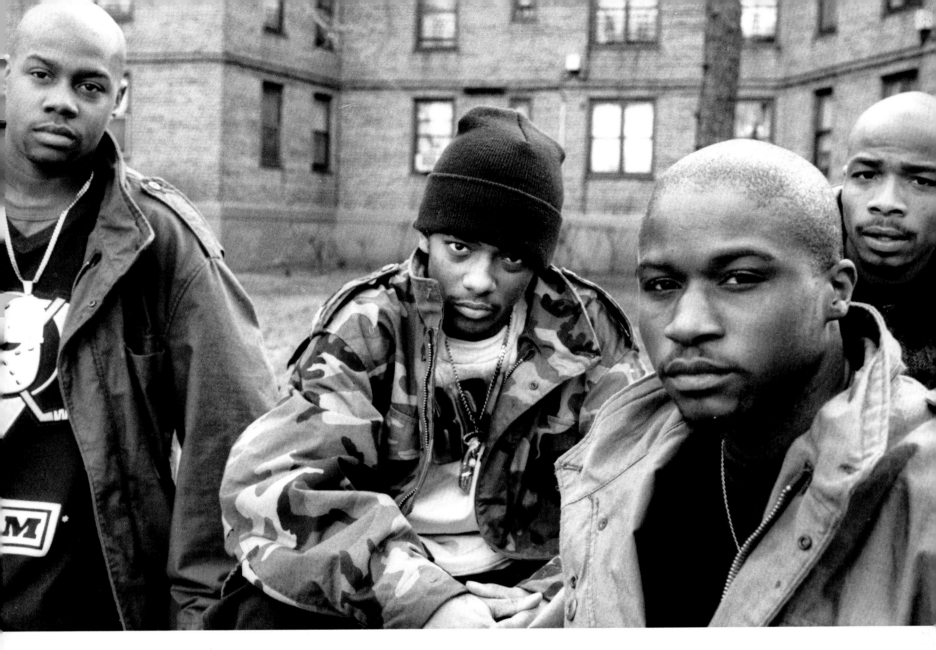

QUEENSBRIDGE, NEW YORK, 1995

DELPHINE A. FAWUNDU

MOBB DEEP

Delphine Fawundu photographed Prodigy and Havoc of Mobb Deep for their second album, *The Infamous*. *Beat Down* was a bootstrap but influential hip-hop newspaper located near Queensbridge Houses in Long Island City, where Fawundu met the group for the photo shoot. Fawundu thought it was important to capture the group on their home turf, with Queensbridge serving as inspiration for the album's gritty, hard, and unapologetic visuals. The photo shoot showcases the two MCs with their friends, Ty Nityy, Big Twin Gambino, and his brother Scarface, who passed away shortly after this photo was taken. The friends all grew up together on 12th Street on the 41st Street side of Queensbridge.

"We rolled up to Queensbridge and met Havoc downstairs. He walked us up the stairs of a building and knocked on someone's door. Inside was an older woman and Prodigy. I'm not sure whose apartment it was, but meeting the older woman, who could have been somebody's grandma, instantly brought things down to earth. Feelings of home lingered within me, and it felt like I was meeting strangers that I already knew.

"For this shoot, I used a Nikon FM2 and a Mamiya 645. My film of choice was Kodak T-MAX for black and white. I would use either Agfa or Fuji for color.

"Looking at the contact sheet, you can see how strongly the '90s played a role in how these artists crafted their look; it was the thing to sport a boldly labeled T-shirt, sweats or jeans by young black designers such as Karl Kani, Walker Wear, Mecca, and Enyce. I was inspired by how all these elements came together, making New York hip-hop such a force at that time. It just felt so powerful and it was all happening right before my eyes, and my camera."

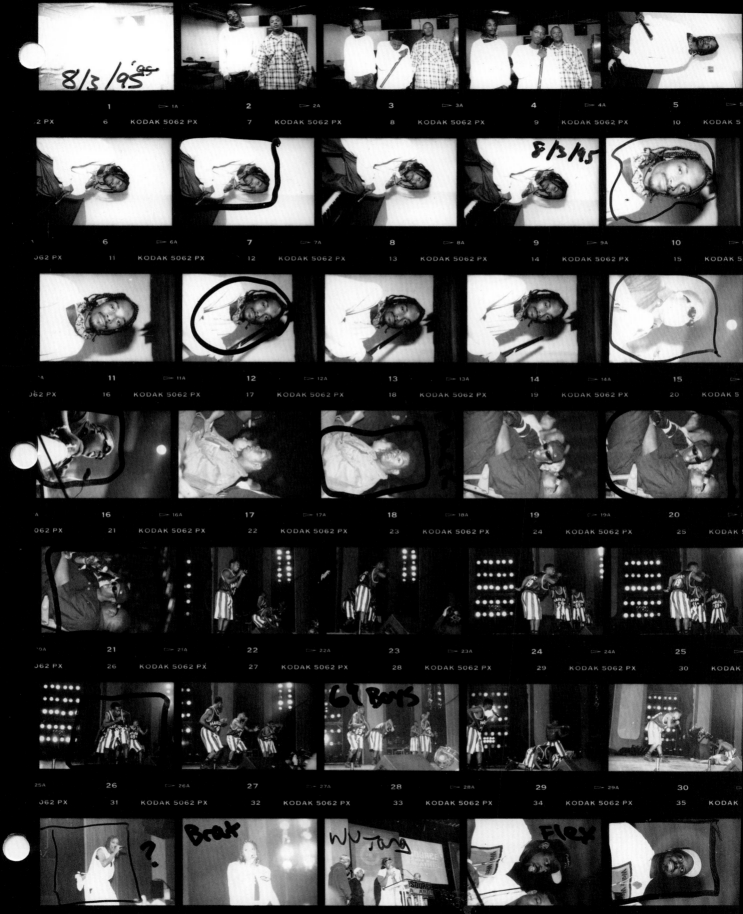

AL PEREIRA

THE SOURCE AWARDS

"*The Source* Awards were the hip-hop version of the Grammys, and having an awards show just for hip-hop was important. Many of the mainstream awards shows weren't giving hip-hop the attention it deserved, and the ceremony filled that need.

"Everyone in hip-hop seemed to be there that night and the climate was very charged, although I was oblivious to the reasons for the tension. Puffy's Bad Boy label was the hottest label in music and they were making the scene with Biggie and Craig Mack. The Death Row Records crew, comprised of Snoop Dogg, Dr. Dre, Suge Knight, and many others, were there too.

"Later that night, I was in the audience just getting some crowd photos and I walked over to where Puff and Big were sitting. It was at that moment that Suge Knight announced, 'Any artist out there that wanna be an artist, stay a star, and won't have to worry about the executive producer trying to be all in the videos, all on the records, dancing—come to Death Row!'

"Suge was, of course, talking about Puffy. He started getting booed by the New York crowd, and I could hear all this going on but I hadn't realized that I'd caught the exact moment when Puff and Big were hearing Suge's tirade. I noticed everyone around Puff and Big was getting agitated but I was so focused on getting the visuals that I wasn't listening that hard to what was being said. Years later, I now understand what was happening and I'm just glad I didn't stop taking photos at that moment, especially since it played a part in the media hype of the East Coast/West Coast rivalry that began shortly after.

"That whole night was just drama. You also had Snoop Dogg's tirade ('The East Coast ain't got no love for Dr. Dre and Snoop Dogg?'), and then Diddy finally got onstage and responded to Suge's dig ('I live in the East, and I'm gonna die in the East'). The events of that night reverberated through hip-hop. The contact sheet shows all of it from start to finish, like a film unfolding."

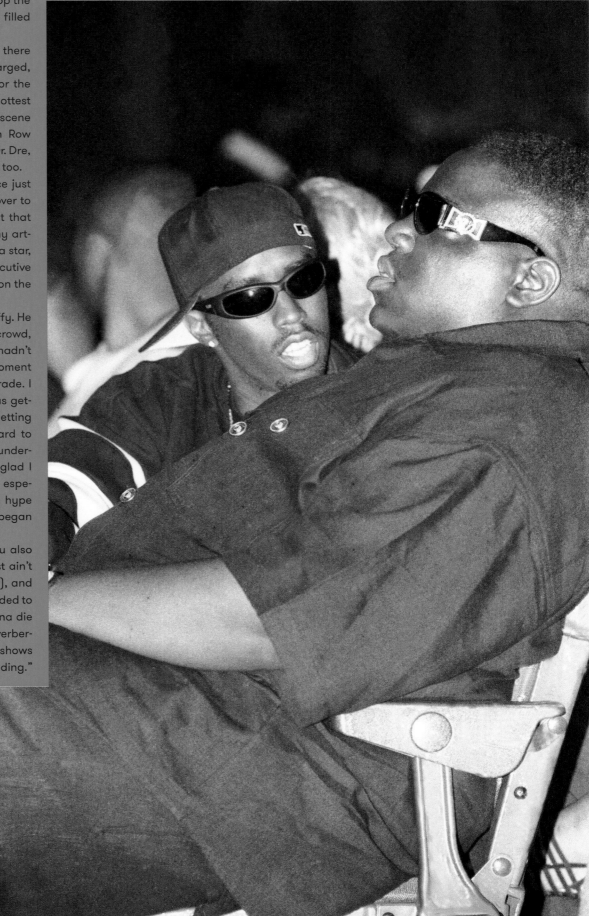

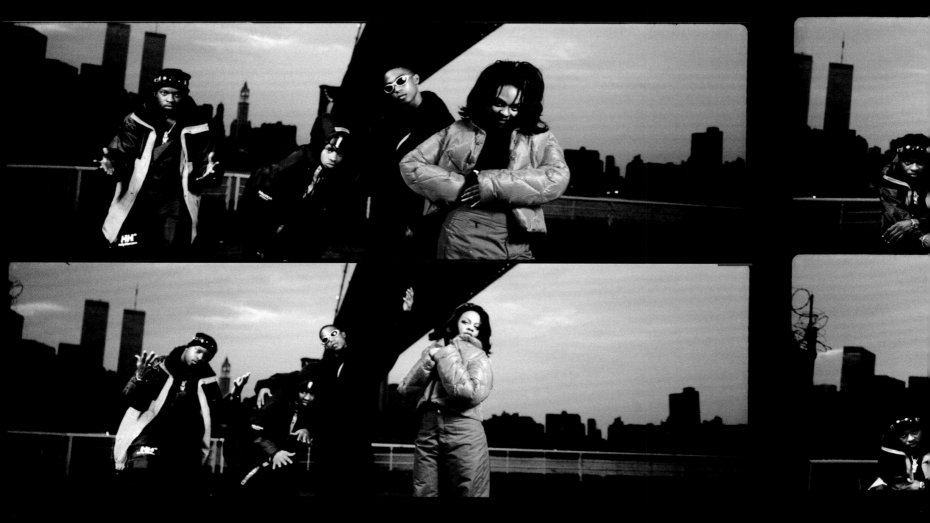

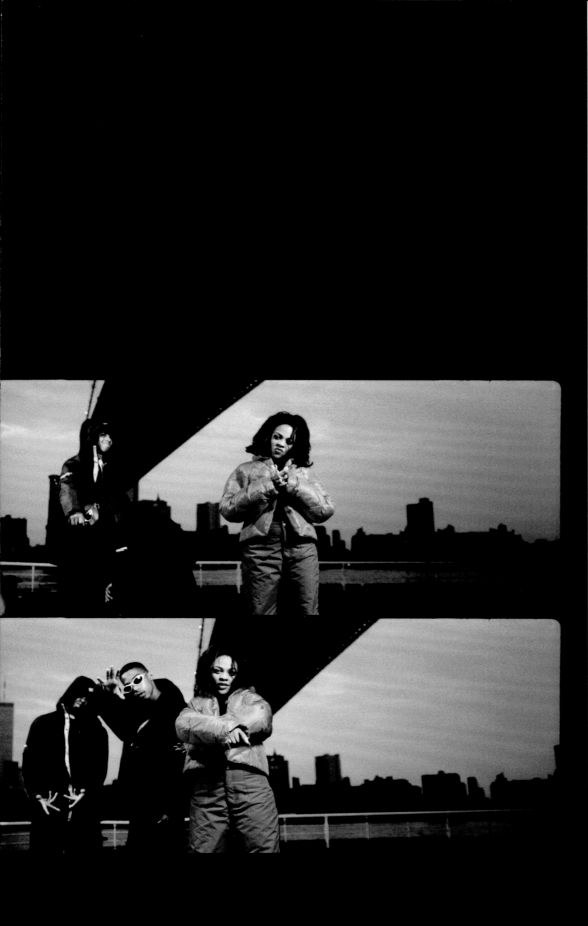

DANNY HASTINGS

LIL' KIM AND JUNIOR M.A.F.I.A.

"I used a Widelux camera, which was perfect for this expansive shot with these important New York landmarks. The styling was also significant as I showed key hip-hop brands at the time like Helly Hansen, Nautica, and even Bolle goggles, a very '90s aesthetic. Biggie was there that day too, but he wouldn't let anyone take his picture. He was just kind of there as the big bro to the group. I wish I could've gotten a photo of Big in front of the Twin Towers but there were strict orders from his label not to photograph him that day. Both the towers and Big are gone now, so I regret not getting that shot."

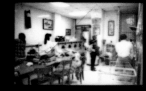

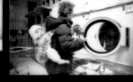
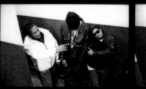

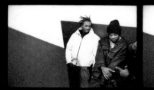

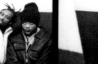

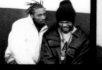

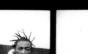

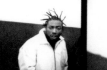
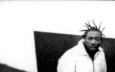
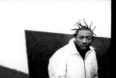
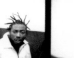
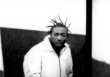

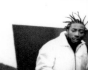

SUE KWON

OL' DIRTY BASTARD ON THE SET OF THE "BROOKLYN ZOO" MUSIC VIDEO

Unfiltered and unapologetic, the image of Wu-Tang Clan rapper Ol' Dirty Bastard holding a 40-oz., high on life and cracking himself up among friends and fellow Wu-Tang members, captures the raw energy that was characteristic of early New York hip-hop.

"I knew I had to be ready to get a quick shot of ODB because, in my experience, he would give 200 percent and then suddenly would decide to stop and leave. It was never angrily, but I think that when he'd had enough, he just did what he felt like. I showed up to the set and it was typical commotion, with moments of downtime and setup, so I managed to grab a few photos of ODB goofing around, making these silly faces. Diane Martell, the video director, is in a few of the shots with him, and I love that Method Man is in several of these shots as well; the ones with him are my favorites. But as soon as I saw frame 36A, I knew it was the one. I loved his expression, that unguarded moment. He had been posing and maneuvering as he often did, and then right after shot 36, he just cracked himself up."

"The contact sheet is from a roll I probably started in December of 1994 using a Leica M6. As a result, I have a lot of images of my neighborhood that I shot on here, like my regular laundry spot at 194 Mott Street. I remember being fascinated by the woman with her child in the laundromat. As a photographer, I was equally interested in everyday life, and to have these characters alongside Mr. Wonderful (that's what I jokingly called ODB sometimes) is just very New York, like a New York City visual stream of consciousness."

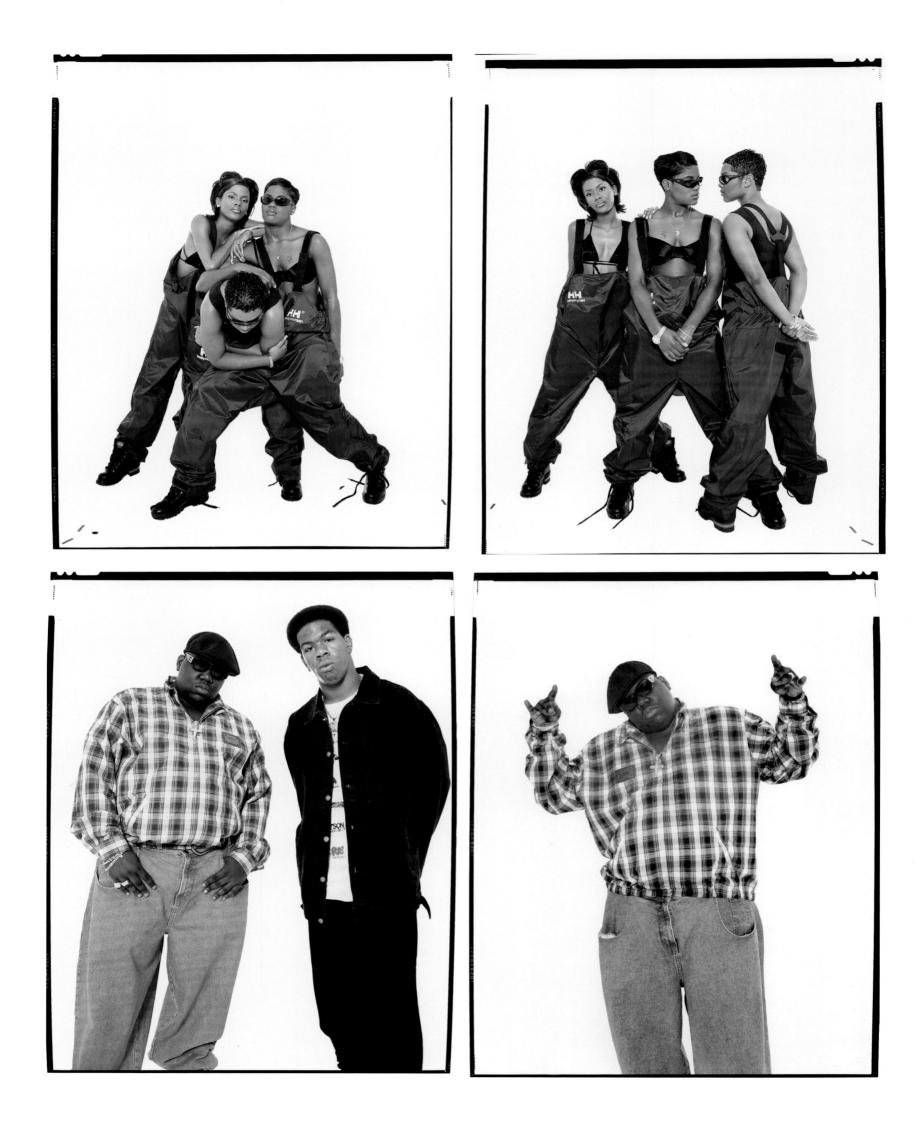

NEW YORK CITY, 1995

JAYSON KEELING

BAD BOY FAMILY

"Photographing the Bad Boy family at the height of their fame was daunting. They were such a powerful collective. I love the shot of Puffy with his arm stretched forward like 'Look at us.' All of his artists were there—Faith, Biggie, Total, and Craig Mack. They were kings and queens at that moment. I decided to use a large-format 8"x10" camera as a way to make the shoot feel very epic. I was inspired by Richard Avedon and his American West series, where he made large-format portraits of everyday people against a clean white backdrop. He left the black border visible when he printed, and that series is now regarded as an important hallmark in the history of portrait photography. I wanted this Bad Boy shoot to have that same feel to it. It felt larger-than-life in many ways, and I thought photographing them in this large-format, narrative way reinforced that. The shoot feels regal to me."

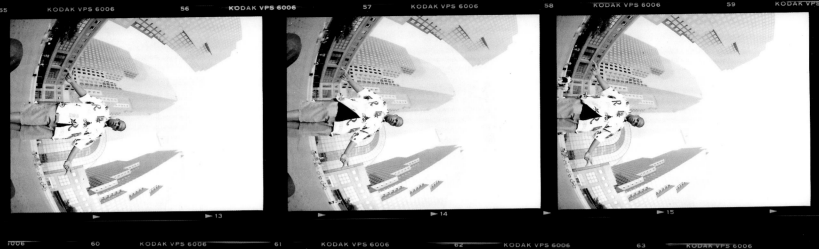

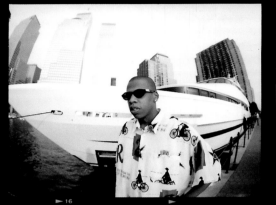

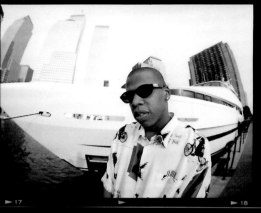

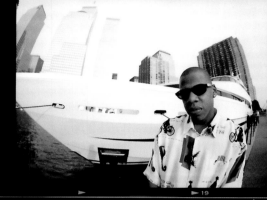

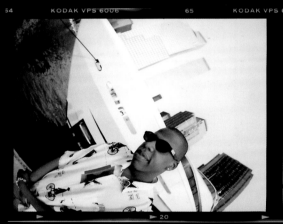

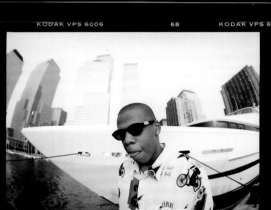

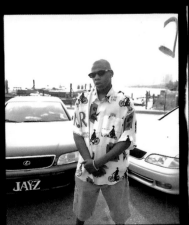

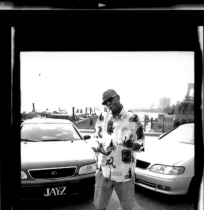

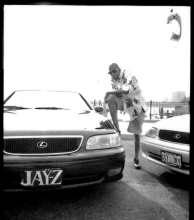

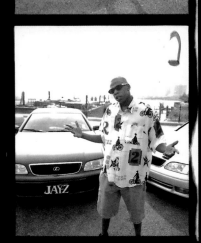

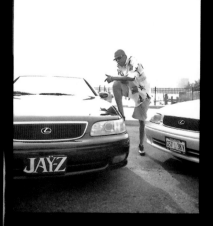

JAMIL GS

JAY-Z'S FIRST PHOTO SHOOT

"I remember thinking that Jay was really re-sourceful. It wasn't a big production and, to save money, he had me picked up by a few of his friends in a Lexus from my apartment on Avenue A. It was the same Lexus for Jay's 'Dead Presidents' video.

"We drove to Jay's condo off Atlantic Avenue and Flatbush in Brooklyn. Damon Dash and Kareem 'Biggs' Burke were there along with a friend from Virginia. He had just moved in, so it was sparse and didn't have much charac-ter yet, so we decided to hit the streets. I was inspired by the album cover of Donald Byrd's *A New Perspective*, a legendary Blue Note album cover that had the jazz artist in the background of a cool car looking regal and smooth. Based on that, I had a clear idea of how I wanted to photograph Jay. Luckily, it synchronized with Jay's own ideas.

"I shot on a Pentax medium-format with a fish-eye lens, and the film was Kodak Tri-X 400. I wanted to try something with silhouettes of cars, so Jay came prepared with two Lexus GS's and a custom-made vanity plate that we stuck on with gaffer tape. Jay also strategically placed two bottles of Cristal in the windshield. The idea was to shoot him surrounded by sym-bols of material wealth like the Twin Towers and luxury yachts. As long as we got those elements down, he was open and cool with whatever I wanted to do. When I asked him to pose in front of a giant yacht and told him that one day he would own one himself, he smiled and responded, 'No doubt . . .'"

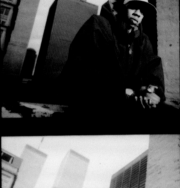

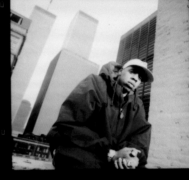

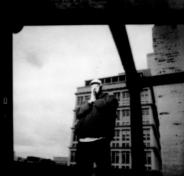

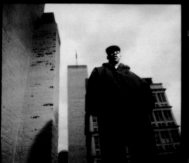

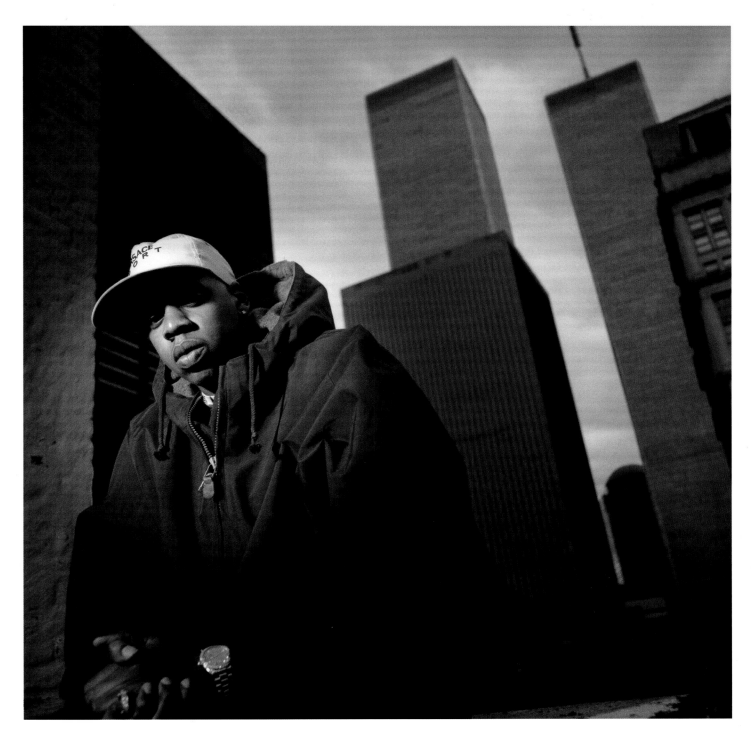

NEW YORK CITY, 1996

DANNY HASTINGS

JAY-Z, *STRESS* MAGAZINE COVER SHOOT

"It was clear Jay was out to conquer the world and this was just the beginning of his ascent. I had only heard one or two songs from *Reasonable Doubt,* but right away I could tell this was going to be a historic day. I waited for Jay in the reception area of his office for almost two hours, until I finally saw him through the glass conference room door. I guess he had been in meetings all day, because when he finally came out, he was really standoffish. He only had fifteen minutes before he had to get back to another meeting. But regardless, he looked so focused.

"We had access to the roof so I decided to take him up there, because he was thinking big and becoming this entrepreneur about to change the game up. It was around 5:00 p.m. and the sun was starting to set. In those fifteen minutes, I shot twenty-four frames using a Hasselblad and one of the first portable strobes, the Norman 400B, with a diffuse reflector. I noticed all the geometric lines the buildings were forming, and I moved around with my camera until I could see Jay was in the perfect spot in relation to the towers. I did a few shots where Jay is in focus in the foreground and the buildings are out of focus, and vice versa. We selected the one where Jay was out of focus for the cover to convey the feeling that Jay was this powerful building himself, amongst the other powerful buildings."

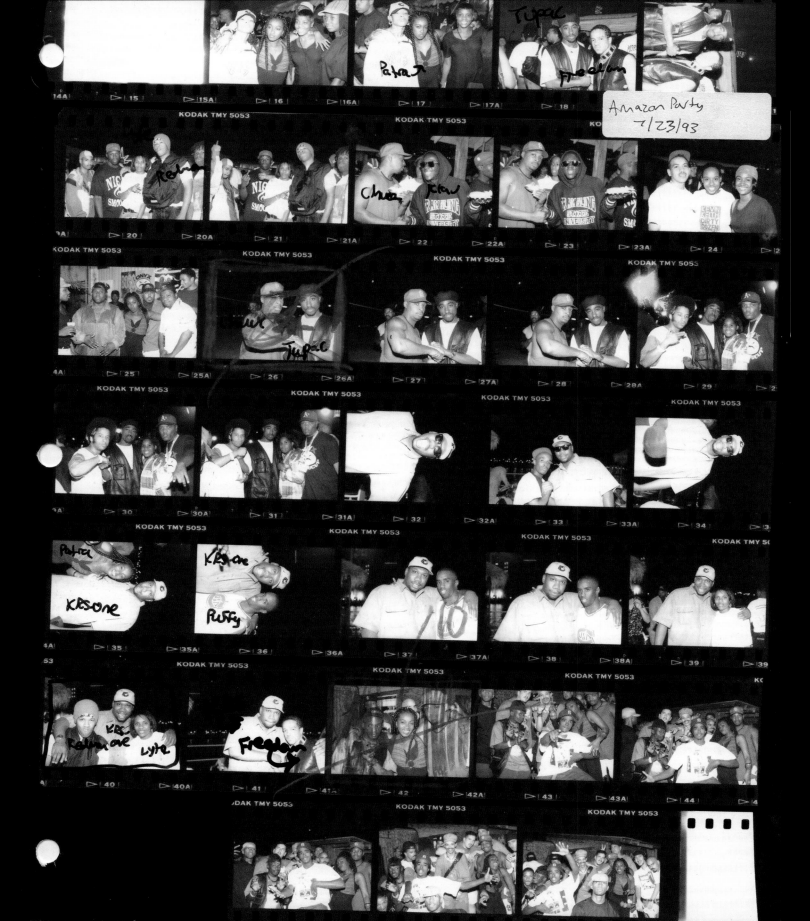

the artists wore, their style, their individuality. Hip-hop is about taking your personal experience and expressing it your own way, and when so many communities come together inspired by that, it makes culture. That culture needs to be documented, which is where photography comes in.

For me, shooting is really personal and I'm still evolving and researching. When I first started, I used to have a problem with interrupting people's space. I'm a 6'5" black guy, so taking a camera into people's candid moments to get those shots was a challenge. My good friend Stephen Vanasco gave me some advice once. It was really simple, but he said, "Just don't be afraid to get the shot," and that changed my thinking. It gave me the freedom to experiment and make mistakes and learn from it. I was trying to do more street work and force myself to get into situations where I wasn't necessarily comfortable.

When I first starting looking at photos on Instagram, I began to notice the difference in quality that some of my music friends were posting. D-Nice, Evidence, and DJ Babu (all hip-hop musicians who also shoot seriously) had some amazing shots, so I asked D-Nice why his photos look so much better than others. He told me that he shoots with a Leica, and I just fell in love with the history of the brand. I'm a heavy researcher and that led me down a photography rabbit hole. When I get into something, I *really* get into it, so when I held a rangefinder in my hands instead of a DSLR, it felt like what real photography should feel like. I've never shot with anything automatic because I like the control of manual shooting.

Then I started asking, "Who are the greats of photography?" and "Who do people look up to in the field?" Each person I spoke with had a different viewpoint. Just like in hip-hop, certain individuals came along and changed the game. Henri Cartier-Bresson was the father of shooting with purpose in the street. Robert Capa basically invented war photography, jumping out to document soldiers in battle was something completely new. To me, his story was like that of a rock star. You can draw parallels like that with different MCs, different

DJs, and see how both fields evolved; how styles developed and how people broke rules based on what existed before. That rule-breaking is hip-hop, it's photography, it's painting, and it's life. It's creating something new. Moments don't happen twice and that's why photography, a medium that captures history, is so important.

I'm blessed to come from an era that was pre-computer. When you recorded in analog, it was about respecting the process and respecting the time. Everyone knows that the studio vibe can be a magical thing, and the same thing can be said for developing in a darkroom: using film slows you down and makes you respect the process. But because of smartphones and the Internet, we've lost some of the tactile aspect of creating things. That's why I always say empathy is so important in your work. We're human and we like to touch things, and our work is the defining of a culture. We need to have that empathy and that spirit in both music and photography.

Now, anyone can make music and anyone can be a photographer. Back in the day, not everyone had access to those tools because it was very expensive to create something, but these days some kid who couldn't afford to record a track or buy a roll of film isn't faced with those barriers. How do you show the new generation the importance of these defining moments? New York City is never gonna look like "that" again. Hip-hop is never going to look like "that" again. Trains are never gonna look like "that" again. That's why these photographers served the culture and had this impeccable way of transferring empathy. The image is part of how you're presenting the music to the people, and the two are invariably linked. We're all still aiming to express ourselves. Thank God people had the wherewithal to document this history.

Legendary audio engineer **GIMEL KEATON** is most known for his wo boards with Jay-Z. Jay-Z would s name on the records themselves— of acknowledgment to give to an time. Guru's ability to communic technical terms, not only to artist creatives, and business professio has led to his reputation as the fo bridging the gap between hip-hop community. Through this love for innovation, Guru cofounded Era o a social enterprise designed to sh culture and technology intersect.

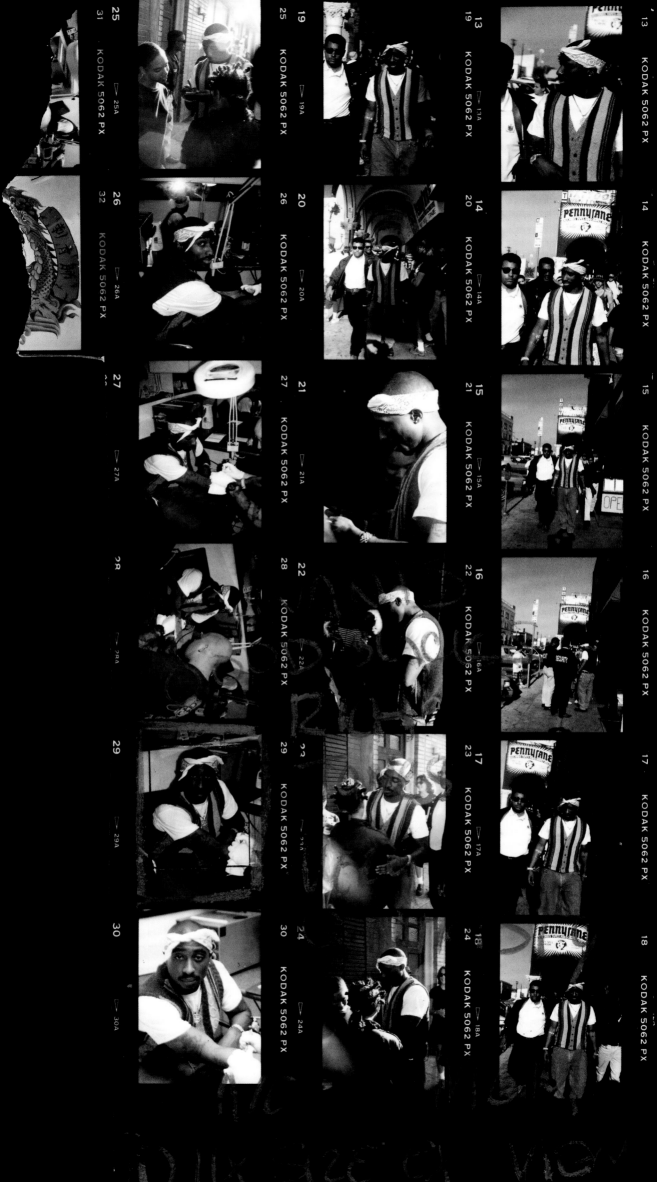

VENICE BEACH, LOS ANGELES, 1996

MARK HUMPHREY

TUPAC SHAKUR IN VENICE BEACH

"The Venice boardwalk was always a great place to shoot because it had so many characters and a lot of cool street stuff going on: BMX riders, skateboarders, weightlifters and bodybuilders, scammers, just about everything, really.

"While I was photographing this cast of characters, I noticed a bunch of security guards walking down the boardwalk and people starting to gather around them. Naturally, I ran over to see what was going on, and saw Tupac walking down the street, confident, but also looking around nervously. He was already very famous, so people were recognizing him and beginning to swarm. He ducked into a tattoo shop, and everyone except him and his entourage were stopped at the doorway. I squeezed my way to the very edge of the door and started taking photos.

"At one point he looked right into my camera and gave me a very stoic expression. I can't quite tell what that expression is but it was very powerful. He wasn't looking at me like 'Fuck off,' but more like accepting that being photographed had become part of his life. I never tried to make money on this photo. I just put it away as a memory. I couldn't see the tattoo he was getting but I later found out it read *Trust Nobody*, which was somewhat prophetic."

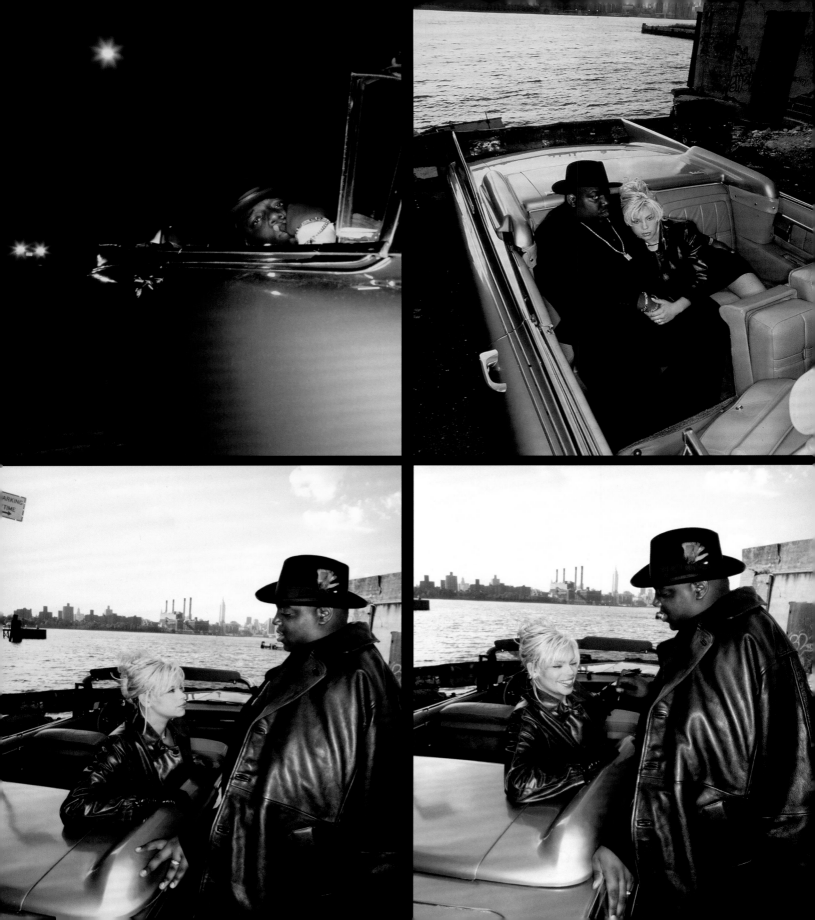

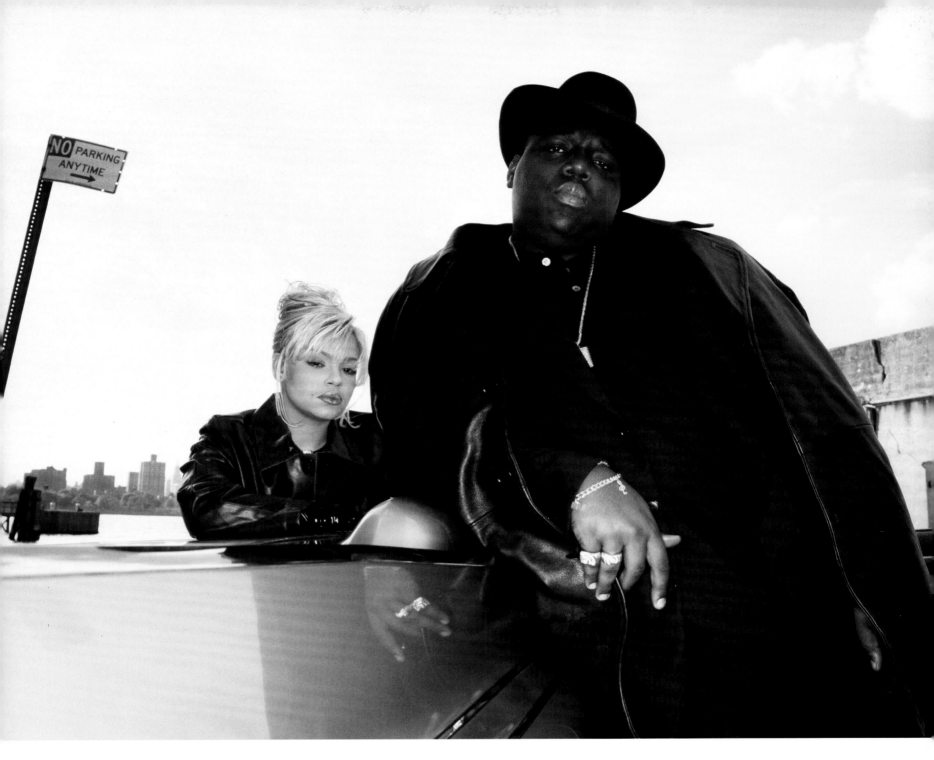

BROOKLYN, 1996

ERIC JOHNSON

BIGGIE SMALLS AND FAITH EVANS

"*Vibe* magazine's photo editor, the late George Pitts, really believed in my instincts to create something iconic. He told me that people were really starting to notice my work as a photographer and that it was time for me to shoot a cover. George gave lots of young photographers their first opportunities, and had this way of making you feel very confident about your work. He and the team at *Vibe* left the concept to me. I wanted it to have a classic cinematic sensibility.

"Big and Faith were married, and you know, living in this crazy world and going through stuff. I thought it would be interesting to shoot them like a classic Hollywood couple.

"I found this remote location on the docks of Brooklyn. When Biggie first saw it, he was like, 'This is where they dump the dead bodies. This is where they dump the dead bodies.' He really kept going on about that, you know? Everyone else was scrambling around getting work done, but he was really obsessed with that idea.

"I like the moodiness of this shot, and something about how they're leaning back and staring. It's just very mesmerizing. All the shots show different aspects of the way they were together and the way they felt for each other. It turned out to be this incredible human moment with the two of them."

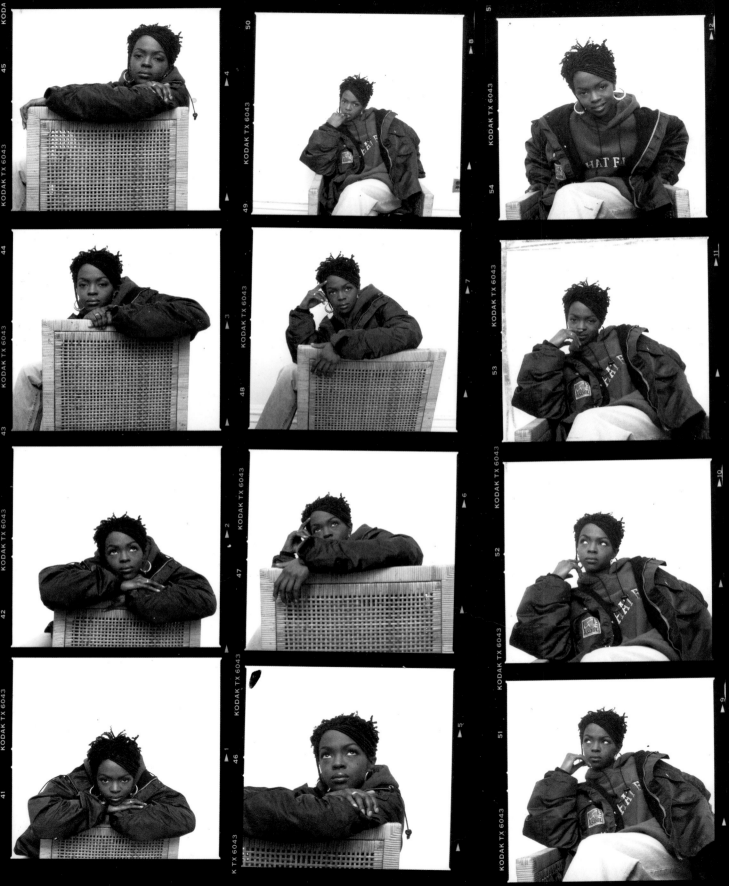

JAYSON KEELING

LAURYN HILL AND THE FUGEES

"These were photos for *The Source* as Lauryn and the Fugees were about to release their album, *The Score*. We shot at my house in Fort Green. When they were coming in, there was a dead bird blocking the doorway and Wyclef said, 'Oh my God, this is a really bad omen.' But we laughed it off. Wyclef brought his sister and brother, and when he arrived the first thing he said was that he wanted to have his guitar in every frame. Lauryn wasn't feeling that great, so she was trying to chill and sleep when she wasn't being photographed. I remember I brought her tea at one point, and Wyclef started playing Jimmy Cliff's 'The Harder They Come.' By the end of the shoot, that bird in the doorway had somehow come back to life and we were all a bit shocked."

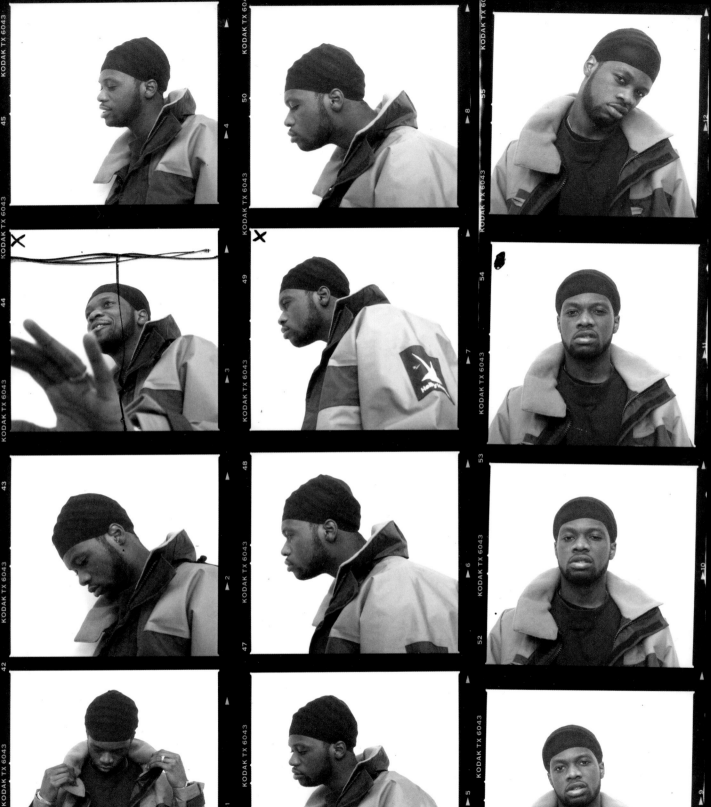

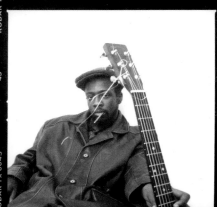
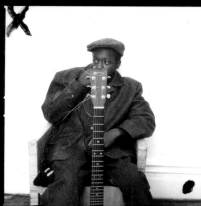
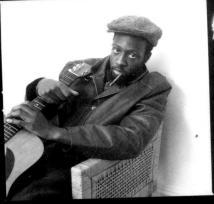

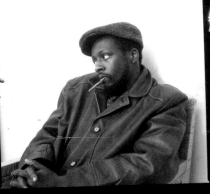

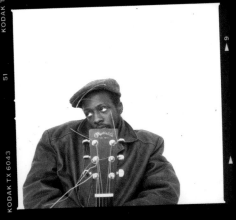

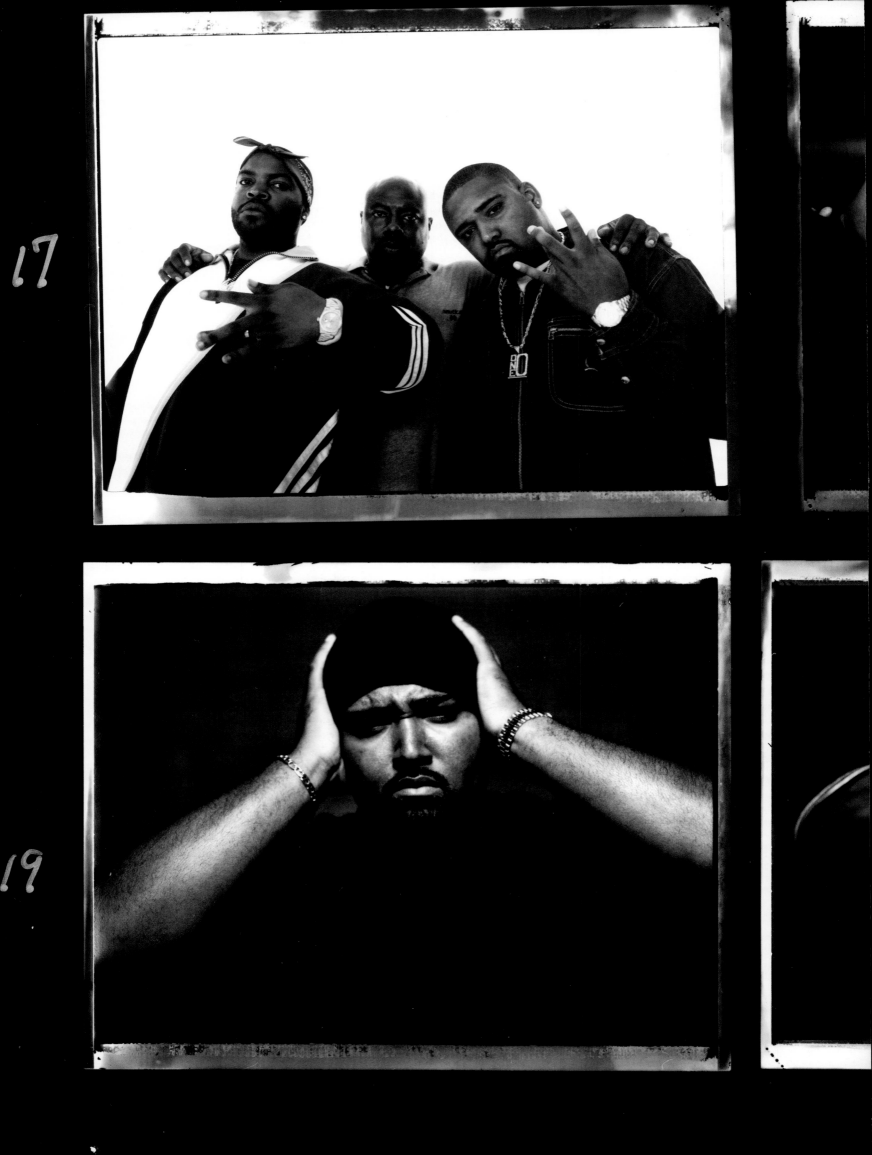

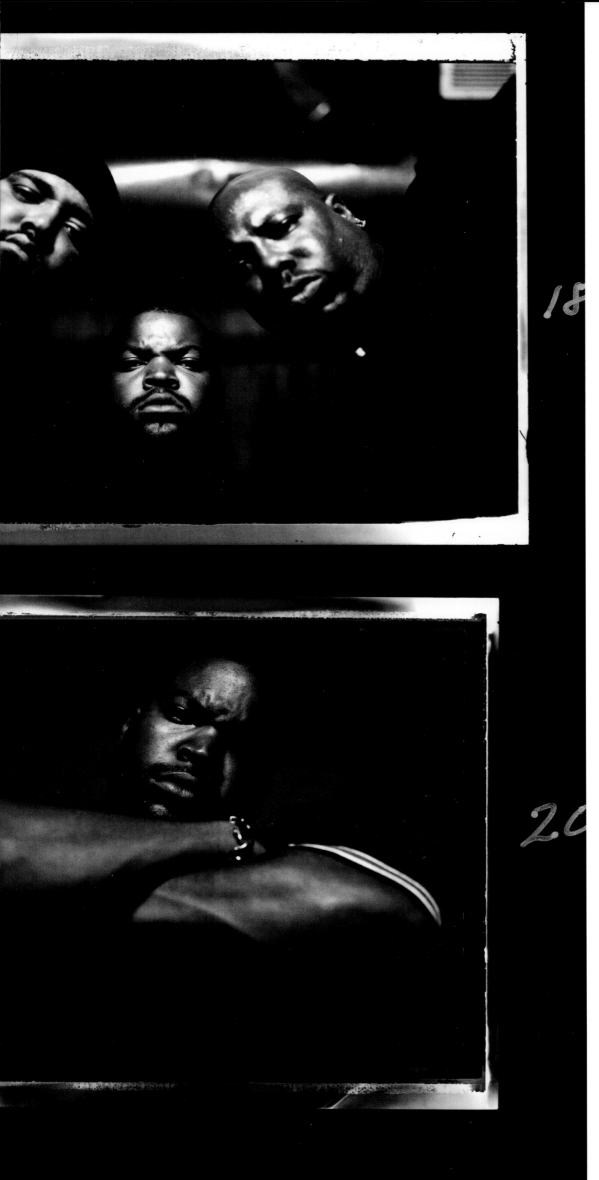

LOS ANGELES, 1996

MIKE MILLER

ICE CUBE AND WESTSIDE CONNECTION, *BOW DOWN*

"I've been photographing the West Coast hip-hop scene from the very early days, so I knew Ice Cube from N.W.A and knew what he was like to photograph. For the *Bow Down* cover, Ice Cube requested that I shoot him on a video set. Westside Connection was kind of a supergroup with Cube, WC, and Mack 10. All three of them were amazing to photograph. I captured this with Polaroid 665 negative film, but the actual cover was taken with a Maimya 7 film camera. The image of Cube with his arms folded just has this quiet power to it. He had been at the center of a lot of important moments in hip-hop, and he was one of those artists where you see his experiences all come out in the pictures. As portraits, these images convey the focus and strength of three powerhouses of West Coast hip-hop."

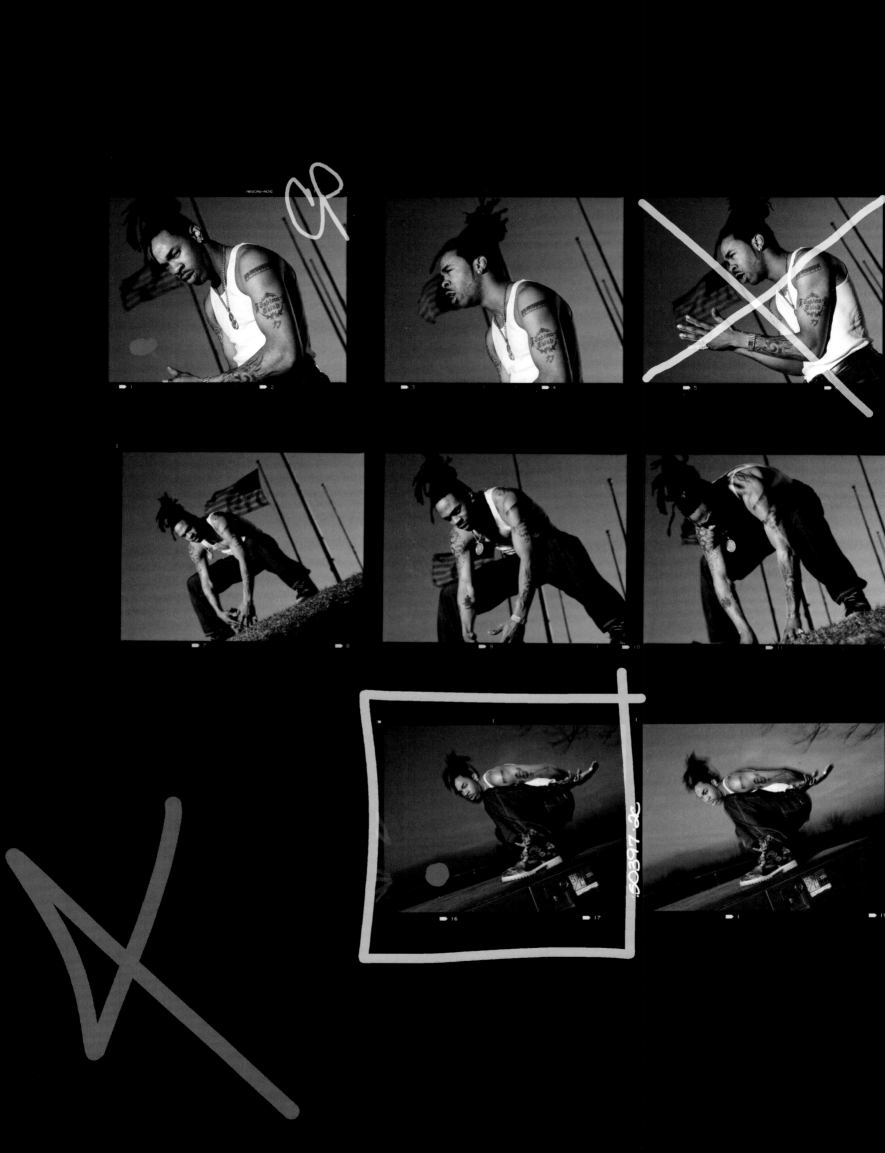

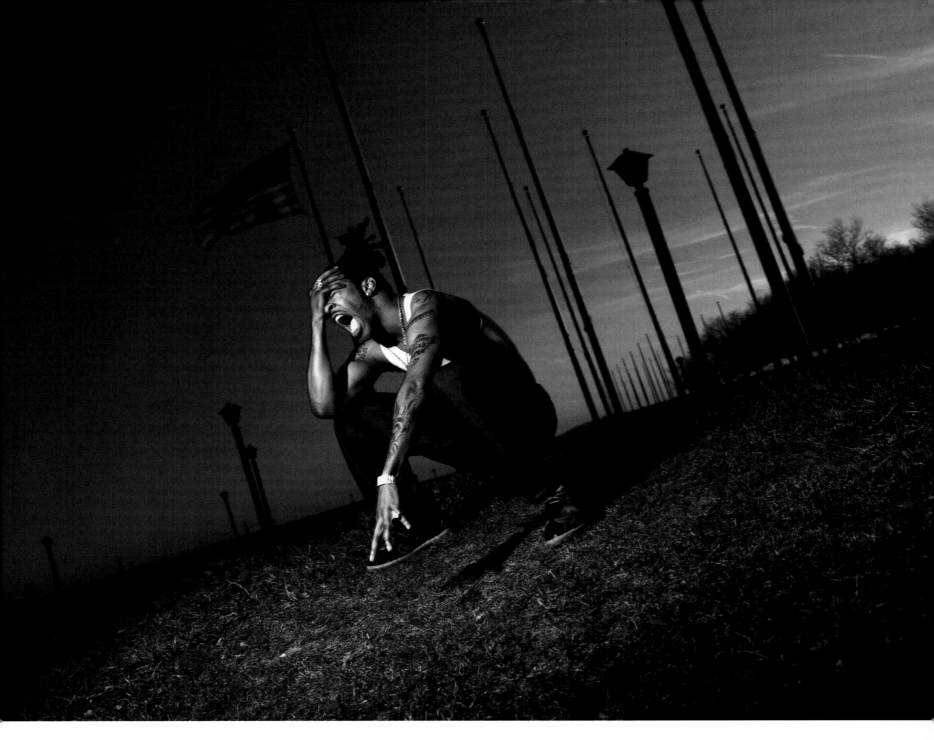

NEW JERSEY, 1997

CARL POSEY

BUSTA RHYMES

"Being from California, I always loved to photograph near the water. Something about it made people feel more free and took them away from the hustle and bustle of the city. I took Busta to Liberty State Park for this shot, and I love the way it feels slightly eerie, slightly deserted, and Busta has the flag behind him. He has his hand on his head and is giving out this scream. It's like a scream into the void of the landscape. I didn't really have to tell Busta how to pose or anything. He was very calculated and confident with his image and pose. I was somewhat surprised by how he just came up with the power that made for these images. Some people just know what they gotta do in front of the camera."

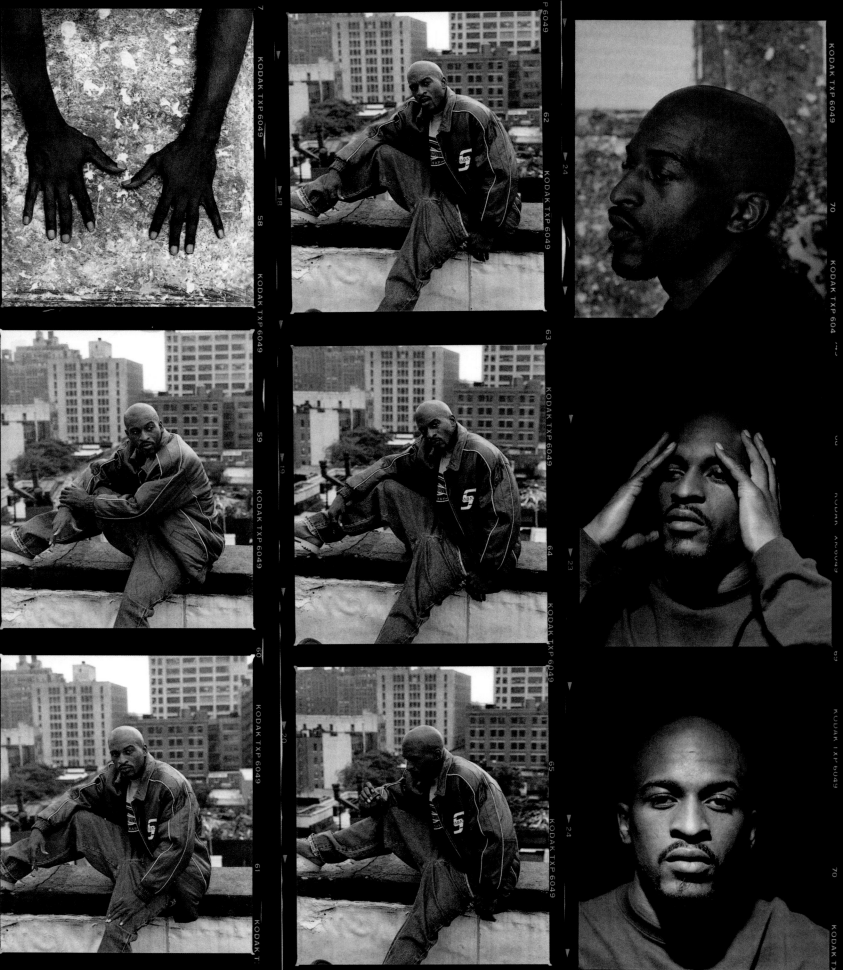

NEW YORK CITY, 1997

ADGER COWANS

RAKIM, *THE 18TH LETTER*

"Rakim and I got along right away. He had a strong character and we talked about history and life. I really liked his mind. He was also very masculine. I have three brothers and I grew up around a lot of uncles and other men, so I really understood that energy Rakim was giving. It was important to me to get some of that energy onto the film.

"I thought Rakim had a great profile, so that's what I concentrated on capturing. Using a Mamiya RZ67 and a Nikon with strobe lights, I put him against this door that was very beat-up. I also thought his hands were something to photograph.

"I'm proud to have made these images of someone who is such an important part of hip-hop. Photography added imagery to the hip-hop movement, and showed fans who these artists really were."

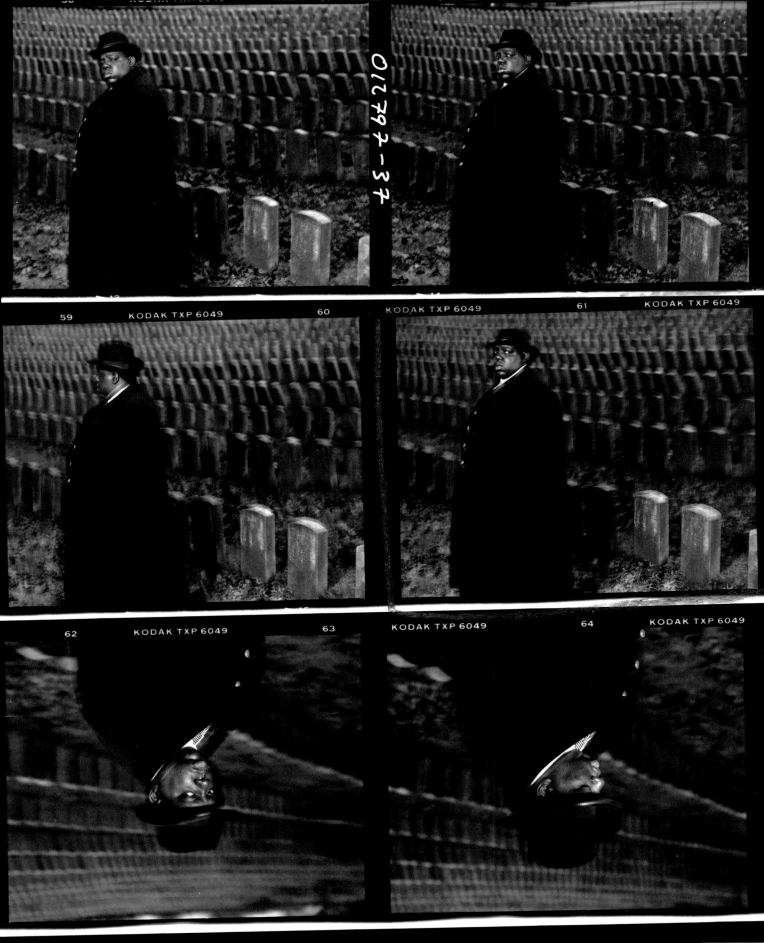

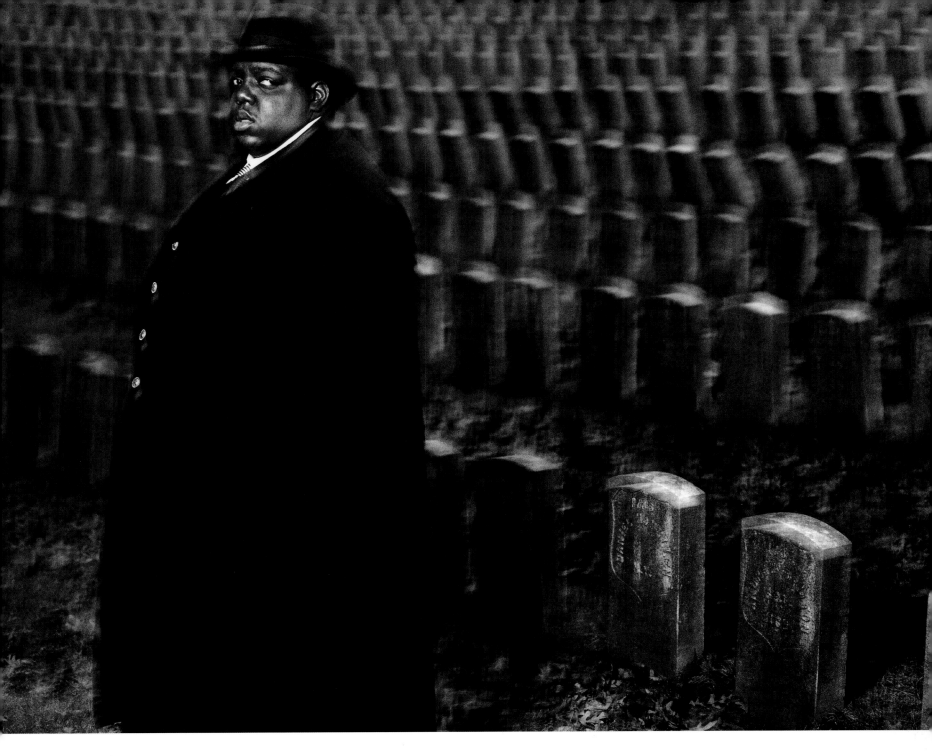

QUEENS, 1997

MICHAEL LAVINE

BIGGIE SMALLS, *LIFE AFTER DEATH*

"The shoot took place at the Cypress Hills Cemetery in Queens, with Biggie wearing a long black coat and black bowler. He looked very ominous, and this image feels like a Hitchcock portrait or something. Biggie brought a huge entourage—bodyguards, multiple SUVs. The graveyard where we shot was so big that we had to use an SUV to get up the hill to where we got this image. Puffy was in the front seat; Biggie was in the back. An Elvis song came on and Puffy was like, 'What the hell is this crap?!' Then Biggie was like, 'Elvis was *cool*.'

"Biggie had a cane and was hobbling around that day, so it took him a minute to get over to the tombstones. I had him stand in in front of a hearse with the license plate changed to 'B.I.G.'

"Biggie died six weeks later and this image became the cover shot for the double album *Life After Death*."

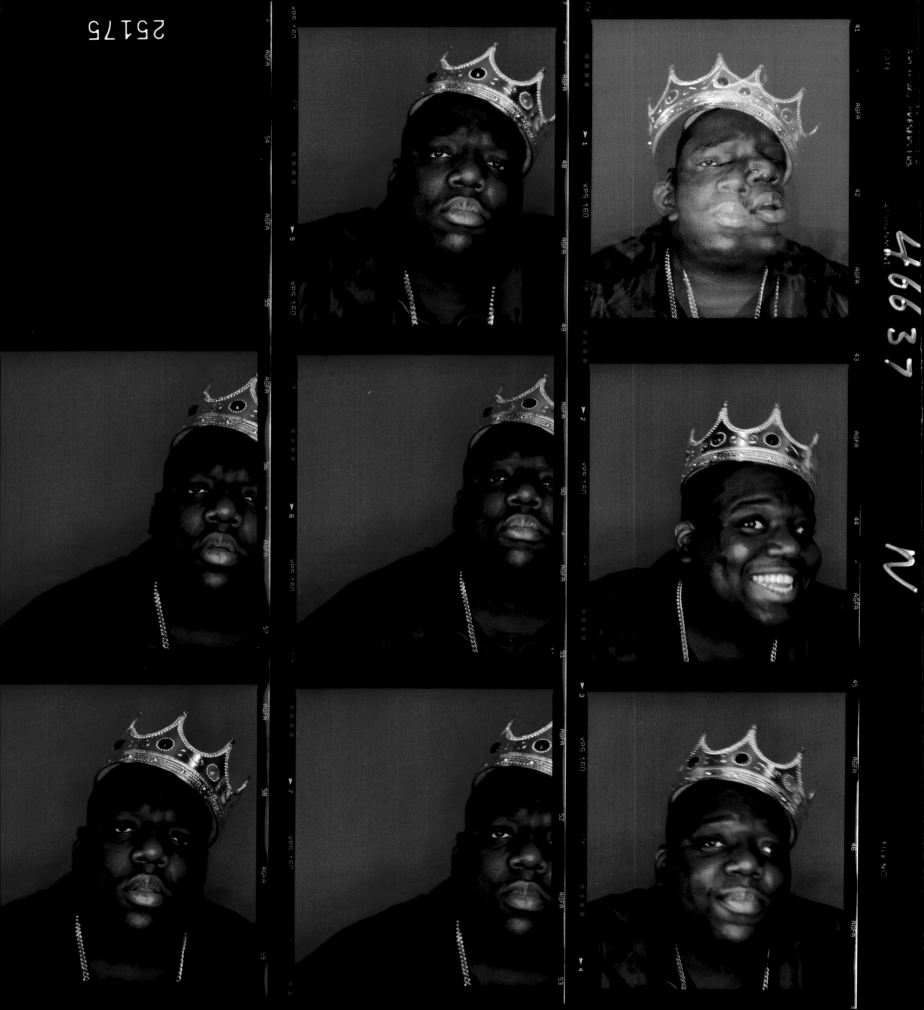

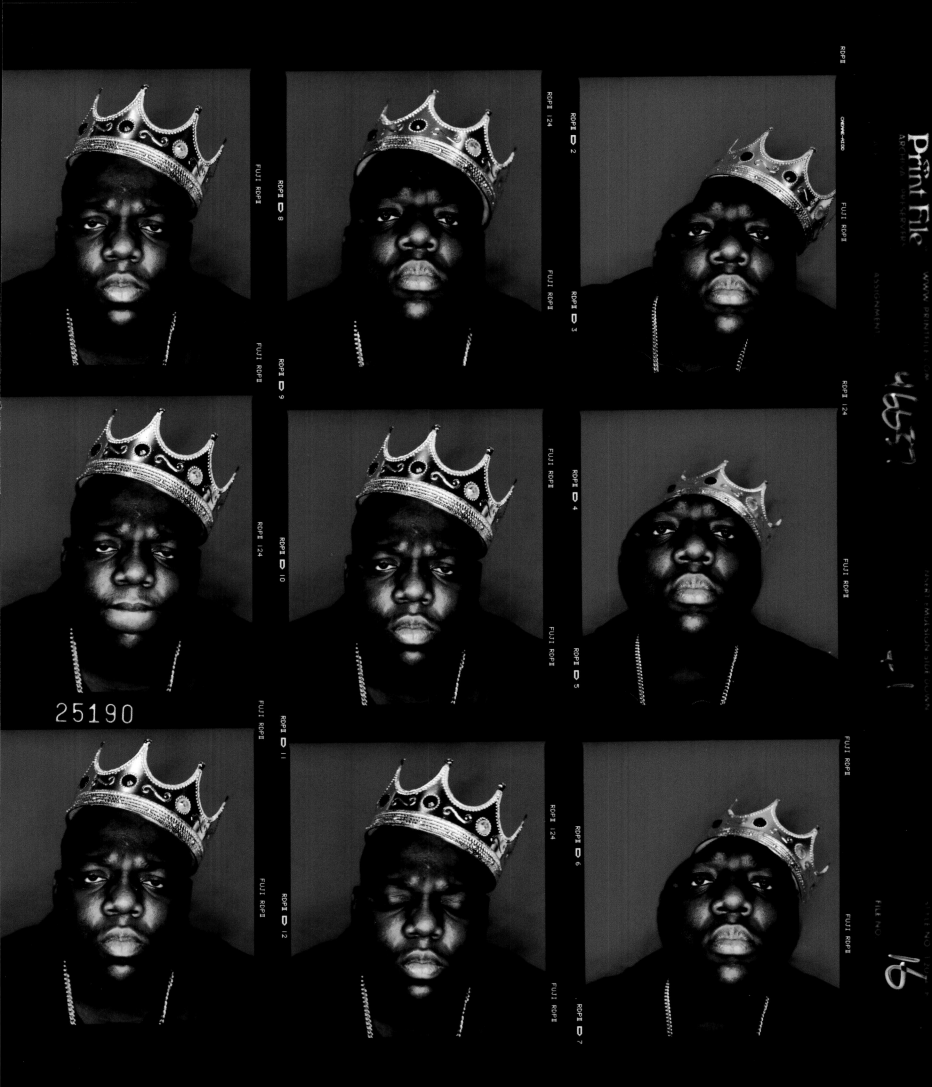

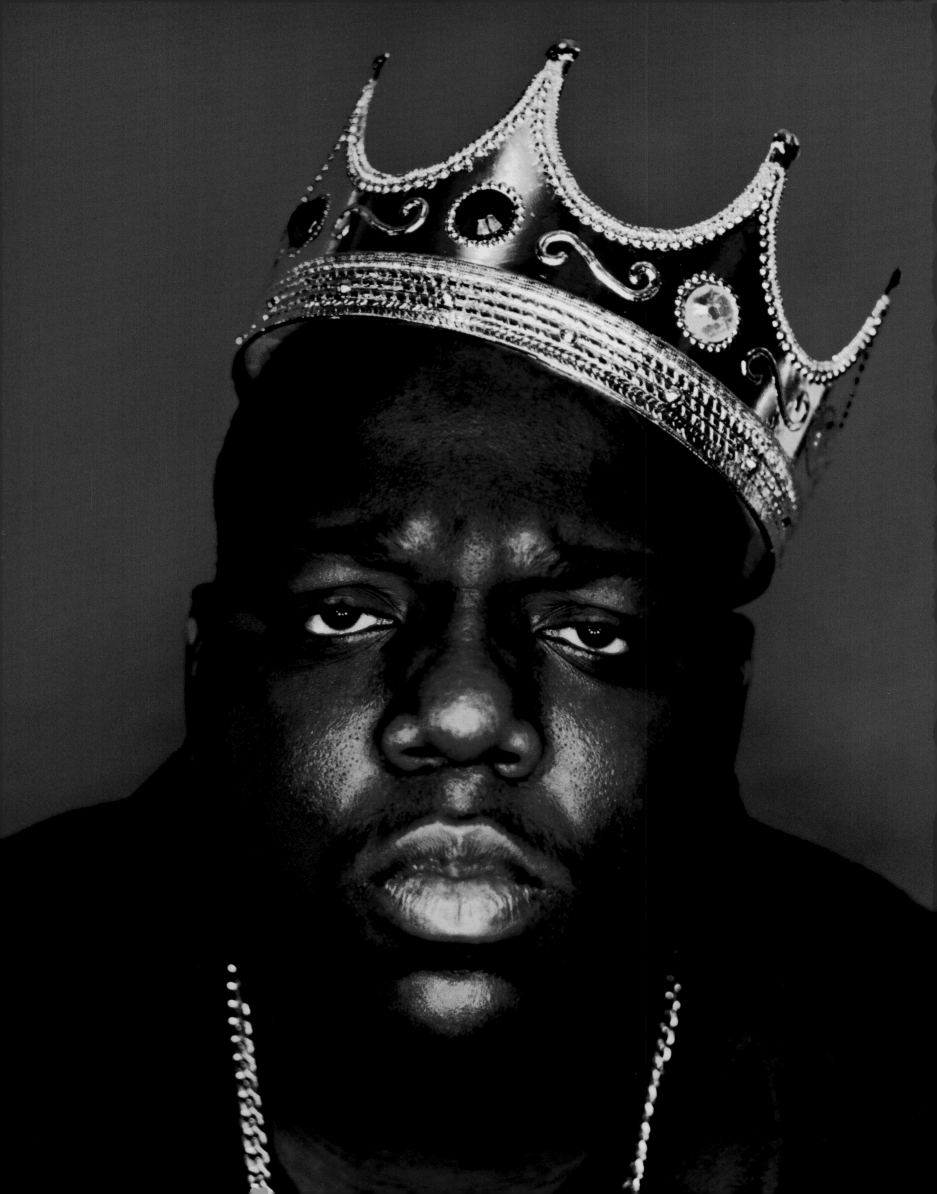

BARRON CLAIBORNE

BIGGIE SMALLS, "KING OF NEW YORK"

Renowned photographer Barron Claiborne's "King of New York" photo has become one of the most recognized images in all of hip-hop as a symbol of greatness, remaining one of the most iconic representations of the genre's proliferation into American visual culture. The contact sheet, especially the one with the rare smiling Biggie, is a de facto holy grail of contact sheets.

Notorious B.I.G. arrived at Claiborne's studio at 100 Greenwich Street near Wall Street. Biggie, accompanied by Sean "Diddy" Combs, Lil' Cease, stylist Groovey Lew, and a few others, was "open to whatever" Claiborne had in mind for the photo that day. Claiborne, working on a commission for the cover of *Rap Pages* magazine, had his idea ready. The self-taught photographer wanted to portray Biggie as a king—the King of New York, to be exact.

Biggie left Claiborne's studio that day and headed straight to the airport for Los Angeles. Three days later, he was killed in a drive-by shooting outside of a *Vibe* magazine party at Petersen Automotive Museum in Los Angeles.

"I had already photographed Big one time before, in a white suit for *Rolling Stone* magazine. I generally didn't shoot a lot of rappers because the aesthetic wasn't my thing. For this shoot, I told Big's team that I wasn't interested in photographing him if he was just gonna show up wearing sweatpants. At the time, hip-hop images were pretty stereotypical for the most part. I have no interest in negative portrayals of black people or showing people at their worst. Even if it was real, that shit bores me. Most black people are just living their lives, and most of the hip-hop imagery showed people in Jacuzzis, imagery made for teenage boys—but not this one. This photo is about hip-hop but it's also beyond that. This was simply about photographing Biggie as the King of New York. He is depicted as an almost saint-like figure. This shot is *the* shot and it's iconic. I still have the crown, too.

"The symbolism of the crown was meant to convey greatness and something bigger about hip-hop and this man who had made it to the top of his game. I used to love Richard Avedon and Irving Penn and how disciplined their photos were, so I really planned out this photo and I had a definite vision for what I wanted. So when I shared the concept with Big's team, they were up for it, but still we had a few challenges during the shoot.

"Every time I thought of Biggie, I always thought of him as a big West African king, but Puffy wasn't so into it, he kept saying that he worried Big looked like 'the Burger King.' Big was laughing it off and was trying to reassure Puffy that it was a cool concept, and everyone finally got on the same page. Groovey Lew was the stylist and responsible for Big's look, and he also was an important part of this day. I used a Mamiya RB67 with Fuji film, and I cross-processed the film. From the contact sheet, I chose the one photo I thought was most poignant. The images are all pretty similar. I usually don't give photo editors a lot of choices.

"A few days after Biggie died, someone called to tell me that the image was being carried throughout Biggie's funeral procession in Brooklyn. That was meaningful to me. It meant people perceived this image as representative of Biggie. When people die young, as Biggie did, they are mythologized through imagery. As a photographer, to have a photo that everybody knows is rare. It's so different from my other work that many people don't realize I even took that photo.

"I'm proud of the image. There are so many images of black people, rappers or not, that you don't see in American culture. You rarely see them as regal. When you see something different, you embrace it. The fact that he died made the symbolism stronger. He had to die for this image to have that symbolism. The king sacrificed. But Biggie has the crown."

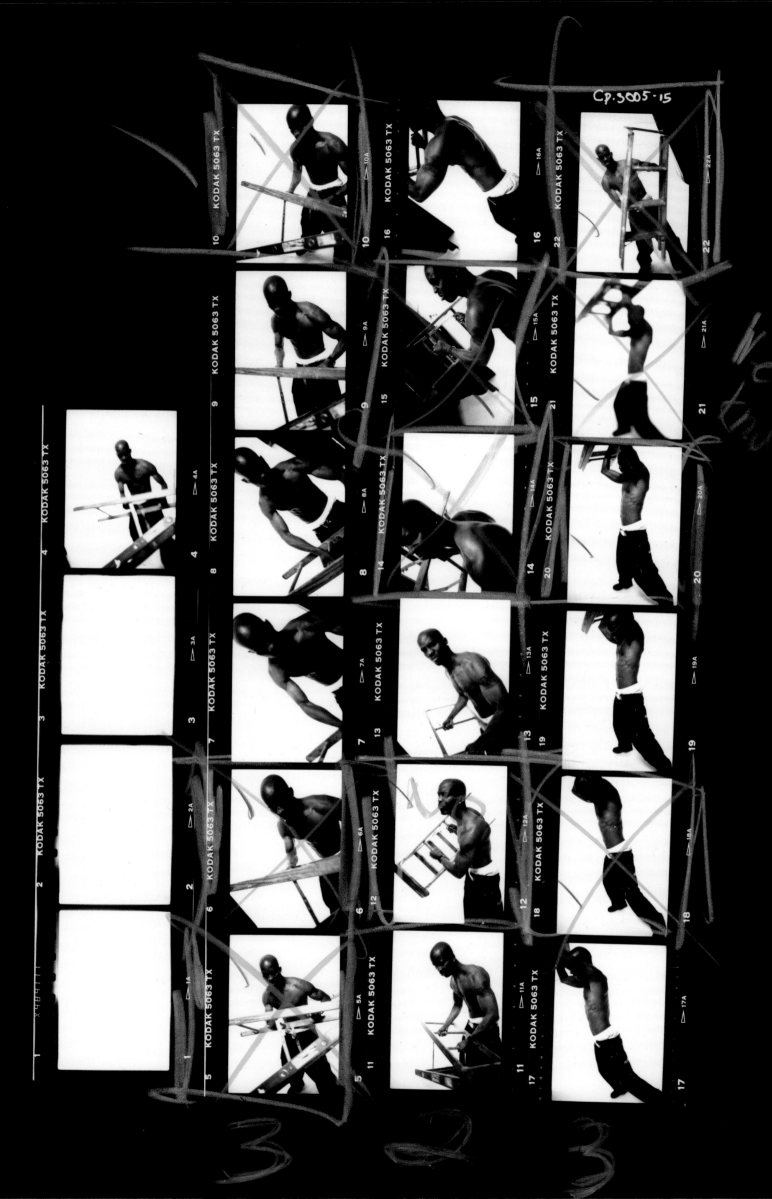

CARL POSEY

DMX

"DMX was already famous on the streets and known for being part of Ruff Ryders when New York radio station Hot 97 commissioned me to shoot this portrait. He had become a bit of a rock star and brought this energy into a space whenever he stepped into it. For the shoot, I knew I was going to have him against a simple white backdrop so we would have room to play and experiment. He came in very energetic but the shoot went in and out of this super-high-energy feel, so we just went with it. Neither of us liked the shirts the stylist brought, so we decided to shred the shirt and that turned the energy up even higher. The frame with his arms out was taken during a pause in that high-energy shooting. Often, when you pause, you can get that shot that's quiet but also has an energy."

JAMIL GS

THE FIRM

"The Firm was like this hip-hop supergroup. All three of them—Nas, AZ, and Foxy Brown—had reached a level of success by this time, so getting the three of them together was a real challenge. AZ was an hour late, Nas was an hour late, and Foxy was even later, like hours and hours, so I decided to work with AZ and Nas first and got some individual shots. I remember Nas was wearing this big 'QB' (Queensbridge) medallion.

"I shot this at a Sony Studios soundstage. I was always really inspired by the Blue Note albums, so I used filters for the lights and also added a filter on the lens, and that gives it the red tone. When you apply red filters to black-and-white photos in particular, it does something really magical to skin tones."

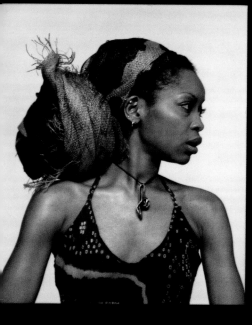
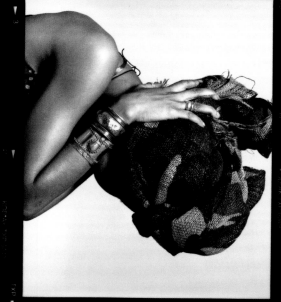
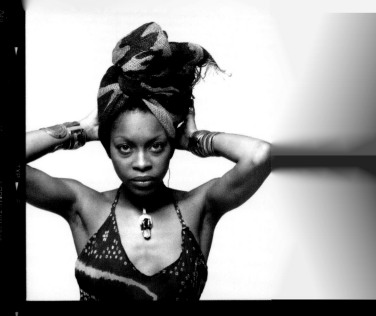
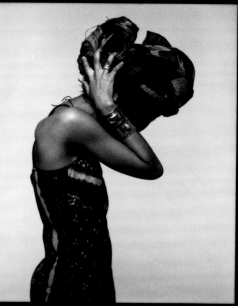
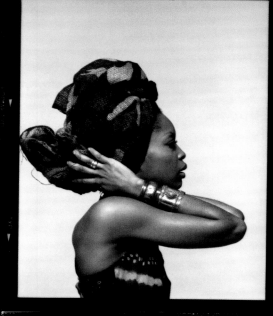
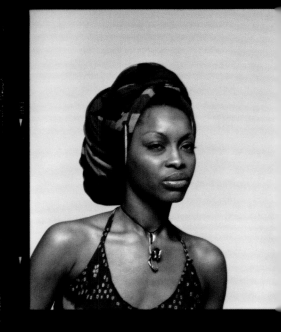
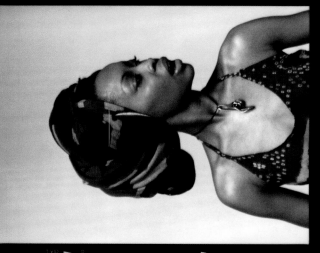
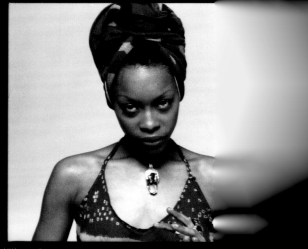
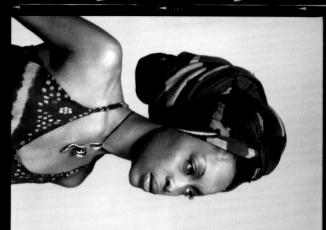
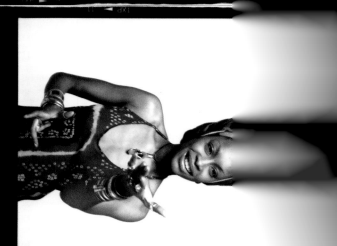

MARC BAPTISTE

ERYKAH BADU, *BADUIZM*

"Erykah was living in Brooklyn at the time and I used to see her in the neighborhood after she got signed by Kedar Massenburg, who was a friend of mine. He had me listen to her music and eventually I was brought on to shoot the cover. Photographing Erykah is never a straight line, she is so creative. Erykah is methodical and she thinks about everything from A to Z. Since this was her first album, she was all about the music and especially intent on making a powerful visual to go with it. She wanted a cover image that would make people pay attention, so we collaborated with then stylist Andrew Dosunmu. Back in those days she always rocked the head wrap, and that's how we settled on the profile shot for the cover. When you have someone like Erykah, you have to include them in the creative process. She sticks to what she likes, and she fought for that specific shot to be the cover image. She showed beauty in a whole different way."

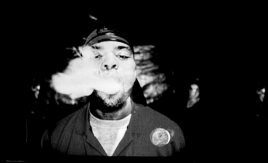
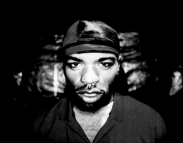
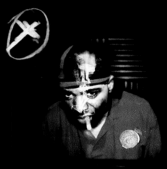

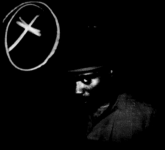

14855

NEW YORK CITY, 1997

JEROME ALBERTINI

METHOD MAN

"*Trace* magazine was a startup English magazine that was beginning to get traction in New York. They had a very stylized way of shooting and asked me to photograph Method Man. I met him at the studio when he was recording solo. It was a very low-key environment—just him, the engineer, and a few other people. I walked around and found a simple wall where we could do a tightly cropped portrait. You don't really have to tell Method Man to do anything when the camera is out, he knows how to play with the image and have fun with it. He came strolling up with a big blunt in his hand and I told him that we should use the smoke to create a really intense, moody visual. I shot with a Pentax 6×7 camera using slow-speed film and an open flash. The blur of the flash created these mesmerizing visuals with the smoke."

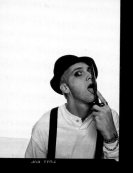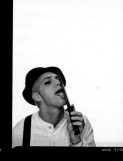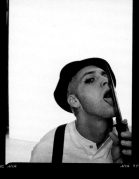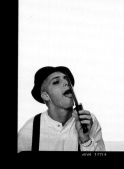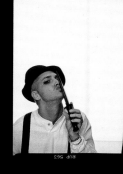
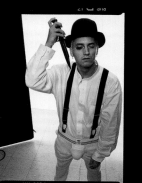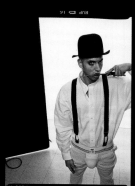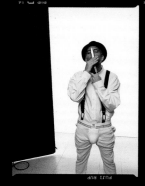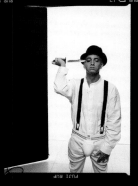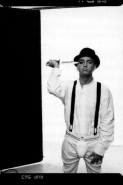
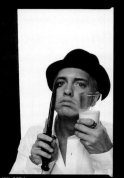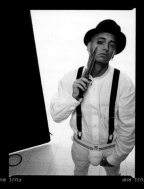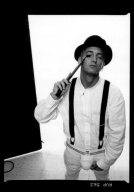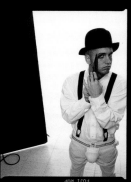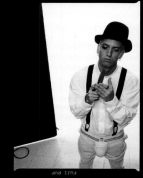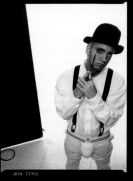
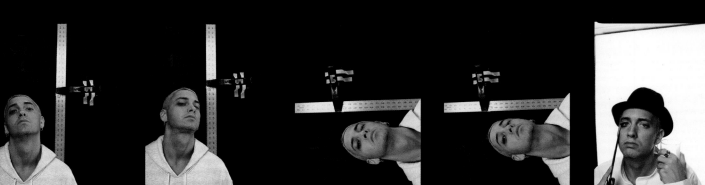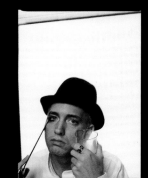

JUS SKE SALGUERO

EMINEM, *STRESS* MAGAZINE COVER SHOOT

"Davide Sorrenti was a big photographer who passed away around the time of this shoot. He was my best friend, and I had gotten into photography through him and his brother, Mario, who was also an amazing photographer. I was more into music and DJ'ing, not photography, but I got this commission for *Stress* magazine and thought it was a great opportunity. We dressed Em up as the protagonist Alex from the film *A Clockwork Orange*. The concept was a dis to a rival white rapper, Cage, who was then known for his song 'Agent Orange,' which references the film.

"Many years later, this was used for a *Spin* cover as well. The outtakes were stored away in a shoebox for years until I had them archived recently. When I look at the outtakes, I always focus on the one thread coming out of his hat that I never Photoshopped out. I was kind of new to this, and I thought maybe it was cheating to fix that afterwards."

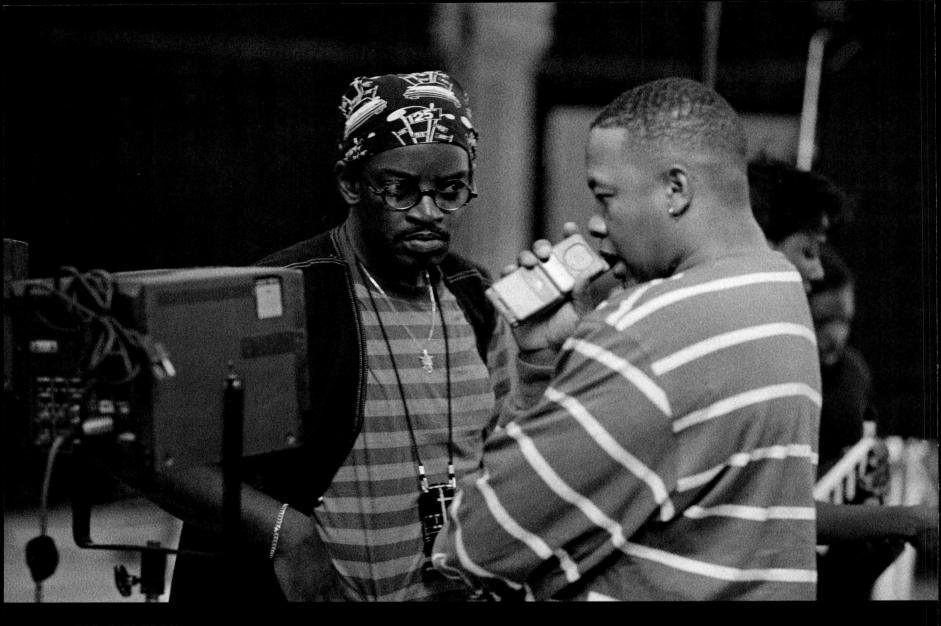

END OF THE GOLDEN ERA

I grew up in a house filled with books, newspapers, and magazines—analog content of all kinds. We had subscriptions to all the major names like Life, Time, Newsweek, Look, The New Yorker, Popular Science, Esquire, *and of course,* Ebony *and* Jet. *My dad was an intelligent, curious guy who followed current events, global politics, cultural goings-on, and music, especially jazz, and those traits rubbed off.*

I remember my dad had a cherished vintage copy of *Esquire* that he and his friends would often pull out and discuss. There was a two-page spread of a photo that would come to be called "A Great Day in Harlem." My dad and his friends would pore over this photo of several dozen top jazz musicians all posing in front of a townhouse in Harlem. They'd marvel at how incredible it was that these important musicians were all together at the same time for this picture. Like a game, they'd excitedly call out every name in the photo. "There's Thelonious Monk, standing next to Mary Lou Williams,

that's Lester Young, and look at Dizzy." Now it's like magazines barely exist anymore because technology has transformed so much—and that smartphone in your pocket, that's one of the main reasons digital dominates.

Because of all that info around me growing up, I had a keen sense early on of what was going on in the world, and even before I could fully comprehend all the written words, I'd look at those pictures again and again. Like the classic adage, pictures for me were worth way more than a thousand words; I'd say ten times a thousand for my inquisitive self,

As a young Bed-Stuy, Brooklyn, teen navigating the rough and raw New York streets in the '70s, I began to follow the mobile disco DJs who would inspire the creation of hip-hop music. Little-known names like Grandmaster Flowers (the original grandmaster), Maboya, Plummer, Pete DJ Jones, and many others were underground street stars drawing thousands of cutting-edge inner-city youths to their park jams, block parties, and self-promoted disco events. By the late '70s, hip-hop music was getting stronger in the streets, led by popular DJs and their rapper sidekicks. City-

wide, hood stars were emerging and the news was spreading through the word-of-mouth grapevine.

As the Sugar Hill Gang, Grandmaster Flash and the Furious Five, Funky Four Plus One, the Sequence, Treacherous Three, and Kurtis Blow began to release records that made an impact on the charts and on ears outside of the city, the first hip-hop coverage in print began in black teenage pop-music mags like *Right On!, Word Up!*, and *Black Beat*. These magazines were mainly filled with color publicity photos from labels and articles akin to press releases. Most journalists saw budding hip-hop culture as a passing fad soon to fade away. But I felt deeply, early on, that this was beyond a fad or a trend—and was determined to play a part in proving it.

I'd been plotting and planning my assault on popular culture in the late '70s, focusing on transitioning my graffiti painting ideas onto canvas, then into galleries, museums, and ultimately becoming a serious artist. I was also closely watching the emergence of the punk rock and new wave movements, and seeing the massive coverage these movements were getting in the press and "zines." One of my more successful ideas was to put all of this in a movie, thinking it would validate graffiti artists, DJs, rappers, and break-dancers as real creative artists by cinematically changing the perception. This led to me connecting and collaborating with Charlie Ahearn on what became hip-hop's first feature film, the cult classic *Wild Style*.

The Lower East Side was my stomping ground, and to promote the coming release of our film in 1982, the *East Village Eye*, one of the neighborhood's prominent counterculture publications, decided to do a big story on what was happening with the film and the culture that inspired it. They published several articles, including a cover story, getting into the fashion, the music, the dancing, and the graffiti art featured in the movie. In fact, it was the first time the term "hip-hop" was used to describe this new movement—and just like that, hip-hop journalism was born.

Ten years later, in the early '90s, hip-hop was like a cultural revolution unleashed, raging globally. My show, *YO! MTV Raps,* was getting record-breaking ratings and turning millions on to this exciting new phenomenon. To learn more about what was happening in hip-hop, you ran to your local newsstand to grab the latest copies of *The Source, XXL, Rap Pages, Stress,* and *Vibe*. You'd spend quality time turning the pages, absorbing all of the content, and soaking in those pictures, scanning every detail closely as you looked at them again and again. Young urban people of color, who were loud, proud, black, and bold, in new styles of clothes, jewelry, and sneakers, were very far from the norm, and you had to look long and strong to adjust to the radical newness of it all.

Until recently, serious photographers like those whose work you see in this book went to professional photo labs like Duggal or Modernage here in New York City to have their exposed film developed. An employee would hand you a legal sized envelope with your negatives and contact sheets full of rows of smaller examples of the photos you shot. With anticipation throbbing, you'd pull out the contact sheets to see what you got for the first time. If you got it right, maybe one, two, or a few photos would illustrate an article soon to be published. But the rest of the dozens of shots taken would often never be seen again.

One of those photographers is Lisa Leone, a longtime friend whose shots of me on the set directing Snoop's first video—for "Who Am I? (What's My Name?)"—catalogued a project I'd spent nearly that entire summer trying to finish after gang violence broke out the first day of the shoot. Police helicopters (ghetto birds) swooped in, hovering overhead, and they shut us down—forbidding the video to be shot in Snoop's hometown of Long Beach. Lisa hung in there for a couple of weeks, her first time in LA, and later caught the shot of me pensively looking at Dr. Dre, waiting for his feedback to a scene I'd just shot and was showing him on the video monitor. I also asked Dre when Snoop would show up for other important scenes I needed to shoot. Dre let me know he liked the scene I was showing him and he also told me Snoop had gotten caught up in a "187," L.A. slang for a shooting, and was laying low. Eerily like the title of the song Snoop would soon release, "Murder Was the Case." Trust me, I was numb when I heard that news.

My connection with the beginnings of hip-hop in France are one of the most exciting chapters in my creative life. Right there as it all went down in Paris and New York City was another photographer, Sophie Bramly, a North African–born, French-raised hot girl in the mix with a camera. The shots Sophie took are some of the culture's rarest and least seen images. She took important photographs in the early '80s of seminal players in the hip-hop game in New York and later Paris as the culture was beginning to blossom. Her shot of me in a trench coat coming from a White Castle in the Bronx with a few "murder burgers," as we jokingly called them, is for me like time traveling, or going back to the future.

Renaissance man Gordon Parks is one of my most significant creative influences. As a youngster in the 1970s, seeing *Shaft*—the game-changing film he directed—was a transformational experience for black youth like me, because black heroes in movies simply didn't exist. I'd later learn of Gordon's forever dapper elegant swagger, his writings, his music, and his groundbreaking photography of the black American experience in *Life* magazine and elsewhere.

In 1998, I got a call to head up to Harlem for a photo shoot. The idea was to re-create the renowned photo my dad and his friends loved so much: *Esquire* magazine's "A Great Day In Harlem." This would be the hip-hop version that ended up being a three-part foldout cover of *XXL* magazine.

When I showed up on 126th Street off of Lenox Ave. in Harlem for the shoot, there were hundreds of people on both sides of the street, buoyantly greeting and chatting with each other; the vibe was like being at a summertime block party. I was happy to see so many friends and familiar faces, innovators and giants in hip-hop culture. Debbie Harry and Chris Stein from Blondie, De La Soul, Jermaine Dupri, Ice Cube, Rakim, Luke, A Tribe Called Quest, Fat Joe, and Slick Rick who I'm standing right behind in Gordon's photo. It was a well-represented gathering of everybody from every era and everywhere, all on one side of the street in front of the original building and the buildings on either side, a total of three townhouses and the stoops filled with over two hundred members of the hip-hop family.

Across the street was the maestro, Gordon Parks, in his eighties at the time, talking to assistants who were scurrying about and relaying his instructions on a bullhorn, trying to get us to stop chatting and ogling each other and get in position for the picture. I went over to quickly introduce myself to him and humbly bowed while shaking his hand. He said he was aware of my work and had learned a lot watching *YO! MTV Raps,* then he smiled graciously as he put his pipe back in the corner of his mouth, and he went back to looking through the lens of his camera. I stood there a moment, dazed, feeling a historic chill, and getting goose bumps knowing this was a special and very rare moment, to be surrounded by so many peers and comrades while being photographed by my hero.

A few years ago, I realized my great day in Harlem was almost twenty years ago, a place I now call home. I came to the profound conclusion that Gordon's "A Great Day in Hip-Hop" marks the end of the golden era—a time frame from the mid '80s to the late '90s that gave us a constant stream of some of the most important, influential, and fundamental artists and music in hip-hop history. Everyone from Run-DMC, Whodini, and LL Cool J to Tupac, Biggie, Jay-Z, and Nas, were all born, bred, and collard-greens-fed in the boroughs of New York City. This would all change soon after, as the headquarters shifted to Atlanta, Florida, New Orleans, Texas, and other locations across the United States. Rappers from these areas now had their turn to dominate as the digital revolution rolled in hard, changing the way we access music and how we see images.

Thank you, Vikki Tobak, for taking us there, back to the golden era of hip-hop photography in all its analog glory.

FRED "FAB 5 FREDDY" BRATHWAITE is a hip-hop pioneer, visual artist, and former graffiti artist. As the original host of MTV's *YO! MTV Raps*, he was responsible for bringing hip-hop culture into the living rooms of mainstream America and around the world. His numerous projects in art, film, music, and television include *New Jack City, Juice, Who's the Man?, Just for Kicks,* and *Wild Style*, which he also produced, stars in, and composed all the original music for.

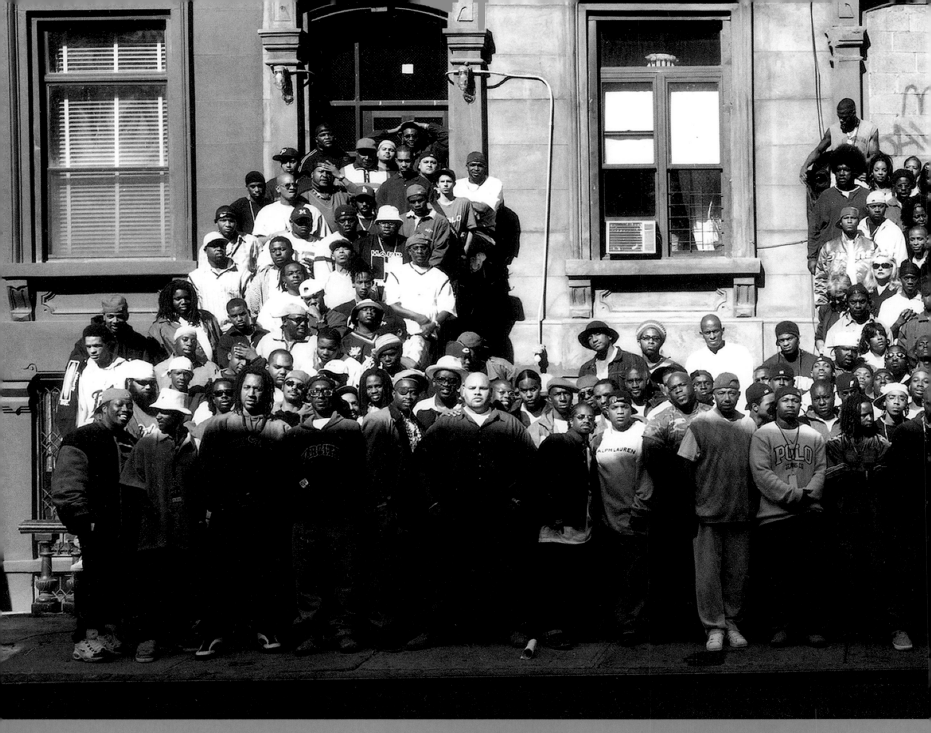

HARLEM, 1998

GORDON PARKS

"A GREAT DAY IN HIP-HOP," *XXL* MAGAZINE

On a Harlem stoop in 1998, Gordon Parks shot what would become an epic feat of hip-hop photography. "A Great Day in Hip-Hop," brought together over two hundred hip-hop artists across a foldout cover for *XXL* magazine. Rakim, the Native Tongues, Hierolyphics, Scarface, E-40, Fab 5 Freddy, Black Moon, Twista, and Pete Rock were just a few faces in the crowd. The shoot is considered a landmark event not just for the photography legend behind the camera but also for referencing a prior generation of jazz greats who also changed the course of culture. Taken at 17 East 126th Street, the photo pays tribute to the August 1958 image "A Great Day in Harlem," which showed fifty-seven jazz artists, taken by Art Kane, shot in the same location for the January '59 issue of *Esquire* magazine.

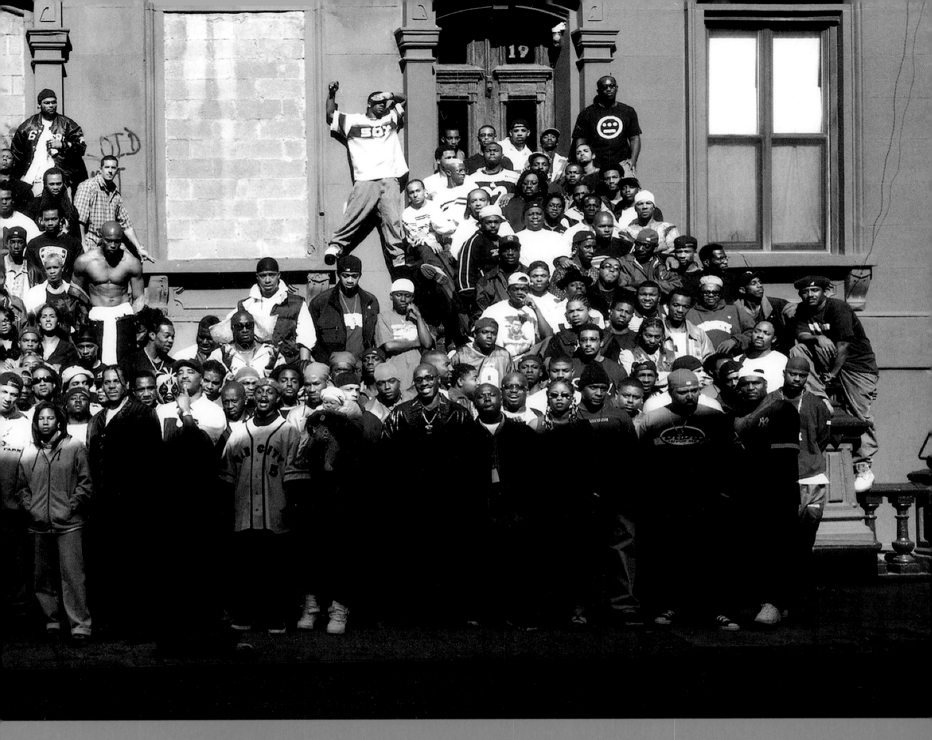

MICHAEL A. GONZALES

THE MAKING OF "A GREAT DAY IN HIP-HOP"

Forty years after the original Art Kane photograph was shot, my girl-friend, Lesley Pitts, who had recently opened her own publicity firm, came home excited one evening and told me about a meeting she'd had that afternoon at Harris Publications, the parent company of the rap magazine XXL. Under publisher Dennis Page and editor in chief Sheena Lester, the magazine had been holding its own alongside The Source and Vibe, despite launching just a year prior. "XXL wants to remake the 'A Great Day in Harlem' photograph except with rappers," Lesley said. "And they want me to work with them to do it." It all began to make sense, at least in my mind.

Like jazz, hip-hop had come from the bottom of the popular culture heap. Although jazz was once, as essayist Michael Molasky put it, "the music of choice for aspiring artists and intellectuals with an anti-authoritarian bent," by 1998 hip-hop had become the soundtrack of artistic rebellion. "So," I asked Lesley, "who are they going to get to shoot it?" She stared at me blankly, shrugging her shoulders. "Maybe they should try to get Gordon Parks," I said. Lesley smiled and her eyes got bright. At that moment, Parks, the pioneering black photographer and filmmaker, had frequently been in the public eye. As a Harlem boy born a few blocks away from the brownstone where Kane shot the ensemble of jazz musicians, I knew firsthand how much the community had changed in the forty years since the original picture was taken. That neighborhood had seen it all—from riots and blackouts to heroin and the crack years. While I originally wasn't going to attend, something told me I'd be missing a genuinely historic moment if I stayed home. Getting out of the taxi in front of 17 East 126th Street, I wasn't surprised to see that one of the brownstones was sealed up, with the windows and doorway bricked closed. Seeing Lesley talking with the head of the Fruit of Islam, the security division of the Black Muslims, I stood to the side, wondering why the street was so empty. "I thought you weren't coming," Lesley said, kissing me on the cheek. "I was afraid I might miss something," I laughed. "It's 11:00 a.m. Where is everybody?" Pointing to a massive church on the next block, Lesley explained, "That's where everybody is staying until it's time to take the picture." As I headed towards the Metropolitan Community United Methodist Church, I was suddenly overwhelmed by the excitement of the moment. Already I could see Kool Herc, members of the Wu-Tang Clan, Russell Simmons, Grandmaster Flash, Kool Keith, Pete Rock, and various mem-

bers of The Roots. I saw more familiar faces as I walked into the church's basement, including Fab 5 Freddy, A Tribe Called Quest, Fat Joe, Debbie Harry (Blondie), MC Serch, and countless others. "Everybody stopped what they were doing to be here today," Wyclef Jean observed. "That is the power of hip-hop." Over the next couple of hours, folks began to gather, often greeting one another like long-lost relations at a family reunion. Blondie producer/guitarist Chris Stein asked writer Amy Linden to introduce him to Mobb Deep. Media assassin Harry Allen was smiling widely, calling out to Daddy-O. Big Gipp from Goodie Mob was chatting with Busta Rhymes. "I don't think society thought we would make it this far," said Queen Pen, one of the few female rappers to show up. "I think they thought we were going to come in like a fad and leave." At some point, Gordon Parks showed up and the rappers and other folks started moving towards the next block. Russell Simmons and Nelson George helped direct the crowd of over a hundred artists towards the three door-ways, while I went and sat on the stoop behind where Parks was preparing. Rakim told me years later, "Earlier, I had sat down and kicked it with him. Then, I just stood around and listened to him talk and watched as people showed him love. I just wanted to stand by him, bro. It was a blessing; I'll never forget that day." While most people knew who Gordon Parks was, I wondered if they understood that the soft-spoken cultural warrior who had snapped shots of Malcolm X and Grace Kelly was a regal fighter from Fort Scott, Kansas, who had come, much like themselves, from nothing and shaped himself into an icon. Though separated by a few generations, Parks understood these "kids." He knew their pain and shared their desire to be heard and seen by the masses. Parks recognized that these revolutionaries had selected rhymes and rhetoric, turntables and technology, as their

"weapons of choice" in the same way he had once chosen his camera. Suddenly, people started clapping loudly. Turning around, I saw rapper (Reverend) Run, formerly of Run-DMC, walking up the street, just in time. As the rowdiness soon turned to calm, a strange hush came over the block. As Harry Allen said earlier that day, "What this says is what I've always believed, that black culture is a continuum of black people: of our will, of our will to live and to be heard. That is what today represents. Everybody is going to get together for one picture, and what it says is, 'I was here, these are my brothers and sisters and this is what we did. We changed the world.'" Looking at the scene across the street, the three stoops covered with hip-hoppers from the East, the West, the South, and everywhere in between, I experienced a sense of pride I still can't describe. Home on the streets of Harlem, I truly felt as though I was part of that collective dream known as hip-hop. Seconds later, Gordon Parks took the shot.

Harlem native **MICHAEL A. GONZALES** has written about pop culture since the '80s. His work has been published in *Wax Poetics*, *The Village Voice*, *XXL*, and numerous other publications.

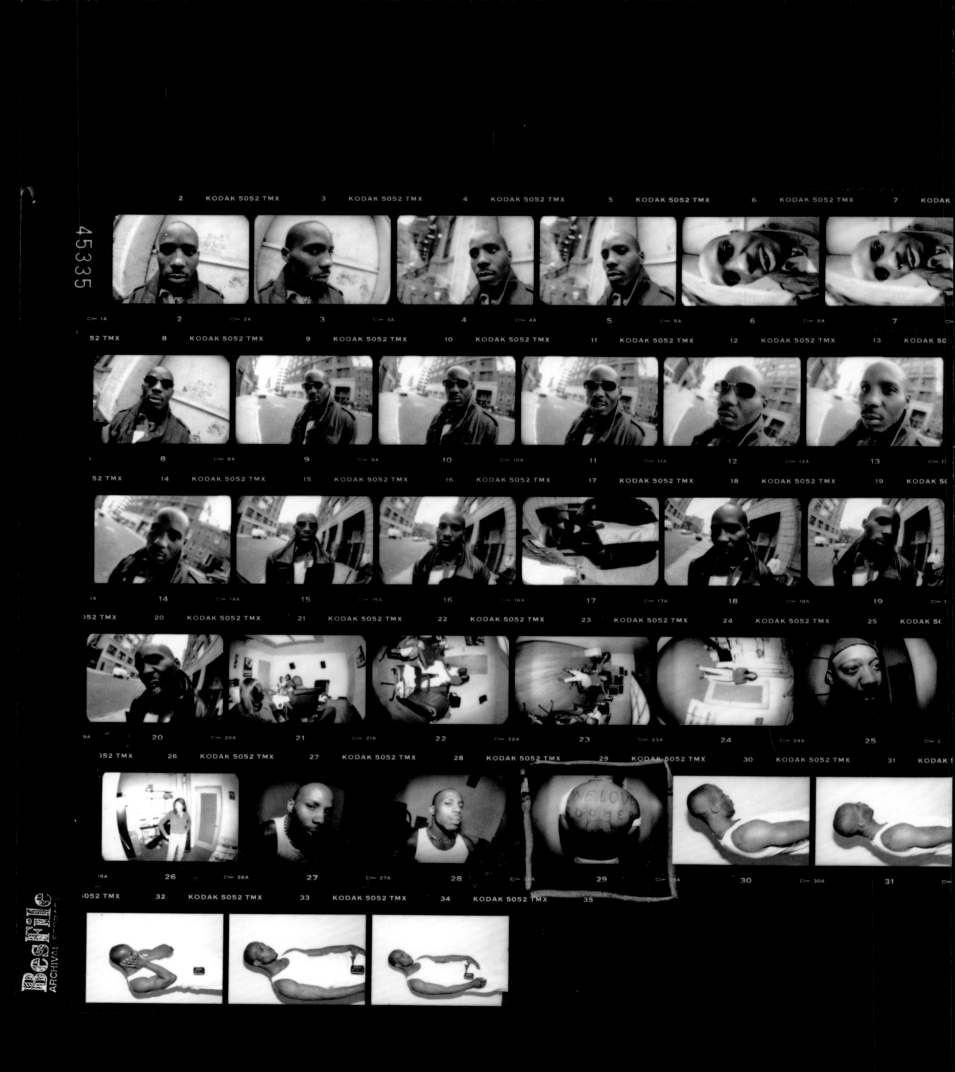

MIKE SCHREIBER

DMX

"I started my career shooting concerts and parties, and then selling the photos to hip-hop magazines. I'd been sending slides to *Rap Pages* for a few months when I got a call from the photo editor asking if I'd be interested in shooting DMX for a feature in the magazine. This was the first feature I'd ever been asked to do, and I jumped at the opportunity. 'Where My Dogs At?' was out, and DMX was the hottest rapper at the time, so this was a REALLY big deal to me.

"I grabbed my Pentax K1000, a Rolleiflex that I bought at the flea market and some film and headed down to the Def Jam office in TriBeCa. I had no idea what I was doing, but I was young and hungry so it was all good.

"When I arrived, I was told by the publicist that I'd have fifteen minutes with him. She brought me to an alley behind the office where X was chillin' with a bunch of his people from Yonkers. Everyone was just hanging out, not concerned with any photo shoot, and all I could think about was that I only had fifteen minutes! Without thinking, I announced that I needed everyone but X to go to one side of the alley.

"You could've heard a pin drop. Everyone was just staring at me, trying to figure out who this skinny white boy, telling them where to stand, was. (Insert uncomfortable laughing emoji.)

"Thankfully, X told everyone it was cool and to clear the area so we could get some flicks. At one point, he lifted his shirt so I could get a shot of the tattoo on his back. It was a portrait of a pit bull with the words 'One Love Boomer' written over it. He told me it was a tribute to his dog Boomer who'd been run over and killed by a truck. To be honest, it looked more like it had been carved rather than tattooed.

"When we were done, the publicist turned to me and said she couldn't believe I said that to them. I said, 'You told me I only had fifteen minutes!' In my mind, that was my big shot and I wasn't about to blow it!

"The funny thing is, I ended up spending a few hours with him in the recording studio that night, got some great pictures, and successfully completed my first assignment."

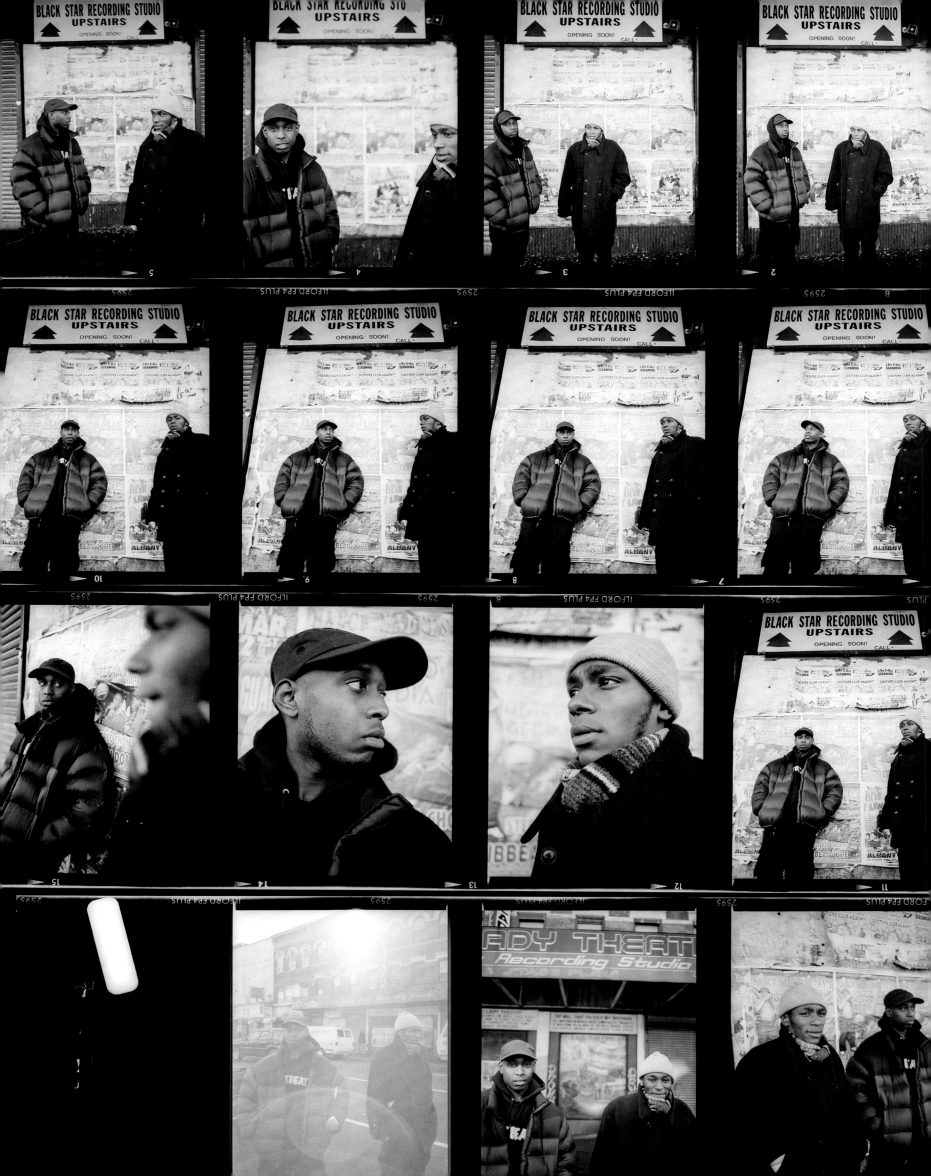

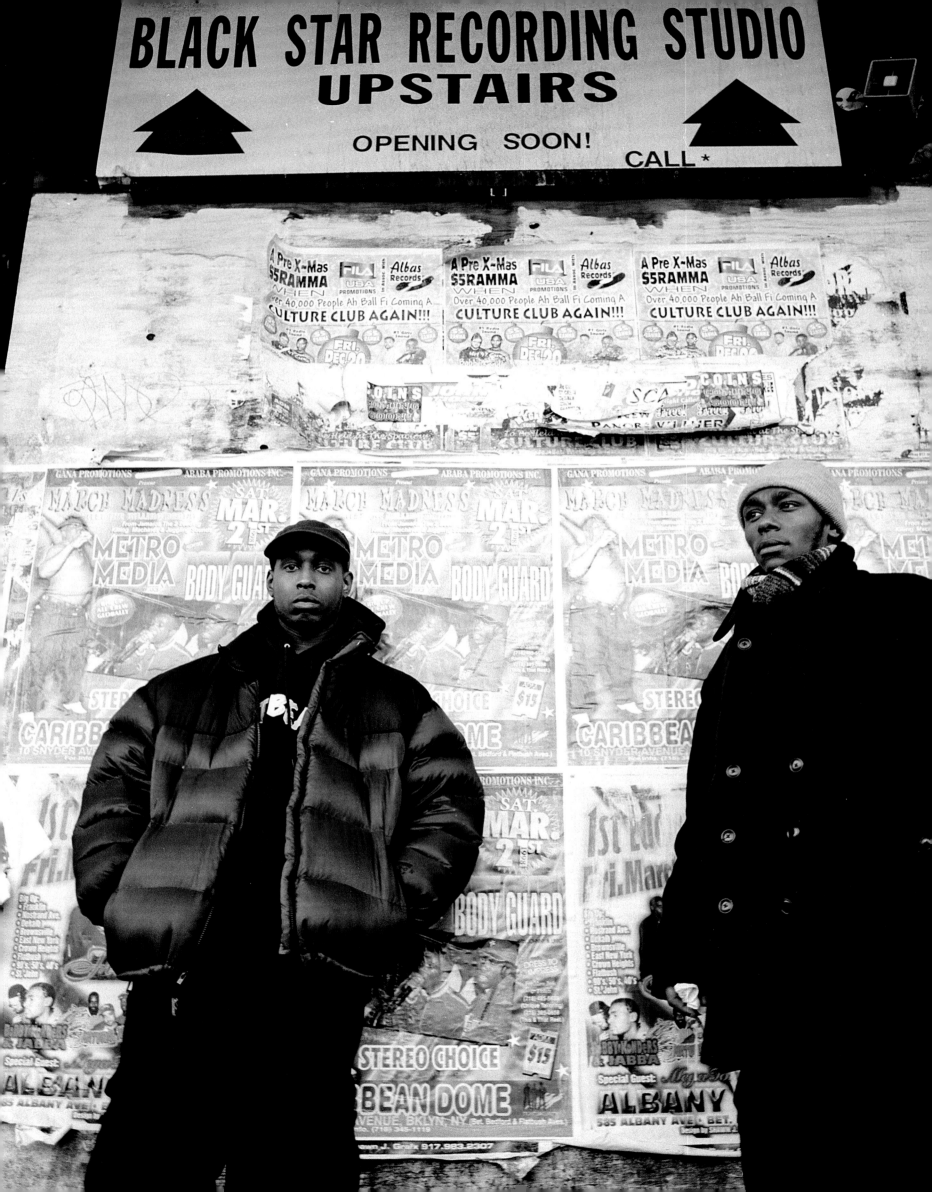

BROOKLYN, 1998

EDDIE OTCHERE

BLACK STAR

Black Star's only studio album, *Mos Def & Talib Kweli Are Black Star*, was widely recognized as one of the most innovative hip-hop albums of all time for its independent aesthetics and forward-thinking lyricism. The title is a reference to the Black Star Line, a shipping line founded by Pan-Africanist Marcus Garvey, and a nod to the group's musings on history and Black Power in their music.

By the time photographer Eddie Otchere was asked to shoot the cover, he had already moved to New York from London with "a bag full of mixtapes, promo vinyl, and magazines from my hombres in Europe," and was working as the photographer for underground hip-hop label Rawkus Records.

"Shooting for Rawkus was part of my mission to give independent hip-hop a fighting chance. Hip-hop like Black Star was derided at the time, it was referred to as 'backpacker hip-hop.' A lot of the kids that listened to it wore backpacks, as was the style, and that's where the term was coined. I was definitely in the 'backpack' camp. That was my aesthetic, and I was always drawn to hip-hop with that vibe.

"Mos Def struck me as some sort of savant, and Talib as a social-political theorist who happened to form rhymes. They seemed like learned brothers who, with their eloquence and wit, could not only string sentences together to uplift our collective consciousness, but could also add the musical inflections that kept heads bobbing and an entire generation bouncing to their style of poetic Brooklynism. To me, they were the postmodern incarnation of the Garveyite Back to Africa movement.

"The shoot took place in Brooklyn on a Saturday morning. I met up with Mos, Talib, and Black Shawn, who worked as A&R at the Rawkus office on Broadway in Manhattan, and he drove us to Nostrand Avenue in Brooklyn to meet the guys. I stopped for a Guinness Punch at the Jamaican spot opposite the Black Lady Theater, which was our location. We shot the album cover on the street, and the cover for their single on the roof above the Jamaican jerk place. There was no set, set pieces, or equipment; it was just another day in Brooklyn shooting with a Bronica 6/45, Mamiya C330, Minolta X-700, and a Canon Rebel.

"After the shoot, I spent days printing in the darkroom and then sent the package of shots to New York. I had no idea one of these shots made the cover of the album or the single 'Respiration' until I saw it in a record store!"

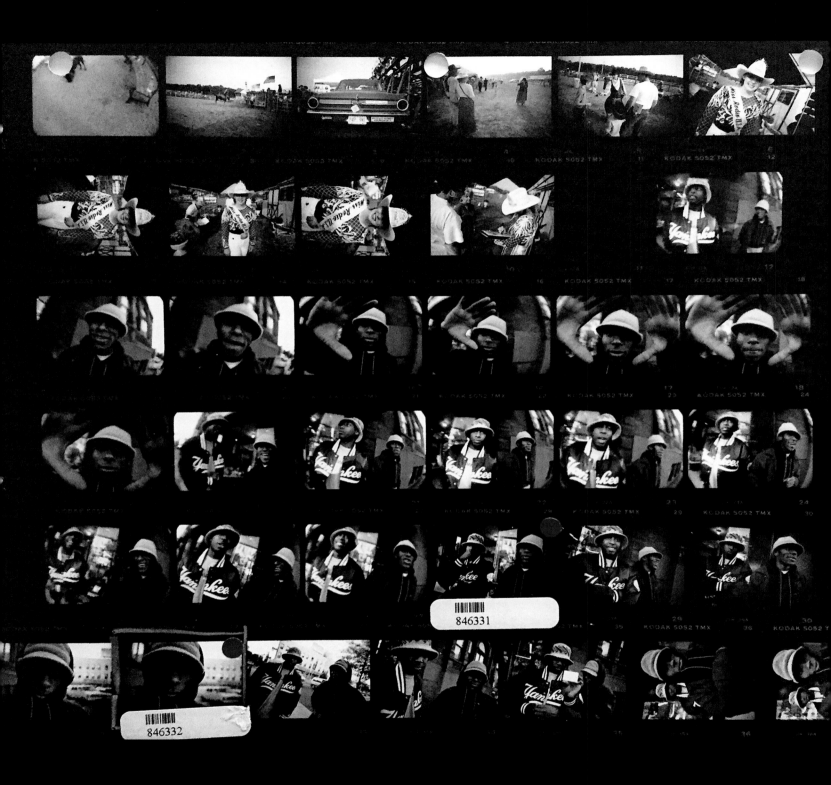

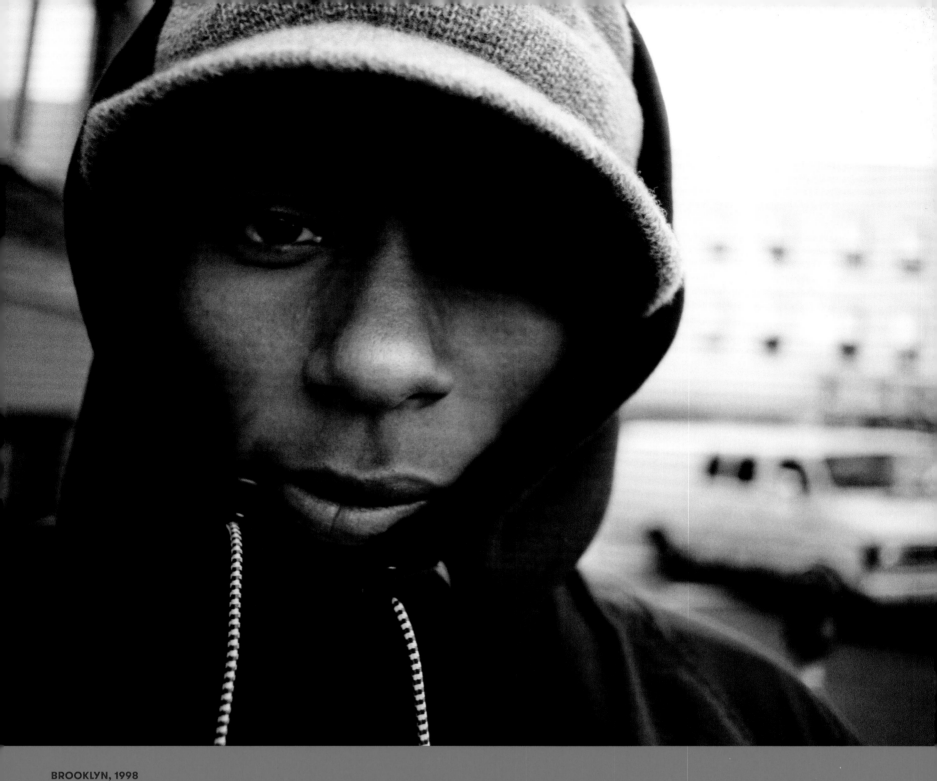

MIKE SCHREIBER

MOS DEF

Photographer Mike Schreiber used his trusty Pentax K1000, a humble workhorse camera made in Japan, to photograph Mos Def and Talib Kweli in front of Nkiru Books, one of the longest-operating African American bookstores in Brooklyn, where Talib worked as a teenager.

"I was already familiar with Mos from my time photographing at Lyricist Lounge, a well-known club where MCs competed for lyrical supremacy. I looked at this portrait as an opportunity to shoot people without a mic in front of their face. It's clear that there's an obvious standout image, the one of Mos in the hoodie. I always knew that was a good portrait, but I wasn't thinking 'Yeah, I got this' when I was shooting. I was just going with it. When I developed the photos and saw the contact sheet, this image definitely stood out, though. But then again, so did the picture I took of Miss Rodeo USA."

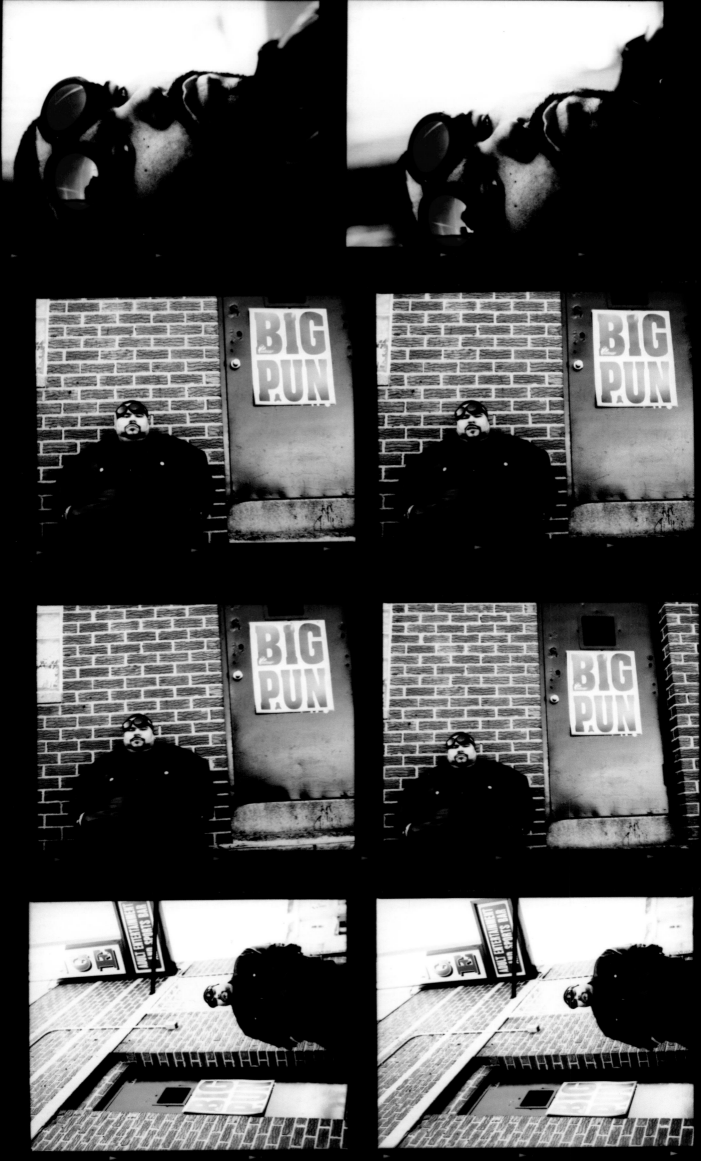

DANNY HASTINGS

BIG PUN, *CAPITAL PUNISHMENT*

"This is a really tight shot of Pun, but it's also really telling of who he was. I shot the cover for his *Capital Punishment* album near the Sue's Rendevous gentleman's club up in the Bronx. Pun was of course from the Bronx, so it was natural to shoot there. I always felt full-body shots were a bit impersonal unless you had a reason for them to be full-body, so at one point while shooting, I decided to do a tight profile shot which I hoped would end up on the cover. I think he was used to posing in this very like 'hey what's up?!!' way and wasn't used to very tight close-in shots. I had to get him comfortable with that, but I think this portrait that we ultimately used for the cover is a classic shot.

"Pun was the dopest Latino rapper that ever lived, and the first Latino rapper to ever go platinum. I knew so many Latino rappers at the time that never got their recognition. It felt pretty special to represent the Bronx to the fullest, and as a Latino myself, it meant so much to me to be a part of that history-making album."

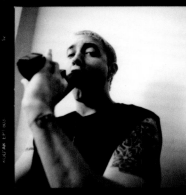

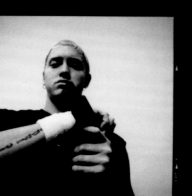

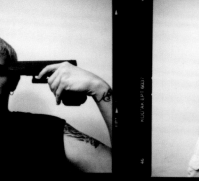

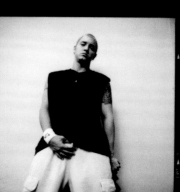

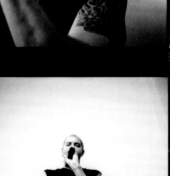

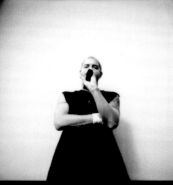

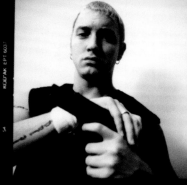

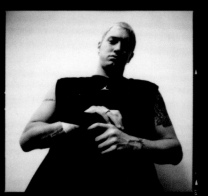

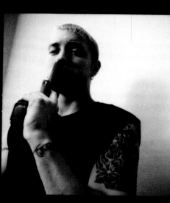

ARMEN DJERRAHIAN

ARMEN DJERRAHIAN

EMINEM

"There's a famous Kurt Cobain image where he has a gun in his mouth, and there's also the Dr. Dre *Source* cover with the gun to his head. I had both of those images in mind, but the Kurt Cobain one more so. So I decided to buy this BB gun to use as a prop. And, mind you, it was really hard to get a gun in Paris, even a fake gun. So I go to meet up with them, I think they were at a Holiday Inn or something, and they just loved these fake guns and Eminem starts doing his thing. Afterwards, he and his tour manager, Marc LaBelle, wanted to go to the store where I got the guns from. The next thing you know, me, Eminem, Mark, and Paul Rosenberg (Eminem's manager) went to the store and bought like ten guns. We had a big shoot-out in the Holiday Inn hallway where they were staying. But what's even crazier is that he tried to board a plane in London to get back to the States, and he went through customs with all these toy guns! He was banned from the UK for like two years after that. I probably shouldn't have taken him to the gun store that day."

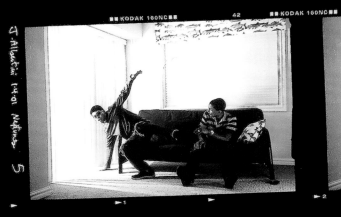
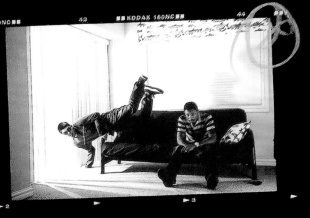
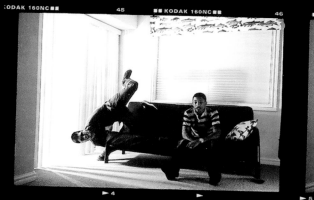
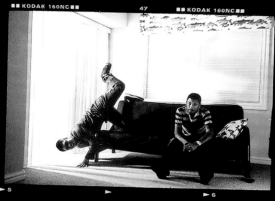
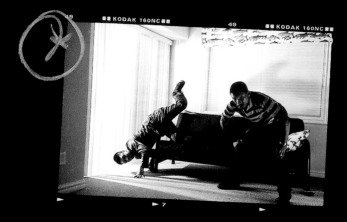
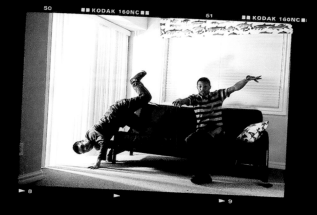
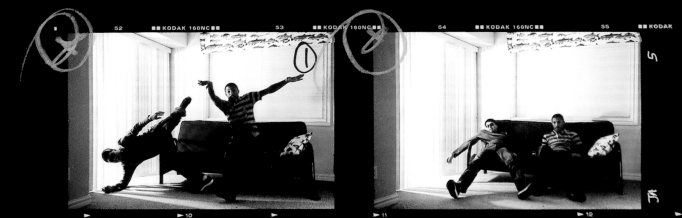

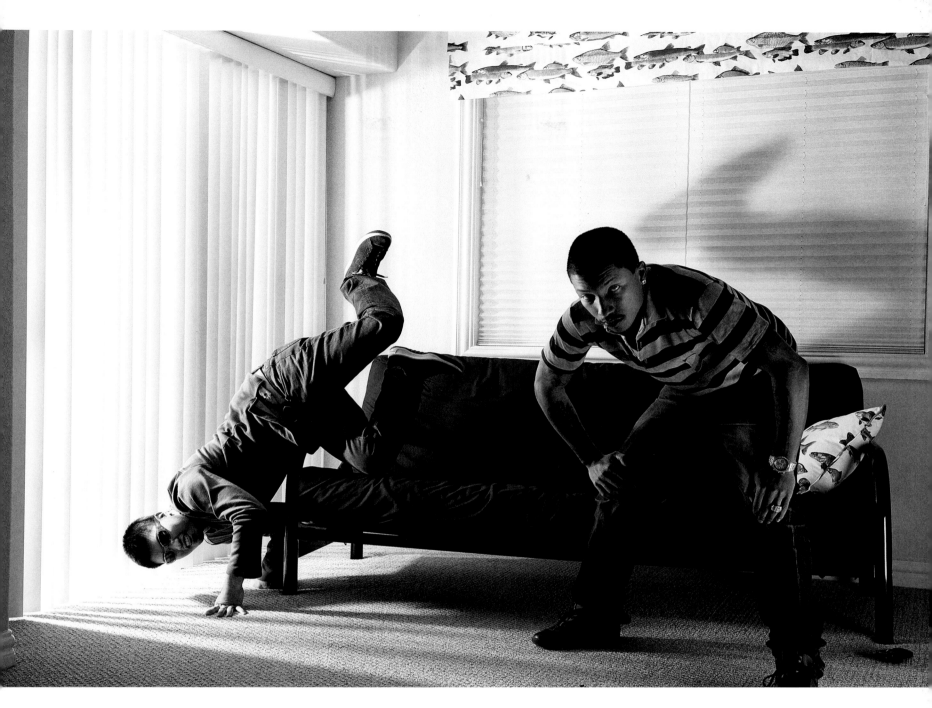

VIRGINIA BEACH, 1999

JEROME ALBERTINI

THE NEPTUNES

"I went to [Pharrell Williams and Chad Hugo's] studio in the middle of the winter. It was absolutely freezing. *Entertainment Weekly* was doing this column about up-and-coming artists and wanted me to get a quick photo. I shot this with a Contax and a 35mm Nikon. I walked around for like twenty minutes to get a feel for the place, and eventually I went downstairs and saw that couch and the blinds. I just told them to do what came natural, and they started goofing around with poses. They weren't super media-savvy or anything, they were just having fun."

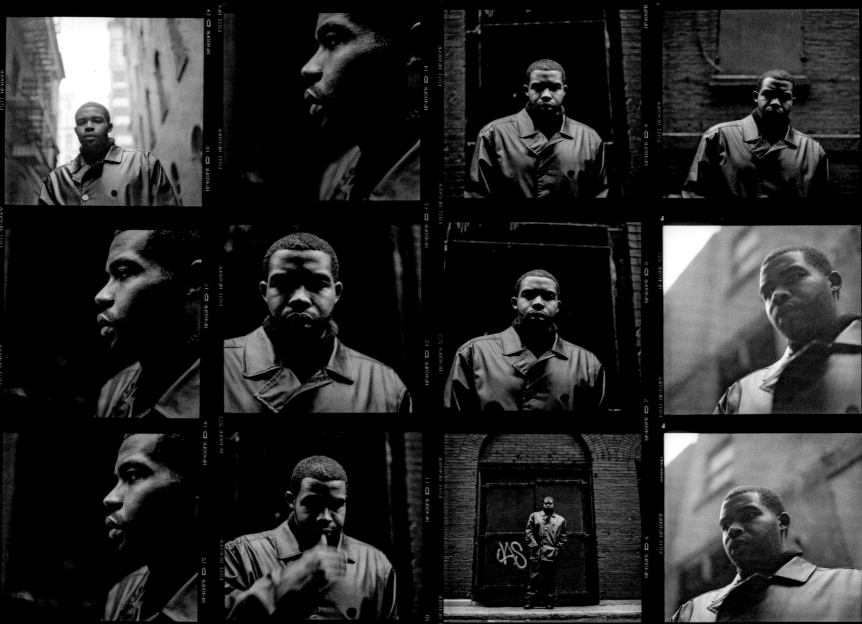

EDDIE OTCHERE

PHAROAHE MONCH

"As an MC, Pharoahe Monch is very conceptual. I hadn't even heard the album when I shot this photo, but I knew his reputation as one of the best lyricists in the game and being way ahead of his time. He was getting ready to release his solo debut, *Internal Affairs*, and we happened to both be at the Rawkus office on the same day. I had a really amazing camera with me, the Mamiya C330, which is medium-format, fully mechanical, and just a real beauty of a camera. These cameras have two lenses; with one lens you see the image and do the focus, and with the other the camera takes the photo. The focusing is done with the extension of bellows, which is great if you want to get a close portrait like this one. I wanted Pharoahe's portrait to feel like a jazz portrait, so we went down to an alley and made these moody, beautiful grain images."

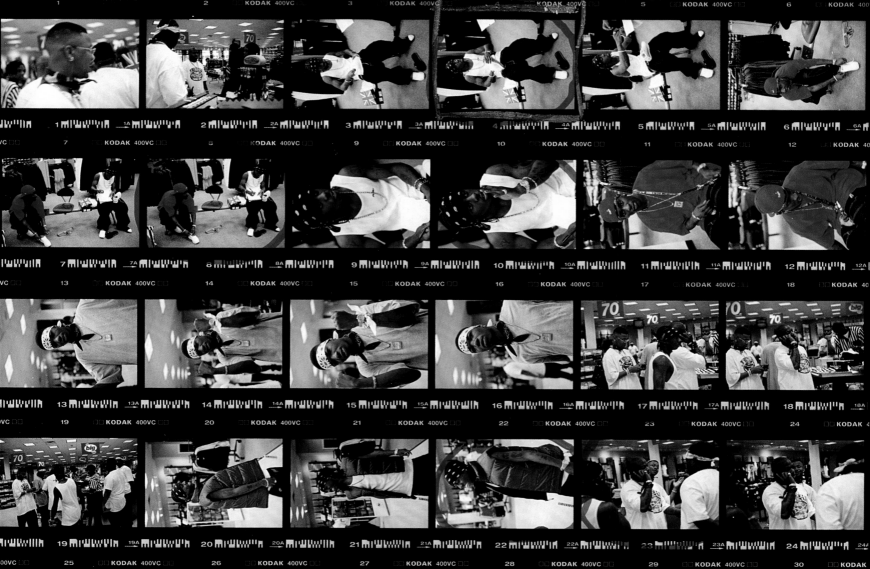

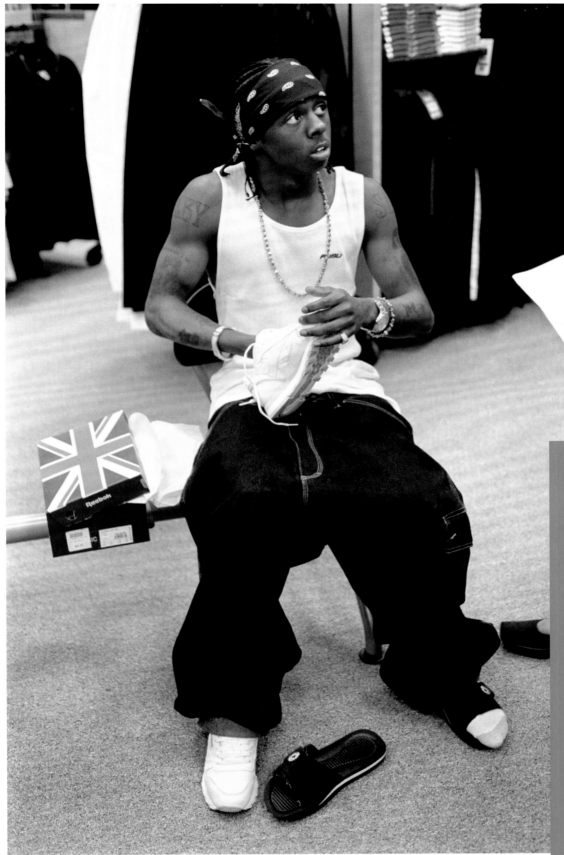

NEW ORLEANS, 1999

ERIC JOHNSON

CASH MONEY

"Every once in a while, a photographer will get these gigs where you get a real glance into someone's world and you get to spend the entire day with them. This was one of those assignments. They all look like friends—a way they haven't looked collectively in over a decade. Lil Wayne before the face tats, Baby before the beer belly, Juvenile, Turk, B.G., Slim, Mannie Fresh, they're all included. At this point Juve was the main guy, so my assignment was to photograph Juvenile and the Hot Boys, the group that had a lot of the Cash Money crew in it. I used a really small, inconspicuous camera, a Contax G2 35mm, so I was really able to be a fly on the wall.

"Cash Money was a total startup—this was before their big deal with Universal Music and the office had records strewn everywhere, young guys hanging out. That early vibe at labels was something I had seen back in the day in New York, but of course this was very different from New York—this was the South and they were about to make their mark.

"Everyone arrived in their own car and we caravanned around all day to different places around town like 'a day in the life.' Manny Fresh had a red VW Beetle and I remember thinking, 'Oh, that's not a very baller car,' but I also thought it was cool he was doing his own thing. I love the shot of Weezy in a sneaker store trying on a pair of Reebok Classics. This was the first time I met Lil Wayne, and he was super young and curious and just bouncing around."

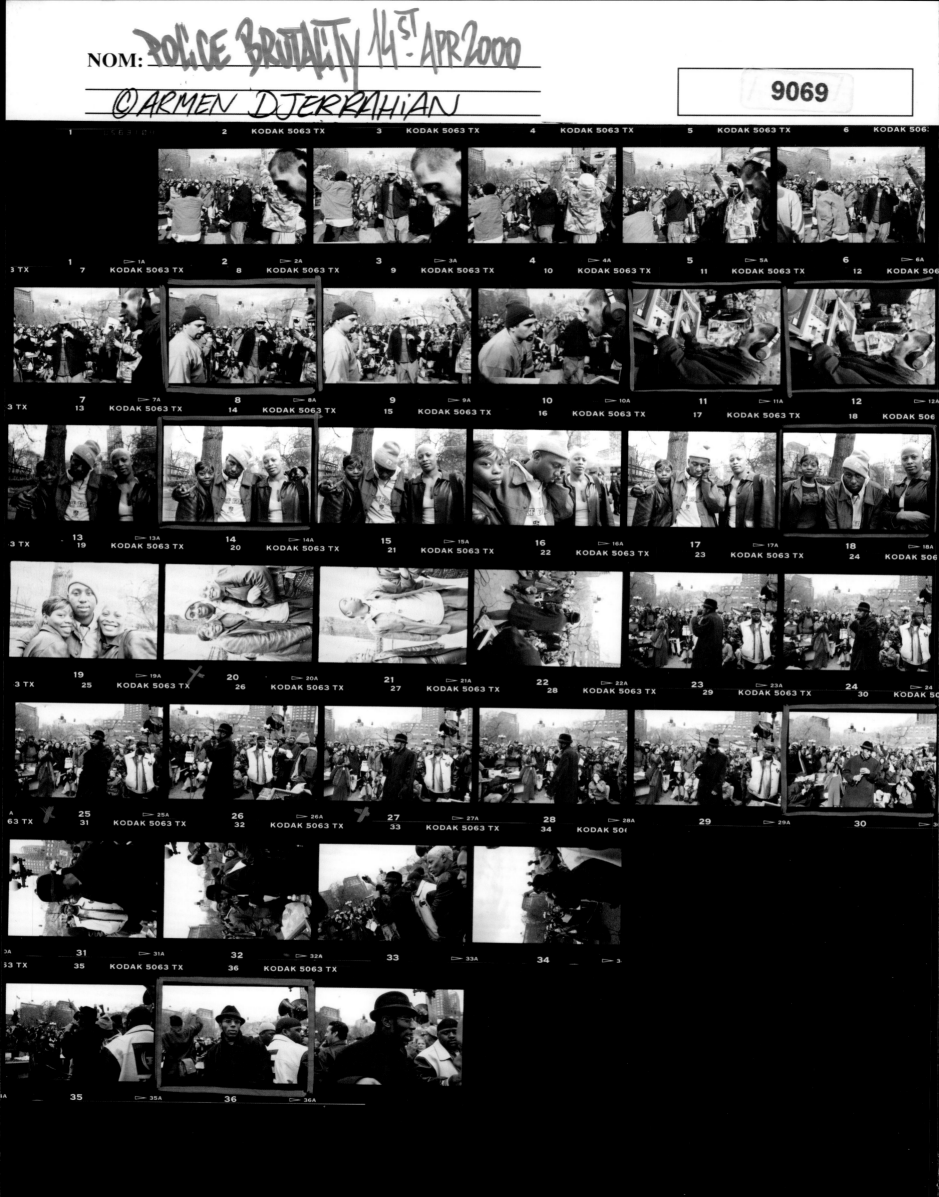

NEW YORK CITY, 2000

ARMEN DJERRAHIAN

MOS DEF

"I love the way Mos is dressed in this photo, like he's from a different era or something. It reminds me of Martin Luther King or Malcolm X, someone from the civil rights movement. On this day, I was shooting a group called Non Phixion. You can see DJ Eclipse on the contact sheet along with another Rawkus artist Shabaam Sahdeeq. They told me they were going to a demonstration in Union Square to protest police brutality, and I thought it was important to capture this moment of artists being politically active. It was a weird political time in New York, and a lot of artists were trying to share knowledge with their music. Mayor Giuliani was in office and everybody was trying to mobilize against his new 'quality of life' laws. His 'zero tolerance' policy and fines for minor offenses were really impacting New Yorkers. Police were cracking down and there were lots of reports of police brutality, so there was a lot of emotion this day. You can see it in their faces."

ATLANTA, 2000

MICHAEL LAVINE

OUTKAST, *STANKONIA*

"We photographed all day around Atlanta in different scenarios and different outfits that André and Big Boi had chosen, so we had a lot to select from for the cover. The outfits they had that day were just amazing. I really trusted their ideas, and just let them take the lead. The flag shot was just something we thought was poignant. I was blown away that André had the flag made especially for the shoot. What does it mean that the flag is black and white? I was never told."

219

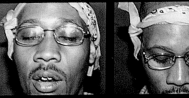
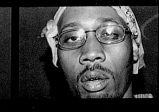
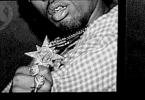
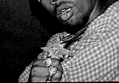

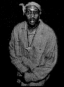

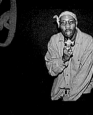
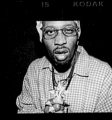
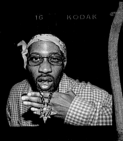
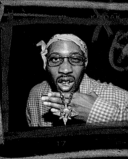

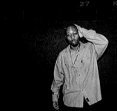
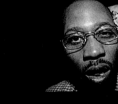

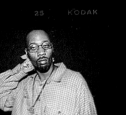

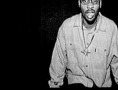
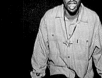
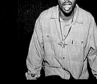
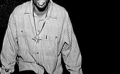
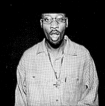

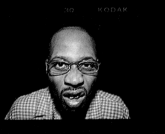

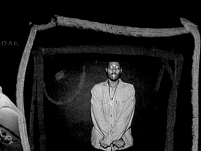

JEROME ALBERTINI

WU-TANG CLAN

When Jerome Albertini captured his group portrait of the Wu-Tang Clan, he had no idea it would be one of the few images of (almost) the entire group to ever be made. With the exception of ODB, who was in prison at the time, the rest of the Wu-Tang crew made it to the studio that day to shoot an editorial for *The Source* magazine.

"I think the magazine wanted to elevate things with the visuals and make the shoot a bit more stylized. I also wanted to buck the trending hip-hop aesthetics, and position Wu-Tang in a more upscale way. I was thinking about Richard Avedon and the way he shot artists on simple backgrounds. I was like, 'OK, that's nine people. How do I capture this many people in one good photo?' Getting nine subjects to come together at once on a white backdrop can be a challenge, and the lighting is especially difficult.

"I set up a second set on the side of the studio to shoot individual portraits. I shot with a little Contax to make it more informal. The Contax is really small, and it almost makes you look like an amateur. RZA had the Five Percenter medallion and he was holding it up in the frames. He asked me at the beginning of the session what I wanted to do for visual concepts. He was really interested in the visuals. The individual portraits were great, but by 5:00 p.m. we still didn't have a group shot. Finally, Method Man took charge and just a said, 'OK, my dudes, let's do this, let's get this group shot,' and everyone got together on the white backdrop and started posing. I finally got the group shot."

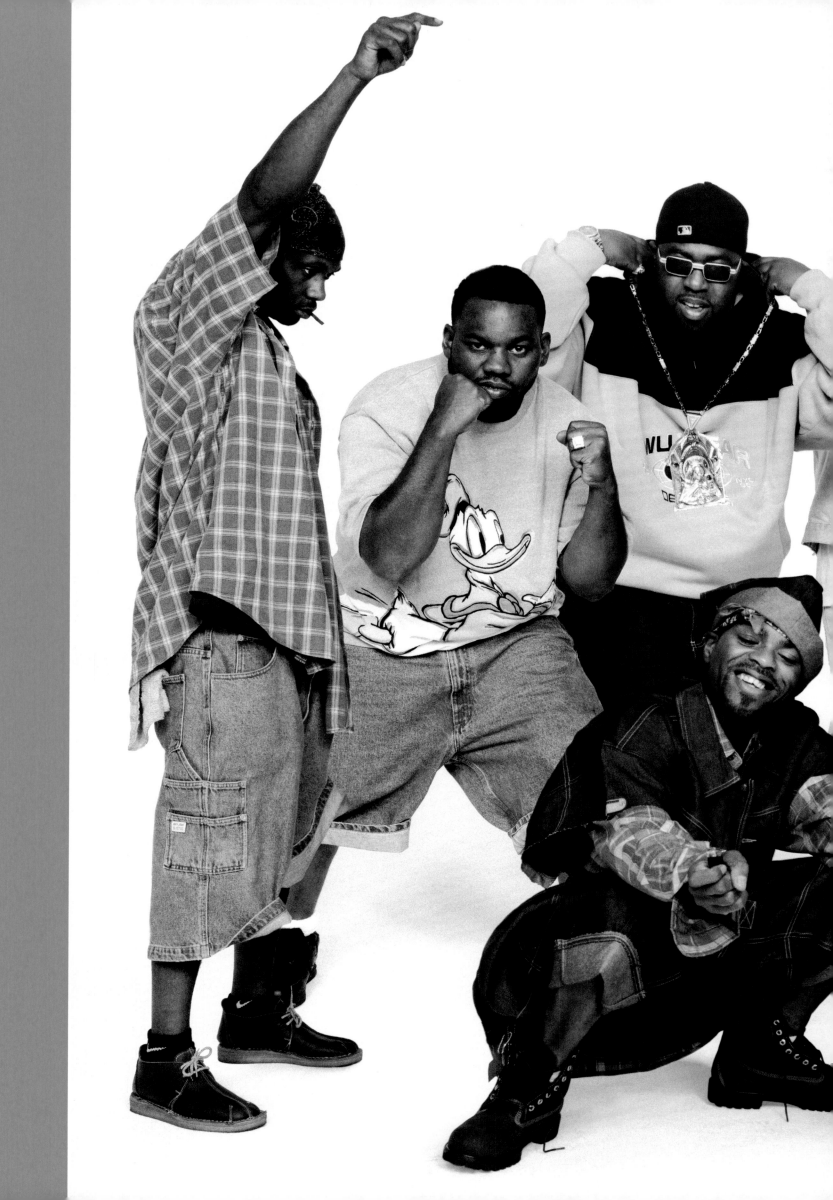

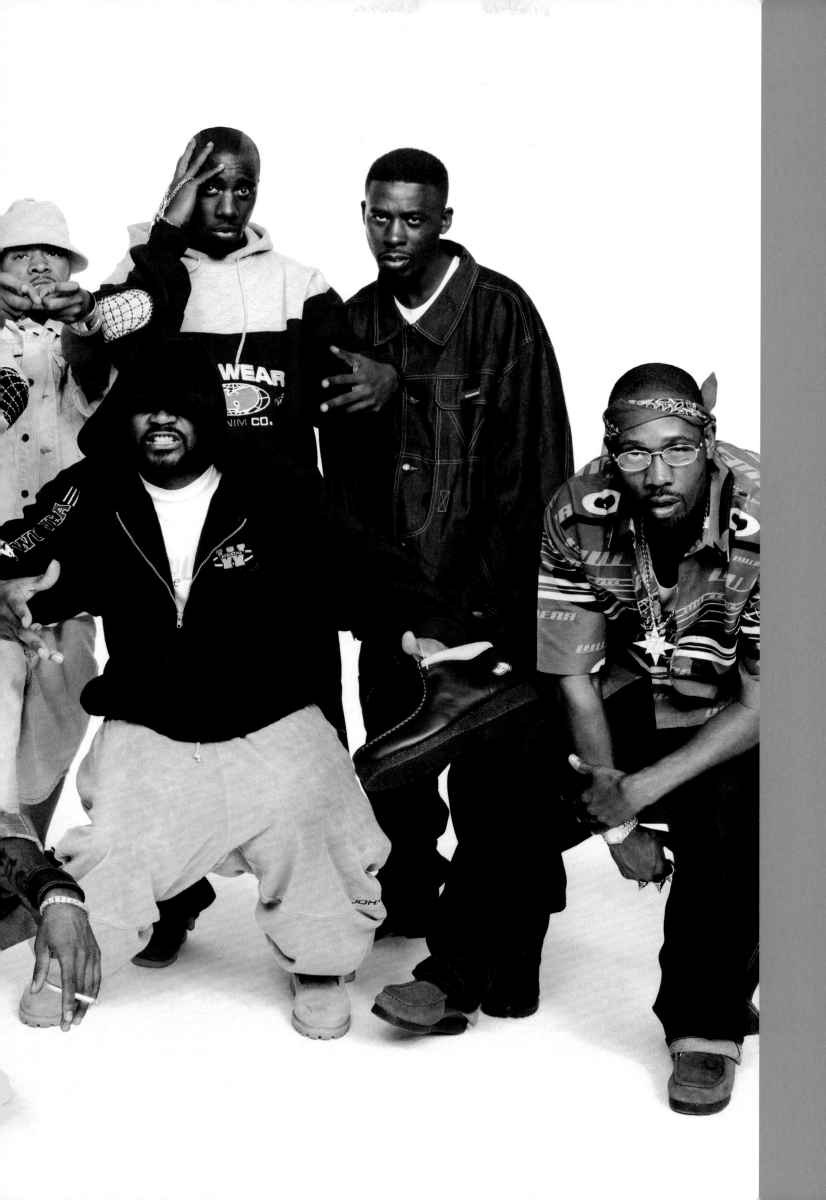

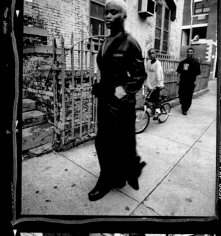
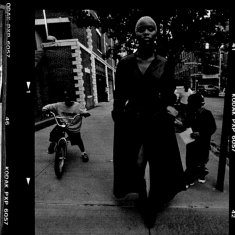
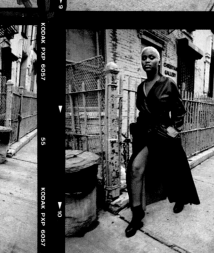
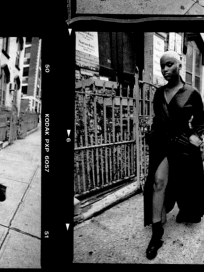
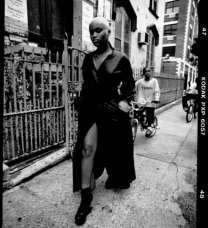
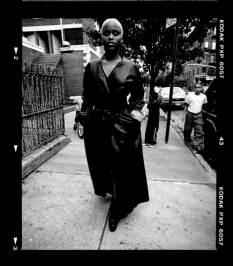
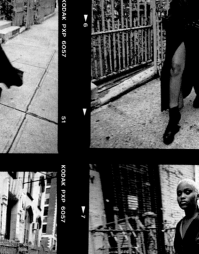
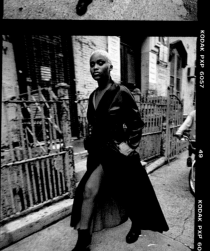
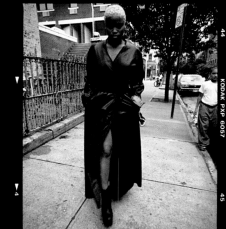

36180-2

ERIC JOHNSON

EVE

"This shoot feels much more 'fashion forward' than a lot of the hip-hop imagery that was being created at the time. Nowadays, hip-hop and fashion are so seamlessly joined, but this was a bit unusual, to see hip-hop look like it's walking a runway or something.

We shot on the Lower East Side and Eve's stylist, Kithe Brewster, brought all these looks. We were playing around with this idea of toughness and beauty. I used my Mamiya RZ with 120 film to give this photo a cinematic, dramatic effect.

"One of the things I love about this photo is the kids on the bikes in the background. Those were kids from the neighborhood and, at the time, the L.E.S. was still pretty 'hood. These kids had so much spunk and kept wanting to see the test Polaroids I was creating as I was shooting. They were like, 'Come back and show us the photos.' And I guess I was like, 'Yeah, OK.' And this one kid, he was so sharp and street-smart, totally called me out and was like, 'You're not coming back to show us nothing, I know you're not.' So I was honest, like 'You know what? Yeah, I'm probably not. I'm working right now.' Such a New York kid. Such a New York moment."

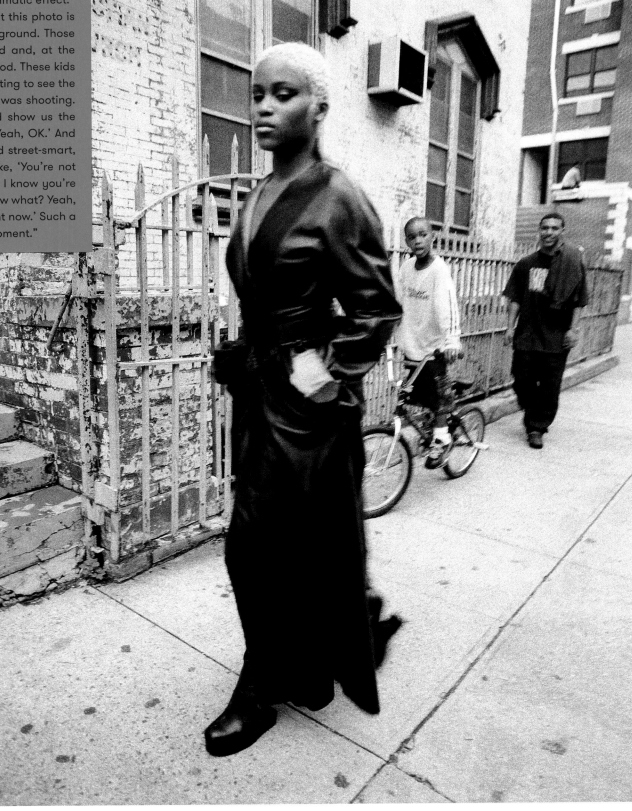

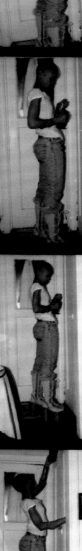

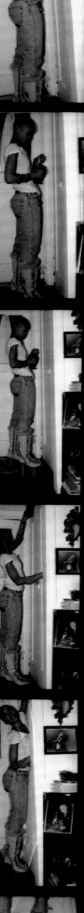

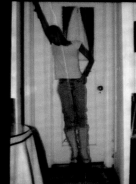
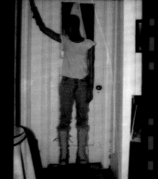

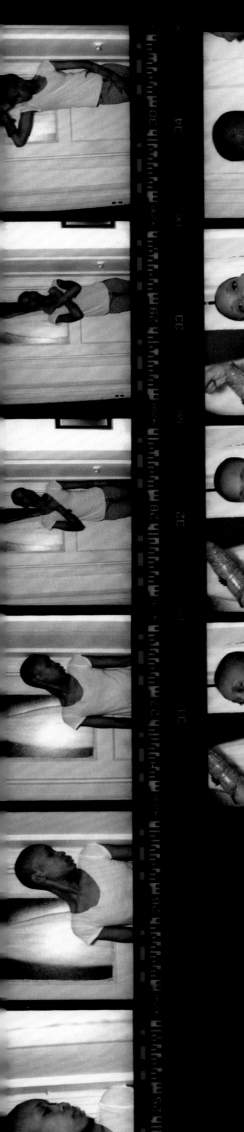

ERIC JOHNSON

ERYKAH BADU

"Somebody told me that a woman in Spanish Harlem, Ms. Mami was her name, had this apartment that was really stripped down and had all of this great raw energy. The apartment had a very Latin aesthetic. It was neat but also very crowded with stuff. I brought Erykah up there to shoot. Erykah, of course, is known for having this amazing way about her—very ethereal and conscious and just incredible. She walks in and was just like, 'Hey, Ms. Mami' like she had known her for years. I don't know if Ms. Mami knew who Erykah was.

"She was wearing a head wrap when she arrived, but then went into the bathroom and shaved her head. Her hair was already shorter than usual, but she went into the bathroom and just completely changed her look from what the public was used to.

"I was shooting with my 35mm Contax. The shot of her making the muscle in the bathroom ran on the cover. It's a horizontal shot that they put on a vertical magazine. These shots are just so gorgeous and raw, and I really respect her for being so open. I mean, who else looked like that at the time? It was a pleasure to work with Erykah at that moment, because she was still just being true to herself. She even brought her own clothes to this shoot."

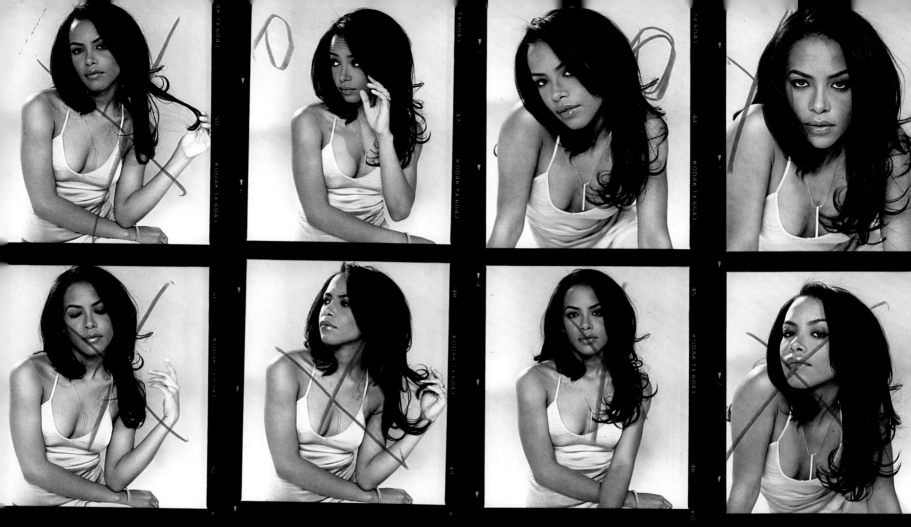

ERIC JOHNSON

AALIYAH

"Aaliyah marked up these contact sheets herself and she rejected a lot more than I thought she would. The shoot was initially commissioned for *Entertainment Weekly* to promote her new album *Aaliyah*. When I look back at this shoot, I realize that I took her lead on most of it. She had already grown into her own.

"We shot at Pier 59 Studios over on the West Side Highway. She was totally lovely, her mom was lovely, and we all got along famously. She was beautiful in a natural way. It's interesting that I'm so tied to Aaliyah, because I didn't really know her that well. I'd never met her before the shoot. But I loved her; I always thought she was so cool. It would be great to say we did this and we did that and we'd go out to dinners, but that wasn't our exchange.

"After my shoot, we sent the photos to her and she marked them up. She died just a short while after. When she passed away, this image was used on the cover of *Vibe* magazine."

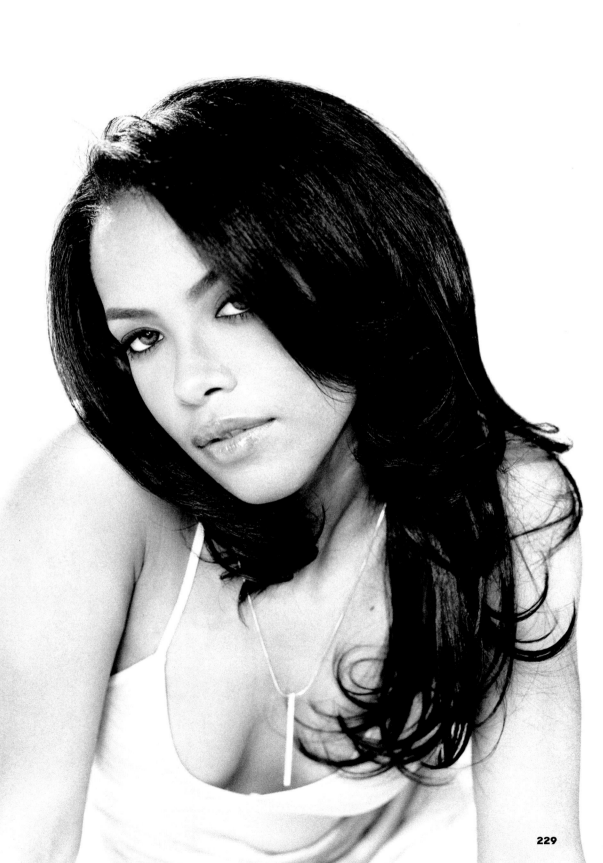

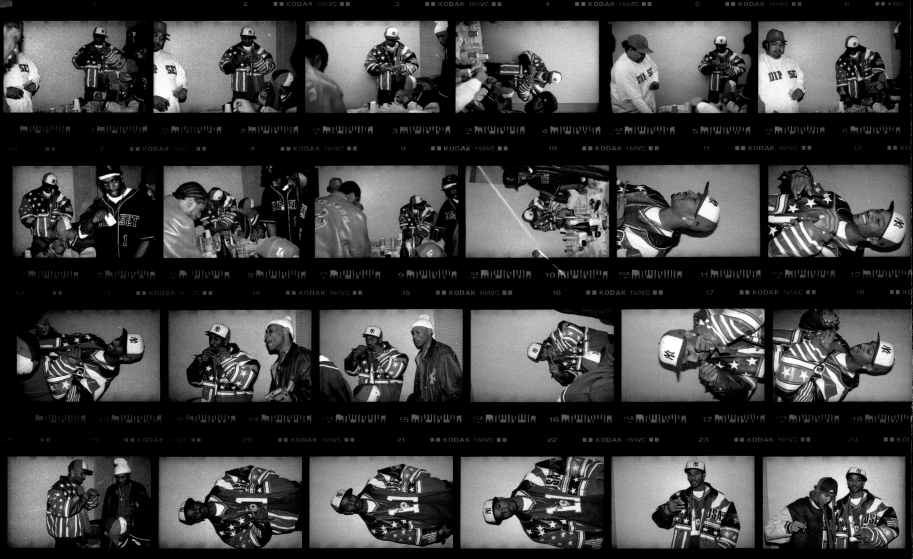

ERIC JOHNSON

CAM'RON, *COME HOME WITH ME*

"Cam was always for underground heads, perhaps fans who loved that harder New York sound. Since the album referenced his home in Harlem, I wanted the shoot to be where he's from, but I didn't feel the cover had to be of Cam'ron's actual house. Cam's Dipset crew was there that day, so we went next door to Juelz Santana's apartment building and I was like, 'We definitely have to shoot here.'

"Then we went over to the basement of the adjoining building. The Dipset guys was rocking jerseys, playing cards, and sipping Hennessy. It's interesting to stumble upon scenarios like that, because you can visualize the many nights they probably had there hanging out and doing their thing. That's one thing I think is really great about what I do—I get to peep into lives that other people would never see."

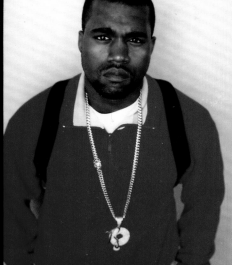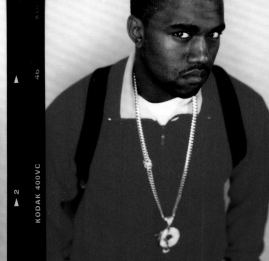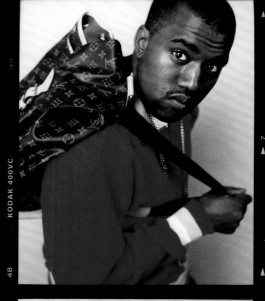

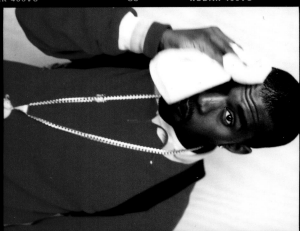

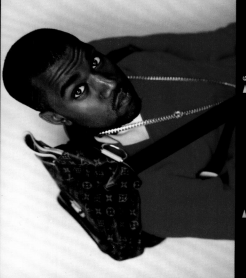

CHICAGO, 2003

NABIL ELDERKIN

KANYE WEST'S FIRST PHOTO SHOOT

"I was living in Chicago at the time and heard about this new artist, Kanye West, but I couldn't find him anywhere on the Internet. His domain name was available, so I bought it for twenty bucks and I guess this was a bit of a lucky break. His label wanted to buy the domain off me and I told them I would do it in exchange for a shoot with Kanye. A few days later Kanye called and said, 'I heard you want to shoot some photos' and invited me to meet him in his neighborhood. This was before *The College Dropout* was released, so the photos I took became Kanye's first press images. It was the start of our working relationship."

233

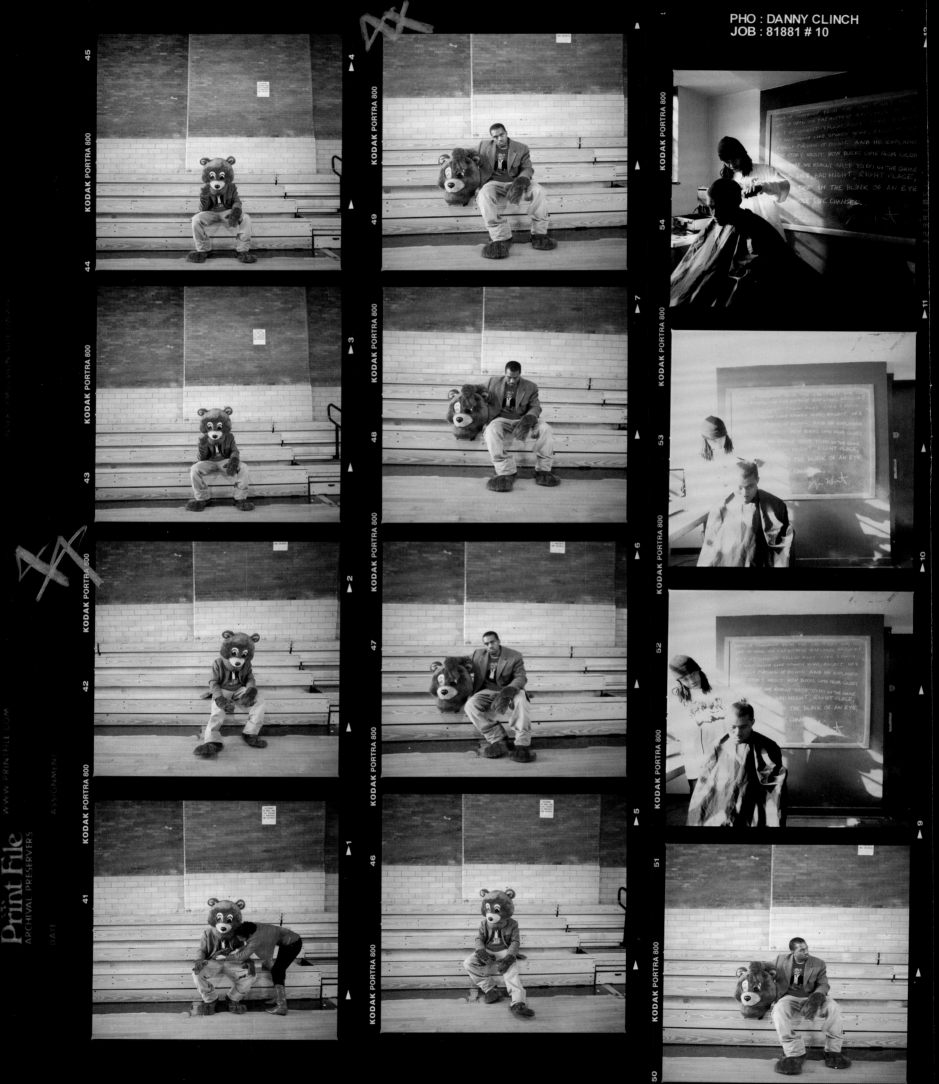

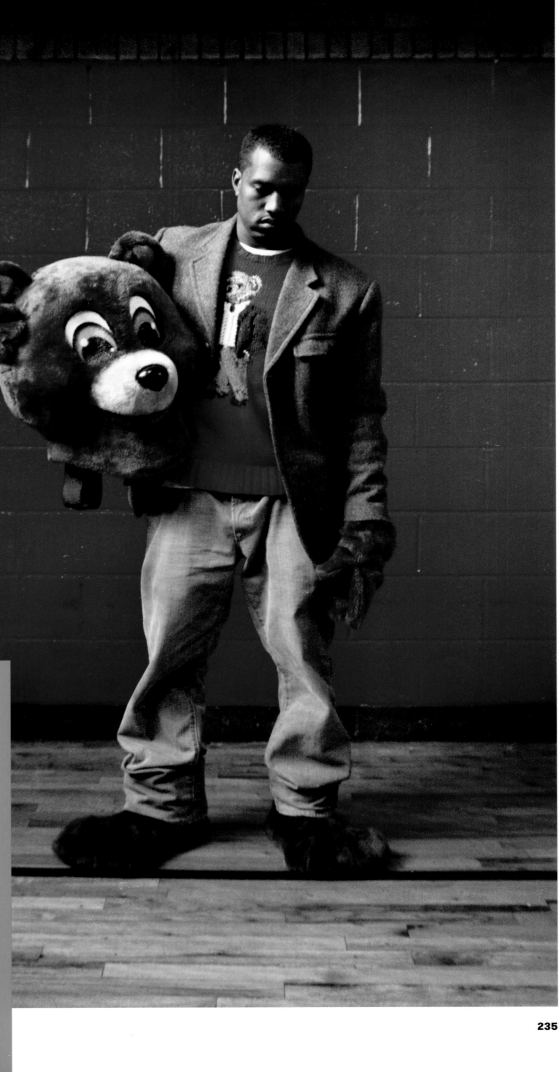

HARLEM, 2003

DANNY CLINCH

KANYE WEST, *THE COLLEGE DROPOUT*

"Kanye was someone who clearly had a vision for what he wanted. By the time I did the cover of this album, I had already done a lot of classic covers and knew how to respect an artist's vision. His style was just really unique, and was not typical of other hip-hop visuals at the time. He envisioned a high school yearbook theme, and we photographed the cover at Lt. Joseph P. Kennedy Community Center in Harlem. I got the sense that he really wanted to take a chance with this debut, and the portrait on the bleachers became this very symbolic image."

A B

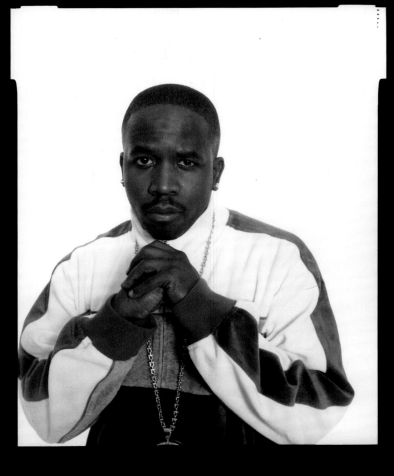
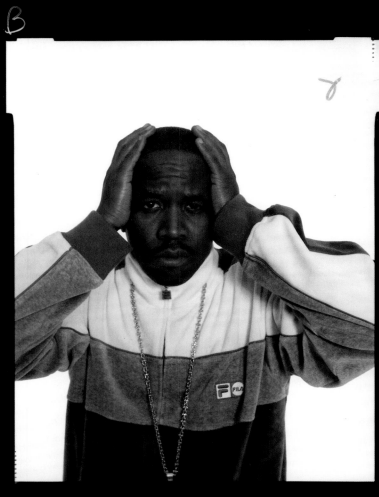
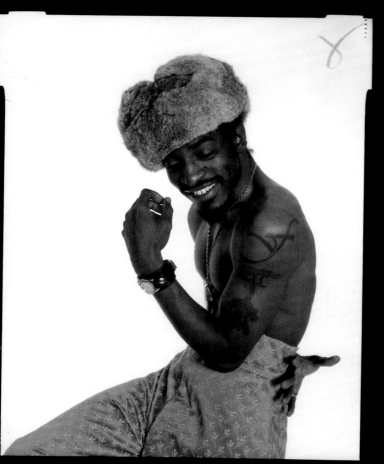

ANDRÉ 3000

"At the time I was obsessed with 4×5 cameras, which is like shooting at the turn of the century because it takes a long time, but has amazing detail. Even though each shot takes a few minutes to set up, I had a feeling OutKast would be into it. I used a Sinar camera to shoot this for *Spin* magazine's feature on the group. André was an amazing-looking man, dressed in baggy pants and a fur hat, and Big Boi looked great in true hip-hop style. They kept playing this one song over and over again, it was infectious, so different from the hip-hop I had heard up until then. It turned out to be 'Hey Ya,' and a couple months later they became super famous. The poses that André threw that day were incredible. Some people are very aware of their body language, and you could tell he was going to become a star."

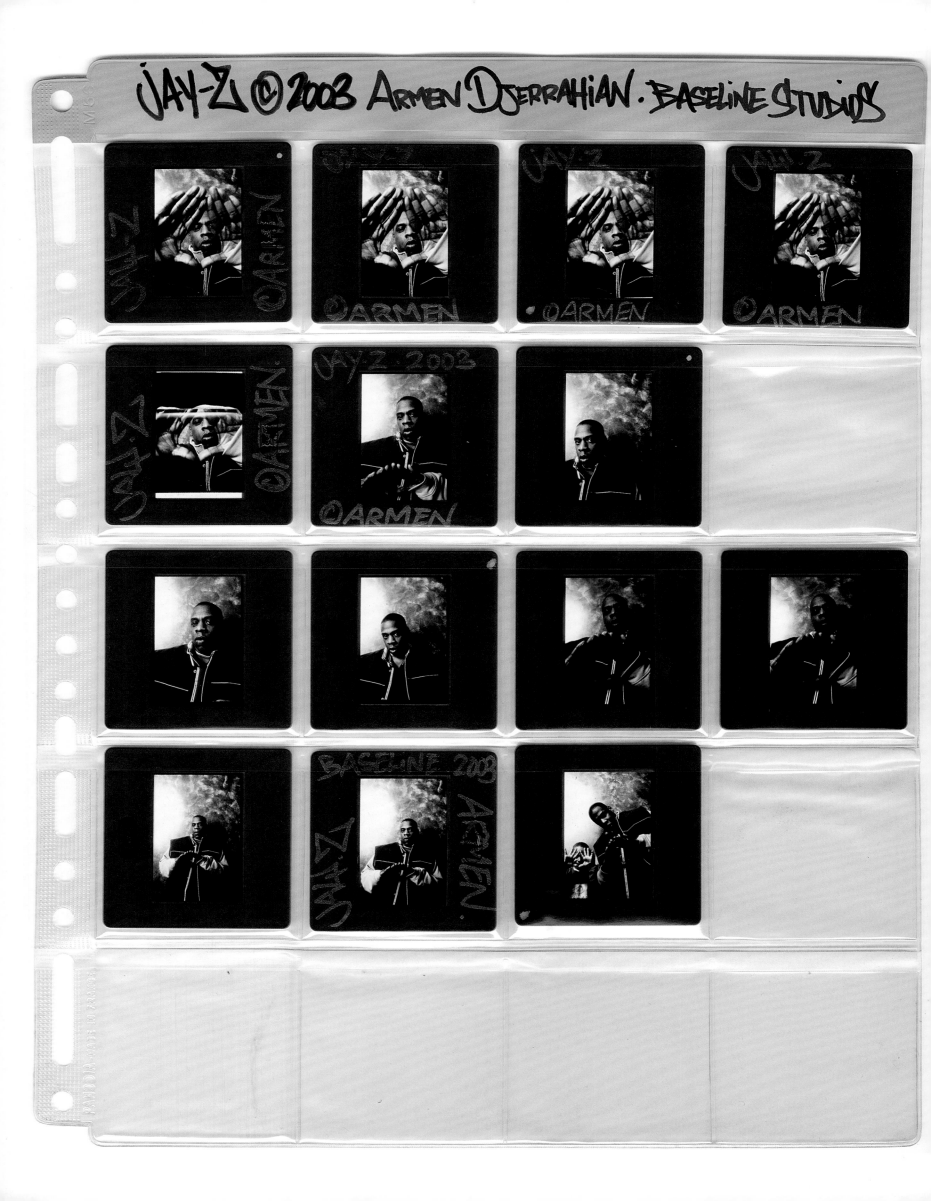

ARMEN DJERRAHIAN

JAY-Z

"This pose with the diamond symbol was synonymous with the Roc-A-Fella family and has become one of my best-known shots. But when Jay threw the sign initially, I was almost annoyed because it hid most of his face. I knew that if I didn't have Jay's face, it wouldn't make the cover of a magazine, so I made sure I at least got his eye in there or something. I was using my Nikon F4 with Polagraph film, which is a very special type of film made by Polaroid that allows you to create a black-and-white slide. The slide selections are all very similar, but there's one photo of Jay with a kid, and I don't know who he is or how he got in the shot."

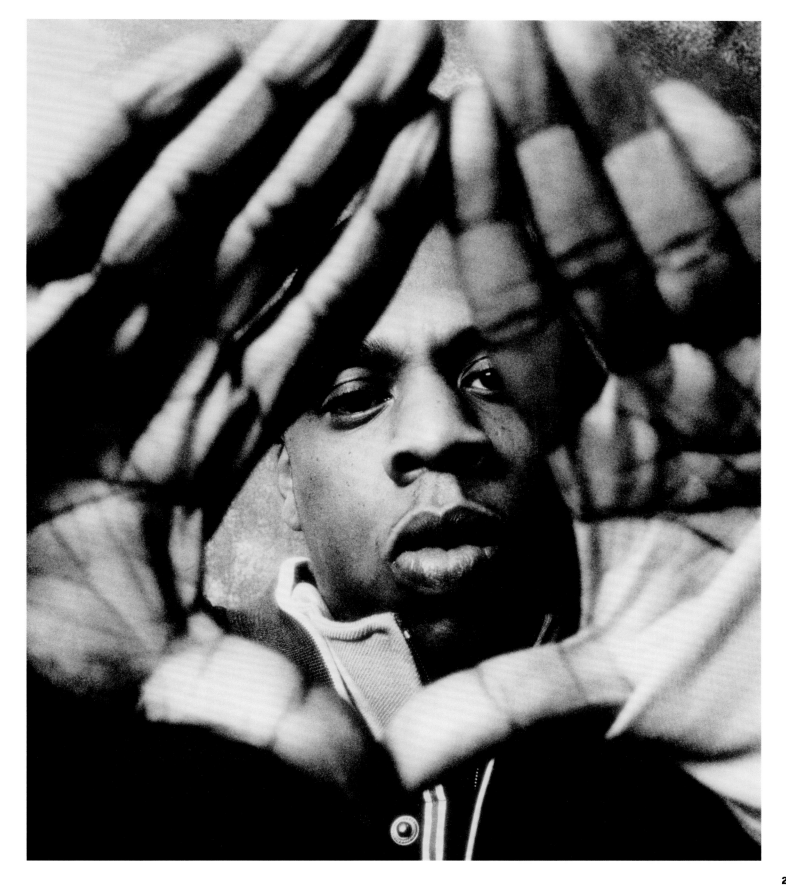

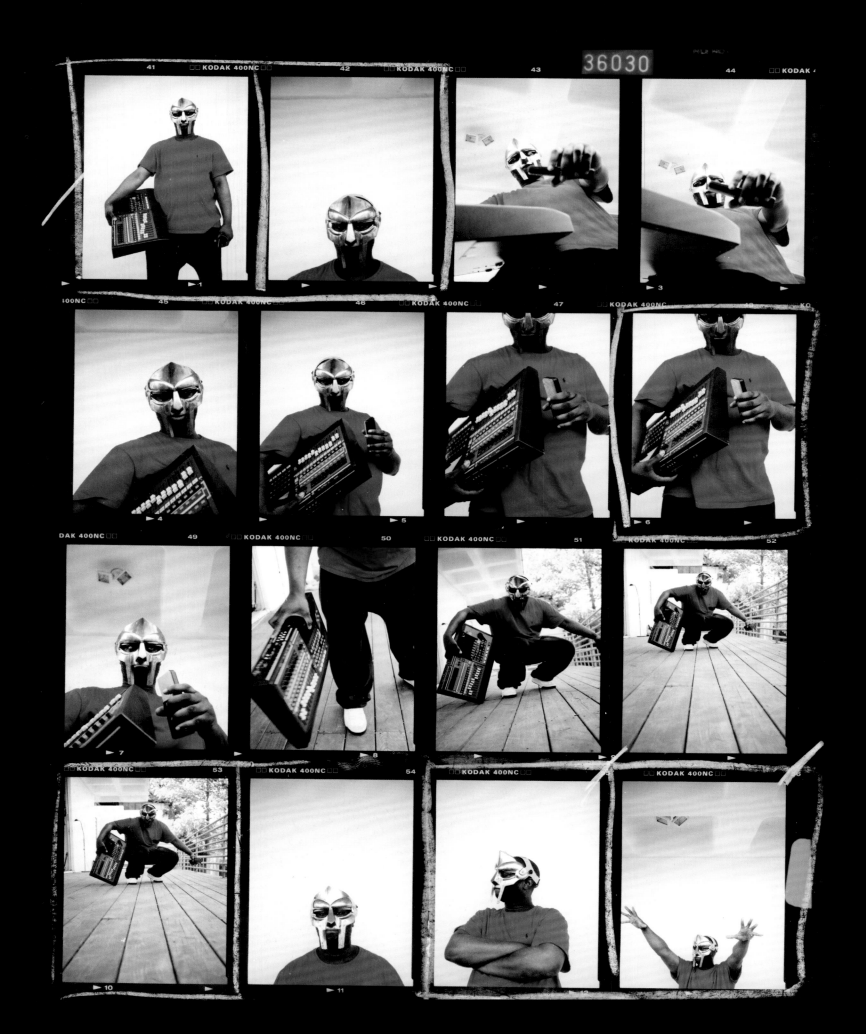

ERIC COLEMAN AND JEFF JANK

MF DOOM AND MADLIB, *MADVILLAINY*

ERIC COLEMAN: "Madlib and Doom were staying at this old bomb shelter that happened to be at a house that served as the Stones Throw headquarters. I got the call from art director Jeff Jank to come and photograph them. He didn't specify what the photos would be used for; he was like, 'They're together right at this moment, they're cooperating, let's do it.' Thankfully, I didn't know this was going to be a cover because I would have been really nervous. I met Doom first as 'Dumile,' the actual person and not the rapper, and was like, 'OK, this is what he looks like.' He was wearing a red Polo T-shirt because he was a 'Polo head.' Once I 'normalized' him as a regular person, I could then photograph him with the mask.

"When Doom put on the mask, things became surreal. Suddenly, it was like I was photographing a mask and not the person; the guy behind it almost didn't matter. And that's when the portrait happened.

"I shot about five rolls total using my Fuji GA645 and Hasselblad against the only white wall at the house."

JEFF JANK: "Doom seemed so obscure then; no photos, albums under different names, his records in and out of print. He and Madlib were both like the anti-pop star, and that's exactly how the album was shaping up. If there was ever a chance to try and define someone with an image, this was it. Instead of focusing on the mask as an object, I wanted it to evoke the man wearing the mask. I definitely don't think of the photo we selected for the cover as just an image of a mask. It's a photo of a complex man who just so happens to have a metal mask on."

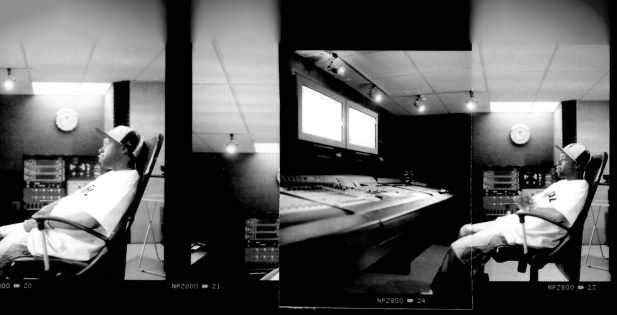

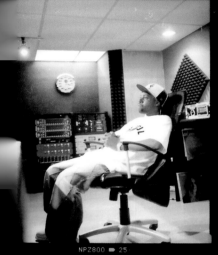

BRIAN "B+" CROSS AND ERIC COLEMAN

J DILLA

BRIAN B+: "This was around the beginning of Dilla's Jaylib project for Stones Throw. The idea was for me to go to Detroit and photograph Dilla in such a way that we could put photos of Otis [Madlib] and Dilla together and somehow get them to work together. Dilla didn't let too many cats photograph him, he wasn't that comfortable with many photographers, so I'm honored that he trusted me.

"We arrived on a red-eye and went straight to his house, which was absolutely pristine. That's the first thing I noticed, he was like a neat freak. Jesus Christ, you could eat your dinner off the fucking floor! Ma Dukes was there too, and we just hung out. When we went record digging, he went straight to the $0.29 section.

I was surprised that he was going for the inexpensive records, but came to realize afterwards that he was the king of buying cheap records."

ERIC COLEMAN: "At the shop, I asked Dilla what he bought and he was like, 'Nah, I don't show people what I bought.' I was slightly offended but also had so much respect that I didn't dwell on it. I was like, 'You're the master of this, I get it.' Later that night, we went back to his house and he started listening to the music he bought in his home studio. At one point, I looked over and saw him at the console. It was one of those moments where an artist is in their happy place. He was going hard, getting really into the music, and I took the shot."

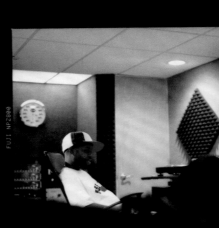

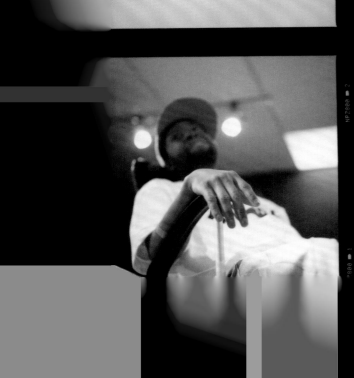

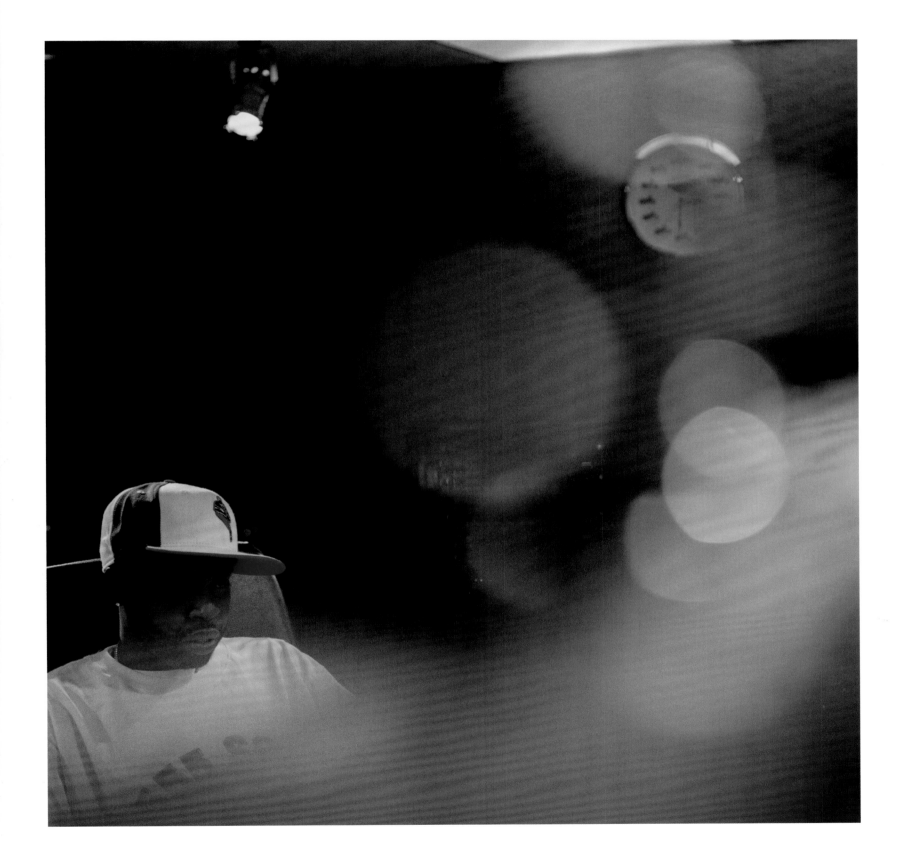

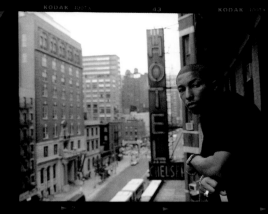
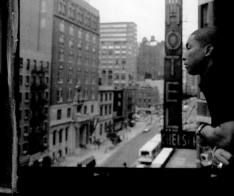

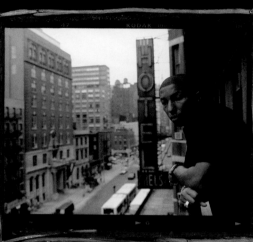
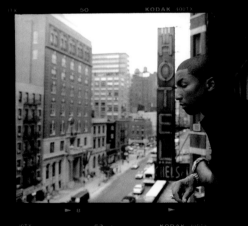

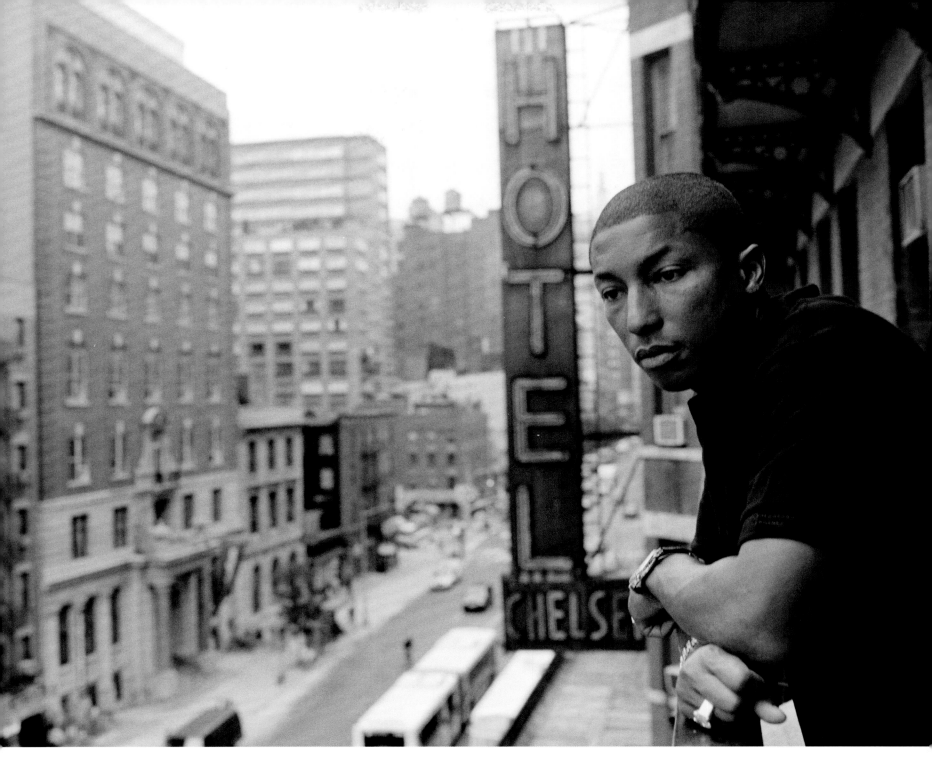

CHELSEA, NEW YORK, 2004

MELODIE MCDANIEL

PHARRELL WILLIAMS

"This image was taken for *Complex* magazine. I wanted to shoot at the Chelsea Hotel as it's such an iconic, historical landmark, having housed some of the greatest thinkers, musicians, writers, and artists of our time. I thought it would be amazing to see Pharrell there as my way of not only honoring him as a notable artist, but also recognizing hip-hop within the hotel's legacy of great American music and art.

"I will say that it took Pharrell some warming up to the idea of shooting in a space as unassuming and gritty as this one! But that's also what I liked about photographing him there: it was really different to capture a hip-hop artist in this way. Sadly, since this photo was taken, the Chelsea was sold and completely renovated. All of that raw flavor and texture that fans of the landmark appreciated is now gone. So to me this photo is like an awesome time capsule that captured a great musician in one of music's most iconic haunts, before the winds of time erased its visual history."

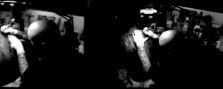

LOS ANGELES, 2004

ESTEVAN ORIOL

50 CENT AT MISTER CARTOON'S TATTOO SHOP

"Mister Cartoon is a tattoo artist—he's done everyone from Beyoncé, David Banner, and Nas to Prodigy and all the G-Unit guys. We had two tattoo shops next to each other in Downtown LA at the time, and a lot of artists from New York would come to our shop when they were in town. 50 Cent had just arrived in Los Angeles, where he had a meeting with Jimmy Iovine. He was in the process of being signed to his first record deal. 50 knew about the shop and came down to get his tattoo. I had my Canon A-1 camera with me and thought it was an important, intimate moment to photograph. 50 Cent knew he wanted the big 50 on his back, which was done using a Chicano style of lettering, a very Los Angeles style of tattoo."

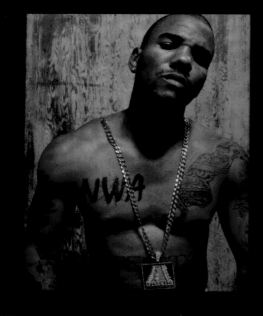
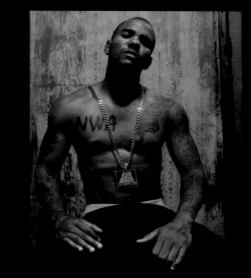
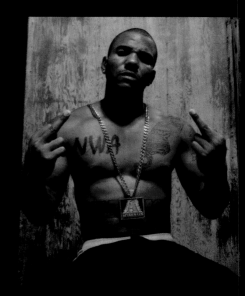
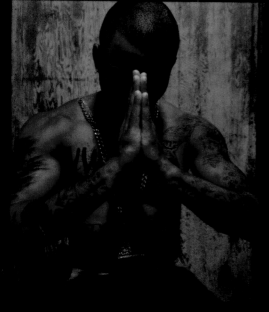
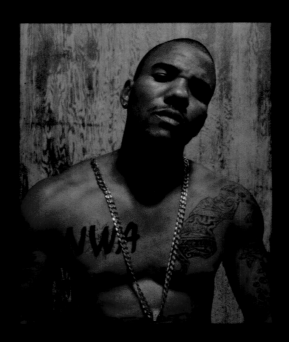
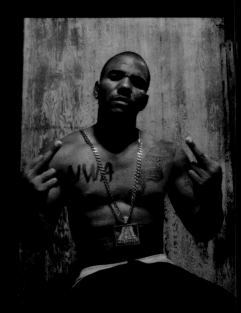

PATRICK HOELCK

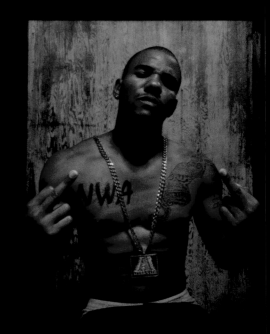

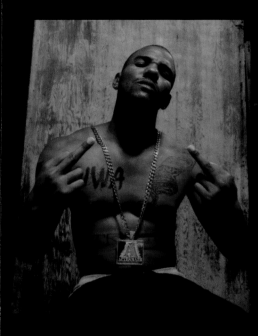

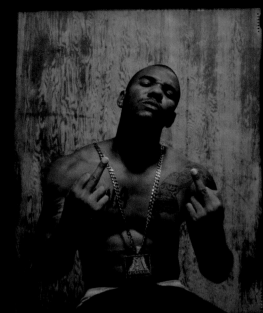

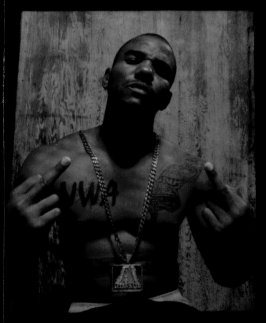

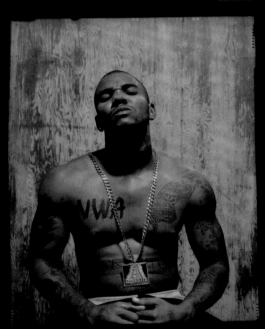

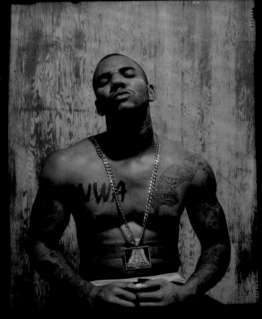

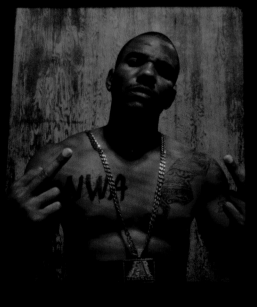

SOUTH CENTRAL, LOS ANGELES, 2005

PATRICK HOELCK

THE GAME

For this early shoot with The Game, photographer Patrick Hoelck traveled to the artist's home turf of South Central LA to capture this ethereal, moody shot for *Vibe* magazine. *Vibe*'s then photo editor, George Pitts, commissioned Hoelck after seeing his earlier work shooting videos for some of hip-hop's best and brightest.

"One thing that stands out about that day is how many cops were hanging around. In the middle of the day The Game asks me, 'Hey man, you want something from Starbucks?' I said yes and watched him go over to the cops, hand them a wad of cash, and they drove off. I never had an LAPD do a coffee run before and tried not to think about how weird that was, but I guess this was just the way The Game's world was at the time. Kids from the neighborhood started coming around our set, and I noticed a lot of them had guns tucked into their pants. I thought that was really brazen with the LAPD just a few feet away.

"The Game was always on and very focused. The shot with his hands clasped in a prayer pose is pretty deep. I wanted the portrait to have that feel of simplicity to it, with his hands in a saint-like pose. I used my Mamiya 6×7 and a Toyo 4×5 land camera for this shoot. I'm glad I shot this on film."

251

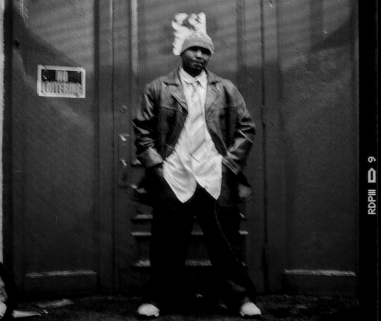

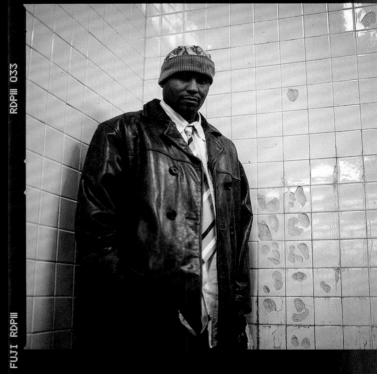
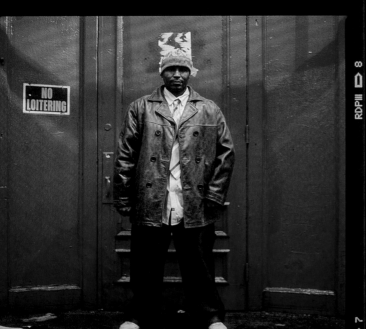

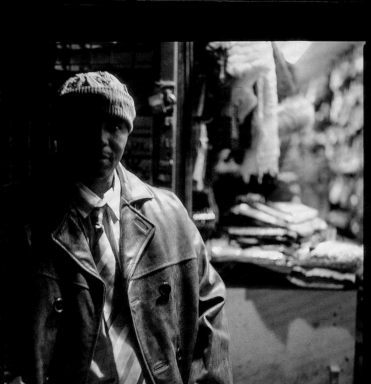
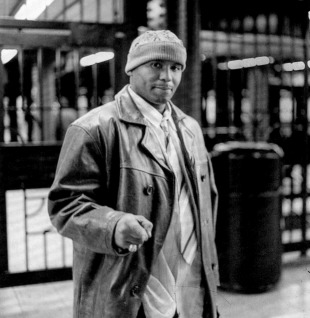

NEW YORK CITY, 2005

TREVOR TRAYNOR

KOOL KEITH

"I was a huge fan of Ultramagnetic MCs and all of Kool Keith's various alter egos, like Dr. Octagon. I was on Canal Street and I saw him in a jewelry store through the window. I had my Hasselblad around my neck and I guess I looked kind of official. So we make eye contact, he kind of gives me this sign that it's OK to come in the store. I walk in, and he's trying on all this jewelry and was like, 'What do you think?' I told him he looked good and the two of us left the shop and went down into the subway where we took all these shots, including this one shot in front of a red wall, which I thought looked really cool. We kicked it for a few minutes and then he jumped on his train and I jumped on mine. I never got to show him these photos."

253

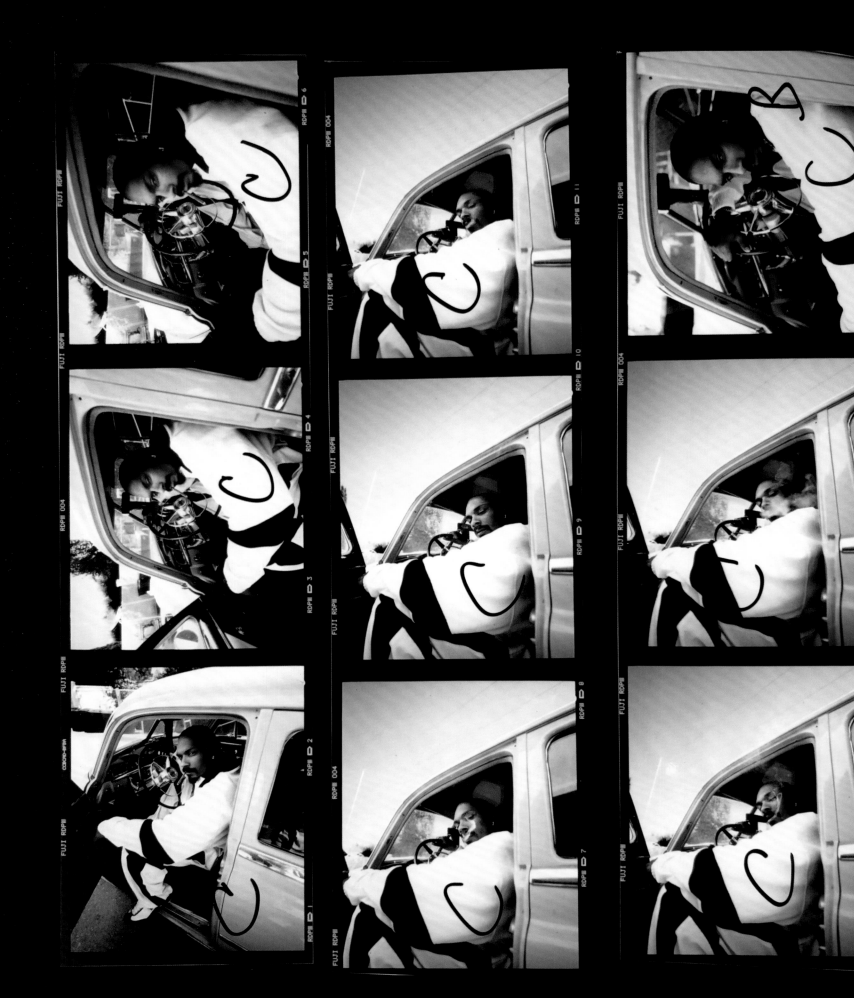

MIKE MILLER

SNOOP DOGG

"Snoop and I have collaborated since 1991, and I always liked to get his input on what shots he liked after we worked together. He would mark up the contact sheets with his initials, either a C or B for his full name, Calvin Broadus. For the cover of *The Last Meal*, we decided to shoot at his house, an hour outside of Downtown Los Angeles. When I arrived, security guards greeted me. I parked and walked up to the door, and Snoop let me in. He introduced me to his wife and his three kids. They were all eating breakfast, so I went back outside to set up a few backdrops. During the shoot, I used a Mamiya 7 camera. Snoop was easygoing and down for whatever. One shot was in a light green 1950s Oldsmobile with old-school white walls. I think he named it Maggie Mae or something? I remember he said it was his favorite ride. It ended up being the shot on the back cover of the album."

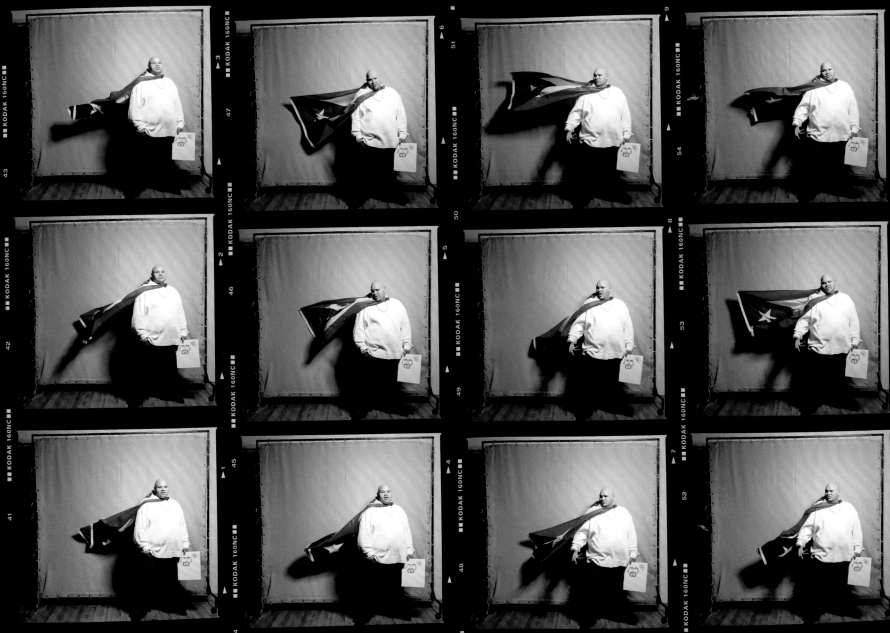

RAY LEGO

FAT JOE

"It was a rare night-shoot and Fat Joe showed up three hours late with over twenty-five people in his posse. Something had just happened and they seemed to be on the 'war path.' They sat around a huge round table and I just got this vibe to stay away for a bit. Eventually, Fat Joe walked on set. He was holding the drawing he made and we were joking that it looked like Mr. Clean or even Dennis Rodman. I remember him saying, 'I been Fat Joe my entire life' but actually, at the time of the shoot, he had slimmed down quite a bit, so we joked that he was now 'Chubby Joe.'

"I wanted the light to fall off hard and look dramatic, so I kept it simple with one large lightbank overhead. I used cutters to knock down the light around him to make him stand out and look 3-D. I used a rolling room divider as my background, and a wind machine to blow the flag. I shot this with my Hasselblad, so each shot feels epic. After around twelve rolls, he and his friends started to loosen up with some really funny banter. After some angle changes, we were done. They left as quickly as they arrived."

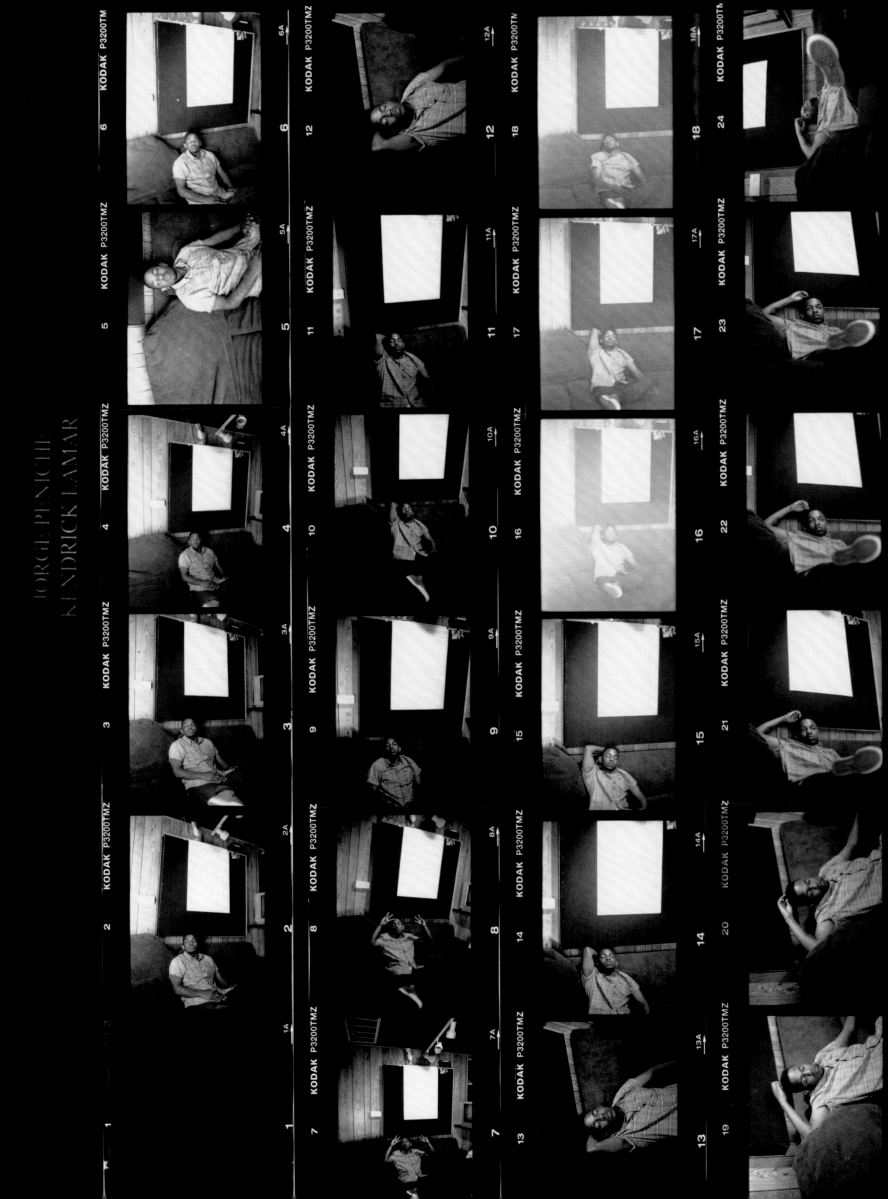

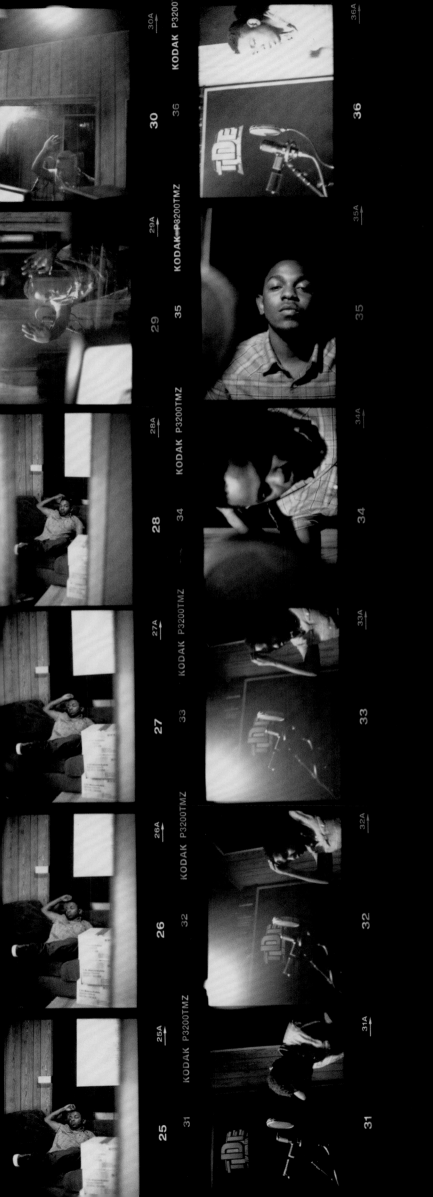

JORGE PENICHE

KENDRICK LAMAR

Before he became Compton's golden son and a Pulitzer Prize–winning artist, Kendrick Lamar was still a local rapper figuring things out and making his way. Jorge Peniche met Kendrick at Top Dawg Studios to shoot these intimate photos.

"I was first introduced to Kendrick through The Game in 2007, and we were part of a relatively small circle in LA hip-hop at the time. At the time, the hottest thing in LA was Kendrick's label mate Jay Rock. Kendrick was still known as K-Dot, and was sort of the hype man for Jay Rock for a while. When Kendrick finally got the platform, he went in on both his music and his visuals. Nowadays, he's known for these very cinematic visual narratives, and you can feel some of that same energy in these early photos.

"I arrived and found Kendrick sitting back on the couch, pensive and in deep focus. I almost didn't want to shoot that moment as he was so still. When he stepped to the mic to record, he kept that pensive concentration. The studio series feels very real, the way artists go through challenges when recording but then push through to ultimately make something great. Kendrick was very self-aware and, photographing him, I knew it was just a matter of time before he made his mark.

"After the studio, we went to Tam's Burgers in Compton. Kendrick was really comfortable there, I think he went there quite a bit. I like how he's looking out at the city or at his reflection in one of the photos. I also learned that his favorite menu item was the chili cheese fries! These photos are very candid and were taken at a time when I had great access to an artist who was about to become a legend in his own time."

Lyrics

I believe MCs make great artists (Eminem, Jay-Z, Biggie, Pac). It's just a matter of knowing the advantages and disadvantages of being a wordsmith in a climate where everyone isn't a wordsmith...

Work Ethics

...Take away Jay's ability to make great songs and you will have one of the hardest working human beings I've ever encountered...his work ethic is a major part of why he's one of the most successful artists ever.

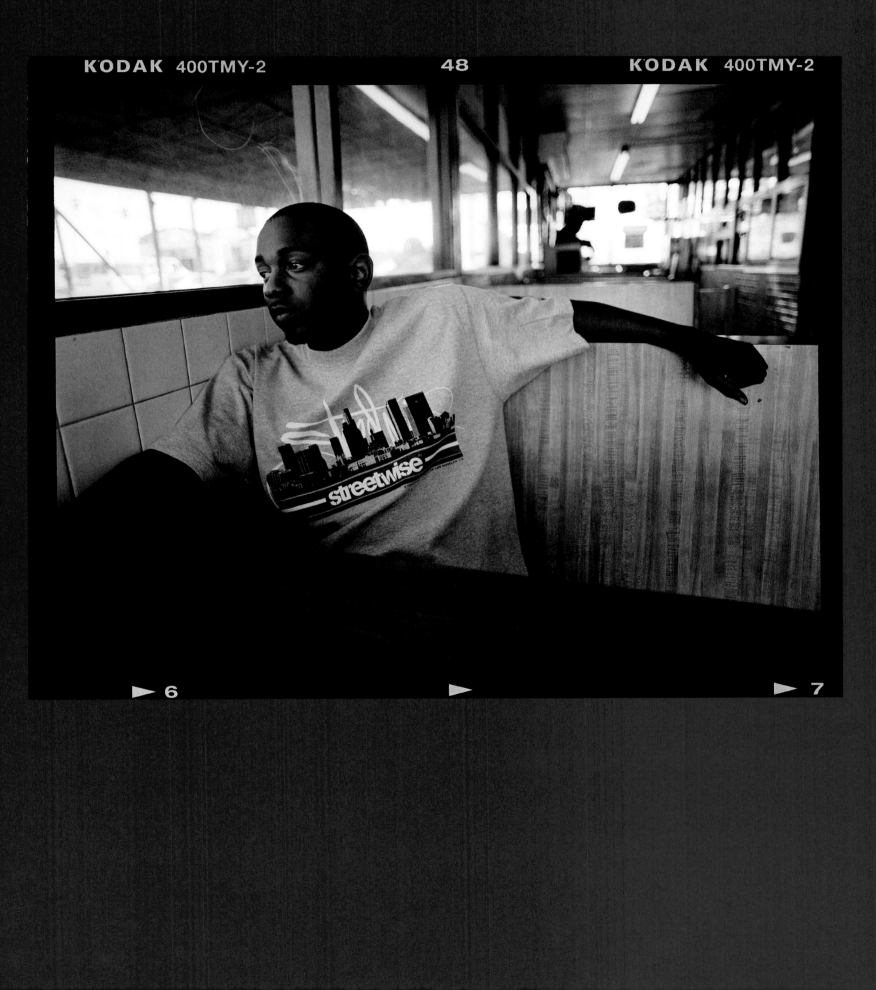

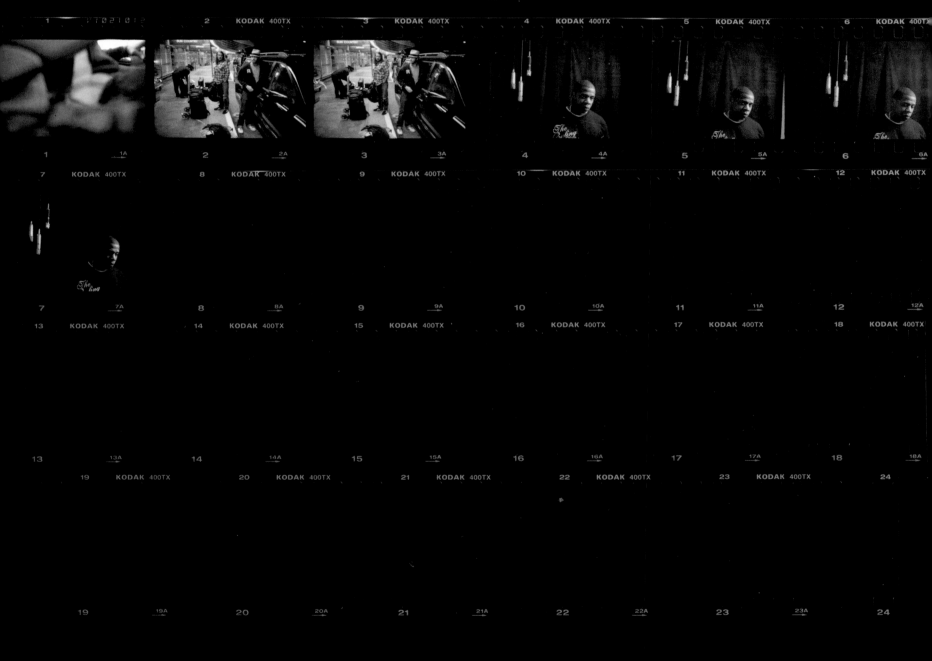

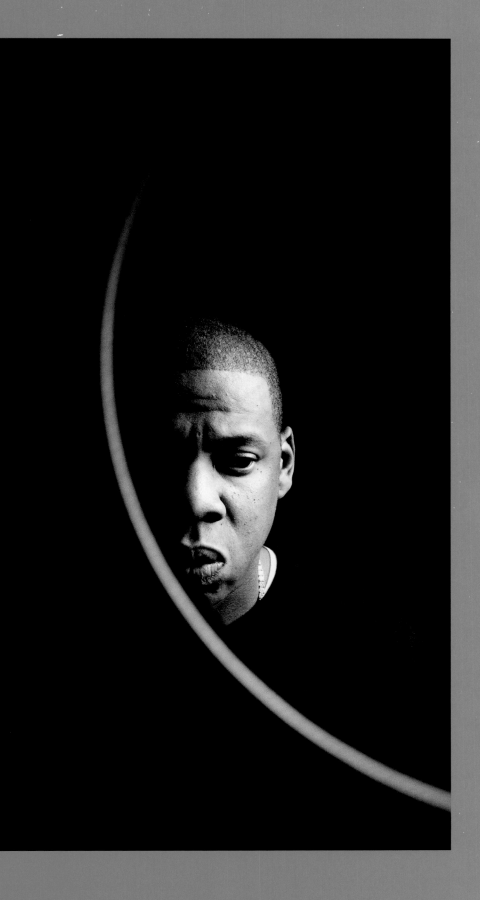

MANHATTAN, 2007

DANNY CLINCH

JAY-Z

"Twelve minutes. That's the amount of time I had with Jay to get this portrait. I know this because this was one of the first projects I shot digitally, so I can see the time code. I went to Jay's recording studio near his office in downtown Manhattan. I had to work with the elements I had in the studio, and one thing I noticed as I was looking around the studio was the spit guard, which reminded me of those classic Blue Note jazz moments which are so timeless and stylistically influential. The spit guard didn't have a screen on it, and I asked the engineer if I could photograph Jay in front of it. I like how moody and cinematic the photo turned out. The studio is a sacred space for artists, so this image speaks to that intimacy."

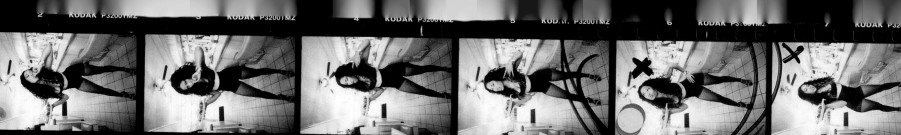

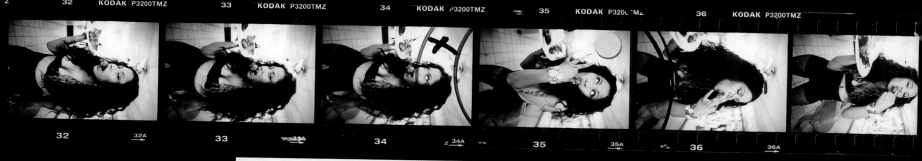

264

BOATWRIGHT

MINAJ

werful women, sexy or more demure,
hey want to be. Honesty and inner
very attractive to me, and Nicki had
this shoot, I wanted to capture Nicki
racing and subverting the male gaze.
ember the name of the diner, unfortu-
e's photo editor, Dionna King, chose
on after Nicki expressed that it was
to her to have the shoot in Queens,
turf. This was Nicki's first shoot for
probably her first feature shoot.

was cool. Down-to-earth. I'm pretty
was on board with my and Dionna's
wanted her to lay on the countertop,
akes, play with syrup—the usual kind
she was down, anytime I asked her to
ing lascivious, she was down.

looking at the proofs now, I can't
andout shot. Every time I look, I see
sane image I hadn't noticed prior."

265

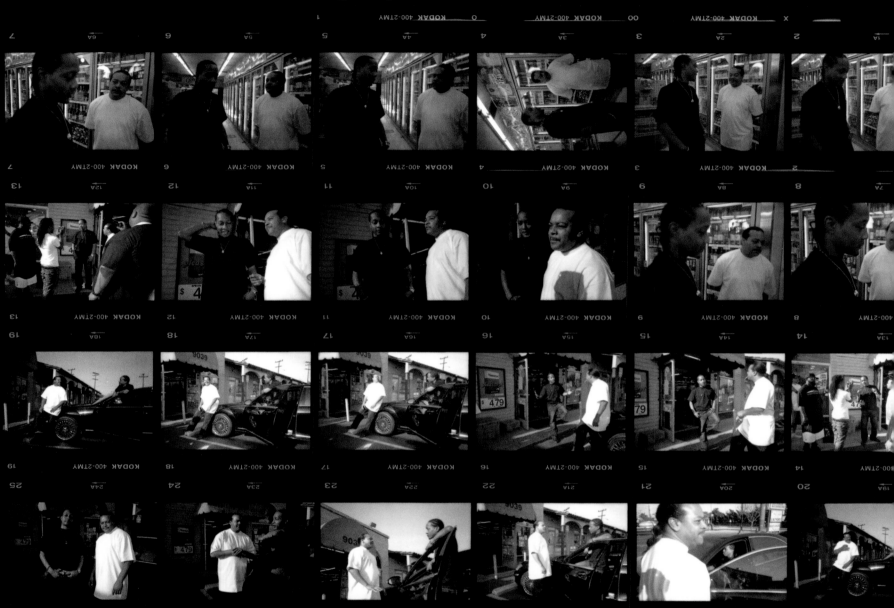
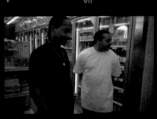

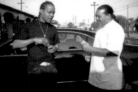
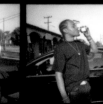

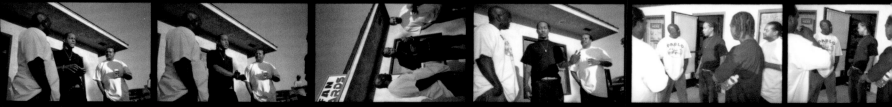
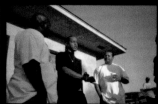
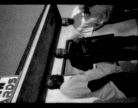
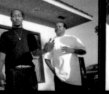
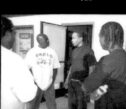

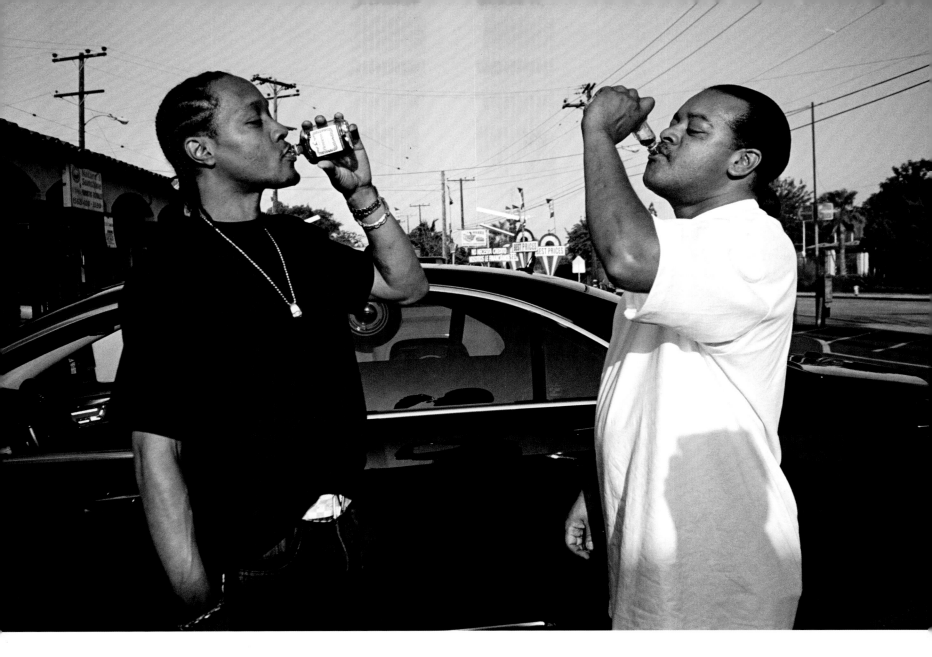

LOS ANGELES, 2010

JORGE PENICHE

DJ QUIK AND SUGA FREE

"Quik is known for putting the West Coast on the map for hip-hop—both as an MC and as a producer. You can feel his influence on the next generation of West Coast artists like Kendrick Lamar, Schoolboy Q, Vince Staples, and Tyler, the Creator. Quik produced Suga Free's seminal album, *Street Gospel*, but this was the first time they were reconnecting after having a bit of a falling-out. The two of them coming back together to work on Quik's album *The Book of David* was a big deal.

"We made a plan to meet up at a hair salon in Paramount near Compton, which was cool since both of them had to get their hair right. Quik perms it out or braids his hair, and Suga Free perms it out. Once they got that out of the way, we drove in Quik's Mercedes S550 to the liquor store, where I got this shot of the two of them kicking back with some Hennessy. Suga Free is a complete jokester, the way he raps in this very 'pimp' style is the way he talks in real life. And he has a way of making people laugh and come out of their shell. Quik, on the other hand, is often serious, but Suga Free was making him laugh all day.

"On the contact sheet, you see Quik and Suga were having fun and just vibing with people at the local store. Quik was wearing black on black with a Louis Vuitton belt, and he had his shirt tucked in to show off the belt. Suga Free was in a white T—a classic, simple West Coast look. I felt a sense of nostalgia when I saw this image on the contact sheet.

"I don't focus too much on the technical elements when it comes to photography. My priority is to make you feel something."

267

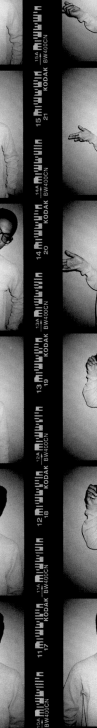
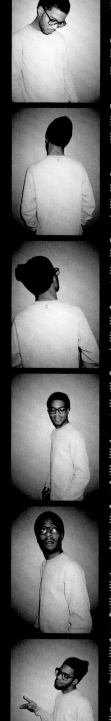

The lighting moved when he moved, so the flash captured him in thought. After about five minutes of all the anti-photo-session antics I could come up with, we were done.

"The contact sheets are beautiful, and when I first saw them I didn't want to even cut them or give them to anyone. It didn't feel like there were any mistakes or outtakes on the roll, it was more like watching a film unfold with each frame related to the next. I shot ten rolls of 120mm and three rolls of 35mm on my Hasselblad 500CM with an 80mm lens, and some with my Contax T3."

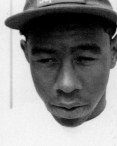

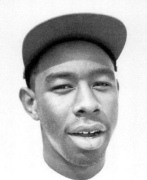

LOS ANGELES, 2011

JORGE PENICHE

TYLER, THE CREATOR

"Tyler had done this video for his song 'Yonkers,' which really put him on the map in Los Angeles. I reached out to him on social media and got to this guy Heathcliff, who coordinated the shoot. He told me, 'Whatever you do, don't try to give Tyler instructions on how to pose or ask him to smile.'

"We linked up in Pan-Pacific Park in LA—which was close to the Fairfax area and other skate places like Supreme and the Hundreds, where they used to skate and hang out. There was a solid white wall on the street and he gave me all these great expressions, I didn't force them out of him.

"Tyler comes from a generation where visuals are so integral to everything he does. Even when he started with Odd Future, he was designing the group's clothing and thinking a lot about the relationship between music and visuals. His music and his whole vibe are really unique, so when I photographed him, it was all about energy and emotion."

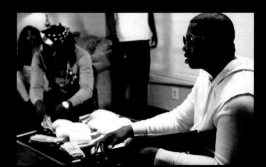

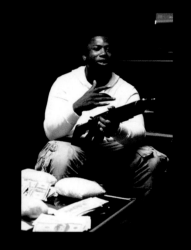
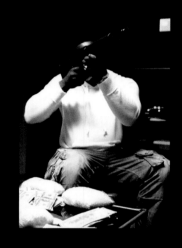
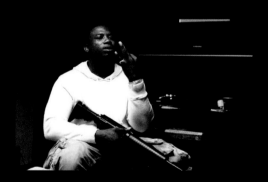
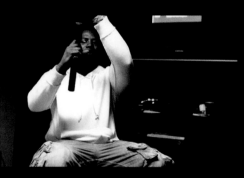
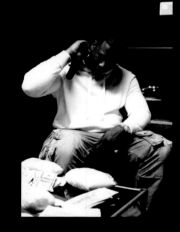
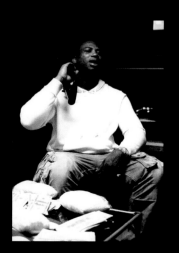

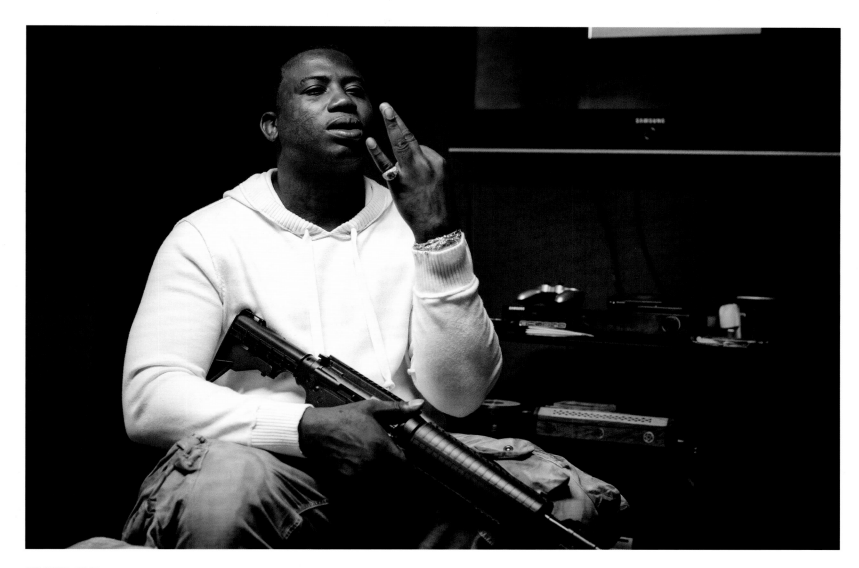

ATLANTA, 2012

CAM KIRK

GUCCI MANE ON THE SET OF THE "SHOOTERS" VIDEO

"I knew Gucci's collaborator Young Scooter pretty well, and he got me onto the set of the 'Shooters' video. These guns and drugs are all just props. When people see this photo without knowing the context and that it was shot for a video, they can get the wrong idea. It definitely looks like there's some crazy stuff going on, but they were just having fun with it, really.

"I later showed Gucci this series of images and he loved them. He used an image from the session for his album *Trap House III*. Right after that album dropped, he went to prison for pleading guilty to a federal firearms charge. I like to capture images of artists in the early stages of their careers, and that's a crucial time to establish trust with a new artist. Part of that is shooting in a style that is reminiscent of an analog shooter. Although I shoot mainly digital, I always take time to get to know who I'm photographing. That has been my approach to documenting the Atlanta rap scene."

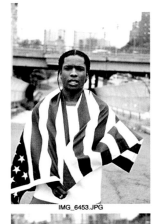 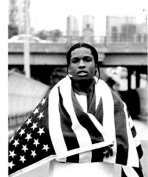 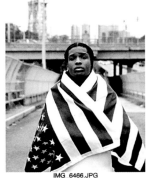 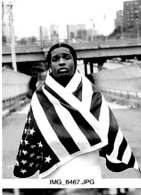 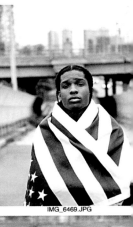

IMG_6453.JPG IMG_6461.JPG IMG_6466.JPG IMG_6467.JPG IMG_6469.JPG

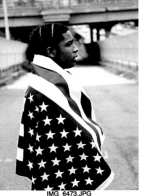 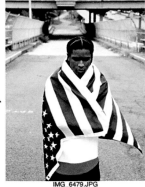 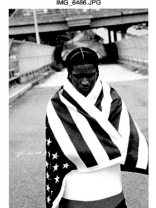 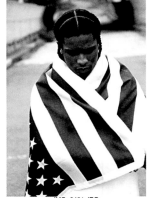 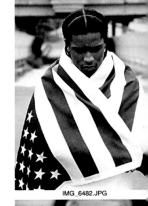

IMG_6473.JPG IMG_6479.JPG IMG_6480.JPG IMG_6481.JPG IMG_6482.JPG

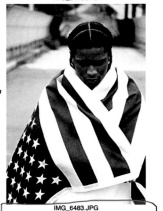 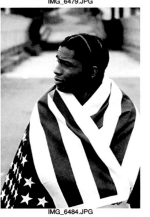 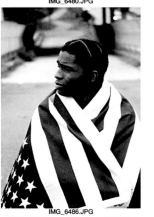 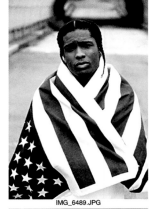 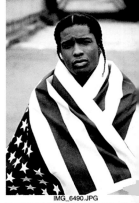

IMG_6483.JPG IMG_6484.JPG IMG_6486.JPG IMG_6489.JPG IMG_6490.JPG

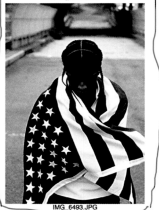 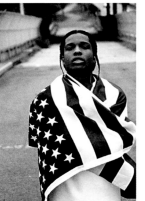 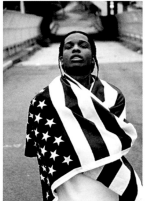 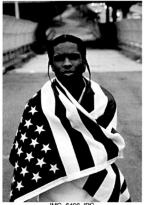 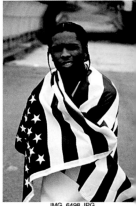

IMG_6493.JPG IMG_6494.JPG IMG_6495.JPG IMG_6496.JPG IMG_6498.JPG

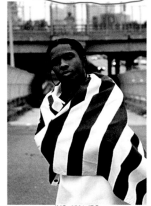 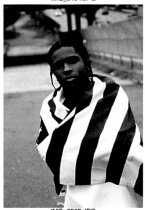 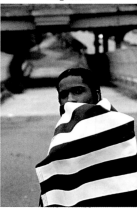 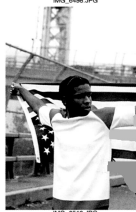

IMG_6501.JPG IMG_6502.JPG IMG_6505.JPG IMG_6506.JPG IMG_6510.JPG

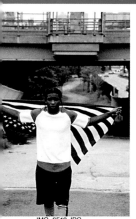
IMG_6513.JPG

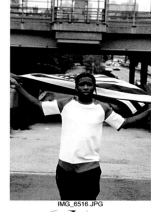
IMG_6516.JPG

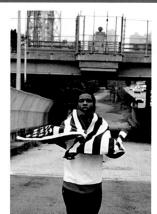
IMG_6519.JPG

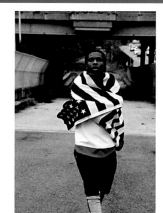
IMG_6521.JPG

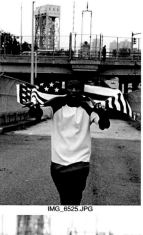
IMG_6525.JPG

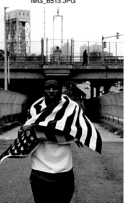
IMG_6526.JPG

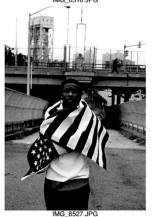
IMG_6527.JPG

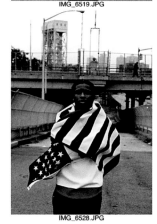
IMG_6528.JPG

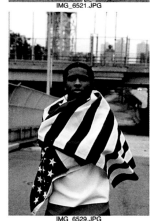
IMG_6529.JPG

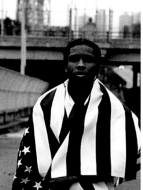
IMG_6530.JPG

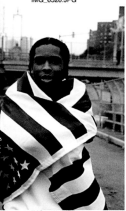
IMG_6534.JPG

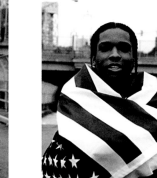
IMG_6535.JPG

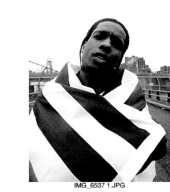
IMG_6537 1.JPG

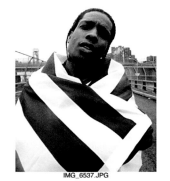
IMG_6537.JPG

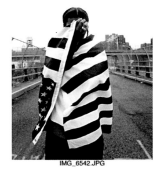
IMG_6542.JPG

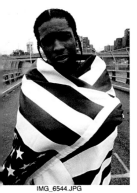
IMG_6544.JPG

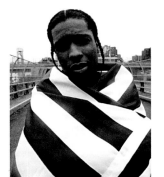
IMG_6545.JPG

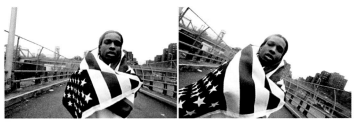
IMG_6555.JPG

IMG_6556.JPG

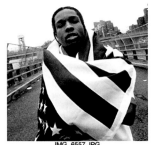
IMG_6557.JPG

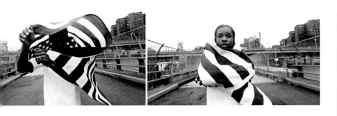
IMG_6572.JPG

IMG_6577.JPG

IMG_6580.JPG

IMG_6591.JPG

IMG_6597.JPG

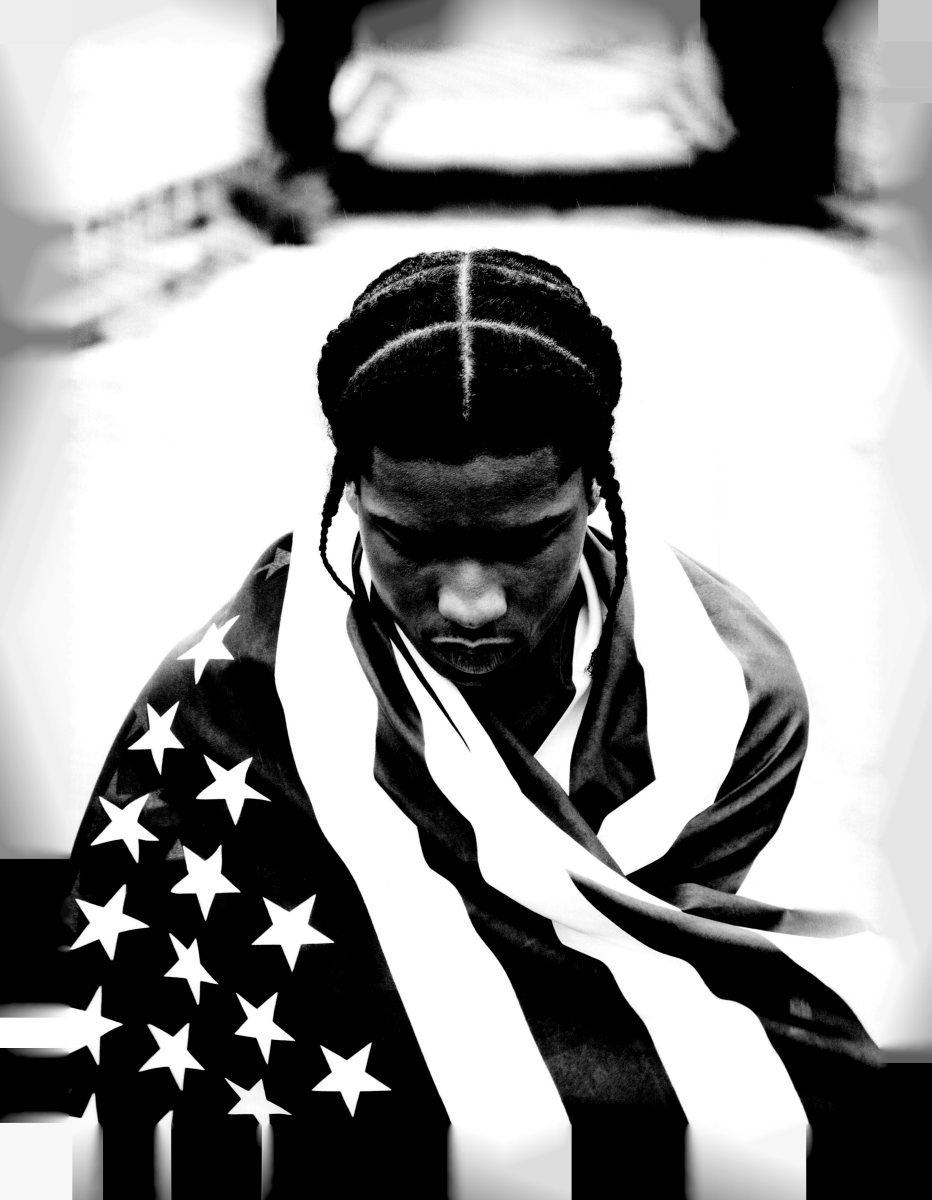

PHIL KNOTT

A$AP ROCKY, *LONG.LIVE.A$AP*

With the transition from film to digital, photographers are adapting to new workflows and a shifting language for hip-hop visual culture. Likewise, the contact sheet has transitioned from a pure working document to a more creative inspiration for sequencing or selection. Photographers now use them in different ways and for different reasons. Some don't even use them at all. But the more things change, the more they stay the same for people on both sides of the lens.

When A$AP Rocky was ready to craft the visuals for his much-anticipated debut, *LONG.LIVE.A$AP*, the creative vision he brought forth signaled a full-circle moment for hip-hop. Rocky's legal name is Rakim Mayers, after the legendary Rakim. There is even a story of the time Rocky's mother spotted the legendary MC stopped at a red light in Harlem, and actually got him to sign baby Rocky's diaper. Hip-hop full circle indeed.

For Phil Knott, creating Rocky's album cover was equally a full-circle moment. For a seasoned photographer who spanned the analog-to-digital transition, photographing a young, defining artist in the same location where, many years prior, the film *Juice* was created, was a reminder that photography serves the larger continuum of storytelling and documenting culture.

"I remember the transition from analog to digital because there was suddenly a whole new set of rules for photographers. Eventually it all became pretty standard, but I still very much think like a film shooter. Everything I've learned to do with film, I've brought with me to the digital world, and I approach shoots the same way I always have. My approach is to get into what a person is about or go to the spots where they're from.

"When I was hired to shoot Rocky's album cover, I decided it was important to shoot with him in his neighborhood in Harlem. I went location scouting along 127th Street, where I met one of A$AP Rocky's boys. We walked around for a while, and I remember there being some talk of a bridge scene from the movie *Juice* that was shot nearby many years earlier. Even though these guys were babies when that film was made, it still resonated with them and had become this stuff of urban lore.

"On the day of the shoot, Rocky showed up with the flag and we moved over to a nearby studio to get the cover photo, which I shot with a Canon 5D. I didn't think anything of him bringing the flag, as it just seemed like a natural statement that he wanted to make. We shot it upside down to signify a state of unrest. Afterwards I worked with Erwin Gorostiza and Chris Feldmann, the art directors at his label, Sony, on the selection.

"As a photographer, it's really special to be a part of an artist's first record. That's something I've always treasured. It reminds me that the role of a photographer doesn't change, regardless of the tools we use. It's still the eye that counts, as well as the composition, the instinct, and that love of looking at people and understanding what they're all about. At the end of the day, it's still about looking."

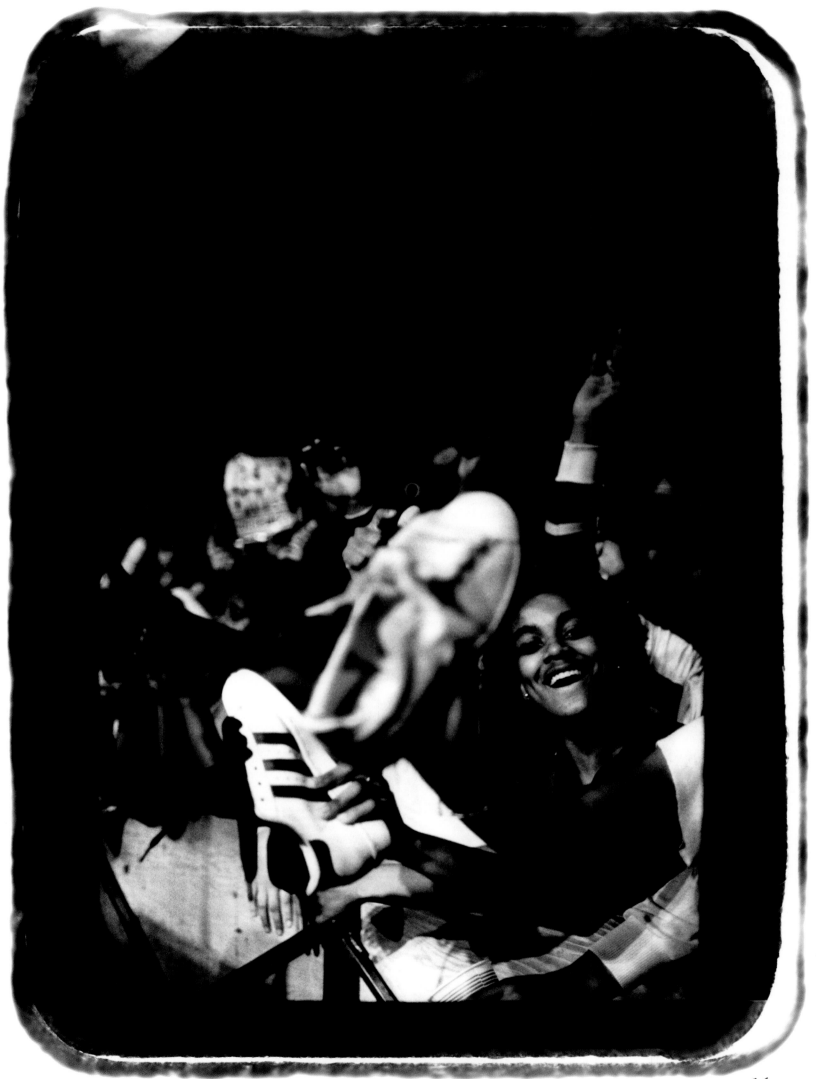

RONDMCPHILLY. LWATSON.86

ACKNOWLEDGMENTS

First and foremost, I am deeply grateful to all the photographers who generously shared their archives and stories with me and to the creative minds who contributed their scholarship to this book. That trust, spirit of collaboration, and mutual respect made this book a testament to what documenting culture means.

A deep and sincere thank you to all the amazing writers, editors, and curators I've had the honor to work with over the years, including most recently at *Mass Appeal* while I researched this book. A heartfelt thank you especially to Sacha Jenkins for the early support, wise words, and sense of humor. The entire *Mass Appeal* team including Rob Kenner, Peter Bittenbender, Roberta Magrini, Brette Graber, Jon Colclough, Mike Steyels.

Jeff Mao, Andrea Duncan Mao, Gabe Alvarez, Noah Callahan Bever, Brent Rollins, Elliott Wilson, Danyel Smith, David Hershkovits and *Paper* magazine, Mickey Boardman, Kim Hastreiter, Bucky Turco, Joseph Patel, S. H. Fernando, Andrew Dosunmu, Andy Breslau, Cey Adams, Brian Coleman, Adjua and Styles P, Sheena Lester, Amy Linden, Freddy Anzures, Tresa Sanders, Lenise Logan, Nelson George, Ilyasah Shabazz, Mark Speltz, Amanda Smith and the Gordon Parks Foundation, Adrian Bartos/DJ Stretch Armstrong, DJ Clark Kent, Nick Quested, Bobbito Garcia, Franklin Sirmans, Trevor Eld, Jeff Chang, Ala Ebtekar, Max Glazer, Faith Newman, Michael Gonzales, Havelock Nelson, Yolanda Ross, Kris Ex, Siba Giba, Rob Aloia, Sohail Daulatzal, Sultan Al-Qassemi, Jessica Stafford Davis, Henry Thaggert, CeCe Chin, Carl Weston, Cristina "Dulce" Veran, Steve Chaggaris, Michael Pollack (special thanks!), Rob "Reef" Tewlow, Matty C, DJ Enuff, Darren Gold, Charlie James, Anthony Geathers, David "Dee" Delgado, Brent Lewis, Andre D. Wagner, Photo Rob Mayer, Lucian Perkins, Esther Anderson, Mark Ronson, Bill Spector, Bugsy, Maggie McCormick, Rob Aloia, Julie Grahame, Koe Rodriguez, Khalik Allah and 365 exposures.

Payday Records/Empire Management massive: Patrick Moxey, Neale Easterby, Dino Delvaille, Richard Ramsey, Shani Saxon, Tracii McGregor, Sarah Honda, Gordon Franklin, Panchi, Big Shug, Jeru, Dap and Malachi, Phat Gary, and Mr. Dave, and supreme love to the Elam family.

Glenda SanPedro, Leto Rankine, Eric Smith (Detroit crew), Northgate apartments and Lincoln Towers, caseworkers, Horizons Upward Bound, Focus Hope.

Laura and David Krane, Olana and Zain Khan, Heidi Abrams, Shona and Alex Macgillivray, Dena Muller, Kara Meyers, Carl Saytor at Luxlab, Duron Jackson, Jennifer Samuel, Barry Michael Cooper, Emz, Bonz Malone, Chi Modu, Narisa Ladak, Mohamed Somji, Raj Malhotra, Barry Cole, Javier Starks, John Seymour and Sweet Chick, Abdul Abdur-Rahman, Sadie Barnette, Casey Stickles, Ipe Kgositsile, Adrian Loving, Kevin Powell,

Bill Bernstein, FOTODC and Svetlana Legetic, Sophie deRakoff and Kevin Bray, Nell's (Jessica Rosenblum, Basil, Belinda Becker, Lucian, Darry Dismond, Andrea Richter, Stan Williams, and all the party people).

Nobuyoshi Araki, Daido Moriyama, Masahisa Fukase, John Gossage, Nan Goldin, Gil Scott-Heron, The Last Poets, Stephen Shames, Nick Haymes, and Lena at Little Big Man Gallery.

Syreeta Gates for your dedication to archiving hip-hop culture and your help in this book.

Alexandrea Silverthorne, Kristie Chua, Jasper Kange for the design eye, James McDonough, Dapper Dan, Sybil Pennix, Misa Hylton, Groovey Lew, April Walker, June Ambrose—fashion architects of a very specific visual legacy.

I want to especially acknowledge Anne Kristoff, friend, ally, and the brains behind the operation for your advice and support of the project.

A heartfelt thank you to Monika Woods, my book agent, for your guidance and support; the fantastic team at Clarkson Potter: Jenni Zellner, my awesome editor who never cracked under pressure, for your brilliance and commitment to this story; Jennifer Wang and Stephanie Huntwork for the design vision; Robert Siek, Philip Leung, Natasha Martin, and Kevin Sweeting for you enthusiasm and commitment to this project.

The good folks at Photoville: Sam Barzilay, Laura Roumanos, and Dave Shelley. A huge thank you to Gary Harris (r.i.p.) for your razor sharp instincts and sincere encouragement, and for firmly believing in this book from the jump; Allena Willis for being an amazing wingman; Bijan, Irina Tikhonova, Lydia Tobak; and to my deepest heart and soul: Nick and Cam.

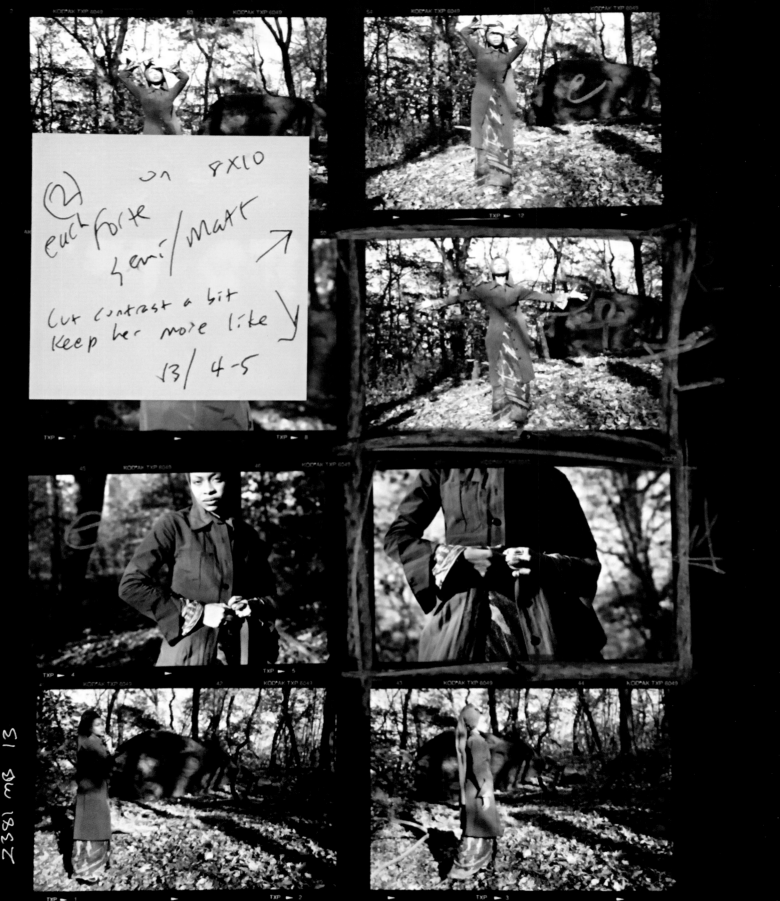

INDEX

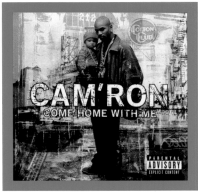
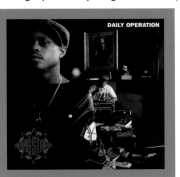

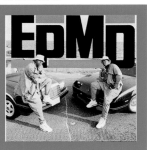
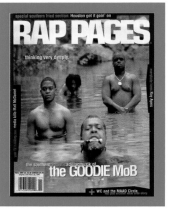

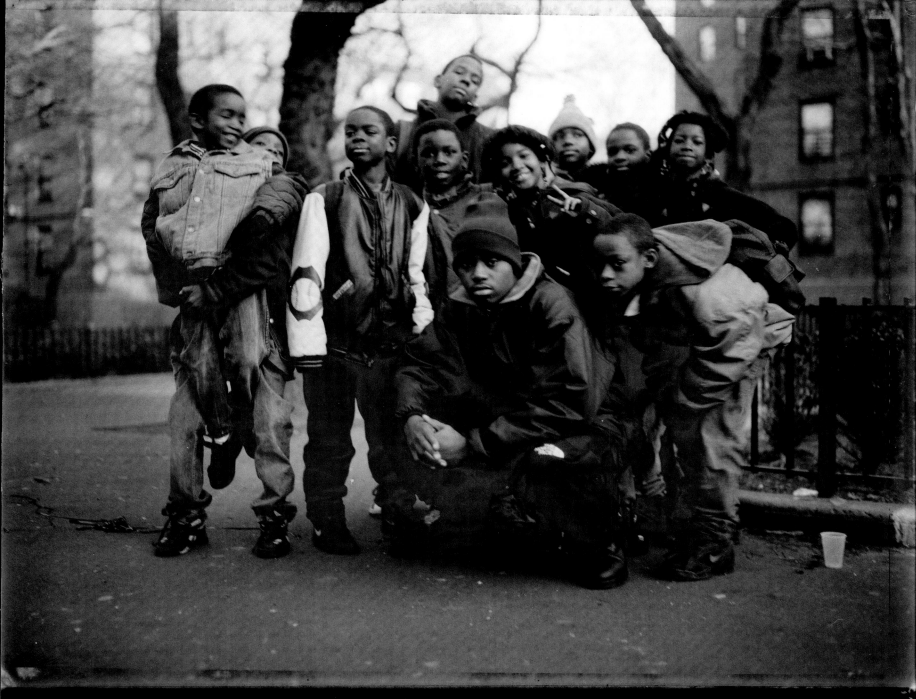

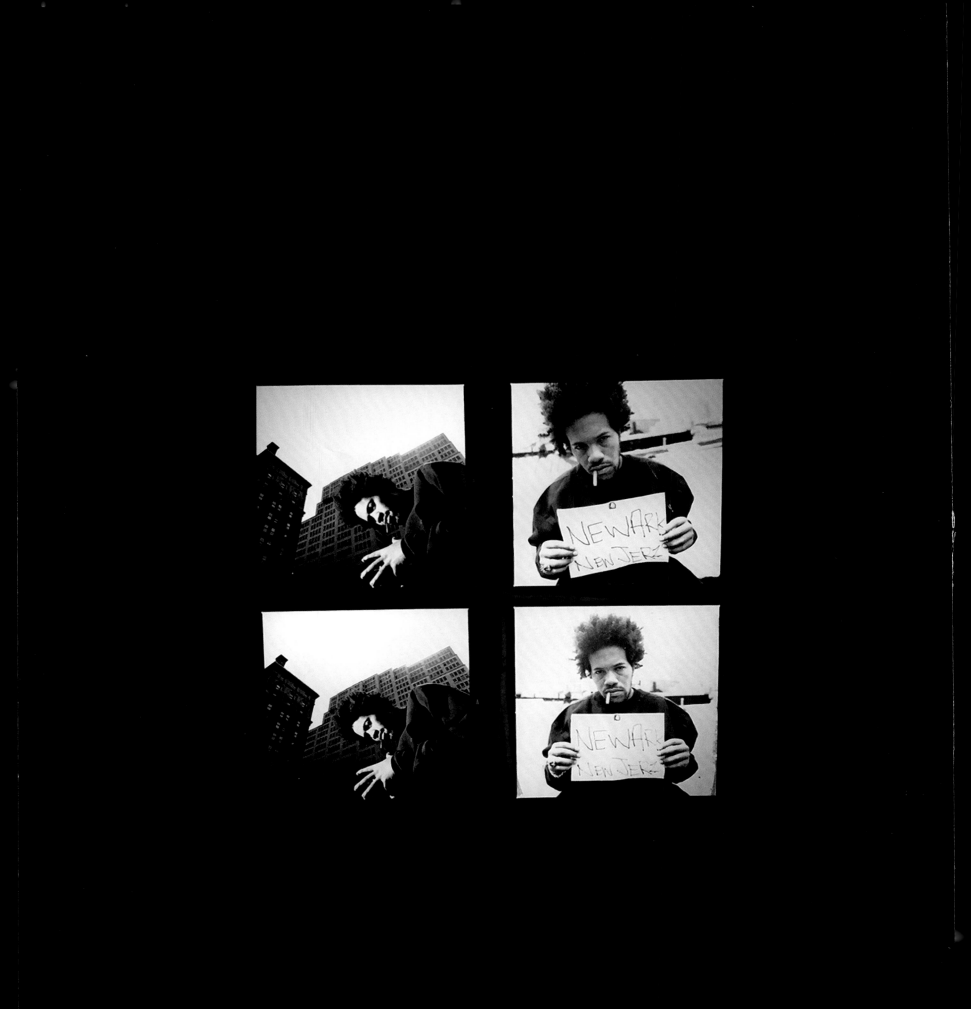

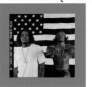
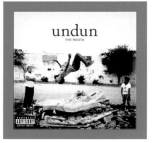

ABOUT THE AUTHOR

VIKKI TOBAK is a journalist whose writing has appeared in *The Fader, Complex, Mass Appeal, Paper, i-D, Vibe,* the *Detroit News, The Undefeated, Red Bull Music Academy Daily,* and many others. She is a former producer and columnist for CNN, CBS MarketWatch, Bloomberg News, and other leading media organizations. Vikki is also the founding curator of FotoDC's film program and served as a commissioner for the Palo Alto Public Art Commission in Silicon Valley. She has lectured about music photography at American University, VOLTA NY, Photoville, and the Museum of Contemporary Art Detroit.